CULTURAL

STUDIES

Volume 10 Number 1 January 1996

In the ten years since this journal was founded, the field of cultural studies has expanded and flourished. It has at once become broader and more focused, facing as it does the challenges of global economic, cultural and political reconfiguration on the one hand, and of new attacks on the university and intellectual work on the other. As we look forward to the next decade, we expect *Cultural Studies* to continue to contribute to both the expansion and the integration of cultural studies.

With this expectation in mind, the journal seeks work that explores the relation between everyday life, cultural practices, and material, economic, political, geographical and historical contexts; that understands cultural studies as an analytic of social change; that addresses a widening range of topic areas, including post- and neo-colonial relations, the politics of popular culture, issues in nationality, transnationality and globalization, the performance of gendered, sexual and queer identities, and the organiz-ation of power around differences in race, class, ethnicity, etc.; that reflects on the changing status of cultural studies; and that pursues the theoretical implications and underpinnings of practical inquiry and critique.

Cultural Studies welcomes work from a variety of theoretical, political and disciplinary perspectives. It assumes that the knowledge formations that make up cultural studies are as historically and geographically contin-gent as any other cultural practice or configuration and that the work produced within or at its permeable boundaries will therefore be diverse. We hope not only to represent this diversity but to enhance it.

We want to encourage significant intellectual and political experimenta-tion, intervention and dialogue. Some issues will focus on special topics, often not traditionally associated with cultural studies. Occasionally, we will make space to present a body of work representing a specific national, ethnic or disciplinary tradition. Whenever possible, we intend to represent the truly international nature of contemporary work, without ignoring the significant differences that are the result of speaking from and to specific contexts, but we also hope to avoid defining any context as normative. We invite articles, reviews, critiques, photographs and other forms of 'artistic' production, and suggestions for special issues. And we invite readers to comment on the strengths and weaknesses, not only of the project and progress of cultural studies, but of the project and progress of *Cultural Studies* as well.

Lawrence Grossberg
Della Pollock

January 1996

Contributions should be sent to Professor Lawrence Grossberg and Della Pollock, Dept. of Communication Studies, CB #3285, 113 Bingham Hall, The University of North Carolina at Chapel Hill, Chapel Hill, NC 27599-3285, USA. They should be in triplicate and should conform to the reference system set out in the Notes for Contributors. An abstract of up to 300 words (including 6 keywords) should be included for purposes of review. Submissions undergo blind peer review. Therefore, the author's name, address and e-mail should appear *only* on a detachable cover page and not anywhere else on the manuscript. Every effort will be made to complete the review process within six months of submission. A disk version of the manuscript must be provided in the appropriate software format upon acceptance for publication.

Reviews, and books for review, should be sent to Tim O'Sullivan, School of Arts, de Montfort University, The Gateway, Leicester LE1 9BH; or to John Frow, Dept. of English, University of Queensland, St Lucia, Queensland 4072, Australia; or to Jennifer Daryl Slack, Dept. of Humanities, Michigan Technological University, Houghton, MI 49931, USA.

CONTENTS

SABA MAHMOOD

CULTURAL STUDIES AND ETHNIC ABSOLUTISM: COMMENTS ON STUART HALL'S 'CULTURE, COMMUNITY, NATION'[1]

ABSTRACT

The author argues that despite the recent intellectual opening characterized by the institution of cultural and postcolonial studies, certain parts of the world (such as the Middle East, Eastern Europe) and social movements (such as politico-religious and ethnic) continue to occupy the paradigmatic status of backward cultural Others in the ruminations of writers from the left and right of the political spectrum. Taking S. Hall's essay 'Culture, community, nation' that appeared in the October 1993 issue of *Cultural Studies* as a template, the author shows how arguments made with a progressive political agenda sometimes converge argumentatively and epistemologically with those of the conservative right in their failure to decenter normative assumptions derived from the entelechy of Western European history about ethnic and religious aspirations. Illiberal results of profoundly liberal ideologies, such as nationalism, continue to be explained through culturally particularistic arguments so as to avoid critiquing the fundamentals of Western European liberal–humanist projects. Symptomatic analyses that explain the success of ethnic and politico-religious movements as signs of socio-cultural disorder, cultural backwardness and/or lack of appropriate modernization fail to take these movements seriously: that must be dealt with through argumentation. Both the critics and champions of modernity take the West as their point of departure, and political languages that depart from the recommended repertoire of public expression are often dismissed. The author calls for a historically specific and culturally nuanced analysis of movements that are often considered to be the antithesis of modernity in order to both parochialize the Western experience of modernity, and to understand the significance of these movements to the present historical moment.

Cultural Studies 10(1) 1996: 1–11

KEYWORDS

Stuart Hall; ethnic; religious; nationalism; history; modernity

Stuart Hall's 'Culture, community, nation' in the October 1993 issue of *Cultural Studies* seems to capture the suspicion and dismissal with which most intellectuals of widely divergent political persuasions treat contemporary social movements (in regions as disparate as Eastern Europe, Central Asia and the Middle East) inspired by religious, ethnic and nationalist affiliations, without investigating the historical, political and economic particularity of each case. As someone who has respect for Stuart Hall's erudition and commitment to critically progressive politics, it was with some alarm that I read what may best be described as a division of the world yet again into 'big and small' nations, culturally backward absolutist regions, and by implication civilized areas, as a means to explain the rise of ethnic and religious movements around the world. Such characterizations evoke modernization theory paradigms that felicitously explained the Janus-faced character of modernity, global capitalism and nationalism as simply matters of cultural misfit between the best intentions of such projects and the unfortunate consequences that seemed to follow in large parts of the world. Whereas analyses of this kind are rather widespread in popular and most academic journals, the recent intellectual opening characterized by the institution of cultural, postcolonial, subaltern and feminist studies, etc., has given one reason to believe (perhaps falsely) that positing the essential backward nature of cultures as explanations for any kind of political development is *passé*. Yet, as a student of politico-religious movements, I am quite troubled at the stubborn persistence with which certain areas of the world continue to occupy the paradigmatic status of backward cultural Others in the ruminations of intellectuals from the left and right of the political spectrum.

There is, of course, a personal aspect to my engagement with Stuart Hall's text, and it is best clarified at the outset. As a feminist activist in the United States and Pakistan under the US-supported militarist-theocracy of Zia ul-Haq, I have resonated in recent years with Stuart Hall's reconceptualization of a Gramscian vision of political struggle and the relevance of progressive intervention on multiple cultural fronts. Yet as a student of Islamic movements in the context of late-capitalist modernity, I was taken aback by characterizations in his article such as 'political cultures with strong ethnic and religious absolutist traditions' and 'species of *fundamentalism* every bit as backward-looking as those to be found in some sections of the Islamic world' (1993: 355, 358). Since Pakistan may easily fit Hall's schema, I had to ask: could Pakistani society, often characterized as a 'fundamentalist Islamic state', be analyzed by its 'ethnic and/or religious absolutist tradition', or would it be more accurate to take into account the cynical and opportunistic character of contemporary warfare and politics that made Pakistan into a front-line state for the geo-political game between the US and USSR, thereby making political opposition to

Zia ul-Haq's regime difficult if not impossible? It is quite surprising that someone with Hall's familiarity with attempts to legitimize racist practices in Britain, through similar arguments of 'cultural backwardness', could revert to such forms of argumentation. In fact it is precisely because of Hall's particular political positionality, and the respect I have for his work that it became all the more important to understand why and how certain forms of reasoning, despite the best intentions to hold progressive ideals, slip into ideological constructions of Other cultures.

In what follows I will treat Stuart Hall's aforementioned article as a template to work through what seems to me a curious paradox: how is it that arguments made with a progressive agenda converge epistemologically and argumentatively with those of the political right, perhaps unintentionally, in their failure to decenter normative assumptions derived from the entelechy of Western European history about the political aspirations of ethnic, nationalist and/or politico-religious social movements? And despite our renewed commitment to cultural difference, what are the political and cultural limits that seem to police our engagement with difference? Finally, how do these conceptual limits obfuscate, rather than clarify, our understanding of the new social movements occurring in large portions of the world today? These are some of the questions that will guide me as I outline Hall's argument, and comment on the significance of the political baggage that his analysis seems to carry.

Big and small nations

Hall begins with a tribute to the late Raymond Williams, and moves on to discuss the revival of 'nationalisms in *big and small societies* and the aspirations of marginalized peoples to nationhood', issues that have become a hallmark of the late modern world in the 1990s (1993: 352; emphasis added). Hall correctly notes that instead of the increased homogenization and cosmopolitan consciousness that discourses of modernity (in their capitalist and socialist forms) had predicted, particularistic attachments (e.g., to nation, culture and religion) have been on the rise. He traces the impetus behind this revival to the paradoxical logic of global capitalism, insomuch as it encourages particularistic loyalties to national cultures and states while at the same time generating transnational global imperatives that impel regional economies toward integration through capital, commodity and human migrations (354). Two parallel features that Hall considers characteristic of this development are: 'the re-valorization of smaller, subordinate nationalisms and movements for national and regional autonomy' by groups dominated by the 'big nation-states', and the concomitant 'growth of a defensive reaction by those national cultures which see themselves threatened from their peripheries' (354). To elucidate the former tendency, Hall gives the example of ethnic movements in Eastern Europe and Central Asia that had previously been 'submerged' under the 'supernationalism' of the Soviet Union. The white supremacy

movements in France and Germany, and the formation of the Northern League in Italy serve as examples of the latter.

Even though Hall acknowledges the linked and parallel development of 'ethnically pure' nationalist movements in Western Europe and the non-Western world, he is careful to distinguish them, first, by the division of big and small nationalisms:

> The drive to nationhood in many of the 'ascending' small nationalisms can often take the form of trying to construct ethnically (or culturally, religiously, or racially) closed or 'pure' formations in the place of older, corporate nation-states or imperial formations; a closure which comes, in Gellner's terms, from trying to realize the aspiration, which they see as the secret of success of the great modernizing nation-states of Western modernity, of gathering one people, one ethnicity, gathered under one political roof.
>
> (Hall, 1993: 356)

Hall's use of the 'big and small nations' trope merits some attention. One may ask what makes certain nations small and others big? Certainly it is not an indication of the size since, we can assume, Britain would qualify as a big nation. Is Japan a big nation or a small one? It seems that the big and small nomenclature is an ideolgical distinction that indicates some sense of superiority of the big nations in relation to the small ones, usually achieved either through colonial domination of other nation(s), or (inter)national economic domination, or both (some would argue one is not possible without the other). It also follows from Hall's argument that, at the very least, small nationalisms are imitative of the big nation-building strategies, but gravely mistaken in their strategic endeavors to ascend the global ladder. Hall does not indicate what the appropriate behavior would be for 'small nations' to be successful in their emulation. More significantly, one may ask why the histories of various nations/peoples must be seen through the singular lens of Western European dynamics (small nations aping the big ones) in order to understand the socio-political realities of cultures that have radically different historical dynamics and socio-political projects? This form of analysis utilizes Western European history as a silent but privileged referent to all social and political developments in the non-Western world, and any departure from the pre-determined script cannot *but* point to the 'failings' of such societies to abide by the prescribed behavior.

Hall seems to be heir to a longstanding tradition of argumentation in which the 'small and big nation' trope is coterminous with other parallel distinctions such as traditional/modern, savage/civilized, East/West, etc. Anthropologist Ernest Gellner, to whom Hall refers, is only one of the authors of this tradition. Among others are Hans Kohn, John Plamenatz and Elie Kedourie – all of whom were major figures in the debate on nationalism through the 1950s and 1970s. In an attempt to come to terms with the illiberal effects of a profoundly liberal ideology, there was an

outpouring of literature to explain how human tragedies such as that of Nazism in Germany, fascism in Italy and Spain, and the two world wars were acted out in the name of nationalism. A distinction was drawn between the 'good nationalism' of the Western European variety and the 'bad nationalism' of the Eastern European, German, Asian and African kind, in order to preserve pristine and idealized notions of human-liberalism, and blame the contradictions germane to this ideology on the deviancy and immaturity of Other cultures. Hans Kohn wrote:

> In the modern West, nationalism which arose in the eighteenth century, the Age of Enlightenment, was predominantly a political movement to limit governmental power and to secure civic rights. Its purpose was to create a liberal and rational civil society representing the middle-class and the philosophy of John Locke. When nationalism ... penetrated to other lands – central and Eastern Europe or to Spain and Ireland – it came to lands which were in political ideas and social structure less advanced than the modern West.
>
> (Kohn, 1965: 29–30)

Kohn continued to expand this line of argument to discuss how Germany, Asia and Africa were to persist in hijacking the well-intentioned project of nationalism through human history. Kedourie made a similar argument by distinguishing between 'patriotism' versus 'nationalism': the former described the civilized behavior of Western European nations, whereas nationalism appropriately captured the divisive and xenophobic character of the non-Western peoples' struggles for nationhood (Kedourie, 1960: 73–4). John Plamenatz further amplified the distinction between Western and Eastern nationalism, whereby the former was synonymous with the liberal ideals of the Enlightenment, and the essence of the latter was represented in the history of the Balkans and the rest of Eastern European cultures still besought with kinship, religious and territorial loyalties (Plamenatz, 1976). Gellner expanded this argument in his now classic book *Nations and Nationalism*, and argued that world cultures were of two varieites: 'savage/wild' and 'cultivated/high'. Whereas the 'cultivated or garden cultures' were intrinsically equipped to carry out the project of statehood in their 'complexity and richness, most usually sustained by literacy and by specialized personnel', the wild cultures tended to get mired in ethnic or nationalist conflicts in their attempts to emulate the process of statehood (Gellner, 1986: 50–1). This is a genealogy derived from Morgan and Tylor's social evolutionism, which also influenced the writings of Marx and Engels. Predictably, Gellner included Eastern Europe, Central Asia, Africa and the Middle East as representative of the 'savage culture' typology. In various renditions of the same theme, he has expanded his repertoire to include terms such as 'folk' and 'little' traditions to signify the savage cultures, and 'high/industrial/modern' cultures to signify the cultivated kinds.

Good and bad social movements

Clearly Stuart Hall, having experienced and written about the logic of racism as one incarnation of the high/low culture division, would not be sympathetic to the arguments listed above – his agreement with Gellner notwithstanding (1993: 354, 355). Yet elements of this kind of reasoning are ineluctably central to Hall's thesis, and alert one to the power and influence such arguments carry in their persistence to reappear in the most unlikely of places. Consider, for example, the distinction Hall makes between nationalist struggles of the decolonization era and those being waged currently in different regions of the third world, in an attempt to show that nationalism can be put to progressive or reactionary uses:

> The nationalism of, say, 'Third World' countries in the era of de-colonization, which were produced as the counter-discourses to exploitation and cultural colonization and linked with critical cultures and political traditions, had a very different political meaning and trajec-tory from those which have been generated as the historical reaction against imposed state socialism *but which have reappeared in political cultures with strong ethnic and religious absolutist traditions.*
>
> (Hall, 1993: 355; emphasis added)

Hall is clearly referring here to Central Asia and Eastern Europe as regions under the Soviet sphere of influence. One is compelled to ask, especially given the tradition of scholarship discussed above, why these cultures should be considered ethnically and religiously absolutist? Is there some-thing pathological that confers this status in them? It is significant that these areas are non-Protestant in their religious orientation: primarily Catholic, Orthodox Christian and Muslim. To distinguish Anglo-Saxon projects and the institutions of Western Europe from those of Eastern Europe and the non-Western world is an old and familiar modernist ploy, so as to deflect fundamental critiques of liberal-humanist ideological frameworks. Samuel Huntington echoes this sentiment in a recent article in which he argues that, after the end of the Cold War, it is the cultural division of Europe into Western Christianity, Orthodox Christianity, and Islam that is the most significant dividing line along which future global conflicts will be waged (1993: 30). Central to these discussions of non-Protestant areas is the assumption that it is the imbrication of religion with politics that gives rise to 'absolutist' practices in its intolerance of differ-ence. Yet if we were to examine human history we would realize that it is the secular, modernizing states in the last two centuries that have instituted the most intolerant and genocidal operations, and this record remains unmatched when it comes to the violence committed in the name of re-ligious and ethnic communities. Prejudice and bigotry have persisted despite the legalistic separation of religion and the state in most of contem-porary Western Europe and the US.

It is, however, apparent from Hall's work on Afro-Christian Rastafarian practices in Jamaica (1985) that he does not insist that the Anglicized conception of privatized religion be made a condition of modernity for *all* cultures regardless of their respective histories and traditions. He insightfully analyzes the creative character and polyvalent symbolism of Rastafarian religious discourse, and considers it capable of generating or influencing a variety of political projects. Hall's careful discussion stands in contradistinction to popular images of Rastafarianism as an escapist and hedonistic form of political protest. It is puzzling, therefore, that he neglects an equally amenable inquiry into other religio-cultural traditions and dismisses them through invocations of cultural backwardness. It may be that Hall's sympathy towards Rastafarianism *and* for decolonization movements is similar insomuch as both are judged to be politically progressive and 'produced as the counter-discourses to exploitation and cultural colonization and linked with critical cultures and political traditions' (1993: 355). While I can respect Hall's desire to support certain causes over others, it does not however follow that the movements he does *not* support are any less resistive to 'exploitation and cultural colonizations' than the one he *does* uphold, or that they do not belong to 'critical cultural and political traditions'.

The Islamic movement in contemporary Algeria is a case in point: it belongs to a long tradition of anti-colonial struggle and Islamic critique, and is opposed to both Western political and cultural hegemony and socialist-styled statist rule. We may choose to differ with the political goals and strategies of the Islamists in Algeria (and there are a variety of positions among them), but any simple labelling of complex socio-political movements only serves to accentuate ahistorical readings of politico-cultural traditions that have acquired a paradigmatic status of the regressive irrational Other in discussions on standards of progressive behavior. Appeals to systems of morality and justice have historically been made on the basis of a wide range of socio-political ideologies, and bigotry comes in a variety of guises; consider the divergent trajectories of and sympathies for Catholicism in colonial Latin America and liberation theology more recently.

Furthermore, it is quite apparent that ethnic, politico-religious and nationalist movements have been able to apprehend people's goals and aspirations, in various parts of the world, in ways that socialist or left-liberal politics have failed to do in the present historical moment. If we are unwilling to dismiss the large number of participants as delusional in their support of these movements then, I would contend, it is of paramount importance that we debate and engage with the specificity of their arguments in order to assess the potential, creativity and/or danger of such projects to progressive politics. Symptomatic analyses that explain ethnic and/or politico-religious movements as signs of socio-cultural disorder and/or persistence of cultural backwardness fail to take them seriously as political challenges that must be dealt with through argumentation. As Hall conveys in his analysis of late-Thatcherite Britain, left and socialist

constituencies need to connect with the feelings and experiences of ordinary people who supported Thatcherism, and rearticulate their lives in progressive idioms so as to displace the hegemony of Thatcherism and its incarnations – in short to argue and engage with the specificities of people's apprehensions and ideals (1988: 170–1).

Partially and fully modern cultures

Hall's characterization of certain modes of resistance as foreign to the enterprise of modernity is best expressed in another key distinction he makes between 'big versus small' nations. Hall contends that while 'fundamentalisms which are afflicting "modern" national cultures are not only arising from the very heart of modernity' (e.g., the white supremacists in Europe, Protestant fundamentalists in the US), movements described as a 'species of *fundamentalism* every bit as backward-looking as those to be found in some sections of the Islamic world' are 'often ambiguous responses by those *either left out of "modernity" or ambiguously and partially incorporated* in one of its many forms' (e.g., Serbian nationalism, Islamism, etc.) (1993: 358; emphasis added). Hall does not clarify how these movements are only partially modern, and in what ways they are 'fundamentalist'. I would argue that to reduce a wide range of socio-political movements (in Germany, France, Eastern Europe, Central Asia and parts of the Islamic world) to a substratum of religious dogmatism and political conservatism, subsumed under a single category of fundamentalism, is analytically problematic to say the least. In addition, Hall's evocation of Islam in this context irresponsibly plays into the contemporary version of European demonization of the 'fanatical Muslim', thereby perpetuating, rather than challenging, the use of bigoted imagery.

More importantly, the objection I have to this kind of characterization is the implicit assumption in Hall's analysis that exclusionary and absolutist practices are somehow only partial incorporations into modernity. A variety of social movements from Protestant fundamentalism to politico-religious movements (in India and the Middle East for example) are often characterized in recent literature as either partially modern or anti-modern (see Marty and Appleby, 1991). Such analyses construct an oppositional other, culturally and ideologically backward, exonerating the modern conditions that helped make this kind of political position possible. Susan Harding, in her research on Protestant fundamentalist movements in the US, raises the following objections to these explanations:

> Singly and together, modern voices represent fundamentalists and their beliefs as an historical object, a cultural 'other,' apart from, even antithetical to, 'modernity,' which emerges as the positive term in an escalating string of oppositions between supernatural belief and unbelief, literal and critical, backward and progressive, bigoted and tolerant. Through polarities such as these between 'us' and 'them,' the modern subject is secured. . . . Fundamentalists, in short, do not simply exist 'out

there' but are also produced by modern discursive practices.

<div align="right">(Harding, 1991: 374)</div>

Harding is insistent that, at a time when studies of cultural marginality are on the rise, this conceptual space should not be limited to familiar left constituencies (such as people of color, indigenous peoples, gays, lesbians, etc.) but that the analytical tools, made possible by recent intellectual debates, be used to interrogate those we hold to be our existential and social opposites (1991: 302). Such an analysis may reveal the imbrication and co-implication of modernity and its supposed antithesis in ways that may force one to undertake nuanced and historically accurate readings of conflicts that have enormous implications and stakes for all the protagonists. As Zygmunt Bauman (1989) has argued persuasively, the Holocaust was made possible by the unique and necessary conditions of modern bureaucracy, scientific management and instrumental rationality, and bears testimony to the destruction modernity can and does make possible. His analysis confronts the reader with the troubling reality that the technological and organizational powers of modernist states (of the capitalist or socialist variety), combined with the impersonal practices of civil institutions and the opportunistic character of economic and political markets, pose the most forbidding challenges to human survival. The Bosnian tragedy analyzed in the context of Bauman's and Harding's admonitions perhaps does not appear as simply a demonstration of Serbian cultural backwardness, but as a situation produced by the most civilizing projects of human history – a profoundly disturbing proposition.

Hybridity and modalities of power

Finally, I will close with some brief comments on the notion of hybridity posed by Hall. He argues that the ability to live with difference and hybridity is the key challenge of the coming century, and the communities most suited to this task are those displaced from their places of cultural origins, living in diasporic situations, and carrying the multiple marks of their cultural travels (1993: 361–2). Whereas it is customary to pose hybridity as a contemporary challenge, it would be useful to remember that people have lived with difference historically – whether it was Afghans, Turks, Hindus, Christians and Persians living in South and West Asia, or the multiple communities that commingled under Ottoman rule, or the diversity of Southeast Asia. While arguments (by Hall, Rushdie, Bhabha, etc.) for the merits of hybridity are understandable in light of appeals to essentialist notions of racial/ethnic identity, their celebratory nature seems dismissive of political struggles, predicated on closure of communitarian identities, as a 'return to the past' (Hall, 1993: 362). Ella Shohat (1992) has made a similar critique in the pages of *Social Text* that I will not rehearse here, except to point out that the success of socio-political movements against cultural and political assimilation is often critically dependent on the ability of a group to mobilize on the basis of a shared past and

historical identity – fragmented as it may be. The crucial role that the black consciousness movement played in the anti-apartheid struggle during the 1970s and 1980s is a case in point.

Hall's (and others') analysis also seems to ignore how mobility and displacement are characteristics of modern political power that have, more often than not, resulted in forced assimilation, political cooptation, destruction of linguistic and cultural heritage, as well as internalized prejudice among communities undergoing hybridization. Referring to Hannah Arendt's experience with the Nazi mobilization, Talal Asad notes:

> She is ... aware of a problem that has escaped the serious attention of those who would have us celebrate human agency and the decentered subject: the problem of understanding how dominant power realizes itself through the very discourse of mobility. For Arendt is very clear that mobility is not merely an event itself, but a moment in the subsumption of one act by another. If people are physically and morally uprooted, they are more easily moved, and when they are easy to move, they are more easily rendered physically *and* morally superfluous.
>
> (Asad, 1993: 10–11)

Native-American and Palestinian histories are further illustrations of the same point. The ineluctable relationship between modalities of power and the process of migration is further apparent in the direction people usually move from and to. Whereas it is quite common (and acceptable) to migrate, for example, from Africa to the United States, it is seldom that people leave the latter to settle in the former – even anthropologists look askance at those who go 'native'. All this is to say, the optimistic note that Hall sounds in his ruminations on cultural mobility and inter-mixing does not take into account the limits this hybridity creates and the forms of subjection it makes possible.

In conclusion I would like to reiterate that my engagement with Hall's text is animated by a desire to understand the kinds of analytical assumptions we continue to be heir to, despite our best intentions, and how these reify boundaries of cultural otherness, political persuasions and objectives. Perhaps if we were to be faithful to the message cultural studies has presented, it would be to take the specific histories of cultures seriously and, in the words of Dipesh Chakrabarty (1992), 'provincialize' Western European experiences – whether of its majority or minority populations. It is clear that the universalist project initiated by Europeans has been reinvented by other cultures, and in a sense we cannot analyze any part of the world without simultaneously speaking of European history as well. However, the problematic of particular cultural practices and histories also makes it incumbent upon us to challenge the global currency that Western modernity enjoys, so as to explore political languages that seem to depart from and question this hegemony.

I would like to thank Talal Asad, Jane Collier and Richard Wood for their close reading of and commentary on earlier drafts of this essay. They are in no way responsible for problems that remain in the text.

References

Asad, Talal (1993) *Genealogies of Religion*, Baltimore: The Johns Hopkins University Press.

Bauman, Zygmunt (1989) *Modernity and the Holocaust*, Ithaca: Cornell University Press.

Chakrabarty, Dipesh (1992) 'Provincializing Europe: postcoloniality and the critique of history', *Cultural Studies*, 6(3): 337–57.

Gellner, Ernest (1986) *Nations and Nationalism*, Oxford: Basil Blackwell.

Hall, Stuart (1985) 'Religious ideologies and social movements in Jamaica', in R. Bocock and K. Thompson (eds) *Religion and Ideology*, Manchester: Manchester University Press: 269–96.

—— (1988) *The Hard Road to Renewal: Thatcherism and the Crisis of the Left*, London: Verso.

—— (1993) 'Culture, community, nation', *Cultural Studies*, 7(3): 349–63.

Harding, Susan (1991) 'Representing fundamentalism: the problem of the repugnant Other', *Social Research*, 58(2): 373–93.

Huntington, Samuel (1993) 'The clash of civilizations?', *Foreign Affairs*, 72(3): 22–49.

Kedourie, Elie (1960) *Nationalism*, London: Hutchinson University Library.

Kohn, Hans (1965) *Nationalism: Its Meaning and History* (3rd edn), Toronto: D. Van Nostrand Company.

Marty, Martin and Scott Appleby (1991) editors, *Fundamentalisms Observed*, Chicago: University of Chicago Press.

Plamenatz, John (1976) 'Two types of nationalism', in E. Kamenka (ed.) *Nationalism: The Nature and Evolution of an Idea*, London: Edward Arnold.

Shohat, Ella (1992) 'Notes on the "post-colonial"', *Social Text*, 32/33: 99–113.

STUART HALL

RESPONSE TO SABA MAHMOOD

I am grateful for the close attention which Saba Mahmood has paid to my short essay on Raymond Williams ('Culture, community, nation', *Cultural Studies*, October, 1993). There are many formulations which her thoughtful comments have led me to reconsider, where my phrasing has not been careful or scrupulous enough. However, I have not revised the basic thrust of my argument. I think there are probably some fundamental differences between us and since they reflect on a debate about how identity and difference are to be negotiated in the present phase of globalization, I have focused my response on those issues.

I hope that it is clear both from recent and earlier work of mine that I do not have an essentialist reading of religious, ethnic or national affiliations or movements *per se*. I believe that, from a political point of view, these are nothing essentially, in themselves. They have meaning and value which differ from one conjuncture to another, and that value is realized in articulation with other discursive practices. They are not fixed and can be transcoded, as the configurations of which they are a part shift. The difference between the role of nationalism in the national liberation movements in some African states and its role since independence is a case in point. To take another example, Baptism was a progressive religious force in pre-abolition Jamaica but is often a reactionary one in the post-civil rights southern states. It follows (the case I argue in my 'New ethnicities' article, Donald and Rattansi, 1992) that no appeal to the essential character and meaning of any politico-religious movements can replace a critical analysis and political assessment. Hence what I called the 'end of the essential black subject' (where things are good *because* they are black) and – inevitably – the beginning of criticism and the struggles over politics for different positions within black communities and between black communities and others.

The second point is that the rough-and-ready distinction I tried to make between 'open' and 'closed' forms of ethnicity is certainly conceptually underdeveloped, but may nevertheless have some purchase in the present situation. There are few movements without a strong appeal to certain shared forms of identification, and we know the positive role this has played in movements of the oppressed and marginalized, which I acknowledge. That, in my view, is why we cannot do without *some* form of 'ethnicity' (everybody has one, just as everyone is gendered). The question

 © 1996 Routledge 0950–2386

then is whether the identity affirmed around which political mobilization takes place functions *primarily* as a mode of exclusion or is sufficiently open to difference as to constantly criticize its own 'closure' and attempt to move beyond it. This distinction is all the more necessary if, as I do, one accepts that the very notion of 'identity' always involves a certain degree of exclusion; and if antagonisms frequently arise precisely when that which has been excluded functions as a constitutive outside and returns to haunt and trouble the 'closure' which has been effected. (I share this position with Laclau and Mouffe, and with Judith Butler). Given that argument, the necessity to try to distinguish forms of identity which, as I put it elsewhere, are able to 'live with difference' from those which require to 'consume, destroy or expel the Other' in order to survive becomes all the more urgent. I do not get a clear sense as to whether or not Mahmood acknowledges this problem (even if my formulation of it is inadequate).

As I have been at considerable pains to point out (and as I say again in this essay) this is a distinction which *cannot* be applied wholesale in an essentializing way. Unlike the modernization theory of which Mahmood accuses me, it does *not* divide the world into permanently stabilized open/closed societies, nor does it ever attempt to fit some corresponding notions of modern/backward on to the distinction but insists on applying the distinction *across* the so-called First/Third World divide. That is to say, it is precisely a strategy designed to get around the kind of fixed binary thinking into which so much of modernization theory falls (and which, in my essay 'Cultural identity in question' in Hall, Held and McGrew, 1992, I extend as a critique to both Liberalism and many versions of Marxism, as well as much Enlightenment thinking). Mahmood knows this, though it seems convenient for her argument to try to show that I am *really* a secret modernization theorist underneath, because of the sentence of mine which she quotes: 'species of fundamentalism every bit as backward as those to be found in some sections of the Islamic world'. The sentence takes the form it does because its principal referent was to the resurgence of ethnically and racially closed (i.e., in my terms, fundamentalist) forms of national identity in Britain, the US and other parts of western Europe, which is hardly a 'modernizing theorist's' use of the term.

I think the real problem here, which Mahmood does not however confront clearly, lies not with the first part of the sentence, which she virtually ignores in her article though it was the main burden of mine, but the second. I think she finds it unacceptable to say that there is *any* form of fundamentalism to be found in *any* section of the Islamic world. I am not clear whether this is because no forms of politico-religious fundamentalism are actually to be found there, or because it is not politically correct to refer to their awkward existence. Either way, I am afraid I cannot agree. I specifically do *not* say that all Islamic movements or societies are fundamentalist; even less do I suggest that some of them are essentially or primordially so. I go out of my way in the article to repudiate that kind of essentializing thinking about 'Islam' as a generic enemy. We may certainly argue about *which* movements are fundamentalist and *how much* they are

and even *why*. But I cannot accept what seems to be the underlying predicate of this part of her argument, that it is a reactionary thing as such to say that any Islamic society is or could be moving in a 'fundamentalist' direction.

Pressed for an example I would be tempted to say 'Algeria', with the emphasis on 'moving towards'. But actually I do not have to go to the trouble to produce or defend an example of my own because, contradictorily, Saba Mahmood produces an example of her own. She says, accusingly, that 'Pakistan may easily fit into Hall's schema', though I do not in fact discuss it. However, she herself characterizes Pakistan as having until recently been 'under the US-supported militarist theocracy of Zia-ul-Haq'. I am happy to concur. I think that the regime of Zia-ul-Haq was indeed a US-supported militarist theocratic regime and I would want to characterize it as exemplifying many of the worrying features of a society impelled under these circumstances towards what I called 'closure'. Mahmood may not accept the characterization, but she herself provided the description. Who am I to argue?

Mahmood suggests that I use 'the trope' of big and small nations as a way of distinguishing between nationalist movements in western Europe and the non-western world. But the passage she quotes does not make any such distinction and it is not one to which I subscribe. It had nothing whatsoever to do with this distinction.

It was entirely governed by the fact that the entire talk was delivered in Wales, about Wales, which was the nationalism on which Williams wrote most extensively, and I was in that passage referencing the phenomena – in addition to the many other types of nationalist movements there are in the world – of a revival of nationalist aspirations among small European nations, rather like those nationalist movements of the nineteenth century in Europe, and the contrast they presented with the often older, usually larger, imperializing nation-states. Mahmood seems so anxious to smoke out from my words some ideological implication which is not there that she seems altogether to miss the principal focus of the talk – namely the resurgence of Welsh nationalism (which, I assure her, is not taken in Wales as any less significant because Wales, in comparison with England, happens to be 'small'!). I may be, unconsciously – as she says – 'heir to a long-standing tradition of argumentation' in which the 'small and big nation' trope is coterminous with other parallel distinctions such as traditional/modern, savage/civilized, but I challenge her to produce any statement of mine which faintly suggests or could be taken as suggesting that Wales is either 'traditional' or – Heaven forfend, 'savage'! It is a total misreading, which is utterly blind to the context in which the argument is made.

I have to ask again, why this desire to push on to me views I neither hold nor expressed? And, again, I have to say that I can only assume that I am serving as a kind of substitute target. I happen to quote, without anathematizing him, a view of Ernest Gellner's that one of the impulses behind European nationalism was to supplant local and particularistic

affiliations with more 'national' ones. I think he is probably right. It does not follow, nor is it the case, that I therefore agree with some, much, most or everything that Gellner has written about nationalism, for I do not. But I can see that to quote Gellner at all is taken as tantamount to 'being in the camp of' Hans Kohn, Plamenatz, Kedourie – and no doubt by extrapolation a host of other writers. Not only do I have fundamental disagreements with many of the judgements of these writers, but I can hardly, from what I have actually said in my article, be saddled with the view, for example, quoted extensively from a 1955 text of Hans Kohn's, that nationalism in the Enlightenment was a political movement to limit government. I suggest Mahmood has another look at the essay on the 'West and the rest' which has a passage precisely criticizing the Enlightenment for this 'less and more advanced' argument before she tries to saddle me with its absurdities.

No doubt there are weaknesses and gaps in my argument and I must confess that I would have taken them more seriously had there not been, in the comments, a persistent, almost wilful, effort to read me as somehow complicit with a galaxy of writers with whom Mahmood obviously has a fundamental quarrel but with whom, as far as I know, I have little if anything in common. But I am afraid this proposition can only be sustained by wildly misreading both the substance and context of what I actually said. I see, two pages further on, that I am also to be accused of fellow-travelling with Samuel Huntington's ludicrous notion that we are about to enter a new age of religious wars, and no doubt there are even greater demons to come with whom I have been somehow unwittingly (or wittingly) consorting. Unfortunately, I do not think an elaborately contrived and spurious guilt by association is a very good or useful way of conducting a debate about such serious matters.

References

Donald, J. and Rattansi, A. (eds) *'Race', Culture and Difference*, London: Sage.
Hall, S., Held, D. and McGrew, T. (eds) *Modernity and its Futures*, Cambridge: Polity.

IEN ANG AND

JON STRATTON

ASIANING AUSTRALIA: NOTES TOWARD A CRITICAL TRANSNATIONALISM IN CULTURAL STUDIES[1]

ABSTRACT

This paper attempts to develop a critical transnationalist perspective in cultural studies from the localized cultural and political context of contemporary 'Australia'. It takes the Australian nation-state's current geo-economic and geo-political preoccupation with a so-called 'push into Asia' as a starting point for a questioning of dominant discourses of international relations and the place of 'Australia' within it. In particular, the paper aims to deconstruct the binary divide between 'Asia' and 'the West' which still informs official discourses of the 'Asianization' of Australia. In order to do this, it is suggested that the world must be conceived as a set of interconnected and interdependent, but distinctive modernities, signalling both the success and the failure of the universalizing European project of modernity through colonial expansion. From this historical perspective, 'Asia' and 'Australia' no longer appear as absolute binary opposites, as they can both be seen as historical products of the European colonizing/modernizing project. The paper then moves on to critique the privileged status of the nation, not only in the official international order but also in cultural studies. A critical transnationalist cultural studies must take the centrality of the nation-state in the modern world system seriously, though not for granted. The nation-state is put within a transnational frame by highlighting its complex and contradictory role within the fluid and dynamic forces of global capitalism. It is these forces which inform the current conflictual rapprochement of 'Australia' and 'Asia'. However, this – desired and contested – rapprochement cannot be understood without its proper contextualization within and against the background of the divergent (post)colonial histories of both 'Australia' (as a white-settler colony) and 'Asia'. This illuminates the necessity of addressing the intersections between cultural studies and postcolonial theory in developing a critical transnationalism.

Cultural Studies 10(1) 1996: 16–36

KEYWORDS

cultural studies; Asia; Australia; postcolonialism; nation/nationalism; globalization

In a recent article on that fashionable intellectual venture called 'cultural studies', Fredric Jameson acknowledges the importance of 'the fundamentally spatial dimension of Cultural Studies' (Jameson, 1993: 46). This concern with space – or more concretely, the spatial determination of cultural studies theory and practice – has become an urgent one in a time when cultural studies is increasingly perceived and experienced by its practitioners as an international project. With this internationalization, or better, transnationalization of cultural studies comes a whole series of questions: what kind of world is constructed by cultural studies? What sort of a place is the world according to cultural studies? And how does it see its own place in that world?

This paper is an attempt to carve out a terrain for a critical transnationalist perspective in cultural studies. Such an effort cannot be made from a spatially neutral position. Indeed, one of our main arguments is that a critical transnationalism must always be enunciated from, and engage with the political peculiarities and necessities of, a particular spatial/cultural context if it is to avoid reproducing affirmative or dominant forms of transnationalism, as currently most assertively promoted by the forces of global capitalism. As we are writing this paper in Australia, we are interested in developing a critical transnationalist perspective which can productively intervene in critical understandings of this country's place in the world in this particular historical conjuncture. In doing this, we hope to clarify – by way of exemplification, which in the context of this paper will necessarily remain provisional and schematic – how a practice of critical transnationalism can be brought to bear in cultural studies.[2]

Any theorization of Australia's cultural location in a transnational frame from an Australian perspective must start by distinguishing Australia, the geographically specific and spatially bounded nation-state, from 'Australia', the discursive nomination articulated by an open-ended proliferation of a range of diverse, sometimes incompatible, discourses. The relation between the two is not static, but subject to change and contestation. There is, in other words, a constant struggle over the representation of 'Australia', whose equivalence with the nation-state bearing that name cannot be taken as given, but is always actively constructed and reconstructed. This symbolic construction of 'Australia', which is used to support and critique the administrative running of the nation-state Australia, necessarily takes place in relation to a set of differences against whose background the identity of 'Australia' is established. These differences are located in the transnational realm beyond the (symbolic) boundaries of the nation. In this respect, two areas of concern today inform much intellectual debate in this country, inflecting two distinct ways in which 'Australia' is discursively located in a transnational frame. First of

all, there is the constant call in public discourse over recent times, enunciated mainly by representatives of mainstream politics and the business world, for Australia to become (or recognize itself as) 'a part of Asia'. Secondly, and often seen as in stark contrast with the first, there is the lingering concern with Australia's historical origin as a British settler colony. In Australian cultural studies, this concern is expressed in a critical interest in 'postcoloniality' and the related tendency to call Australia a 'postcolonial nation' – as was the case, for example, at the conference where this paper was first presented. In their disparate discursive domains, each of these positions opens up a space for a particular, and selective, understanding of 'Australia' in its transnational context. The latter aims to invest a solidly historical perspective in the imagination of 'Australia', tracing it back to its intimate connection with, and dependence on, the history of (British) colonialism. In this sense, the discourse of postcolonialism is oriented toward a redemptive understanding of the past. The former, on the other hand, might be considered radical, in so far as it signals a fundamental unsettling of established notions of 'Australia' and, in designating 'Asia' as Australia's destiny, formulates a future-oriented discourse of Australia's place in the world.

By juxtaposing these two apparently antagonistic discourses, we hope to elaborate how a critical transnationalist perspective can productively intervene in and contribute to Australian cultural studies. More specifically, we want to follow the lead of an 'Asian' turn in the public political discourse and suggest that an 'Asian turn' – i.e., a critical engagement with the more far-reaching implications of the claim that Australia is 'a part of Asia' – in a critical transnational cultural studies can qualify and expose some of the limits and silences of the claim that Australia is a 'postcolonial nation'. The net effect would be an increased and more complex understanding of the place of 'Australia' in the current new world (dis)order created by global capitalism.

Historically, the dominant political discourse in Australia has situated 'Australia' as a 'Western' or 'European' country, utterly distinct from, and often threatened by, its northern 'Asian' neighbours. The construction of this antagonistic relation was grounded on an essentialist binary divide between West and East – or, as it is usually termed nowadays, Asia. The, one could say, exilic consequences for 'Australia' of this Eurocentric Orientalist division of the world into the 'West' and the 'Rest' has recently been restated by US political scientist Samuel Huntington in his (in)famous article 'The clash of civilizations?' in the authoritative journal *Foreign Affairs*. Huntington views the contemporary world as divided up into 'seven or eight major civilizations' (1993: 25).[3] He argues that, since the ending of ideological conflict with the end of the Cold War, international conflict will increasingly be caused by civilizational differences. In a revealing footnote he makes a cautionary remark about Australia which suggests the impossibility, if not foolishness, of a country attempting to move from one 'civilization' to another:

Owen Harries has pointed out that Australia is trying (unwisely in his view) to become a torn country in reverse. Although it has been a full member not only of the West but also of the ABCA military and intelligence core of the West, its current leaders are in effect proposing that it defect from the West, redefine itself as an Asian country and cultivate close ties with its neighbors. Australia's future, they argue, is with the dynamic economies of East Asia. But, as I have suggested, close economic cooperation normally requires a common cultural base.

(Huntington 1993: 45)

Such a cultural base, according to Huntington, does not and cannot exist for Australia because 'Asia' and 'the West' are two intrinsically incompatible 'civilizations'. In the face of such a rigid ideological exhortation, the idea of an 'Asianization' of 'Australia', while by no means unproblematic in terms of its conjunctural politics, acquires critical discursive purchase – if only because it marks the possibility of a deconstruction of a universalist theory which, in its grandiose hypostatization of 'Asia' and the 'West' as two mutually exclusive categories, perilously reproduces the Eurocentric legacy of Orientalism.

In the past decade or so official public rhetoric has changed in Australia. There is an insistent call for Australia to 'push into Asia', to 'enmesh with Asia', to become an integral 'part of Asia' (see Frost, 1994). That the motivation for this dramatic change lies in the perceived economic necessity for the Australian nation-state to align itself more with the extensive booming region to its north, is clear. But this drift toward economic 'Asianization' has been accompanied by a more comprehensive shift in the cultural imagination of 'Australia'. This is exemplified in didactic attempts to sensitize Australian business people to the diverse cultural specificities and sensitivities of the Asian region as a trade and market area, an increased emphasis on the teaching of Asian languages in schools, a general effort (e.g., through radio and television) to heighten an 'Asia-mindedness' among the population, and so on. In other words, there is a clear desire among the national leadership to bring about not only an economic 'Asianization', but also a *cultural* 'Asianization' of sorts.

Ironically, however, dominant rhetoric on the 'Asianization' of Australia, in its very insistence on the need to bridge the gap between (corporate) Australia and (corporate) Asia, only ends up affirming the very discursive binary oppositioning of 'Australia' and 'Asia' which it strives to overcome in the first place. For example, one of the staunchest proponents of Australia's 'enmeshment with Asia', Professor James Mackie, has this to say

Soon, very soon, we will have to be capable of meeting them [Asians] on their terms ... If we continue to turn our backs on them ... we are doomed to isolation and insignificance as a nation.

(Quoted in Perera, 1993: 17)

The apparently unselfconscious manner in which 'Asia' is relegated to the realm of 'them' here, even if the thrust of the rhetoric aims at a 'meeting' with 'them', suggests that the binary divide constructed by Orientalism is by no means overturned by the pragmatic discourse of Australia's 'Asianization'; it is merely complicated and updated by it.

A more enabling transnationalist discourse will have to perform a rethinking of both 'Australia' and 'Asia' which goes beyond the reproduction of the entrenched binary divide between the two. How can this be done? It is here that a critical transnationalist cultural studies can intervene. As a first step, it is easy enough to make the theoretical move, common in contemporary cultural studies, that identifies both the 'West' and 'Asia' as discursive constructs, and ones which are a product of the West's own thinking. The refamiliarization of 'Asia' inherent in this recognition and subsequent renunciation of the Orientalist process of representational Othering would, then, facilitate a repositioning of 'Australia' as no longer caught between two radically distinct cultural arenas – a part of the 'Western' world but geographically located in Asia – but understood as simultaneously having its own 'identity' while, politically, striving to inflect the international experience of the Australian nation-state as an integral part of an always already Westernized (if not 'Western') Asian region. In other words, both 'Asia' and the 'West' must be seen as part of one and the same modern world.

Involuntary modernities

If 'Asia' must no longer be thought of as Other, this is not just because of the moral/ideological liability of the discourse of Orientalism, but because the region that has come to be called Asia has become an inherent part of, and force in, the contemporary global condition. The history of European colonialism and imperialism comes into play here. One important element in the problematic relation between Australia and the nation-states of Asia is that they are all, in different ways, the consequences of this history, which involved the export of modernity from Europe to the rest of the world. The binarism still dominating Australian discussion about 'Asia' is founded in the parallel but opposing modern European constructions of 'Asia' and 'Australia'. Where 'Asia' was discursively constructed as the Orient, that Other against which the 'West' defined itself, 'Australia' was constructed as a settled outpost of the 'West', an attempt to realize a society on the principles of European modernity in a space outside Europe. It is from this perspective that East and Southeast Asia, geographically the Near North, could nevertheless be designated as the Far East by the Australian subject. And as the current official Australian preoccupation with the region is dominated by talk about Southeast Asia (as in the diplomatic focus on ASEAN), it is illuminating to add that the category of 'Southeast Asia' itself, as Milton Osborne has remarked, only came into being during the Second World War 'as a result of military circumstances', although the foundations for such a category were laid in the pre-war

period when 'anthropologists and historians had begun to take account of the similarities that could be found between one region of what we now call Southeast Asia and another' (Osborne, 1990: 4). The kinds of similarities looked for – such as 'rituals used by various royal courts' – would have confirmed the exclusion of Australia, which was categorized as 'Western', from this new construct of 'Southeast Asia'.

Just like 'Australia', then, 'Asia' – as well as the modern nation-states that now make up this entity – is a product of European colonial expansionism. This is the case even for those countries which were not materially colonized by European powers. As Naoki Sakai has observed in relation to Japan, for example, 'Japan' is a discursive construct which is not external to the West: 'Even in its particularism, Japan was already implicated in the ubiquitous West, so that neither historically nor geopolitically could Japan be seen as the *outside* of the West' (Sakai, 1989: 113). In the modern world system, Asia owes its very existence to the West. This points to what Sakai calls 'the involuntary nature of modernity for the non-West':

> Modernity for the Orient [. . .] is primarily its subjugation to the West's political, military, and economic control. The modern Orient was born only when it was invaded, defeated, and exploited by the West. This is to say that only when the Orient became an object for the West did it enter modern times. The truth of modernity for the non-West, therefore is its reaction to the West. [. . .] Of course, the Orient reacted to the West's expansion and put up *resistance* to it. Yet in this very *resistance* it was integrated into the dominion of the West and served, as a moment, towards the completion of Eurocentric and monistic world history.
> (Sakai, 1989: 114–15)[4]

The important notion of involuntary modernity highlights the inherent displacement which is constitutive for the incorporation of Asian social formations in the modern world system (which is why, for example, in Miyoshi and Harootunian's words, 'Japan's history is suffused with the sense of the dominant Other and its own marginalisation' (1989: xi)), just as Australia's (dubiously) postcolonial status – about which more later – renders the derivative, secondhand, artificial nature of *its* modernity inevitable. In this formal sense, Australia and Japan inadvertently have more in common than is generally recognized: both are de-centered in relation to the source of the universal project of modernity (i.e., Europe). What obscures this commonality, however, is the fact that while 'Australia' is institutionally and discursively positioned in 'the West', albeit on its periphery, 'Japan', despite its current status as an economic superpower and, therefore, according to the old core/periphery logic, its (dubious) entry into the core of world hegemony, remains resolutely positioned (and self-positioned) as part of the 'non-West'. As R. Rhadakrishnan has noted in a different context, 'this divide perpetrates the ideology of a dominant common world where the West leads naturally and the East follows in an

eternal game of catch-up where its identity is always in dissonance with itself' (Rhadakrishnan, 1992: 86).

One way to avoid reproducing this dualism is to examine the ways in which the forced appropriation of modernity in the peripheries has resulted in the emergence of multiple, indigenized modernities, some of which now threaten to precipitate what the old Euro-American core sees as 'the decline of the West'.[5] The new powerhouses of so-called Asian capitalism, with Japan chief among them, testify to the fact that the hegemony of Western modernity needs to be questioned. As David Morley and Kevin Robins observe:

> Japan is significant because of its complexity: it is non-western, yet refuses any longer to be our Orient; it insists on being modern, yet calls our kind of modernity into question.
>
> (Morley and Robins, 1992: 155)

Yet is is important to realize that 'our kind of modernity' in Morley and Robins's discourse is European modernity (which is itself an abstraction), not the postcolonial brand of Australian modernity. From an Australian perspective, Japanese modernity might offer the opportunity to question Australia's unproblematized identification with the West, and so acquire a clearer focus on, and come to terms with, its own experience of (postcolonial) decenteredness (see Chakrabarty, 1992). The unrelenting obsession in Japan with the West, especially the US (which itself stands in a problematic relation to European modernity), as the master (*sic*) Other in relation to whom the Japanese continuously feel compelled to maintain their distinctiveness, suggests that the so-called decline of the West, at least in economic terms, has not yet eclipsed the global *cultural* hegemony of 'the West' (see e.g., Yoshino, 1992; Iwabuchi, 1994). However, Australia, too, in its very postcoloniality, is decentered in relation to this notional 'West' (see Gibson, 1992). In a non-Western context, the 'Western' is transformed from an organic *topos* of identity into a powerful, explicitly named other – an Other which has the power to penetrate the body of the (non-Western) national Self; hence, the prominence of the concern with 'Westernization' in those parts of the world which are excluded from the 'West'. What we need to recognize is that Australia, too, despite the fact that it now firmly considers itself 'Western', is the *outcome*, not the origin of the Westernization/modernization of the world. Historically, the establishment of Australia, first as a settler colony and later as an independent nation-state, must be posited at the receiving end of the European project of modernity (even though Australia did emulate European colonizing/modernizing projects when it became a [modest] colonizer in its own right).[6]

In a crucial sense, the project of modernity has failed. No matter how violent European colonial and imperial forces were or how receptive non-Europeans were to the adoption of new ways, 'modernization' and 'Westernization' were ultimately impossible in any complete sense, not least because the idea of a totalized 'modern/western' way of life was itself

a fiction not actually lived out anywhere – not even in Europe itself, for in Europe too there were heterogeneous cultural histories the traces of which the universalizing project of modernity could not erase. And while it is true that much colonization went on within 'Europe', for example that of the Breton region by the French and that of Ireland by the English, such colonization was subsumed within the developing rhetoric of 'Europe' in contrast to the external colonization, and sometimes settlement, of the 'non-European' Other. Hence, one of the most fundamental markers of modern expansionism has been the experience of colonization and decolonization. The rocks on which the fantasy of a globalized, universal modernity foundered were the actual, irreducible cultural differences which the modern project wished to eradicate but found itself unable to. Nevertheless, the project of modernity did not fail completely. After all, it produced the structural framework, the fundamental infrastructure, of the world we now live in: a global capitalist world, carved up into distinct nation-states, but tightly interconnected through trade, a strict system of 'international relations' and, not least, an increasingly complex global communications network. In this modern world-system, to use Immanuel Wallerstein's term, there is no outside, we are all always-already inside the system. That is to say, in this totalized world (dis)order, there is, in structural terms at least, no longer any truly different culture – that is to say, a culture untouched by 'Western' culture in its broadest sense, most importantly, capitalism.

The claim that we now live in a 'postmodern' world can be of use in this context, if we understand postmodernity in the global context as the experience of the simultaneous success and failure of modernity in the production of a singular but deeply fractured world system. That is, the effect of the failure of the universalizing project of modernity has produced a proliferation of distinctive, indigenized modernities and it is the co-existence and simultaneous (in)commensurability of these differentiated modernities which can be described as the postmodern experience on a global scale.

Problematizing the (inter)national

We can now begin to delineate some of the parameters of our conception of a critical transnationalism in cultural studies, Australian cultural studies in particular. A critical transnationalist perspective would reproduce neither the binary divide between West and non-West, nor the universalizing assumptions of modernity, but aims to gain an understanding of the world as a place of juxtaposed, contradictory, and overlapping, always unfinished and evolving modernities. In this respect, cultural studies can be inscribed as the postmodern, transdisciplinary reconstitution of anthropology and sociology, combined in a world where the distinction between these two modern disciplines has become meaningless. If sociology was concerned with 'our own' 'Western' society/ies – that is, in the epistemology of representation, cultures which are (like) 'us' – and anthropology

was concerned with cultures that were constituted as Other – not (like) 'us' –, then a critical transnationalized cultural studies exists in, and reflects upon, a world where all cultures are both (like) 'us' and (not like) 'us'. It needs to develop a theoretical tool-kit which will enable it to examine the practices of familiar *difference* in a world where 'us' is now more or less everywhere but where 'us' is never as self-identical as modern ideology would have liked it to be, even in the Euro-American core of the Enlightenment tradition.

This proliferation of transnational difference complicates the task of cultural studies. This is exemplified by the recent protests against Anglo-American dominance within cultural studies, mostly articulated by Canadian and Australian practitioners (see e.g., Morris, 1992; Blundell *et al.*, 1993),[7] which signals an attempt to delineate cultural studies as a discursive formation *different* from the hegemonic, universalizing modern disciplines such as sociology and anthropology, as well as philosophy (the Enlightenment discipline *par excellence*) or, for that matter, psychology or economics. There can be no one cultural studies, so the argument goes, but only a multiplicity of context-specific cultural studies traditions. This multiplicity has tended to be founded on the particularity of nation-states. This forms the background for the claim for a distinctively *Australian* cultural studies, characterized by a particular set of theoretical concerns and substantive interests, elaborated through, and engaging with and within, a peculiarly 'Australian' modernity.

In many ways, this emphasis on national distinctiveness is important and illuminating. For example, elaborating the terrain for a national but not nationalist cultural studies, Graeme Turner distinguishes between a British national culture in which, he suggests, the lack of mention of 'Britain' in television advertisements – its exnomination – is a consequence of the fact that '[i]n these British representations, nationality seems utterly naturalized, always already in place', whereas 'in Australian representational genres, Australia is explicitly figured (and interrogated) as image, myth – nation' (Turner, 1993: 8). Turner's point here has to do with the particularity of the Australian national condition: 'living in a new country does involve constant encounters with, and definite possibilities for intervening in, an especially explicit, mutable but insistent, process of nation formation' (8). He goes on to argue that the effect of the experience of this always-already problematic national identity is that '[t]his fact provides so much of the grounding for cultural studies work within the Australian context that one finds it hard to avoid dealing with it at one level or other' (9). Turner uses this point to explain why so many of the essays in his collection of Australian cultural studies material refer to the problematic of Australian national identity.

Such a concentration on national identity needs a corresponding degree of critical self-awareness if it is to avoid an unreflexive nationalism. As we will elaborate below, Turner invokes postcolonial theory as a way of heightening the recognition of Australia's distinctive, and historically determined, national identity relative to Britain, and in the world more

generally. At this point however we want to suggest that while postcolonial theory has an important use as a way of understanding 'Australia' – and many other countries also – it tends to leave unproblematized the project of national identity itself. This produces many elisions, both conceptual and practical. We will go on to discuss some of the conceptual elisions, however it is worth just mentioning one of the practical elisions.

Australian cultural studies pays little attention to the question of regional distinctiveness. To take one example, as a result of its focus on the nation as the site for enunciating its speaking position, there is little discussion of identity in relation to other political units – for example, New South Welsh identity, or Western Australian identity.[8] For that matter, the old debates over the cultural differences of Sydney and Melbourne have not been taken up in the new Australian cultural studies discourse (see e.g., Docker, 1974), and they have not been added to with discussions of Brisbane, Adelaide, Cairns, Perth, or any other city. What has developed, which is very important, is what John Frow and Meaghan Morris, in their introduction to their *Australian Cultural Studies* reader (1993), describe as 'The practice of place', consisting of accounts which rise out of the particularity of experience in concretely identified locations (e.g., a particular motel, or Fremantle, the site for the 1986–7 America's Cup). Unfortunately, however, these accounts of the hermeneutics of 'the local', which are an attempt to explicate the experience of the recognition of the intimate connection between situatedness and 'knowledge', are generally not brought into explicit connection with the 'national' preoccupations outlined by Turner. Were these two dimensions of the experience of Australian place (the local and the national; the hermeneutic and the institutional) to be critically juxtaposed and brought to bear on one another, the ensuing work might go some way to making more reflexive the taking up of a 'national' speaking position in Australian cultural studies and help to problematize the relationship between the unified nation-state Australia and the much more fluid and heterogeneous discourse of 'Australia'.

At the conceptual level, the concern with national identity, while important in its de-universalizing impetus, doesn't suffice if it doesn't take into account not only its historical, but also its spatial, transnational context. After all, the concept of the nation cannot be introduced without at the same time problematizing it. So far, however, cultural studies has mostly questioned the national for *internal* reasons: for example, by pointing out (over and over again) that the nation is an *imagined community*, that national 'identity' is an historical construct rather than a primordially given entity, that the 'unity' of any nation can only be achieved through the imposed assimilation or containment of its 'minorities', and so on. The juxtapositioning of the local and the national we referred to above would serve just this purpose of internal critique of the construction of national identity, as well as an emphasis on other key markers of internal fracture such as race, gender and class. What we want to add to this internal, historical demythologization of the nation is a more structural critique of

the privileged rhetorical status of the subject of the nation in the international spatial order.

As we have observed before, in the ideological claim to a universalized modernity it is precisely the nation-state which has been granted universal recognition and validity as the authorized marker of the particular. To quote Wallerstein, 'in our modern world system, nationalism is the quintessential (albeit not the only) particularism, the one with the widest appeal, the longest staying power, the most political clout, and the heaviest armaments in its support' (1991: 185). The internationalism emanating from this officially sanctioned universalist particularism – most explicitly institutionalized in the United Nations – constructs a model for a global culture based on interrelations between distinct, mutually exclusive, singular national units which are declared equal in formal status if not in concrete content. This absurd but powerful ideological fantasy of equivalence seeks to establish an imaginary 'unity in diversity', indeed a global 'imagined community' supposedly segmented into constituent, mutually exclusive, singular national imagined communities which are presumed formally commensurate and in principle interchangeable – much like the teams participating in the Olympic Games. It is clear that this liberal pluralist containment of inter/national 'difference', which, it should be noted, is one of the markers of the successes of the project of modernity, cannot go unquestioned in a critical transnational perspective. As the ideology and practice of the nation-state is one of the most ubiquitous exports of European modernity, the politics of which we need to recognize, it is the concept of the nation-state itself, and its strategic reliance on constructing a national identity as a means of legitimation, which needs to be problematized. In this vein, the concern with Australian national identity must be cast in the final knowledge that the Australian nation-state is (just) another partially successful, but at the same time highly specific, site of European modernity. In a critical transnationalist perspective, the (post)modern distinctiveness of individual nation-states which flows from their different encounters with, and indigenizations of, modernity – which helped to produce the very existence of those nation-states – needs to be recognized. The politics of nationalism, which can so easily arise from a concern with the national, and which is sometimes advocated as a strategic essentialism for less powerful nation-states, has, as a part of its ideology, a forgetting of the historical particularity of the nation-state as such, and emphasizes only the partial historical and cultural idiosyncrasy of specific nation-state formations. This, we suggest, is the theoretical starting point for critically examining both Australia and discourses of 'Australia' in a transnational frame. The next question is, how to describe that transnational frame?

Entering global capitalism

The economic imperative behind 'the Asian turn' exposes the fact that a critical transnationalism cannot ignore or overlook the importance of

structural trends in the capitalist order in shaping cultural orientations and interrelations. If the proejct of modernity created a world of formally distinct nation-states – with predominantly separate economies, particular national cultures and sovereign claims to national destinies – this distinctiveness is increasingly being subverted by many developments such as transnational communications technologies but, most importantly, the forces of transnational capital and their effects, for which national borders matter less and less. As Robert Ross and Kent Trachte point out, a 'new system of global capitalism is discernible over the last twenty years' (1990: 6) – that is, since the late 1960s. In a similar vein, Manual Castells has described 'the accelerated internationalisation of all economic processes' (1989: 26). This has been enabled by the development of new information technologies and it has transformed the global practice of capitalism.

One of the fundamental features of the expansion of global capitalism is the reconstitution of the core/periphery structure which characterized the developmentalism, and modernization rhetoric, of monopoly capitalism. The economic reasons for the transformation are complex and not our concern here. It suffices to note that one aspect of the change has been an increasing industrialization of parts of the old periphery. Ross and Trachte explain that:

> The regional patterns of growth characteristic of the era of monopoly capitalism have been altered. Not only has the Third World experienced manufacturing growth, but it has grown more rapidly than the mature industrialized economies. The same is true of the recent pattern of growth within the European continent.
>
> (Ross and Trachte, 1990: 96)

As is well known, the area where this growth has been most spectacular has been 'East Asia'. Between 1965 and 1981, Hong Kong, Taiwan, the Republic of Korea, Singapore, Malaysia and Thailand all had real growth rates in manufacturing of over 10 per cent. Indonesia's rate of 7.9 per cent between 1965 and 1980 increased to 13.9 per cent between 1970 and 1981. During the same period none of the core countries had a growth rate of over 10 per cent and Japan, signalling its changed structural position in the global economy, had an annual manufacturing growth rate that dropped from 16.3 per cent in the period 1965–1970 to 4.2 per cent in the period 1970–1981 (Ross and Trachte, 1990: 95). The changes in the siting of manufacturing plant signalled by these different rates have been partially precipitated by the promise of cheap, non-unionized labour. Nevertheless, the changes have also given new economic power to those 'East Asian' nation-states, in the process setting up new overlapping and intersecting sociospatial networks of power and dependency. As Arif Dirlik puts it, 'the narrative of capitalism is no longer a narrative of the history of Europe. For the first time, non-European capitalist societies are making their own claims on the history of capitalism' (1994: 51). That is to say, on a world-historical scale these non-Western modernities are, in Dipesh Chakrabarty's words, beginning to 'write difference into the history of our

modernity in a mode that resists assimilation of this history to the political imaginary of the European-derived institutions [. . .] which dominate our lives' (Chakrabarty, 1993: 30).

This development has an unsettling effect on established core/periphery relations, especially those between 'the West' and 'Asia'. In the period of high modernity, the core/periphery divide was clearly identifiable – metaphorized, for example, in the division of the nation-states of the world into First, Second and Third Worlds. But this neat division has become less and less easily applicable. As Arjun Appadurai has remarked, '[t]he global cultural economy has to be seen as a complex, overlapping, disjunctive order, which cannot any longer be understood in terms of existing center–periphery models (even those which might account for multiple centers and peripheries)' (1990: 6). Appadurai proposes substituting the binary structure of core/periphery with a schema based on the concept of flow. This change expresses in theory the shift from the fixities of monopoly capitalism, exemplified in the tight interconnection between corporate capital and the national economy within the boundaries of the nation-state, to the massive movements across national borders that is characteristic of global capitalism and which, themselves, relativize the sovereignty of the nation-state. Appadurai outlines five dimensions of global cultural flow: those of peoples, media, technologies, money and ideas. These, he considers, 'are the building blocks of what [. . .] I would like to call *imagined worlds*, that is, the multiple worlds which are constituted by the historically situated imaginations of persons and groups spread around the globe' (1990: 7).

Yet these multiple imagined worlds – and the disjunctive cultural flows that bring them about – are not constituted randomly; after all, the movements of global capitalism do not take place in empty space, but always in *already constituted* space. Indeed, what needs to be emphasized is the historical and cultural situatedness of spaces traversed by these flows. Past legacies – and, as we will elaborate shortly, colonial legacies in particular – remain powerful determinants in the present-day trajectories of cultural flows. In this sense, we should perhaps not so much replace the core/periphery schema with that of flow, but rather articulate the two, to account for the ongoing, always shifting, multidimensional, heterogeneous and ambiguous relationalities which constitute our current global predicament. What needs to be highlighted in the theoretical transition from notions of a fixed core and periphery to notions of flow is that the spread of global capitalism does not so much eliminate old bases of relations of power, but rather reinscribes them in a new, more complex configuration, for example, through a disarticulation of the economic and the cultural as sites of power.

To return to the example of Japan, the rise of Japan as a dominant economic power in the last few decades has precipitated a deconstruction of the modern idea of the core as both 'Western' and the site of a capitalist modernity based unproblematically on Enlightenment values. More generally in relation to Asian capitalism, we have recently seen a spectacular rise

in the celebration of so-called Confucian values in East Asia,[9] which is noteworthy, as Dirlik remarks, for 'its articulation of native [i.e., non-Western] culture into a [Western] capitalist narrative' (1994: 52). This does not mean, however, that the *idea* of the 'West' is not still powerful. Stuart Hall has rightly observed that it is 'both the organizing factor in a system of global power relations and the organizing concept or term in a whole way of thinking and speaking' (1992: 278).

It is the contradictions between these two tendencies – on the one hand the fact that actual core/periphery relations are both multiplying and no longer fixed, on the other hand the continuing discursive power of 'the West' as the all-powerful core – which has particularly problematic implications for Australia. In the era of global capitalism, the Australian nation-state finds itself more and more economically dependent on the NIEs (newly industrialized economies) of East Asia. This development has led to the perception of, and anxiety about, an unprecedented overturning of given hierarchies, where 'Asia', previously the powerless Other, now takes on the position of a commanding center in relation to which 'Australia' is (economically) marginalized. At the same time, Australia remains similarly peripheral to 'the West', of which it nevertheless remains, historically and to a large extent culturally, a part. The 'West' provides 'Australia' with a rich source of (cultural) power which continues to produce a sense of superiority *vis-à-vis* 'Asia', a superiority however which is now ridden with anxiety – as expressed in the ominous economic projection that if Australia doesn't change, it risks becoming, in the words of Singapore's Senior Minister and long-term Prime Minister, Lee Kuan Yew, 'the white trash of Asia'. In short, the current global historical conjuncture has created a particularly difficult context for the representation of 'Australia' in the world. Steeped in a heightened sense of decenteredness, and with the economic if not the cultural power of the old core under threat, Australia finds itself, as described by Andrew Milner, as 'a colony of European settlement suddenly set adrift, in intellectually and imaginatively uncharted Asian waters' (1990: 39).

Postcolonial predicaments

The category of 'postcoloniality' has been one of the most prominent foci for understanding 'Australia' within Australian cultural studies. It is an important focus because as a theoretical perspective, postcolonialism implicitly and explicitly puts the nation in a historically determined trans-national frame. Postcolonial theory has a short, but very busy, history which we cannot possibly rehearse here. Our aim is primarily to examine the effects of adopting a postcolonial perspective in understanding 'Australia' and its relation to 'Asia'. The adoption of the category of the postcolonial stresses the construction of a distinct transnational relationality based on a particular past and its effects in the present and future: Australia's history as a British settler colony. This appropriation of post-colonial studies in Australian cultural studies has also served as a strategy

to forge alliances – for example, with Canada and New Zealand[10] – on the basis of a perceived shared historical record: that of having been British settler colonies. This rhetorical appropriation of a postcolonial 'identity' is an act of national self-definition which implies a deliberate decentering of the national self, a self-conscious self-relativization and self-peripheralization in relation to the old core of the modern world-system, in this case, Britain.

Turner has described the predicament of postcoloniality in terms of a series of double binds which arises out of:

> the complexly ambiguous relation between the postcolonial nation and its Other, the colonizing power. While the connection with the Other is precisely what the postcolonial must break, Australians regularly define their difference through binary systems which reconnect them – through, for instance, the conventional Australia/Britain opposition. Although postcolonial identity depends on rupturing the colonial frame, the strongest evidence that such a rupture has been effected seems to be provided when the colonial power acknowledges it; it is as if even the status of postcoloniality is dependent upon the assent of the colonizing Other.
>
> (Turner, 1992: 426–7)

'Postcoloniality', concludes Turner, 'means living with contradictions, occupying positions that can be shown to be less than consistent' (1992: 427). Yet as illuminating as this explication of the postcolonial predicament is, it also reveals some of the problems of singling out a generalized postcoloniality as the key marker in describing Australia's transnational context. As described by Turner, postcolonial discourse critically examines the binary structure which dominated the colonial experience. Conceived in this way, this theoretical project is in an important sense nostalgic, as it treats 'ex-colonial societies as if they were the exclusive result of a colonial past', as Fernando Coronil puts it (1992: 102). From the point of view of a cultural studies seeking to understand the present situation of 'Australia', such a formulation is useful but limited. Capitalizing on a postcolonial status is not an innocent discursive gesture: it strategically *constructs* the basis for an overly coherent (national) identity even though the very defining feature of the postcolonial nation-state may be sought in its contradictory relation to its previous colonizer.

Nevertheless, we do believe that postcolonial theory has an important contribution to make in a critical transnationalist cultural studies. In a recent, highly critical, discussion of postcolonial theory, Dirlik views it as a move away from a Marxian understanding of the contemporary world. In his view, the problem with postcolonial discourse is that it 'divorces itself from the material conditions of life, in this case Global Capitalism as the "foundational" principle of contemporary society globally' (1994: 99). Indeed, he suggests that, 'in its insistence on fragmentation and the primacy of local encounters, [. . .] and in its affirmation of fluid relations and transposable subject positions, postcolonial discourse often reads very

much like a description of life under Global Capitalism' (97). Which is what it should read like, as *Capital* read like a description of life under nineteenth-century industrial capitalism! Of course *Capital* also contained a moral criticism which, one presumes, is what Dirlik finds missing in much postcolonial discourse.

The utility of postcolonial theory, in our view, is precisely that it articulates with a world in which the old fixities of the modern order have been unsettled, including the old moral certainties of the Enlightenment. This is not to suggest that we support a loss of moral criticism but rather that postcolonial criticism – and a transnational cultural studies – needs to recognize that while moral criticism is today, if anything, more important than ever, the grounds on which it is made are now more provisional and need a much greater degree of contextual substantiation. It is not coincidental that postcolonial theory developed at a moment in the spread of global capitalism when the nation-states produced by colonization and settlement began to find public voices and establish ways of examining their pasts, and the influence of their pasts on their presents. In general terms, postcolonial theory developed out of a need to examine the present-day implications of a binary relation which, while fast passing in economic terms, has nevertheless produced a cultural heritage that continues to provide a context for the present. As Bill Ashcroft, Gareth Griffiths and Helen Tiffin imply in the title of their innovative introduction to postcolonial theory in literary studies, *The Empire Writes Back* (1989), postcolonial studies began as the result of the new ability of authors and intellectuals from the previously colonized world to speak and make themselves heard in the old core as well as in their own countries as critics of the consequences of colonialism and the related imposition of 'modernization'. These historical consequences have enduring implications which continue to haunt the present transformations in the world (dis)order. And because the world in which postcolonial theory has developed *is* the world of global capitalism, many of its theoretical concepts and analytic insights – such as hybridity, diaspora, mimicry and, more generally, the problematization of identity and the recognition of the cultural politics of theory – have a potential applicability beyond the particularities of postcolonial concerns. Indeed, it is this which makes postcolonial theory relevant for a critical transnationalist cultural studies analysis of the contemporary world.

While Dirlik is right in emphasizing the importance of capitalism as a 'foundational' category in structuring the modern world-system, what postcolonial theory can offer us is insight into the convoluted historical processes through which all those at the receiving end of colonialism both voluntarily and involuntarily inserted themselves into that world-system. The colonized could only become a recognized part of the modern world by taking on the status of nation-states, accompanied by the inevitable felt necessity of nation building and anxiety over national identity. This historical problematic, aptly described by Turner as a series of double binds, still informs the realities of postcolonial nation-states even as national

boundaries are increasingly being made irrelevant by transnational capital. But these double binds are only effective as they are concretely worked over in specific – notionally national – historical and geopolitical contexts. What a critical transnationalist cultural studies can do is place particular postcolonial experiences, mostly situated within the nation, in a comparative transnational context in which what would be interrogated are the relations between the [in]commensurable modernities which postcolonial nation-states strive to put in place, at the same time remembering that these nation-states are themselves testaments to the simultaneous success and failure of the modern project.

Conclusion

Ulf Hannerz has remarked how, as global capitalism transforms the core/periphery structure, the cultural shifts associated with this development take place unevenly. He takes the example of old settler colonies where historical ties of 'kinship and ancestry . . . connect the periphery to a specific center' (1989: 67), and argues that:

> As people go on speaking English, French and Portuguese in post-colonial lands, in postcolonial times, old center–periphery relationships get a prolonged lease of life. If all this means that the center–periphery relationships of culture tend to exhibit some lag relative to present and emergent structures of political and economic power, it might also mean that Japan could yet come into greater cultural influence in the world.
>
> (Hannerz, 1989: 67)

This quote clarifies succinctly the two main axes of Australia's positioning in the world today: on the one hand, it explains the cultural persistence of Australia's connection with Europe, on the other, it contextualizes the emerging importance of 'Asia' as a significant cultural influence. It is this complex articulation of continuities and discontinuities between past, present and future, real and imagined, which we think a critical transnationalism should attempt to clarify. In this sense, a too one-sided emphasis on the past colonial relation runs the danger of losing sight of the complicated and contradictory, multifaceted positioning of Australia in the contemporary world (dis)order. As Suvendrini Perera remarks:

> In Australia recent recognitions of – and celebratory explorations into – a newfound 'postcolonial' condition often pass over the problems posed by an older national self-image of Australia as regional heir to the coloniser's discarded mantle. This history positions Australia in an unequal and uneasy triangle with Europe (and especially Britain) at one end, and 'Asia' on the other – a relationship perceived as a set of continuing hierarchical rearrangements based on current conditions of military, economic and cultural (which also at times includes 'racial') superiority.
>
> (Perera, 1993: 16–17)

Perera's emphasis on the triangle is particularly illuminating. It points to the fact that a crucial connection can be made between Australia's distinctive history as a British settler colony and the contemporary cultural, political and discursive difficulties it encounters in forging a new relationship with 'Asia'. The very fact that 'Australia' has traditionally identified itself with 'Europe' now complicates its attempts to reorient itself to 'Asia'. In other words, 'Asia' cannot just be substituted for 'Europe' at will; concrete historical processes still affect and refract contemporary relations.

In this context, there is an urgent need to address the significance of what it means for Australia, Canada and New Zealand (and, in a much more problematic way, South Africa) to have common histories as British settler colonies, a particular articulation of postcoloniality the implications of which have remained untheorized so far. As Vijay Mishra and Robert Hodge argue:

> It is especially important to recognise the different histories of the White settler colonies which, as fragments of the metropolitan centre, were treated very differently by Britain, which, in turn, for these settler colonies, was not the imperial centre but the Mother Country.
>
> (Mishra and Hodge, 1993: 39)

Mishra and Hodge go on to say that 'unbridgeable chasms' existed between white settler colonies and non-white non-settler colonies,[11] chasms, we would argue, which still create important differences in the present. These differences, here signalled around the articulation of British colonization and the impact of settlement on the fate of indigenous precolonial cultures, can be brought to bear more generally on the barriers which now complexly tangle Australia's rapprochement with 'Asia', now made up of nation-states which, despite their economic ascendancy within the arrangements of global capitalism, are nevertheless mostly as 'postcolonial' as Australia. However, this postcoloniality is articulated in diverse ways, as a consequence of idiosyncratic histories of these nation-states' negotiations with the forces of modernity, some of which are commensurable and some of which are not.

In this respect, a comparative transnational perspective on the postcolonial articulations of, say, Malaysia, Indonesia, Singapore and Australia would be illuminating. Malaysia was a British colony, but it was not a settler colony, and now bases its national identity on an assertive Malay indigeneity. Indonesia was not colonized by the British, but by the Dutch, whose colonial practices differed significantly from those of the British. Both Malaysia and Indonesia have established Bahasa Malaysia/Indonesia (which is basically the same language) as the official national language, but both insist on the distinctiveness of the two, precisely because their distinctive colonial pasts have led to the imposition of a territorial border between the two postcolonial nation-states which now needs to be legitimated and reproduced culturally. Singapore, formerly one of the Straits Settlements and now an independent nation-state, has much in common with Malaysia in terms of ethnic composition but shares with Australia the

fact that it is predominantly populated by immigrants – in Singapore, the Chinese not the Malays are the dominant ethnic group, creating its own tensions and strains within the region now called Southeast Asia. In the meantime, an important aspect of Australia's postcolonial history was the White Australia Policy, which, although formally abandoned some twenty years ago, still persists in the imagined worlds of many Malaysians, Singaporeans and Indonesians as proof of Australian white racism – and therefore why, from their perspective, Australia *cannot* be 'a part of Asia'. All these intersecting historical trajectories, combined with the imprints of various ranges of precolonial cultures, have produced partially overlapping and partially incongruous postcolonial modernities which still affect and curb the vectors of the disjunctive global cultural flows Appadurai talks about – expressed, for example, in the great number of Malaysian and Singaporean students studying at Australian universities, which itself is a result of the commodification of higher education under global capitalism.

In short, such a comparative project would bring in view the differential effects of the colonial enterprise as it has articulated and shaped particular spaces within the global order, and has helped to articulate the global order itself. In doing so it would help to affirm the recognition of the world as composed of multiple modernities whose boundaries do not necessarily coincide with those of territorial nation-states, and aid in the deconstruction of the modern binary division of the 'West' and 'Asia'. In fact, given the extent to which the project of modernity was pursued through colonization, this is a moment to note the common interests of postcolonial studies and a cultural studies informed by critical transnationalism. In historical terms, the postcolonial moment marks the end, and the failure, of the project of a singular modernity, but it also marks the epistemic moment in which a critical transnational cultural studies focused on the (in)commensurabilities of discrepant modernities becomes a possibility.

A strategic 'Asian turn' in Australian cultural studies, then, would seek to explicate 'Australia' on its own terms as a partial modern nation-state but also, and inclusively, in relation to a familiar but strange 'West' and an equally strange but familiar 'Asia'. In this respect, the very idea of the 'Asianization' of Australia, caught between the geo-economic imperative of a regionalized present and the historical legacy of a (post)colonial 'Western' past, can serve, at the least, to feed the Australian imagination with a sense of the (im)possible: the acceptance of 'Australia' as in 'Asia' but not of 'Asia', as having, in spite of Professor Huntington's prognostications, a heterogeneous (post)modern existence that is both 'Asian' and 'not-Asian'.

Notes

1 This article is a much revised version of a paper first presented at the Postcolonial Formations: Nations, Culture, Policy conference held at Griffith University, Brisbane, Australia, in July 1993. In places we have left in marks of its original presentation. We would like to thank Meaghan Morris for her

detailed and trenchant criticism of the original version. Work on this revised version was done while the authors were visiting fellows at the Program for Cultural Studies, East–West Center, Honolulu, Hawai'i in August 1994. We would like to thank Geoffrey White, Director of the Program, and Wimal Dissayanake for their support.

2 We have developed this further in Stratton and Ang (forthcoming).

3 Huntington distinguishes between 'Western, Confucian, Japanese, Islamic, Hindu, Slavic-Orthodox, Latin American and possibly African civilization' (1993: 25). It is curious that 'Asia' has been divided here in at least four different 'civilizations'.

4 The trouble with this text, of course, is the apparently homogenizing use of terms such as 'the West' and 'the Orient', but we do not want to take issue with this here.

5 Huntington's rendering of a looming 'clash of civilizations' is one response to this perceived 'decline of the West'.

6 In this vein, it is worth noting that the much more aggressive Japanese colonialism was also, in important ways, instigated as a response to the success of European imperialism.

7 For a further discussion of this issue, see Stratton and Ang (forthcoming).

8 Interestingly, in the mid-1980s, a short debate developed in Australian studies over the distinctiveness of Queensland identity (see e.g., Bulbeck 1987), but this has not been taken up as a part of the concerns of Australian cultural studies. However, on the identity of the Northern Territory in relation to 'Australia', see Stratton (1989).

9 For a critical discussion of the new importance being given to Confucian values in East Asia, especially Singapore, see e.g. Chua (1990).

10 As testified in the concept of the conference where an early version of this paper was first presented, and where participants from New Zealand, Canada and Australia gathered together under the umbrella of 'Postcolonial Formations'.

11 The category 'white' here should not be read in simple racial terms, but in terms of its complex historical complicity with 'modern', 'European' and 'Western'.

References

Appadurai, A. (1990) 'Disjuncture and difference in the global cultural economy', *Public Culture*, 2(2): 1–24.

Ashcroft, B., Griffiths, G. and Tiffin, H. (1989) *The Empire Writes Back: Theory and Practice in Post-Colonial Literature*, London: Methuen.

Blundell, V., Shepherd, J. and Taylor, I. (1993) editors, *Relocating Cultural Studies: Developments in Theory and Research*, London: Routledge.

Bulbeck, C. (1987) 'The hegemony of Queensland's difference', *Journal of Australian Studies*, 21: 19–28.

Castells, M. (1989) *The Informational City: Information Technology, Economic Restructuring, and the Urban-Regional Process*, Oxford: Basil Blackwell.

Chakrabarty, D. (1992) 'Provincializing Europe: postcoloniality and the critique of history', *Cultural Studies* 6(3): 337–57.

—— (1993) 'The difference – deferral of (a) colonial modernity: public debates on domesticity in British Bengal', *History Workshop Journal*, 36 (Autumn): 1–34.

Chua, B. H. (1990) 'Confucianization in modernizing Singapore', paper presented at 'Beyond the Culture' conference, Loccum, West Germany, October.

Coronil, F. (1992) 'Can postcoloniality be decolonized? Imperial banality and postcolonial power', *Public Culture*, 5(1): 89–108.

Dirlik, A. (1994) *After the Revolution: Waking to Global Capitalism*, Hanover: Wesleyan University Press.

Docker, J. (1974) *Australian Cultural Elites: Intellectual Traditions in Sydney and Melbourne*, Sydney: Angus & Robertson.

Frost, S. (1994) 'Broinowski versus Passmore: a dialogue of our times', *Continuum: The Australian Journal of Media and Culture*, 8(2): 20–48.

Frow, J. and Morris, M. (1993) editors, *Australian Cultural Studies: A Reader*, St Leonards: Allen & Unwin.

Gibson, R. (1992) *South of The West: The Narrative Construction of Australia*, Indianapolis: Indiana University Press.

Hall, S. (1992) 'The West and the rest: discourse and power', in S. Hall and B. Gieben (eds), *Formations of Modernity*, Cambridge: Polity Press.

Hannerz, U. (1989) 'Notes on the global ecumene', *Public Culture*, 1(2): 66–75.

Huntington, S. P. (1993) 'The clash of civilizations?', *Foreign Affairs*, 73(3): 22–49.

Iwabuchi, K. (1994) 'Complicit exoticism: Japan and its Other', *Continuum: The Australian Journal of Media and Culture*, 8(2): 49–82.

Jameson, F. (1993) 'On "Cultural Studies" ', *Social Text*, 34: 17–52.

Milner, A. (1990) 'Postmodernism and popular culture', *Meanjin* 49(1): 35–42.

Mishra, V. and Hodge, R. (1993) 'What is post(-)colonialism?', in Frow and Morris (1993).

Miyoshi, M. and Harootunian, H. D. (1989) editors, *Postmodernism and Japan*, Durham: Duke University Press.

Morley, D. and Robins, K. (1992) 'Techno-orientalism: foreigners, phobias and futures', *New Formations*, 16 (Spring): 136–56.

Morris, M. (1992) ' " On the beach" ', in L. Grossberg, C. Nelson and P. Treichler (eds), *Cultural Studies*, New York/London: Routledge.

Osborne, M. (1990) *South-East Asia*, Sydney: Allen & Unwin (5th edn).

Perera, S. (1993) 'Representation wars: Malaysia, *Embassy*, and Australia's corps diplomatique', in Frow and Morris (1993).

Rhadakrishnan, R. (1992) 'Nationalism, gender, and the narrative of identity', in A. Parker, M. Russo, D. Sommer and P. Yaeger (eds), *Nationalisms and Sexualities*, New York and London: Routledge.

Ross, R. and Trachte, K. (1990) *Global Capitalism: The New Leviathan*, Albany: State University of New York.

Sakai, N. (1989) 'Modernity and its critique: the problem of universalism and particularism', in Miyoshi and Harootunian (1989).

Stratton, J. (1989) 'Deconstructing the territory', *Cultural Studies*, 3(1): 38–57.

Stratton, J. and Ang, I. (forthcoming) 'On the impossibility of a global cultural studies: "British" cultural studies in an "international" frame', in D. Morley and K. H. Chen (eds), *Critical Dialogues: Cultural Studies, Marxism and Postmodernism in the Writings of Stuart Hall*, London: Routledge.

Turner, G. (1992) 'Of rocks and hard places: the colonized, the national and Australian cultural studies', *Cultural Studies*, 6(3): 424–32.

—— (1993) 'Introduction: moving the margins: theory, practice and Australian cultural studies', in G. Turner (ed.), *Nation, Culture, Text: Australian Cultural and Media Studies*, London: Routledge.

Wallerstein, I. (1991) *Geopolitics and Geoculture*, Cambridge: Cambridge University Press.

Yoshino, K. (1992) *Cultural Nationalism in Contemporary Japan*, London: Routledge.

KUAN-HSING CHEN

NOT YET THE POSTCOLONIAL ERA: THE (SUPER) NATION-STATE AND TRANS<u>NATIONALISM</u> OF CULTURAL STUDIES: RESPONSE TO ANG AND STRATTON[1]

ABSTRACT

What is the epistemological and political status of the nation-state in the current practices of Cultural Studies? What is the relationship between the transnationalization of capital/super-states and the transnational turn of Cultural Studies? Through analyzing discursive sites of 'regionalization', 'the Postcolonial', 'globalization', this essay attempts to pinpoint unquestioned assumptions in the critical phase of 'internationalizing' Cultural Studies. Unless counter-hegemony positions and strategies can be collectively discussed, argued over and formulated, Cultural Studies as an internationalist project will run the risk of losing its critical edges and even reproducing the existing power structure of the nation-states and global capital. An open-ended geo-colonial historical materialism is proposed to revitalize Cultural Studies as part of a global decolonization movement.

KEYWORDS

nation-state; transnationalism; Asia; postcolonial; global capitalism

We live a different 'local', and a different nation [a queer nation].
(A Taiwan lesbian friend, 1993)

I'm an internationalist, because I'm a feminist.
(Meaghan Morris, 1992)

African nation-states were built against the people.
(Manthia Diawara, 1994)

What is the problem?

After the 1970s, according to Masao Miyoshi (1993), transnational corporations have gradually taken over world power, both economic and

political, and become the new 'historical agents' of multinational capitalism. The recent collapse of the Eastern European and Soviet bloc, according to Arif Dirlik (1994), has finally kicked the world into an era of Global Capitalism. According to the economic analyses done by the Super State apparatuses (EC, APEC, NAFTA, ASEAN), Asia or East and Southeast Asia is and will be economically the fastest growing region on earth for the coming decade. Further, because of this irresistible trend which has already Asianized Australia economically, the Australian government (especially the Labor Party) is now promoting extensive cultural exchanges with several Asian countries, in effect leaving Europe for the Asian region.[2] Parallel to the transnational movements of capital and the realignment of the super nation-states, Cultural Studies is also transnationalizing and globalizing itself: *Public Culture* is now subtitled 'A Society for Transnational Cultural Studies'; Simon During, in his edited anthology, *Cultural Studies Reader*, announces that cultural studies is now 'a genuinely global movement' (During, 1993: 13); the newly founded journal, *Positions*, is subtitled 'East Asia Cultures Critique'; Ien Ang and Jon Stratton, writing from Australia, are calling for an 'Asian turn' of Australian Cultural Studies, and more ambitiously, attempt to develop 'a critical transnationalist perspective in cultural studies' (Ang and Stratton, 1995). In short, 'Transnationals' are on the move, the 'Asian' pacific rim is on the rise, and 'global capitalism' is marching forward.

What then is the difference between these two parallel movements: on the one hand, transnational capital and the super nation-states, on the other, Cultural Studies? This is the problematic which I wish to tackle. My short answer is: there is not much difference, or in fact, they are both exhibiting the same movement; the latter is guided by the former and, to put it strongly, transnational-global cultural studies is in complicity with economic neo-imperialism and the neo-colonial politics of nation-state structures. *Unless* counter-hegemonic positions and projects can be initiated, not to install cultural studies as a traditional, conservative discipline of the colonialist past, but to generate strategic knowledge in alliances with resisting subject groups (academic or otherwise) or non-statist, nonconformist oriented social movements across borders, the future history of cultural studies will be written as a 'post-colonialist' discipline just like sociology or anthropology developed in the nineteenth century under the high imperialist project. As David Morley (forthcoming) points out, postmodernism has a complicitous dimension leaning toward the highest stage of cultural imperialism, likewise, transnational cultural studies, if not seriously argued over, can be the vanguard of global capitalism.[3]

In addressing this question (to speculate on the dangerous moves and directions of cultural studies), I want to base my observations on recent 'events' which have taken place in the current 'state' of cultural studies or 'in the field'. I see cultural studies as a field of forces rather than an established discipline (though I have nothing against its desire to be recognized by the mainstream establishment as a discipline), or a banner attempting to gather committed intellectuals to form alternative communities across

multiple dividing lines. I am speaking as someone who, as an inside outsider, is deeply concerned with, attached to and troubled by the current state of the cultural studies 'project' and willing to engage in open-ended dialogues with my friends and colleagues who are also engaged locally and politically. Due to my subject-positioning, located at specific junctions, the following remarks and observations will necessarily have blind spots; I have no certain 'inside' knowledge of the battles fought out in other local contexts. None the less, this is how I see the 'worlds' of cultural studies, which is necessarily non-exhaustive and incomplete, and I don't intend or claim it to be anything else. I hope these remarks will trigger discussion, even if only to attack my blind spots just as I critically engage the equally legitimate positions of other cultural studies friends. I may well be wrong from the point of view of other (geo-political) subject positions, and I might change my mind in the next round of the debate if I'm convinced alternative positions can be more dialogic, more open-ended, more likely to construct collective lines of flight.

The nation-state of cultural studies

Cultural studies is indeed undergoing a critical phase of 'internationalization'. In the past, people who identified with the project of cultural studies were busy doing 'local' analysis, and thus have essentially been local-oriented; now dialogues across borders are beginning to take place. Journals such as *Third Text, New Formations, Cultural Studies, Public Culture, Positions, Media, Culture and Society, Theory, Culture and Society, Social Text, Transitions,* and the recently created *University of Technology Sydney Review,* all seem to willingly create spaces for border crossing dialogues. But this does not mean the dialogue is all that successful and productive.

The most controversial 'dialogue', or should I say monologue, took place at the heart of a 'transnational cultural studies' – *Public Culture* (1993), where a committed Marxist intellectual was bashed. Aijaz Ahmad (1992) in his book, *In Theory: Classes, Nations, Literatures,* critically engages a wide range of relevant issues such as 'Third World Literature', 'Languages of Class', and most importantly 'Three Worlds Theory'; in the process, Jameson, Rushdie and Said, in separate chapters, were polemically read. Isn't this a quite legitimate task? *Public Culture* spends an entire issue having invited essays (except one written by the Verso editor of Ahmad's book, and more interestingly, a reprinted piece from India as an attack on Ahmad from 'within') charging him as an orthodox Marxist, essentialist, economist, etc., and of course to defend the masters, especially Edward Said, a 'public intellectual' who gives tremendous political force to those of us located in the third world context. In recognizing Said's critical power, we should none the less grant Ahmad a legitimate space to engage in dialogue with Said. But Ahmad's more substantial and more challenging arguments on grounding critical analysis on class formation are left behind without being seriously engaged. Ahmad's insistence on preserving and

reinserting the notion of class is echoed in Stuart Hall's (forthcoming *a*) recent caution against the increasing absence of class analysis in cultural studies.

Ahmad's relentless questioning of the category of nation and nationalism parallels what I take to be a serious problem with the current state of 'inter-nationalizing' cultural studies: its unchallenged epistemological boundary of the political nation-state as a 'local context' (and more problematically, the 'ultimate' local context) of cultural analysis without taking into account the increasingly uneven process of globalization and the infiltration of economy, politics and culture, and in effect reproducing the nation-state boundary as it is parallel to the hierarchically and unevenly structured global division of economic and political power. In other words, the nation-state as a historical formation is now taken as a given; there is no critical distance consciously maintained between analytical category and a critic's enunciative position, hence a constant forgetting of the nation-state's questionable status, or worse, an implicating of the critic as a nationalist subject. Recent attempts to write the history of (a homogenous) cultural studies reveal this ambivalent and dangerous tendency.[4] And in fact, the dissemination or diffusionist model of cultural studies from any 'national origin' to other places can no longer account for the articulation of a 'cultural studies' with always-already existing historical practices of cultural critical works in local contexts.[5] It further obscures the possibility to recast the genealogical traces of cultural studies as an internationalist project.

With the trend of internationalization, the 'national(ist)' turn also announces itself. We have recently seen the appearance of 'British',[6] 'American',[7] 'Canadian',[8] 'Australian'[9] cultural studies books which are or will be on the market, as well as a growing cultural studies publishing industry.[10] Does the 'local' necessarily mean the 'national'? If so, perhaps, a united nation (actually 'the united states') of cultural studies could well be established. Does this mean that Stuart Hall (1992) is right to suggest that globalization will in one respect strengthen the demand for national identity? Obviously, the rise of nationalist sentiment in which cultural studies takes part has not so much to do with the progressive post-war nationalism against imperialism throughout the third world, but rather is an internal unifying project to assert a stronger voice and stronger share in the global formation of the super nation-state and capitalism. Of course, the stake here in international cultural studies is not simply to construct local-national stories of cultural studies, or to analyze and deconstruct 'national culture', but also to provincialize the dominant Anglo-American cultural studies. Seen from my geo-political location, if one follows this nationalist logic, the 'international' cultural studies actually means the nation-states of the English speaking settler's world.

On the other hand, we have also seen interesting works coming out of more 'marginal' sites. For instance, the English Department of the University of the Philippines has produced a fine journal, called *English Studies* and a book by Cristina Pantoja Hidalgo and Priscelina Patajo-Legasto, *Philippine Post-colonial Studies* (1993), posing an extremely

relevant question: what does it mean to do English studies in the Philippines? Filipino nationalist historian Renato Constantino (1988, 1990, 1991, 1992) has been writing on the now fashionable enterprise of the nation and nationalism for the past thirty years and has produced over forty books. Kumar David and Santasilan Kadirgamar (1989) edited a collective project, *Ethnicity: Identity, Conflict, Crisis*, covering the emergent political issues on nationalism and ethnic conflicts in the Asian region. These works are all written in the supposed 'international' (colonialist) language, English. But is it because international publishing is structured as such that these works are still not in contact with international cultural studies, which shares with these works similar kinds of concerns? The reverse is more often the case. Scholars situated in these marginal sites are always busy keeping track of what is going on in recent trends of 'critical' theory and cultural studies. This is precisely what I meant earlier by reproducing the existing power structure of global capitalism and the political nation-states. The direction of knowledge flow is contingent upon the volume of power positioned within the nation-state structure.

Granted that national culture is a space for struggle to address 'local' issues and agenda, one should not give up that very possibility if things can be done on that level. And methodologically the national is one among different levels of the local. But we have to pose the question here: does international cultural studies have to be divisionally organized around the axis of the nation-state? I think not. There are infinite possible ways of articulating more progressive lines of distinction in post-national terms such as those grounded in subject positions and groups, and around their intersections: gender/sexuality, class, race/ethnicity. It is simply too easy for certain versions of the 'poststructuralist' trend of cultural studies to give up identity politics; identity (however multiple, partial, momentary, strategic) is the foundation for political alliance and the most powerful political force moving in the third-world context. At a recent Taiwan conference, a southern California-based intellectual historian, in discussing the cyberspace of super-highways, wanted to throw away the entire category of class in the so-called post-colonial, post-socialist, post-Marxist, post-feminist, postmodern media society. American academic intellectuals on the left who have built their career on selling or trashing Marxism can always be theoretically 'radical' (the 'universal abandon' of any 'grand narrative') but politically questionable (giving up marginal political sites of struggle), willing to isolate themselves quite comfortably 'on campus', creating this gigantic imaginary universe in which they unconsciously situate themselves at the center of everything they are talking about.

Of course, one has to contextualize that what this critic is talking about is actually 'America', but he speaks as if it were true everywhere on earth. Indeed, when the international academic publishing industry is increasingly market-oriented towards the 'US' readership (because 'that's where the biggest market is'), it is increasingly difficult to deal with the question of context; for contextualizing can always mean that critical work has to contexualize *for them* (the US readership) the discourse from elsewhere.

When we read articles published in the US, the context is always assumed: the readers do not have to be reminded of the fact that Madonna emerged in a particular historical and geo-political context. But conversely, works written outside the US are always asked to contextualize when addressing 'local' issues, or even to analyze issues within a language or framework which 'American' academics are familiar with. This is how an unconscious nationalism works. It is within such interconnected apparatuses that the 'local context' gets interpellated to the level of the national; the local becomes nationally identified and squeezed under the common-sense schema of empiricist geographical and administrative hierarchy: the local, the national, the regional and the global; within which the nation-state is the centering point of connection. This of course says something about the hegemony of US culture which shapes and conditions the 'critical' mind, as well as the unequal distribution of power and resource. If this is the model that international cultural studies has to follow, then open dialogue on cultural specificities will never be possible. Isn't there the necessity to come up with workable strategies in order to get out of this one-way street and to disrupt the empiricist conception of the world?

I know I have been working on, and perhaps conflating, different levels of abstraction. What I am trying to do is to point out the danger of reproducing the nation-state on epistemological, methodological and political ground. Can the nation-state can be dismantled? How can we deal with national culture without reproducing the imposed structure of the nation-state in our analysis? Is it an untranscendable horizon? Is it epistemologically legitimate to take it as a historical given? Is it possible to keep a critical distance from it while still analyzing it? These are serious issues to be debated. In the following sections, we will see how the ghost of the nation-state either comes into the scene through the front door, or sneaks in from the back yard, through the window, in 'postcolonial' discourse as well as in discourse on 'transnationalism' or 'globalization'. It is a constant struggle to face the category, especially for 'international' cultural studies.

'The Asian turn'?

If a national(ist) cultural studies is deeply grounded in the problematic of the political nation-state, then is there any possibility of launching a new project of a 'regionalist' turn or a 'transnationalism' that bypasses the nation-state?

In the essay 'Asianing Australia: notes towards a critical transnationalism in cultural studies' (this issue), Ien Ang and Jon Stratton begin to formulate a new possibility. For the concerned readers of cultural studies in the region, the title of the essay seems immediately to position the project in a political-economic context. The movement and structuration of global capital at this historical moment cannot be adequately understood without accounting for the 'rise' of Asia or, in an even more ideologically charged term, of the Asia Pacific. Although the global consequences on various levels are still enigmatic, the economic imperative has

suddenly made the sign of 'Asia' acquire a historically unprecedented status and hence it has become a contested terrain: what does Asia mean? Within the region, there are attempts to define or redefine the term. For instance, the Singapore state from the early 1990s on has heralded a policy to elevate its own national identity to an Asian identity. As the Singapore sociologist Chua Beng-Huat (1995) points out, 'It may be ironical that the smallest nation in Asia should present itself as a representation of the world's largest continent and that its political leaders should be among the most vocal in defining the essential "Asian Value" '. This move of defining an Asian value in neo-Confucian terms is of course by no means innocent: 'In self-interest, it is of strategic economical and political importance for Singapore to insert itself into a larger piece. Asia may not need Singapore, but Singapore needs Asia.' It is probably easy to go beyond this single instance to imagine not only that the state apparatuses need Asia, but the agency, hiding behind the political platform, which needs Asia more: the Transnational Corporations (TNCs). Rupert Murdoch's recent move to buy off the first (intended) East Asia regional system, Star TV, is a concrete case in point. This pivotal role which TNCs play in shaping and reshaping the region, especially on a cultural level in redefining boundaries and identities, however, has not yet been adequately analyzed and theorized.

It is within such a process of transformation that one would expect Ang and Stratton's critical transnationalism to expose and deconstruct the directions and hidden motives of the TNCs and the states, or even to identify possible sites or strategies with which to combat them. Thus, one would expect the essay to articulate a version of transnationalism which is critically different from that of the TNCs and the (super) nation-states and to analyze such questions as Who or What is 'Asianing Australia', through what sorts of argument, institutional arrangements, to what end? With the identification of the long-term critical tradition of cultural studies, to address these questions might be the 'critical' edge of a self-conscious transnationalism. These expectations prove to be misplaced.

Ang and Stratton's essay begins by situating itself within a more general problematic: 'With this internationalization, or better, transnationalization of cultural studies comes a whole series of questions: what kind of world is constructed by cultural studies? What sort of a place is the world according to cultural studies? And how does it see its own place in that world?' (1995: 17) The problematic is an important one. It poses the question of how cultural studies can work collectively to better understand different worlds or find possible places from which to change. If this is a collective project, then the question of why transnationalization is necessarily a better formulation, and the very possibility for constructing a singular, unified word-place have to be theorized. The tension between a general project proposed for cultural studies and a contextualized analysis is framed in the following manner:

This paper is an attempt to carve out a terrain for a critical transnationalist perspectives in cultural studies . . . As we are writing this

paper in Australia, we are interested in developing a critical trans-
nationalist perspective which can productively intervene in critical
understandings of this country's place in the world in this particular
historical conjuncture. In doing this, we hope to clarify . . . how a prac-
tice of critical transnationalism can be brought to bear in cultural
studies.

(1995: 17)

It seems to be clear now that the task of the essay is twofold: (1) to perform
a critical transnationalism in cultural studies, by (2) intervening in, and
constructing an alternative understanding of, a particular unity-site
('Australia'). If I am not mistaken, the mission of critical transnationalism
as a general project, though the readers are never informed what 'critical'
might mean in the enterprise, is to understand 'a country's place in the
world', and here the essay concentrates on 'Australia', but the specific
operation can be 'applied' under any other country's name. In other words,
from the very beginning, this version of transnationalism is bound to live
on the level of a unifying sign, the nation-state; through their performance,
we will see 'Australia' put at the center of the stage, from beginning to the
end, becoming a centrifugal point against which other unities are placed:
an Australia-centered 'transnationalism'.

The essay zooms in on a to-be-intervened debate by bringing two discur-
sive spaces in contact: (1) 'the constant call in *public* discourse over recent
times . . . for Australia to become (or recognize itself as) "a part of Asia"'
(18); and (2) in Australian cultural studies, a 'lingering concern with
Australia's historical origin as a British settler colony', which is 'expressed
in a critical interest in "postcoloniality" and the related tendency to call
Australia a "postcolonial nation"' (18). The latter concern, according to
the analytical position, is more reactive toward the past because it can at
best give a 'redemptive understanding of the past', and the former more
'radical' toward the future, since 'it signals a fundamental unsettling of
established notions of "Australia" and, in designating "Asia" as
Australia's destiny' (18). In other words, the narrative strategy is to place
the radical future against the redemptive past, to place the 'public'
discourse against the nostalgic mode of Australian cultural studies. To put
it bluntly, the linear, progressive pathway towards a radical Australian
cultural studies is the Asian turn: 'we want to follow the lead of an
"Asian" turn in the public political discourse and suggest that an "Asian
turn" . . . in a critical transnational cultural studies can qualify and expose
some of the limits and silences of the claim that Australia is a "postcolonial
nation"' (18). This neatly organized temporal pigeon-hole strategy may
block other possible ways of addressing the linkages, as if the Australian
past has nothing to do with Asia but only the British empire. Can't one
establish 'Australia's' relation to 'Asia' in the colonial history? The binary
way of framing the question seems to empty out other ways of under-
standing 'Australia' in the complexity of histories.

This is the essential backbone of the essay. Looking at the staging of the

battle from the outside, I am tempted to pose the following questions: why is an Asian turn necessarily radical, simply because it is future-oriented? This 'public' call for an Asian turn is by no means unproblematic. The 'public' is such a disguised term; it covers up who is the subject articulating this 'imagined community', to whose interests, we might ask, for what ends?[11] Doesn't a discourse of the public imply specific subject positions: white, male, bourgeois holder of the state and economic apparatuses? Indeed, the essay points out, this public call is 'enunciated mainly by representatives of mainstream politics and the business world'. But, is this the level of 'public' discourse at which the essay attempts to intervene? Does this imply that the paper is taking a stand on the side of the state and capital, since it is arguing for an Asian turn? As an outsider, what puzzles me is why the essay accepts the framing of the public call at all? Why does 'Australia' want to be part of or in 'Asia'? If it claims to be a 'critical' project, does it have to operate 'within' the 'public' frame? What are the political stakes involved in this 'Asianing Australia?' What are other critical intellectual discourses on the issue? Or, is this largely in the Australian 'national interests', hence everyone is implicated in it? Beyond the public will of the national leaders, how are women's groups and Aboriginals responding to the 'project'? Where does the essay see itself in the discursive space of the 'public' debate beyond the simple for or against? Or, if the essay takes the Asian turn as an inevitable necessity, what are the historical conditions of existence which produce such turn?

The same argument can be used to challenge the essay's unquestioning acceptance of another important framing, that is to 'call Australia a post-colonial nation'. In what ways is Australia a postcolonial nation? From what subject positions can this be uttered? It is quite obvious that this is a formulation from the angle of the dominant population, the white settlers, and that is why the desire to depart from British influence gestures a desire for the 'post'. (In this sense, it is not entirely a 'nostalgia' of the past, because it is future orientated.) Is it really the case that the critical Australian cultural studies practitioners widely accept the claim, 'Australia is a post-colonial country'? As Ann Curthoys and Stephen Muecke put it, 'for increasingly, within the field of cultural studies, Australia is described as "a post-colonial society". Is it, however, truly post-colonial?' (1993: 180). It is politically an extremely important question to ask. For Curthoys and Muecke, 'A post-colonial political situation might be said to exist only when Aboriginal peoples achieve recognition, compensation and political autonomy, and where their hybrid identities can be confidently assumed' (1993: 180). In this sense, from the material conditions in the eyes of the aborigines, 'post-colonial' condition doesn't designate a past-oriented redemption, but a future-oriented unsettling of the settler's colonization. It is from this angle that we might question the validity of a problematic opposition between past (Europe) and future (Asia) set up by the essay. In fact, if there is anything 'critical' about the paper's analytic operation, it is the deconstruction of any binary opposition, an evil that the essay passionately attacks. Unfortunately, the framing device from the very beginning is

always and already a binarism. Throughout the essay, Australia is set up as the center pole, against which 'Asia', 'Japan', and even 'Europe' are issued their identity. But in the erasure of Aboriginal existence, in their uncritical acceptance of the postcolonial status of 'Australia', we can detect that within the homogenizing entity 'Australian', the only ethnic groups mentioned in the essay are 'white settler' and 'Asians' (not to mention erasing other critical categories such as gender, class and racial minorities). Is this the necessary effect of a 'transnationalism' which only operates on the level of the nation-state, thus following the dominant working logic which divides national identity by 'ethnicity'?

The essay then makes a 'cultural' argument for a re-opening of an intimate relation between Asia and Australia by identifying 'both the "West" and "Asia" as discursive constructs,' both 'a product of the West's own thinking', and then placing 'the Australian nation-state as an integral part of an always already Westernized (if not "Western") Asian region. In other words, both "Asia" and the "West" must be seen as part of one and the same, modern world'. To put it simply, 'One important element in the problematic relation between Australia and the nation-states of Asia is that they are all, in different ways, the consequences of this history, which involved the export of modernity from Europe to the rest of the world'; or in short, both are the product of the European project of modernity (Ang and Stratton, 1995: 20). This mode of drawing or re-drawing the connection between the two unified entities seems to be a forced one, simply a strategy to identify the common traits and then to gain legitimacy for re-mapping Australia into the Asian region. I can't but find the underlining discursive move to be rather Eurocentric. The essay promises us not to reify again the east–west binary, but goes further to unify the world into a totalizing west, a totalization leaving us no space to breathe. If the argument stands, Australia can also be part of Africa or Latin America, or wherever western colonialism has left its inscription, because as soon as they are 'part of one and the same modern world', they share something in common (i.e., 'western' or 'westernized') and are part of each other. Why are the histories before European intervention which still shape the geopolitics of the region not evoked? An almost positivistic epistemic work is at play here, which only pieces together the sameness, the like, but undercuts any longer-term history of the region. Granted that lumping together the geographical map of Asia may well be a European imaginary, Europe has also been dialectically constituted by the 'East'. The claim that Asia is a simple one-way product of Europe loses sight of the complexity of actual historical formations. On what ground can one homogenize the entire Asia into a consequence of European modernity? I am not denying the imperializing forces of European and American empire on shaping modern Asia, but I am contesting the simplification of the specificities of local histories and the reductionist claim which completely ignore the histories of the region before and after Euro-American imperialism. For instance, Thailand has never been a colony in the conventional sense of the term. The Chinese empire had a tremendously threatening impact in the region

long before any European invasion, and still operates in the present age. China had been the referent point against which the dominant bloc of the Japanese, Korean, or Taiwanese cultural imaginary 'constructs' ethnic and national identity. Further, for half a century, Taiwan was under Japan's rule. Japanese imperialism's 'Greater East Asian Co-Prosperity Sphere' project in the early 1940s deeply penetrated local cultures. Can one argue that Japanese imperialism was simply a product of European modernity? (Yes, perhaps, there was that element but not exclusively so.) To envelope the entire world into something called 'the project of modernity', or to attribute the state of being to the failure or success of something called European-Western Modernity, is simply to resort to a meta-narrative but does not help us much to understand the specificities of 'the world' at all.

Paradoxically, the essay argues that to depart from 'the West', and turn to 'Asia', is to deconstruct the 'core/periphery' binarism, to decenter a western-centric, universalist, imperialist project, to regionalize and provincialize itself, so to speak: 'In the period of high modernity, the core/periphery divide was clearly identifiable . . . But this neat division has become less and less easily applicable' (1995: 28). 'Japan' is cited as an exemplary case of deconstructing the western core. Which sector of Japan are they talking about? It's unified and nullified. What is critical is that 'Japan' seems to displace 'Asia' here. Other sites are completely dissolved. With 'the rise of Japan', to cite their term again, is there no longer a core and periphery distinction in the region any more? As I will argue in the last section, Asia as such does not exist. One has to carefully re-map the hierarchical structure (of core, semi-periphery, and periphery) in the new world context of global capitalism within which the Asian continent subdivides itself into multi-levels of rich and poor, strong and weak, political and economic nation-states. Interestingly enough, there seems to be a constant urge to align 'Australia' with 'Japan'; for instance, 'Australia and Japan inadvertently have more in common than is generally recognized: both are de-centered in relation to the source of the universal project of modernity (i.e., Europe)' (21). Indeed, careful readers of the essay will inevitably find the figure of 'Japan' a preferred one, as if it is a model that the authors propose to fill in the space of cultural imaginary for the 'Australian' to position itself. Further, can't this move to relativize core and periphery be read as an expansionist attempt to take the leading position, political and economic, so as to be able to share a larger piece of cake in the 'Asian' region, especially since two-thirds of Australian foreign investment capital has been there?

What does it mean to be 'part of Asia' or 'in Asia' then? The danger of the 'transnationalist' move on a regional level, if one pushes further, lies in inserting itself into the existing nation-state structure, and the fastest way is perhaps to be part of the super nation-state in the region; ASEAN then becomes one of the ideal choices. If 'Asianing Australia' means to join the camp of the ASEAN, rather than participating in alternative forms of projects or conducting critical analysis to pinpoint the hidden politics of the statist project, it can be a political catastrophe. As Constantino argued:

Nationalists of Third World countries know from experience how shrewdly imperial powers coopt valid Third World aspirations and turn these to their advantage. ASEAN peoples should therefore be wary of massive projects being proposed on a regional basis. These projects which utilize the rhetoric of Third World basic needs and cater to Third World hope of modernization may in reality be nothing more than trans-national plans to utilize the resources of these countries more efficiently. In fact, *ASEAN is becoming a platform for the regional schemes of global corporations.* Collective self-reliance based on individual nationalist goals by ASEAN can be realized only by transforming the association into a real regional grouping based on the needs of the peoples of the region and *not acting as an appendage of foreign corporate giants.*

(Constantino, 1988: 38)

What worries me about this call for an Asian turn of a transnational cultural studies is precisely the end effect of serving as the agent of multinational corporate and state power on the cultural levels of articulation.

Foregrounding Australia in Asia via a recuperation of their cultural likeness, Ang and Stratton launch an argument with the postcolonial, because 'a too one-sided emphasis on the past colonial relation runs the danger of losing sight of the complicated and contradictory, multifaceted positioning of Australia in contemporary world (dis)order' (1995: 32); namely, its new identity in relation to Asia cannot be accounted for by the postcolonial company. And in fact, Asia is the solution to the postcolonial nostalgia. At this point, the whole essay reaches a peak moment. As they put it:

A strategic 'Asian turn' in Australian cultural studies, then, would seek to explicate 'Australia' on its own terms as a partial modern nation-state but also, and inclusively, in relation to a familiar but strange 'West' and an equally strange but familiar 'Asia'. In this respect, the very idea of the 'Asianization' of Australia, caught between the geo-economic imperative of a regionalized present and the historical legacy of a (post)colonial 'Western' past, can serve, at the least, to feed the Australian imagination with a sense of the (im)possible: the acceptance of *'Australia' as in 'Asia' but not of 'Asia'* ... a heterogeneous (post)modern existence that is both 'Asian' and 'not-Asian'.

(1995: 34; emphasis added)

Coming around a full circle, 'West' and 'Asia', 'Australia' and 'Asia' (the opposition with quotation marks) finally resurface. By now it should be clear, 'Asia' is the sign which has been hired to 'decenter' the west, at the moment of remembering its 'Western' past, to re-map and reinsert 'Australia' into a new world of the future. Inherited from the European orientalist imaginary of the past, 'Asia' finally comes into being to define the identity or non-identity of 'Australia'. The assertion, Australia is 'in Asia and not of Asia' reminds us of prime minister Paul Keating's by now famous statement, 'Australia is a multi-cultural nation in Asia'; and hence

feeds back to the Australian statist project. The danger of the essay is precisely that it adds to the economic and political levels a 'cultural' vantage point for 'the Australian subject' to recognize *his* 'Asianness' in a postmodern-hybrid rather than binary form. This sophisticated 'cultural' deconstruction and reconstruction does generate a more complex understanding of Australia's relation to Asia, a cultural practice homologous to the policy direction of the state. As is stated earlier in the essay, 'there is a clear desire among the national leadership to bring about not only an economic "Asianization", but also a *cultural* "Asianization" of sorts' (19).

Critics of nationalism, such as Benedict Anderson (1991), have demonstrated that rewriting national history and redrawing the map of the geographical location of the nation in relation to its others (in this case 'Asia') are standard nationalist practices; thus the essay's deconstructive mode betrays its 'cognitive re-mapping' to relocate Australia, and to rewrite the 'history' of Australia, into Asia from a sort of European colonial Modernity, to be essentially an Australian *nationalist* project at heart.

This performance of 'a critical transnationalism', as I hope I have demonstrated at length, is rooted in and uncritically bound up with the nation-state. With no attempt to formulate a critical position from which to distance itself or to challenge the dominant discourse, the trans*national-ist* perspective in cultural studies restages a passive and homogenous 'Asia' only to fill in the imaginary of an Australian national identity. One cannot but ask once again: Why Asianize Australia? Who is the subject 'Asianing Australia'? What specificities of Asia is one referring to? Having deconstructed the Australian imaginary of its Euro-westerness, is it necessary to be another myth-maker of national identity? In the end, if we return to the general project of this critical transnationalism, the proponents seem to owe the readers an answer to the questions: what is the difference between their version of transnationalism and that of the Transnational Corporations? How does the project deal with the question of power exercised in colonialism and imperialism, which has always been transnational in practice? Or, are colonialism and imperialism no longer relevant issues and terms? In short, the hidden danger of a regionalist turn under the banner of transnationalism is that regionalism can be an upgraded ghost of nationalism, and transnationalism a nationalism 'upward', which might continue to consolidate the ideological status of the nation-state.

Not yet the postcolonial era

In the process of arguing for a transnationalist cultural studies, Ang and Stratton attempt to incorporate 'postcolonialism' (the inheritor of colonialism?) into their project. This incorporation echoes the trendy circulation of the term in cultural studies. The unstated epistemological assumption is that postcoloniality is a condition which is shared by a majority of peoples and nations in the modern world-system today; the world has gone beyond the era of colonialism, and hence by extension,

beyond the era of imperialism. Is postcoloniality, and before that the 'post-modern', a universal condition? Is it really the case that a majority of people on earth are now living the postcolonial conditions? What are the political effects of such a claim, of such labelling as the postcolonial? The Global Project of Postcoloniality is what I want to take on here.[12] Herbert Schiller, a Marxist political economist, has, in my view, quite correctly pointed out that this is 'not yet the Post-Imperialist Era' (1991). To echo his insistent point, I want to suggest that 'we' (those who are situated within the geo-political map of the 'Third World' 'nation-states' and, I would even go so far as to say, those colonized subjects living in the first world) have not yet and perhaps will not in the short term enter the post-colonial era.

As an 'Anglo-American' academic product, the postcolonial discourse has in recent years become a fashionable enterprise. Granted, postcolonial discourse has successfully taken over, appropriated and then politicized the energy of postmodernism. But under the condition where places like Hong Kong, Macao and East Timor, among others, are still undeniably colonies, entire third- world spaces are deeply saturated by neo-colonial forces (Constantino, 1988), where aboriginals, local and migrant workers, ethnic minorities, women, gays and lesbians have always been 'internally colonized' throughout the world, where large parts have not even begun to go through the process of decolonization (partially because of the imposed nation-state building projects which have swallowed up social energies), to announce the arrival of a *post* colonial (*post*-imperialist) era, the formation of a postcolonial culture and society, the shaping of a Global-Postmodern hybrid subjectivity, is politically not justifiable. Beyond the therapeutic function so that previous colonizers feel better, postcolonial discourse in effect obscures the faces of a neo-colonial structure in the process of reconstructing global capitalism, and potentially becomes the leading theory of the global hegemonic re-ordering. In short, an all too easy orchestration can generate devastating effects.

One of the strategies commonly adopted by the postcolonial discourse is to universalize a historical periodization, to forge a total rupture in order to legitimate a new invention, presumably inherited from the discourse of the postmodern. This formulation to suggest that 'we' (the entire universe) have entered another historical stage can be extremely imposing, and hence oppressive to the still colonized subject. In a recent book, *Oriental-ism and the Postcolonial Predicament: Perspectives on South Asia*, the editors of the volume, Carol A. Breckenridge and Peter van der Veer open the text with the following announcement:

> The contemporary world is discussed by journalists, scholars, and archi-tects as an age of 'posts': the postmodern, the postnational, and the post-structural ... Yet another 'post' is invoked here: the *postcolonial*. We can therefore speak of the postcolonial period as a framing device to characterize the second half of the twentieth century. . .

To call the second half of the twentieth century postcolonial, then, is

to call for a reappraisal of the way we frame contemporary world history and to emphasize the rupture in national and global relations created by the urge to forge independent nation-states first in the colonial world and now in the 'second world' of Eastern Europe and the former Soviet Union. It brings our attention to the relations between colonialism and nationalism in the politics of culture in both the societies of the ex-colonizers and those of the ex-colonized.

(1993: 1)

With a group of critical scholars, the technology of 'orientalism' (interestingly, the whole book is supposedly about orientalism) bounces back, reproducing the previous problem of area studies. It is a completely 'western' (actually American-dominant) *perspective [superimposed] 'on' South Asia*, which adopts the fashionable first-world *frame*, the postcolonial, as the universal periodization of supposed *world history*. With no exception, none of the authors is locally situated in South Asia to counter such a universal claim. As I have argued just now, the postcolonial is an Anglo-American invention which now claims its universality and legitimacy to 'frame' other parts of the world. If it is indeed a 'bringing together' of both forms of societies, then obviously it is from the 'perspective' of the ex-colonizers, who imagine that a common framing, labelled as postcolonial, can account for a 'world history' of colonialism and nationalism. Is it only within such a frame that 'we' can talk to 'each other'? To use their own words, isn't this a 'reproduction of patterns of domination'? The attempt, they continue, is to formulate 'critical alternatives and methods for approaching the study of *other* world regions' (Breckenridge and van der Veer, 1993: 2; emphasis added). The 'alternative' turns out to be nothing but a re-staging of the good old discursive 'application' (not my term, but theirs). In relation to 'other world regions', it seems clear here where 'they' speak from: the unsaid geo-political subject position is the metropolitan west. The rupture is played out here as another round of a postcolonialist imaginary of 'South Asia'.

Arif Dirlik, in 'The postcolonial aura; Third World criticism in the age of global capitalism', sarcastically answers the rhetorical question, 'When exactly ... does the "post-colonial" begin?', by saying, 'When Third World intellectuals have arrived in the First World academe' (1994: 238). Without sarcasm, my own observation does seem to confirm Dirlik's statement. Sociologically, the initiators of the postcolonial enterprise are indeed mostly third-world diasporic intellectuals; their positioning within the American/British academies has by and large produced progressive effects, up until their coming together under the banner of the postcolonial crew. In the process of struggling for power after long-term residence in the centers of dominant academic institutions, they have postcolonized themselves in a complexly hybrid way, looking at the world partially through 'the imperialist eye', forgetting that their productivity has everything to do with their 'home cultures' – being partially the outside of the dominant 'western' cultural formation and thus able (partially) to see things which

cannot be seen by the 'local' critical theorist (because it's difficult though not impossible for an 'insider' to keep a critical distance from the culture one lives in). Sensitive to what is going on within the changing global power structure, they have produced more 'accurate' knowledge (than the traditional imperial account of the colonies or American modes of area studies from the 1950s onward) inside the dark continents of Asia and Latin America, for instance. Being able to move inside and outside the heart of the hinterland of the advanced capitalist nation-state (that's where they are based) has made them the criss-cross points of the international trafficking of knowledge. The problem is not so much the potential effect (not to address the question of intention) of establishing their hegemonic academic power to direct the future directions of transnational cultural studies, but effects (from the center to the periphery) are generated on the key framing terms of local scholarship and discourses (such as the 'post-colonial'). Of course, this can only be done through the collaboration of third-world 'local agents' – who have their own interests at stake in accumulating more capital and power. They have, in effect, become not our (we who are inside the war zone of the third world) supposed ally but an 'intimate enemy'. They have replaced the old colonial position to re-colonize us. Consider this passage from Dirlik's piece:

Intellectuals in India ask Spivak to explain 'questions that arise out of the way you perceive yourself (The Postcolonial diasporic Indian who seeks to decolonize the mind), and the way you constitute us (for convenience, "native" intellectuals', to which Spivak's answer is 'your description of how I constituted you does not seem quite correct. I thought I constituted you, equally with the diasporic India, as the post-colonial intellectual!' The interrogators are not quite convinced: 'perhaps the relationship of distance and proximity between you and us is that what we write and teach has political and other actual consequences for us that are in a sense different from the consequences, or lack of consequences, for you'.

(1994: 337–8; my emphasis)

Indeed, this one-way street of 'constituting' the local counterpart by the 'transnational' theorist not only says something about the power of the latter, but also points to the critical tension that the distance, difference and antagonism between the diasporic 'Anglo-American' theorists/critics and 'Third World' intellectuals are increasingly greater and stronger. What goes on in the American academy can often times have effects on us who are thousands of miles away. For instance, cultural studies is increasingly defined within the American context by English departments, and quite understandably so: they have got more people and more long-term investment in textual analysis; once they discover the wave of cultural studies, they simply try to take it over and depoliticize the project. Here (in Taiwan), we have always had to politicize cultural studies' 'dirty' connection with the left, with Marxism, feminism and queer politics, with new

social movements, in order to reclaim its critical edge. When all the post-colonial rhetoric began to surface, we had to fight the sad battle against the unfounded transportation of these terms, or behind them, the diasporic father or mother figureheads, whom we used to respect too much to pronounce that 'X is wrong on this', since 'we' are running the risk of losing sight of the (neo)colonial structure which still shapes local culture. Fashionable terms like hybridity, in the local context, become something like a *laissez-faire* pluralism, everything goes, as if every bit of identity bears equal weight and thus blends together like a juice blender. In this sense, if one follows 'their' argument, imperialist cultural penetration is highly justifiable, since not only is the imperialist *himself* hybrid but also there is nothing wrong with the local subject becoming more hybrid (more 'American', more 'Japanese') anyway.

To some extent, I think this sort of argument for hybridity might be more justifiable in the long run, in a paradoxical way. The imperialist always imposes *his* view on the colonized without gaining knowledge by understanding the latter on his/her own terms. Conversely, the colonized mind who knows both sides (even with an inferiority complex) is always turning the colonizer's knowledge against himself (the colonizer); in other words, colonial knowledge can potentially be used to the advantage of the weak party. Historically, the crisis of the colonizer has always been precisely that: there is no mutual exchange of knowledge, but only a one-way strip. One day, the colonizer will suddenly discover how naive *his* mind-set has been, but then it is too late for *him* to know the traditions and cultures of the rising subordinators. That a 'postcolonial' vein of inter-national cultural studies can emerge is perhaps the realization of this colonial relation.

Where does the nation-state sneak back into the enterprise of the post-colonial? Well, on the surface, it does not seem to be connected in any straightforward way. But the underlying epistemological trap of the post-colonial is that the 'post'colonial unambiguously operates on the assump-tion of an independent political sovereignty, meaning the nation-state. Any condition that comes after the departure of the 'original' colonizer who gave political sovereignty 'back' to the 'Native' will be called the post-colonial condition. But if we know, (1) the political nation-state is only one axis of colonialism, and even so (2) the nation-state can historically be seen as an integral part of the colonial project, how can 'the postcolonial' sustain its claim of a total rupture? Further, if analysis is to operate on the economic and cultural levels, one can easily identify the deep structural tie between the neo-colonies and the former colonial powers; or as I have argued earlier, if one looks at the situation from the point of view of the oppressed subject positions of the colonized (labor, women, gays and lesbians, aboriginals), colonization moves on. Therefore, it is quite obvious that the postcolonial is in deep complicity with the political nation-state, and hence is an enterprise determined and circumscribed by the ideology of the nation-state.

As Ashis Nandy has argued in *The Intimate Enemy*, the periodization of

the end of colonialism in the Indian context just cannot be charted out according to the single category of political sovereignty:

> Colonialism in India began in 1757, when the battle of Plassey was lost by the Indians, and ended in 1947, when the British formally withdrew from the country; for other parts of the book, colonialism began in the late 1820s when policies congruent with a colonial theory of culture were first implemented and it ended in the 1930s when Gandhi broke the back of the theory; for still other parts of the book, colonialism began in 1947, *when the outer supports of the colonial culture ended and resistance to it is still continuing.*
>
> (1983: xvi; emphasis added)

Indeed, if one pushes further to look at decolonization from the point of different subject positions (rather than from the abstract category of the so-called national sovereignty which also hides the question of whose sovereign it is or who owns and makes use of it), one would notice that, for instance, in the case of Taiwan, for the previously more privileged middle-class mainlander ('wai-sheng-jen') male subjects, colonialism ends in 1945 when Taiwan came back to 'the mother country' from the hands of the Japanese colonizer; for the presently, politically dominant (previously subordinated) min-nan male population, especially of the capital sector, and a small portion of hakka upper middle class, colonialism continued until a min-nan president took over power in 1988; for the aboriginals, workers, gays, lesbians and women, colonialism continues, and will continue, until the ethnocentric, class, heterosexual and patriarchal structures can be dismantled and decolonized. The prominent subject group is indeed the aboriginal. For the aboriginal writers, Yichiang Paluer and Lawaugau Laikerlaker (1992), 'their' land and territory has been stolen by the 'han' people for the past 400 years;[13] and the ethnic subdivide within the 'han' into hakka, min-nan and wai-sheng makes no sense when dealing with questions of the sharp point of decolonization. It does not matter where one puts the date on the end of colonialism, the claim of Taiwan's 'postcolonial' status can only be enunciated by the Han colonizer.

Seen in both structural terms and the concrete historical practices of subordinated subject positions, the coming of a postcolonial era is perhaps a dream to struggle for. To utter the arrival of a postcolonial universe is, in effect, speaking from a privileged hegemonic space and from specific geopolitical locations, and escapes the question of power and subordination on different levels. This is, however, not to deny the tremendous contributions which postcolonial studies has made. It forces 'contemporary' cultural studies to decenter itself, to go back to histories, to the geocolonial histories; without rigorous historical analyses, critical issues such as the formation of global cultures cannot be adequately explained; it is only a gigantic empty shell with no internal trajectories.

Globalization (or the end effect of colonialism) and trans*nationalism*?

Obviously, the currency of internationalizing cultural studies does not simply come from its practitioners' networking efforts. According to Stuart Hall (forthcoming a), this phenomenon reflects the pressure of the globalization of culture, resulting from the post-cold war restructuration of global capitalism. In almost every locale, the operational logic of local cultures can no longer be more adequately explained without considering its dialectical articulation to the global. One might add that the theme of globalization as it is popularly staged in the dominant trends in cultural studies indicates an anxiety of not being able to know the world, and hence a symptomatic desire to re-map the world. The 1993 Michael Jackson 'Dangerous Trip' to Taiwan demonstrated to us how deeply local popular subjectivity and identity are constituted by the 'global' cultural imaginary of the multinational cultural industry. The younger generations' love for Jackson's presence almost produced a local riot in his concert, which had never happened before. We are indeed the so-called 'hybrid' subjects: we carry black, American, bi-sexual, and multinational record companies' elements inside our bodies, which are progressive in a lot of ways, since it has opened up the hidden potential to leave the ego-centric ghetto, and hence to interiorize the other, to become 'others', especially when blacks have always in Taiwan's Han culture been stereotypically discriminated against, and when 'homosexual' and 'bisexual' do not even register in the dominant culture. But we have to confront the long-neglected issue of cultural globalization inside our popular cultural formation. It is perhaps for these sorts of reasons that globalization has thus become a central issue on the agenda of cultural studies.

But let us reflect for a moment. Is this 'globalization of culture' really 'new'? From each locale, the global can mean different things, unless one wants to argue that globalization only means 'Americanization'. In Taiwan, for instance, the global can actually mean American and Japanese cultural production, and Taiwan cultural products – for instance the entire wave of the so-called New Taiwan Cinema (e.g., *Wedding Banquet*, the first film to have made it into the American market) – have to 'globalize' themselves through, e.g., Warner Brothers, as Hollywood distributor subsidized by the Taiwan state. Culture therefore becomes a nationalist project to remake the nation, to rebuild the state by inserting the sign of 'Taiwan' into the 'international' market, in order to win local national pride and 'American public' support for (imaginarily) joining the United Nations (seen as the ultimate goal of a new nation). But the point is that this contemporary form of globalization has a long history. Japanese cultural influences have been in Taiwan since 1895, and the American 'way of life' has dominated and shaped the state of minds since the 1950s. For instance, the Taiwan invention of KTV, in the States called Karaoke, now popularly spread through various geographic sites such as London, Chicago, Manila, Bangkok, New York, Hong Kong, LA, Tokyo, Peking, and elsewhere, has a colonial genealogy. The Japanese nakasi (a small

band for businessmen to sing with over the dinner table) was transported to Taiwan in the early twentieth century during the Japanese occupation; when it met American MTV (in Taiwan, MTV center signifies movie video renting space) in the 1980s, a visual dimension was added and it was transformed into KTV. This seemingly hybrid form of invented contemporary entertainment technology thus has the traces of the pain and blood of colonial and neo-colonial struggles. In this sense, globalization had come earlier than what was later formulated as cultural imperialism. To disconnect the colonial past and neo-colonial present from so-called globalization simply cannot account for the specificity of the local-global dialectic of histories. Once we situate 'globalization' back in history, and link it to the long-term historical formation of global capitalism, we can see that the trajectories of globalization have been inextricably entangled with the centuries-old history of colonialism.

Although the problematic of globalization can serve as a focal point of dialogue in international cultural studies,[14] perhaps because of the way the first-world critical discourse is situated in an isolated academic milieu, and because of its geo-political location on the top floor of the neo-colonial house, there are blind spots hiding unconsciously in the discursive formation. The problem of 'globalization' in the current discursive space is largely that it neutralizes power relations. Despite Hall's (1995b) warning that the unequal distribution of power in the globalization process has to be brought to the forefront, there is indeed a de-politicizing tendency to wipe out the question of power relations. In the concluding chapter of John Tomlinson's *Cultural Imperialism* (1991), 'From imperialism to globalization', a neutralizing strategy is at work to displace the political-critical concept of imperialism with a non-antagonistic term – globalization. This is a strategy of de-politicization. For Tomlinson, 'critiques of cultural imperialism can be thought of as . . . protests against the spread of (capitalist) modernity' (1991: 173); so far so good. But he goes on to argue that:

> What replaces 'imperialism' is 'globalization' . . . Globalization may be distinguished from imperialism in that it is a far less coherent or culturally directed process. For all that it is ambiguous between economic and political senses, the idea of imperialism contains, at least, the notion of a purposeful project: the *intended* spread of a social system from one centre of power across the globe. The idea of 'globalization' suggests interconnection and interdependency of all global areas which happens in a far less purposeful way. It happens as the result of economic and cultural practices which do not, of themselves, aim at global integration, but which nonetheless produce it. More importantly, the effects of globalization are to weaken the cultural coherence of *all* individual nation states, including the economically powerful ones – the 'imperialist power' of a previous era.
>
> (1991: 175; original emphasis)

One does not have to be a Foucaultian to methodologically challenge the fixation on intention; the similar effectivities of imperialism and globaliz-

ation can be charted. Incapable of charting out the courses of globaliz-ation, the 'replacement' strategy (the stage of imperialism superseded by globalization) which projects a complete rupture is reductionist and essentialist. As we know, third-world sites are loaded within identifiable features of 'western' historical moments squeezed and compressed in the present temporal/spatial zone. In third-world geo-colonial spaces, western 'pre-modern', 'modern' and 'postmodern' or 'late modern' cultural forms and elements blend together in this particular historical point of time. To argue for a global rupture is to speak for the 'imperialist power'. As Said has recently argued:

> A whole range of people in the so-called Western or metropolitan world, as well as their counterparts in the Third or formerly colonized world, share a sense that the era of high or classical imperialism, which came to a climax in what the historian Eric Hobsbawm has so interestingly described as 'the age of empire' and more or less formally ended with the dismantling of the great colonial structures after World War Two, has in one way or another *continued to exert considerable cultural influence in the present*. For all sorts of reasons, they feel a new urgency about understanding the pastness or not of the past, and this urgency is carried over into perceptions of the present and future.
>
> (1993: 7; my emphasis)

Or to use Gramsci's term, Stone Age elements are still operating in our present moment. Sometimes, a dominant one. The historicist periodization always hides the real, long-lasting, operating forces on the ground. Furthermore the disruption of 'cultural coherency' does not make the old nation-states' 'imperialist power' less powerful. It cannot be let off the hook so easily. The discursive effect of Tomlinson's appraisal of the decline of the imperial nation-state might be used to justify their intervention through cultural, economic and political forces, since they are not 'purposeful' and 'intentional'.

Once the rupturing effect has been discursively staged as 'the' truth, in Tomlinson's eye, the globalization process no longer seems to have anything to do with the structural unevenness of power and resources; domination and oppression, first/third worlds, capital/labor, state machine/social subjects, strong/weak distinctions and differences of power relations are all pushed away by this process called globalization. Precisely what the international power bloc would like everyone on earth to believe. Again, I would interpret Tomlinson's blind spots as the end results of the desire to forget the imperialist era, a desire which is constituted by the (local) history and geo-political location into which he is inserted.

Granted that the fast collapse of the socialist 'second world', the internal colonization within the 'third world', the global transformation of politi-cal and economic structures, etc. call for a reconsideration and revision of the 'Three Worlds Theory'. But this sense of urgency does not mean that we must erase the historical condensation of imperialist cultural impacts; to argue for such erasure is escapist and irresponsible. Said in *Culture and*

Imperialism (1993) has quite convincingly demonstrated that the imperialist culture of the past still conditions the present cultural imaginary. On the other hand, whether imperialism has completely been displaced or replaced is an issue worth debating. For some, imperialism 'lingers where it has always been, in a kind of general cultural sphere as well as in specific political, ideological, economic, and social practices' (Said, 1993: 9).

Of course, the neo-colonial imperialism in the post-war era has confronted the 'decolonization' movement; especially in the 1980s and 1990s, the expressive form of imperialism has been very different from that of the early stage.[15] Territorial occupation, military suppression, direct control over political sovereignty, etc., have been re-configured into an operational logic of 'hegemony': multi- and transnational corporations, global capitalism, and super-state apparatuses are the expression of a 'new wave' imperialism.[16] Using strong capital and military forces to take the leading position in international politics, and thus, in effect, forming political and economic dependency and an hierarchically structured international division of labor – these are the fundamental mechanisms for sustaining and reproducing the neo-colonial structure. To be sure, this new form of neo-colonial imperialism is definitely not a logical break, but a deepening of the previous articulation, now with a new mask. The critical conditions for forming the empire and the subsequent structural effects still hold and are intensified, as identified by Magdoff in the late 1970s: '(1) the monopoly structure of big business in the metropolises; (2) the imperative for these economic centers to grow and to control sources and markets; (3) the continuation of an international division of labor which serves the needs of the metropolitan centers; and (4) national rivalry among industrial power for export and investment opportunities in each other's markets and over the rest of the world' (Magdoff, 1978: 140). One might add to the list: (5) the exploitation of labor forces continues to grow (not only in the metropolitan center but also in third-world regional exploitation); (6) the gap between the rich and poor (both between countries and within countries) is greater and greater; (7) environmental conditions deteriorate, especially from the dumping of pollution from the first into the third world to the point where the last pieces of clean land are in the process of being destroyed. I think Schiller is absolutely right that this is 'Not yet the post-imperialist era'; Miyoshi pushes the point further to argue that 'colonialism is even more active now in the form of transnational corporatism' (1993: 728).

But even a position as radical and political as Miyoshi's can still project a blind spot, again, I think, resulting from his geo-political location in North America. The title of his essay, 'A borderless world: from colonialism to transnationalism and the decline of the nation-state' (1993), says it all. In his view, the nation-state is in the process of decline and transnationals have become the new Historical Agent.[17] He is perhaps right in the long run. But once situated in the third world context, one can see clearly that the forces of the nation-state (and nationalism) are not in decline but continue to increase in power (South Korea, Taiwan, Singapore,

Philippines, Indonesia, India, Sri Lanka, all are examples).[18] We have to recognize the rising power of transnational capitalism, but we also have to clarify the role the nation-state has played in this process of transformation; rather than declining, the super-state organizations (again, NAFTA, EC, APEC, ASEAN) have reassembled themselves through alliances to cut up territories, to split the interest, to restructure the market and labor power.

But, if one pushes Miyoshi's argument further, it is possible to suggest that, yes, it is indeed the era of transnationalism, but transnationalism in fact reinforces nationalism, just as nationalism reproduces transnationalism.[19] The global rise of nationalism can be understood in terms of the pressure of the transnational capitalist structure, within which each nation-state mobilizes its internal social forces in order to outwardly join the super nation-state, to share larger pieces of cake in the economic game, in the interests of the local-national capitalist sector but in the name of 'national interest'. In this sense, trans*nationalism* is in effect the product of nationalism, in that it is American or Japanese nationalism which hides itself under the neutralizing term, the transnational. Conversely, it is trans*nationalism* that dialectically generates the rise of third-world nationalism, defensively and ideologically used by the nation-states against the 'bigger' nation-states. Hence trans*nationalism* becomes the political foundation of transnationalism.

None the less, the transnational and global movement, for better or for worse, does call for a critical cultural studies to generate collective projects in confronting the situation.

A geo-colonial historical materialism

As an attempt to think how cultural studies can be justifiably practiced in my own geo-political context, the theoretical and political formulation of a new internationalist-localism developed out of the works of Ernesto Laclau, Chantal Mouffe and Stuart Hall has been proposed elsewhere (Chen 1992a, 1992b, 1995 and forthcoming). Here, I want to briefly summarize the key element of this position and then go on thinking possible collective agenda.

The theoretical articulation is founded on the strategic antagonism between the 'people' and the 'power bloc' on a local level, and elevated to an international and more global one. By people (the sites of identification), I mean organized social subject groups (NGOs, social movements); by power bloc, I mean capital, state apparatuses, the media, etc. The political ethics of this new internationalist localism is 'a theoretical anti-humanism but a political humanism'. This position seeks to psychoanalytically destroy the narcissistic structure of desire and the myth of 'primordial sentiment' (as the foundation of nationalist interpellation) and to urge a dialogic mode of relations with other subjects, to self-consciously interiorize others and to form a critical syncretism (Chen, 1994). Epistemologically, it breaks down the political boundary of the nation-state as the

'ultimate' level of 'local' analysis, and hence refuses to reproduce the existing power structure of neo-colonial imperialism. Methodologically, it calls for analyses emphasizing the dialectical and never-ending multiple tensions between the local and the global, rather than enclosing itself within the local site. Politically, it favors struggles against any form of hegemonic domination across the board and borders, building up alliances of peoples against the international power bloc, in struggles for local and global popular democracy. This position does not trust divisions according to nation-states, or even regions; of course it never trusts the nation and especially the state or super state. The 'new Internationalist(ism)', quite unlike transnationals, multinationals, or globalists, still preserves a long tradition of left radicalism. The politics of naming does matter. The term 'internationalist' is emphasized here because the 'international' or 'transnational' presupposes both a descriptive mode and a non-critical relation to the nation-state. 'Internationalist' registers a political positioning, a counter-hegemonic position across borders, which problematizes, epistemologically and politically, the relation between research as intervention and the existing nation-states as one of the central political sites to maintain and reproduce the structure of local and international powers. The 'new' internationalism inherited the tradition of the international left without the illusion of grasping state power and the party lines of leadership. A non-statist position seeks to investigate 'global culture' from locations identified with subordinate subject groups. Without this type of bold and self-conscious political identification, the analysis and research program might slide into traditional academic practices.

The restructuration of the world power structure (economic/political) has pushed us to rethink the earlier world mapping which, ever since the 1955 Bandung Conference, sharply distinguished three world systems (Ahmad, 1992: 287–318). Although the third world should no longer be romantically reified, to abandon the term once and for all is to erase histories. We have to describe in specific terms the internal hierarchical structure within the third world; to analyze in more precise terms which nation-state in alliance with (transnational) capitals is closer to the centers of power, which to the peripheries, so as to see clearly who is in the leading position to rip off others. For instance, in the East and South East Asian region, the core/periphery image does still seem to hold, politically and economically, but with further complications: the Japanese (in alliance with the remote American) empire is the core; the sub-empire NICs (Singapore, Taiwan, Hong Kong, Korea) are the semi-core; the next generation of NICs surrounding China (Malaysia, Thailand, Indonesia and Vietnam, and more or less so, the Philippines[20]) might be seen as semi-peripheral; and Burma, Laos and Cambodia would be on the periphery. What about China then? (In some ways, it parallels India in the South Asia region.) China, at this historical episode of world politics, is in the process of becoming the zone of the unknown. It has taken capital in from all over the world. And because of the logic of capital – a constant urge to invest with the quickest return rate, and because of its infinitely massive amount

of labor power, natural resources and land, almost no capital generated out of China can be expected to feed back entirely to the investing parties. But don't dream that Socialism will finally win the game. The strategy of an economic capitalism and a political socialism, put forward by the CCP, will finally have to confront the never-confronted emergence of a consumer society, which will in largest scope transform the ideological terrain of everyday life, and of course, the Chinese state never had the experience and doesn't have a clue as to how to deal with it. In short, China and India will be the leading edge to, and a central 'problem' for, world power restructuration. This is a reality that, not only the political (super) nation-states, economic multinationals, but especially progressive international sectors of anyone who has a sense of the world reshaping has to come to terms with, and to analyze in rigorous detail, this general movement of global capital. Failing to find ways to resist may eventually mean that a truly global capitalism will finally come to re-map the entire world.

At the same time, we have to decompose the state's pan-class belonging (essentially occupied by the capital-male bloc), and cannot take nation-state as a non-problematic point of identification. Fanon long ago, in *The Wretched of the Earth* (1968), has warned us that in the process of the anti-imperialist decolonization movement, if the energy of nationalism cannot be channeled into liberating political consciousness and social forces, once the common enemy (colonizer) has disappeared, the most resourceful group, the national bourgeoisie, would take the leading position; in the process of fighting for control of the state apparatus under the name of new nation building, they will cooperate closely with the previous colonialist state, making the colony a neo-colony, and launching an internal colonization, suppressing the working class, peasantry, aboriginals, and women, or worse, moving to other evil ends: cheaply inducing existing ethnic cultural differences, generating ethnic conflicts, so as to win the internal fights between the bourgeois sectors, which can lead to long term ethnic conflicts and ethnic cleansing and wars. Such a warning has proved true in India, Sri Lanka, Malaysia, and indeed in most parts of Southeast Asia.[21]

Fanon's analysis, in both *The Wretched of the Earth* and *Black Skin, White Masks*, proposes a model for confronting the common structural experiences of the third world: colonization —> decolonization —> internal and neo-colonization, a logical movement towards incorporation into the global capitalist system. Moving along this historic-theoretical line, the local site can be articulated to the hierarchically organized neo-colonial structure of global capitalism; on the other hand, it can be linked up with the specific historical and present conditions of particular geographical sites. On this model, perhaps a more adequate 'historical-geographical materialism' (Soja, 1989: 10–75), or to coin a new frame, 'a geo-colonial historical materialism', proper to the space and time experience of the third world as well as its colonial counterpart can be developed to answer questions emerging since the beginning of long-term colonial histories which have shaped and still shape local cultures, on different

levels of the local–global dialectic (for details, see Chen, 1994). The space between the local and the global requires more delicate and complex mediation through geo-politically structured colonial positioning. In this sense, the 'Third World' is no longer posited as a monolithic space to be reified analytically and politically, but designates a common structuration with inerasable historical specificities and differences. From this theoretical framework, a line of inquiry for an internationalist cultural studies on the historical rise of empire, imperialism, colonialism, nationalism, etc., can be carved out. And in fact, this is perhaps the blind spot and weakest area of cultural studies for the past thirty years, largely due in my view to the privileged geo-colonial position within which cultural studies has been operating. How many political and strategic works produced in the field deal with histories of the impact of imperialist forces on the specific cultural sites of the third world? In this sense, a geo-colonial historical materialism can be useful to investigate the dialectical formation of identity between local-national imperial cultures and the culture of the colonized in history. A more collaborative work of comparative colonialism and imperialism is urgently needed to sort out different modes of operation, contingent upon the material basis of the imperial powers, to generate different forms and degrees of colonization, so as to paint more succinct historical pictures of the imperialist policies, both 'at home' and in the colonies. How was cultural discourse ushered in to support a new imperialist cultural imaginary? And how, through 'local' interaction with the colonized culture, was the colonialist state and its governing population to change its gear and formulate its own cultural-national identities? How have the long-term histories of colonial legacies generated a lasting impact on the contemporary crisis of specific locales? (Can we see the current crises in East Timor, Guinea-Bissau, Angola and Mozambique at least partly as a result of the Portuguese colonial legacy, due to Portugal's 'third world' status within the European continent and its subsequent inability to deal with the problems in its former colonies?[22]) These are perhaps the kinds of question that a critical internationalist cultural studies may begin to address.

In this sense, the problematic for a politically charged cultural studies does not simply attempt to attack capitalist neo-imperialism but also seeks to cross the boundary lines of nationalist entrapment, to expose the internal, multiple lines of domination of relations. Following this line of inquiry, my recent analysis (Chen, 1994) indicates that the ideological foundation for forming a Taiwanese sub-empire is actually inherited from the Japanese imperialist cultural imaginary of the past, now resurfacing in contemporary unconscious desire. This may mean that decolonization on a cultural level has really not taken place yet. Whether other similar sites such as Korea, Hong Kong and Singapore (again, NICs) share similar kinds of problems, especially on the cultural, ideological level, is a further question. The Hong Kong situation is particularly acute: still situated within an older condition of a colony, its capital sector expands outwardly and becomes a new colonizer; on the basis of commercial and financial capitals, Hong Kong has become a gigantic shopping mall with a powerful

cultural industry (movie, music, satellite tv) for the entire East Asian region, including the more advanced cultural industry of Japan. Is this a historically unique phenomenon? What is its theoretical and political significance? As my colleague, Lii Ding-tzann (1994) poses the question in the research project on 'Mass culture and the construction of an imagined community: a preliminary examination of neo-colonialism among East Asian countries': Does this signal a new stage of, a rupture in, capitalism? Or, is this internal colonization within the third world a logical step of capitalist formation? In asking these questions, Lii has begun to propose distinguishing old forms of colonialism from the new ones emerging in the margin. Beyond these questions, one might say that the decolonization of deeply penetrating cultural forces has to be a future task of cultural studies, which is by no means easy and simple: what can decolonization mean in this historical conjuncture?; a nativist return to a 'purified' origin?; a postcolonial celebration of hybridity, a notion presupposing purity? What are the possible alternatives?

Finally, I want to say that a new internationalist cultural studies does not have to model itself on the hegemonic modalities of western humanities and social sciences, which are eager to build and discover macro, generalizable, universal, theoretical principles, which end up entering the world of pure abstraction or abstract concepts. In relation to that failed dream, cultural studies, following its own long-term critical spirit, has to pose questions from social realities in terms of those troubling phenomenon; through analysis of the concrete and theoretical explanation to cut into the real world, its production of discursive interventions can perhaps be more liberating and produce more knowledge as practices. Taking histories as the grounding site upon which cultural studies meets political economy is one of the intellectual missions to be fulfilled in the future. This is, in my view, the political epistemology of a new internationalist cultural studies.

Don't get me wrong. I am not saying that *Cultural Studies* should turn into a colonial studies journal but, at one point, it has to unavoidably confront issues of class, economic and global structures of domination; of cultural practices in the history of colonialism onwards; of how new social movements can be brought back to cultural studies as a political project. The battle is definitely not to throw the term cultural studies into a neo-liberal pluralism, but to politicize it, to insist on its connection with traditions of Marxism, feminism, anti-racism, anti-homophobia and anti-colonialism. I insist on 'a new internationalist' cultural studies partially because I have noticed the tendency of cultural studies to be locked into the nation-state divisions; an unconscious kind of nationalism is at work. Paul Gilroy puts this question very nicely:

In recent years, the structure of European nation-state has come under great strain. Nation-states may be waning in their significance but nationalism is certainly not dying with them. It is being reborn in all manner of unexpected and barbarous configurations.

(Gilroy, 1993: 49)

Beyond an imperialist and a nationalist cultural studies, there are other possibilities to give cultural studies a political agenda.

Some of the book stores in the Asian region:

In response to the Editor's request, I am listing the following addresses where publications (journals and books) can be obtained for readers outside the region. I guess the purpose is to facilitate better flow of (alternative) information. I would appreciate it if concerned readers in the region can provide information about alternative bookstores or publishers to enhance further possibilities. Please write to Kuan-Hsing Chen, Center for Cultural Studies, National Tsing Hua University, Hsinchu, Taiwan.

Solidaridad Bookshop
531 Padre faura, Ermita
PO Box 3959, Manila, Philippines
Tel: (632) 59-12-41
Fax: (632) 58-65-81

Popular Bookstore
MIT Building
Doroteo Jose St.
Sta. Cruz. Manila
Philippines

Consumers Association of Penang
87 Cantonment Road
10250, Penang
Malaysia

The Other India Bookstore
Mapusa 403 507 Goa, India
Fax: 91-932-3231

Streelekha Bookstore
67, II floor
Blumoon Complex
M.G. Road
Bangalore 560 001, India

Select Books, Pete. Ltd.
19 Tanglin Road #03-15
Tanglin Shopping Centre
Singapore 1024
Tel: (65) 732-1515
Fax: (65) 736-0855

Fembooks
2 Flr, No. 7, Lane 56
Sec. 3, Shing-sheng S. Rd.
Taipei, Taiwan
Tel: 886-2-363-8244
Fax: 886-2-363-1381

Glebe Books
191 Glebe Point Rd.
Glebe, NSW 2037, Australia

Tienanmen Bookstore
A-11, Bloc 14
Dityome
Shatin, Hong Kong
Tel/Fax: 852-572-5075

Notes

1 The title, and indeed the inspiration, of this essay comes from two sources: Herbert Schiller's (1991) 'Not yet the post-imperialist era' and Masao Miyoshi's (1993) 'Borderless world? From colonialism to transnationalism and the decline of the nation-state.'

 Lii Ding-Tzann, Marshall Johnson, Briankle Chang, Manthia Diawara, Jody Berland, Dave Morley, Hanno Hardt, Naoki Sakai, Jennifer Slack, Masao

Miyoshi have in various stages read bits and pieces of this paper and offered helpful comments.

The National Council, Taiwan, ROC, is gratefully acknowledged for giving me a one-year research fellowship (1994–5), during which this essay was completed.

In particular, I wish to thank Ien Ang and Meaghan Morris for their long-term conversation; Ien's energy triggered me to write this piece by putting together thoughts that have been on my mind for the past three or four years; Meaghan has always given me insight to think further. I thank Larry Grossberg for his careful reading of the text. Of course, again, Naifei Ding's critical force in shaping the argument of the piece has to be acknowledged.

2 Australian trade with North East Asian economies alone is about 62 per cent and rising, while with the US it is 12 per cent and falling. In this sense, Australian capital sector is irresistibly 'Asianized'.

3 For a theoretical account on the formation of global capitalism, see Peet (1991).

4 See, for instance, Stratton and Ang (forthcoming), who challenge and open up the myth of origin in 'British' cultural studies. The interview with Stuart Hall (forthcoming b) also indicates that it is highly problematic to even claim that British Cultural Studies was 'British' to begin with, since if 'British Cultural Studies' presupposes the New Left, and the New Left could not have taken place without the forces of colonial intellectuals from the outside (the Caribbean, Canada, Africa, etc.), who were independent from the tradition of the English left but in dialogue with them, then, as an offspring of the New Left, 'British' Cultural Studies was actually 'internationalist' to begin with. For more detailed argument, see the introductory chapter to Morley and Chen (forthcoming).

5 I would even go further to suggest that, because of its position within academe, debate and discussion within cultural studies tend to be formalized without a lively dialogic energy.

6 Turner (1990); Brantlinger (1990).

7 Brantlinger (1990).

8 Acland *et al.* (forthcoming).

9 Frow and Morris (1993); Turner (1993).

10 See for instances, Brantlinger (1990), McGuigan (1992), Harris (1992), Inglis (1993); among which Inglis's book is the most problematic one. More interestingly, a newspaper-size publication, *The Cultural Studies Times* was released by a group of publishers to promote 'Cultural Studies', which has been distributed in the bookstores on US campuses for free.

11 The whole neo-liberal tradition of the Public, in effect, not only homogenizes but also hides the fact that those who will eventually fight and indeed win more social spaces to insert their voices are the ones who have the most resources. Covering itself with ambiguity, 'the public' can be heralded to speak for the legitimacy of the power and the dominant who have 'won over the leadership' of the public arena; oppressed classes and groups are completely dropped out of the scene. For a recent account of the problems of the 'public' and 'public sphere' in both theoretical and Taiwan contexts, see Hsia (1994).

12 For a common reference to the postcolonial discourse, see Bhabha (1994), Spivak (1990); often times the Subaltern Studies Group has also been appropriated into the project (see Guha and Spivak, 1988). For critical attacks on the postcolonial enterprise and cultural studies, see Miyoshi (1993), Dirlik (1994).

13 The prevalent claim that Taiwan has had 400 years history and before that it's 'pre-history' is clearly a Han utterance, a Han exclusion of the aboriginal history.

14 See for instance, Hall (1991a and b, 1992), Falk (1992), Gomez-Pena (1992–3), Robins (1991).

15 For classics on imperialism, see Hobson (1965), Luxemburg (1976), Lenin (1939), Arendt (1973).

16 See for instance Clairmonte (1989) on transnational capital flow.

17 This 'decline of the nation-state' argument is very much shared by western scholars of the nation-state, such as Hobsbawm (1990), Smith (1983), Anderson (1991) or 'modernization' proponents such as Gellner (1983). For theoretical accounts of nationalism, see Blaut (1987), Balibar and Wallerstein (1991).

18 For recent analyses, see David and Kadirgamar (1989) for the Asian region in general; and Ackerman and Lee (1988) for Malaysia; Manogaran (1987) for Sri Lanka; Chen (1994) for Taiwan; Chua (1994) and Heng and Devan (1992) for Singapore; Heryanto (1994) for Indonesia; Trainor (1994) for Australian nationalism in an earlier period of history, and Louw (1994) for 'New' South Africa.

19 Conversation with Naoki Sakai, May 1994.

20 For recent studies on NICS and the next NICS, see Tan (1993).

21 See David and Kadirgamar (1989), Encarnacion and Tadem (1989), Ibrahim (1989), Ileto (1989), Lee (1992), Phadnis (1990), Sundaram (1989).

22 This thought is indebted to Benedict Anderson's presentations in the Symposium on 'Indomitable Voices: Portuguese Legacy, Nationalism and Cultural Identity in Angola, East Timor, Guinea- Bissau and Mozambique', 28 February to 1 March 1995, UC Berkeley.

References

Ackerman, Susan E. and Lee, Raymond L. M. (1988) *Heaven in Transition: Non-Muslim Religious Innovation and Ethnic Identity in Malaysia*, Honolulu: University of Hawaii Press.

Acland, Charles, Allan, Stuart, Berland, Jody, Davies, Ioan, Seaton, Beth and Straw, Will (forthcoming) editors, *In a Big Country: Studies in Canadian Culture*.

Ahmad, Aijaz (1992) *In Theory: Classes, Nations, Literatures*, London: Verso.

Anderson, Benedict (1991) *Imagined Communities: Reflections on the Origin and Spread of Nationalism*, London: Verso.

Ang, Ien and Stratton, Jon (in press) 'Asianing Australia: notes toward a critical transnationalism in Cultural Studies', *Cultural Studies*, 10(1).

Arendt, Hannah (1973) *The Origins of Totalitarianism*, New York: Harcourt Brace Jovanovich.

Balibar, Etienne and Wallerstein, Immanuel (1991) *Race, Nation, Class: Ambiguous Identities*, London: Verso.

Bhabah, Homi K. (1990) editor, *Nation and Narration*, London: Routledge.

—— (1994) *The Location of Culture*, London: Routledge.

Blaut, James M. (1987) *The National Question: Decolonizing the Theory of Nationalism*, London: Zed Books.

Brantlinger, P. (1990) *Crusoe's Footprints: Cultural Studies in Britain and America*, London: Routledge.

Breckenridge, Carol A. and van der Veer, Peter (1993) editors, *Orientalism and the Postcolonial Predicament: Perspectives on South Asia*, Philadelphia, US: University of Pennsylvania Press.

Breuilly, John (1985) *Nationalism and the State*, Chicago: University of Chicago Press.

Chatterjee, Partha (1993) *The Nation and Its Fragments: Colonial and Post-colonial Histories*, New Jersey, US: Princeton University Press.

Chen, Kuan-Hsing (1989) 'Deterritorializing "critical" studies in "mass" communication: toward a theory of "minor" discourse', *Journal of Communication Inquiry*, 13(2): 43–61.

—— (1992a) 'Voices from the outside: towards a new internationalist localism', *Cultural Studies*, 6(3): 476–84.

—— (1992b) *Media/Cultural Criticism: A Popular-Democratic Lines of Flight*, Taipei: Tang-Sang.

—— (1994) 'The imperialist eye: the cultural imaginary of a sub-empire and a nation-state', *Taiwan: A Radical Quarterly in Social Studies*, 17: 149–222.

—— (forthcoming) 'Yellow skin, white masks? or for a strategy towards a new internationalist localism', in Kuan-Hsing Chen (ed.), *Trajectories: Towards a New Internationalist Cultural Studies*.

—— (1995) Positioning *positions*: a new internationalist localism of cultural studies', positions: east asia cultures critique, 2(3): 680–710.

Chowdhury, Anis and Islam, Iyanatul (1993) *The Newly Industrialising Economies of East Asia*, London: Routledge.

Chua, Beng-Huat (1994), 'Racial-Singaporeans: absence after the hyphen', paper presented at the Conference on 'Identities, Ethnicities and Nationalities: Asian and Pacific Context,' La Trobe University, Australia.

—— (1995) 'Culture, multiracialism and national identity in Singapore', paper presented at Trajectories II: A New Internationalist Cultural Studies Conference, National Tsing Hua University, Hsinchu, Taiwan.

Clairmonte, Frederick (1989) 'The political economy of transnational power', in Peter Limqueco (ed.), *Partisan Scholarship*, Manila: Journal of Contemporary Asia Publishers, 320–43.

Constantino, Renato (1988) *Nationalism and Liberation*, Quezon City, Philippines: Karrel, Inc.

—— (1990) *The Philippines: The Continuing Past*, Quezon City, Philippines: The Foundation for Nationalist Studies.

—— (1991) *The Making of a Filipino: A Story of a Philippine Colonial Politics* (7th printing), Quezon City, Philippines: Malaya Books.

—— (1992) *The Philippines: A Past Revisited (Pre-Spanish-1941)* (13th printing), Quezon City: The Foundation for Nationalist Studies.

Curthoys, Ann and Muecke, Stephen (1993) 'Australia, for example', in Wayne Hudson and David Carter (eds), *The Republicanism Debate*, Kensington: New South Wales University Press.

David, Kumar and Kadirgamar, Santasilan (1989) editors, *Ethnicity: Identity, Conflict, Crisis*, Hong Kong: Arena Press.

Dirlik, Arif (1994) 'The postcolonial aura; third world criticism in the age of global capitalism', *Critical Inquiry*, 20: 328–56.

During, Simon (1993) editor, *The Cultural Studies Reader*, London: Routledge.

Encarnacion, Teresa and Tadem, Eduardo (1989) 'Ethnic self-determination and separatist movements in Southeast Asia', in Kumar David and Santasilan

Kadirgamar (eds), *Ethnicity: Identity, Conflict, Crisis*, Hong Kong: ARENA Press: 70–94.

English Studies, a journal published by the English Department of the University of The Philippines.

Falk, Richard (1992) 'Democratizing, internationalizing, and globalizing: a collage of blurred images', *Third World Quarterly*, 13(4): 627–40.

Fanon, Frantz (1967) *Black Skin, White Masks*, New York: Grove.

—— (1968) *The Wretched of the Earth*, New York: Grove.

Frow, John and Morris, Meaghan (1993) editors, *Australian Cultural Studies: A Reader*, Australia: Allen & Unwin.

Gellner, Ernest (1983) *Nations and Nationalism*, Oxford University Press.

Gilroy, Paul (1993) *Small Acts: Thoughts on the Politics of Black Cultures*, London: Serpent's Tail.

Gomez-Pena, Gullermo (1992-3) 'The new world (b)order', *Third Text*, 21:71–9.

Guha, Ranajit and Spivak, Gayatri (1988) editors, *Selected Subaltern Studies*, Oxford University Press.

Hall, Stuart (1991a) 'The local and the global: globalization and ethnicity', in King (1991): 19–39.

—— (1991b) 'Old and new identities, old and new ethnicities', in King (1991): 41–68.

—— (1992) 'The question of cultural identity', in S. Hall, D. Held, T. McGrew (eds), *Modernity and Its Future*, Cambridge: Polity Press: 274–316.

—— (forthcoming a) 'Cultural studies and the politics of internationalization: an interview with Stuart Hall', in David Morley and Kuan-Hsing Chen (eds), *Stuart Hall: Critical Dialogues*, London: Routledge.

—— (forthcoming b), 'Formation of a diasporic intellectual: an interview with Stuart Hall', in David Morley and Kuan-Hsing Chen (eds), *Stuart Hall: Critical Dialogues*, London: Routledge.

Harris, David (1992) *From Class Struggle to the Politics of Pleasure: The Effects of Gramscianism on Cultural Studies*, London: Routledge.

Hechter, Michael (1975) *Internal Colonialism: The Celtic Fringe in British National Development, 1536-1966*, Berkeley: University of California Press.

Heng, Geraldine and Devan, Janadas (1992) 'State fatherhood: the politics of nationalism, sexuality and race in Singapore', in Andrew Parker *et al.* (1992) *Nationalisms and Sexualities*, London: Routledge: 343–64.

Heryanto, Ariel (1994) 'Chinese Indonesia in public culture: ethnic identities and erasure', paper presented at the Conference on 'Identities, Ethnicities and Nationalities: Asian and Pacific Context', La Trobe University, Australia.

Hidalgo, Cristina Pantoja and Patajo-Legasto, Priscelina (1993) *Philippine Postcolonial Studies*, Department of English and Comparative English, University of the Philippines.

Hobsbawm, E. J. (1990) *Nations and Nationalism since 1780: Programme, Myth, Reality*, Cambridge University Press.

Hobsbawm, E. J. and Ranger, T. (1983) editors, *The Invention of Tradition*, Cambridge University Press.

Hobson, J. A. (1965) *Imperialism*, Ann Arbor: University of Michigan Press (originally published in 1902).

Hsia, Chu-joe (1994) '(Re)constructing the public space: a theoretical reflection', in *Taiwan: A Radical Quarterly in Social Studies*, 16: 21–54.

Ibrahim, Zawawi (1989) 'Ethnicity in Malaysia', in David and Kadirgamar (1989) 126–42.

Ileto, Reynaldo Clemena (1989) *Pasyon and Revolution: Popular Movements in the Philippines, 1840–1910*, Quezon City: Ateneo de Manila University Press (third edition).

Inglis, Fred (1993) *Cultural Studies*, Cambridge: Blackwell.

Johnson, Marshall (1990) 'Classification, markets and the state: constructing the ethnic division of labor on Taiwan', Ph.D. Dissertation, the University of Chicago, USA.

King, Anthony D. (1991) editor, *Culture, Globalization and the World System*, London: Macmillan.

Laclau, Ernesto (1977) *Politics and Ideology in Marxist Theory*, London: Verso.

Laclau, Ernesto, and Mouffe, Chantal (1985) *Hegemony and Socialist Strategy*, London: Verso.

Lee Geok Boi (1992) *Syonan: Singapore under the Japanese (1942-45)*, Singapore: Singapore Heritage Society.

Lenin, V. I. (1939) *Imperialism in the Highest Stage of Capitalism*, New York: International.

Lii, Ding-tzann (1994) 'From incorporation to yielding: preliminary theoretical propositions for a "marginal colonialism"' (manuscript in Chinese).

Louw, Eric P. (1994) 'Shifting patterns of political discourse in the New South Africa', *Critical Studies in Mass Communication*, 11(1): 22–53.

Luxemburg, Rosa (1976) *The National Question: Selected Writings of Rosa Luxemburg*, New York: Monthly Review Press.

Magdoff, Harry (1978) *Imperialism: From the Colonial Age to the Present*, New York: Monthly Review Press.

McGuigan, Jim (1992) *Cultural Populism*, London: Routledge.

Manogaran, Chelvadurai (1987) *Ethnic Conflict and Reconciliation in Sri Lanka*, Honolulu: University of Hawaii Press.

Miyoshi, Masao (1993) 'A borderless world? From colonialism to transnationalism and the decline of the nation-state', *Critical Inquiry*, 19: 726–51.

Morley, David (forthcoming) 'Postmodernism: the highest stage of cultural imperialism?, in Morley and Chen (forthcoming).

Morley, David and Chen, Kuan-Hsing (forthcoming) editors, *Stuart Hall: Critical Dialogue in Cultural Studies*, London: Routledge.

Muto, Ichiyo (1994) 'PP21: a step in a process', *AMPO: Japan-Asia Quarterly Review*, 25(2): 47–53.

Nandy, Ashis (1983) *The Intimate Enemy: Loss and Recovery of Self Under Colonialism*, Bombay: Oxford University Press.

Peet, Richard (1991) *Global Capitalism: Theories of Social Development*, London: Routledge.

Phadnis, Urmila (1990) *Ethnicity and Nation-building in South Asia*, New Delhi: Sage.

Pletsch, Carl E. (1981) 'The three worlds, or the division of social scientific labor, circa 1950-1975', in *Comparative Studies in Society and History*, 23(4): 565–96.

Public Culture (1993) Controversies: Debating in Theory, 6(1).

Robins, Kevin (1991) 'Tradition and translation: national culture in its global context', in John Corner and Sylvia Harvey (eds), *Enterprise and Heritage: Crosscurrents of National Culture*, London: Routledge.

Said, Edward (1979) *Orientalism*, New York: Vintage Books.

—— (1993) *Culture and Imperialism*, New York: Alfred A. Knopt.

Schiller, Herbert (1991) 'Not yet the post-imperialist era', *Critical Studies in Mass Communication*, 8: 13–28.

Smith, Anthony D. (1983) *Theories of Nationalism*, New York: Holmes & Meier.

Soja, Edward (1989) *Postmodern Geography: Representation of Space in Critical Social Theory*, London: Verso.

Spivak, Gayatri (1990) *The Postcolonial Critic: Interviews, Strategies, Dialogues*, New York: Routledge.

Stratton, Jon and Ang, Ien (forthcoming), 'On the impossibility of a global cultural studies', in Morley and Chen (forthcoming).

Sundaram, Jomo Kwame (1989) 'Nationalist alternative for Malaysia?, in Peter Limqueco (ed.), *Partisan Scholarship*, Manila: Journal of Contemporary Asia Publishers, 213–32.

Tan, Gerald (1993) 'The next NICS of Asia', *Third World Quarterly*, 14(1): 57–73.

Tomlinson, John (1991) *Cultural Imperialism*, Baltimore: The Johns Hopkins University Press.

Trainor, Luke (1994) *British Imperialism and Australian Nationalism: Manipulation, Conflict and Compromise in the Late Nineteenth Century*, Sydney: Cambridge University Press.

Turner, Graeme (1990) *British Cultural Studies: An Introduction*, Sydney: Unwin Hyman.

—— (1993) *Nation, Culture, Text: Australian Cultural and Media Studies*, New York: Routledge.

Yichiang Paluer and Lawaugau Laikerlaker (1992) 'History of the development of aboriginal nations in Taiwan', *Hunter's Culture*, 16: 30–41 (in Chinese).

IEN ANG AND
JON STRATTON

A CULTURAL STUDIES WITHOUT GUARANTEES: RESPONSE TO KUAN-HSING CHEN

ABSTRACT

This article is a short response to Chen's critique of our article 'Asianing Australia: notes toward a critical transnationalism in cultural studies'. It is argued that Chen's attack on our article is misdirected. Furthermore, we are in substantial agreement with Chen on many issues, most importantly that the nation-state should not be the uninterrogated site for the development of a 'local' cultural studies. However, we find Chen's politics, and his use of a reductionist Marxist theory, overly simplistic. Moreover, the core/periphery binary which he uses is not adequate to express the complexities of a global capitalist world order in which the sites of power are becoming increasingly decentred. Similarly, the politics of resistance are also more complex than Chen suggests; resistance must be understood in relation to local situations and local tactics, as well as the imperatives of global capitalism. Finally, a properly localized and left-politicized cultural studies must reflexively interrogate the politics of theory, including Marxism, considering its specific 'western' history and recognizing the necessary partiality of theory in a post-colonial world of differentiated modernities.

KEYWORDS

cultural studies; Marxism; theory; resistance; postcolonialism; globalization

Kuan-Hsing Chen appears to us to criticize 'Asianing Australia' with surprising virulence. However, as we hope any careful reader of our article will recognize, what Chen is denouncing in fact are some straw positions he has constructed in order to make his points dialectically by means of attack. To take but one fundamental point about which he and we are in agreement, the nation-state should not be the uncritiqued space on which a locally produced cultural studies should be built. Thus, we make a careful distinction in our paper between Australia as a nation-state and 'Australia' as a contested discursive formation. What we suggest is that the

relation between the former and the latter is never constant and given, and that the struggle over the latter – the struggle over how 'Australia' is made to mean – can be mobilized to help deconstruct the ideological fixity of the former. Indeed, one of the projects of a *critical* transnational cultural studies which we are adumbrating would be the unsettling of not just the nation-state as a secure site from which to write but *any* 'local' site; that is, we are arguing for a cultural studies which has the power and ability to critique its own speaking position. Any cultural studies of this type can only be provisional and partial, precisely because no 'local' positioning (including the social ones of class, gender or race, for example) can ever have the privilege of commanding a definitive theoretical and political closure.

Given the extent of Chen's and our agreement on what a localized 'global' cultural studies should do, perhaps the real source of the untoward attack lies in our differences over the nexus of 'theory' and 'politics'. Thus, Chen argues that our proposal for an 'Asianing' of 'Australia' is 'essentially an Australian nationalist project at heart' and therefore 'uncritically bound up with the nation-state'. Throughout his paper it is clear that Chen sees nationalism-as-such as an inherent evil, and any engagement with the nation-state as necessarily complicit with 'the bad guys'. Here, certainly, we part company with Chen, finding his approach not only theoretically reductionist and politically essentialist, but also historically inappropriate for a world of (in)commensurate modernities dominated by a decentred global capitalism. In our view, a cultural studies sensitive to the specificity of the local cannot presume a necessary correspondence between nationalism and the nation-state on the one hand and 'oppressive' politics on the other. What it needs to analyse and critique is the politics of *particular* nationalisms and the complex power relations operative within (and between) *particular* nation-states, not to argue from a formal, *a priori* condemnation of nationalism and the nation-state *per se*. A cultural studies based on the latter, furthermore, would deprive itself of the capability to understand some of the most salient social movements in the contemporary world, for many of whom nationalist discourses remain important (if ambiguous) resources and the nation-state, for better or worse, provides a significant framework for their very existence and field of operation. Our argument for a 'critical transnationalism' is meant precisely to capture the dual aim of acknowledging the undeniable significance of the nation-state in shaping 'modern' societies everywhere, and the need simultaneously to point to the *limits* of this structure by going beyond the imaginary of the nation as a taken-for-granted positive entity. Such a position demands a careful intervention in concrete realities and discourses and an acceptance of the inevitably limited character of such an intervention, not absolutist (or indeed, 'globalist') political exhortations *à la* Chen.

A good way in here is to take issue with Chen's espousal of the term 'internationalist' in preference to our 'transnationalist'. As he remarks, 'The politics of naming does matter.' Chen prefers 'international' because

'quite unlike transnationals, multinationals, or globalists [it] still preserves a long tradition of left radicalism' (60). In this account Chen's nostalgia for the certainties of European Enlightenment universalism is obvious. It must not be forgotten that the federation of national communist parties and organizations – aimed at the unification of the presumably universal (but mostly European) working class – was known as the International. It is also instructive to remember that the term 'international' first came into use, significantly, at the height of European colonial expansion when 'to internationalize' effectively meant to bring colonized spaces under the colonial rule of European nation-states (King, 1990: 78). 'Internationalism', then, is a universalizing perspective which vindicates the legitimacy of its constituting nation-states, whereas 'transnationalism', while avowedly necessitated as a perspective by the aggressive ascendancy of global capital, can be put to critical use as a 'local' strategy to call the boundaries of the nation in question by thinking *beyond* those boundaries (see e.g., Rouse, 1995).

Chen's account is underpinned by a Marxist description of the role of capitalism and colonialism in the formation of a modern world dominated by nation-states, and by those of Europe in particular. It is clear that Chen still conceptualizes the world in terms of a colonialist core and a colonized periphery. In common with many thinkers today we consider such a binary metaphor to be inadequate to describe the complexities of a global order in which the sites of economic, political and ideological power are becoming increasingly decentred. Nevertheless, we agree with Chen that the baby should not be thrown out with the bathwater. The Marxian analysis of the revolutionary role of capital in the formation of the modern world remains of crucial importance as we enter what, for shorthand purposes, we have described as the 'postmodern' world, which is also, to all intents and purposes, 'postcolonial'. Contrary to Chen, however, who interprets the prefix 'post' rather ahistorically and one-dimensionally as a 'total rupture' between a before and an after, we prefer to use 'post' in line with how Laclau and Mouffe (1990) describe their commitment to a post-Marxism: a theoretical approach which emerges from a deepening of Marx's legacy, but also recognizes the need to go beyond it due to its historical specificity and limitations as a theory developed in the context of nineteenth-century Europe. That is, post-Marxism is not a total rupture from Marxism, but a discontinuous continuation of it, necessitated by the changing relations of power and social struggles in the late twentieth century. Similarly, 'postmodern' is not 'ex-modern', nor should 'postcolonial' be simplistically equated with 'ex-colonial', as Chen seems to imply. The postmodern and the postcolonial do not imply a nullification of the burden of the modern and the colonial; on the contrary, they point to the intensification and proliferation on a global scale of the contradictions, antagonisms and struggles (including those captured under the rubric of 'neo-colonialism') which were put in place by the earlier forces of the modern and those of colonialism and which still have a powerful bearing on the formally 'de-colonized' present.

One of the problems with Chen's position, then, is his uncritical invocation of left radicalism. There was a short time in the history of the modern world when it was possible to define, though even then not always clearly, what was left radicalism. One of the powers of Marx's work was its ability to bring together a critical analysis of capitalism with a clear moral position. This connection was forged in Marx's elucidation of class politics. However, even a cursory examination of what, in many ways, is a very illustrious radical tradition will show that as soon as the left shifted its focus from class oppression and struggle, the moral situation became much more blurred – the position of women, race and the environment, to name but three issues, have all been concerns of major contestation within a left frequently characterized by blinkered patriarchy, racism and a modern scientific and technological economism. It was the taking on board of these issues which helped to deconstruct the platform of classical left politics during the 1970s and 1980s. In a world of globalized capitalism the problem has been compounded, as the antagonisms and contradictions being struggled over have multiplied and proliferated (Laclau, 1990). With hindsight we need to ask if the uniting of the workers of Europe, let alone the world, was ever a possibility. As Gramsci realized, the construction of a working class does not negate all the cultural specificities of the lives of those involved. (And of course nationalisms and the formation of national cultures play an important part in this.) But if all these factors hindered a possible unity of purpose among the workers of a relatively singular 'European' modernity, how much more problematic it is to think of a possible unified (politics of) left radicalism across the modernities of a world further cross-cut by heterogeneous local histories which have now been over-determined by the effects of a Euro-American colonialism driven by capitalism.

In these circumstances the binaries and certainties of the Marxian dialectic seem somewhat dated. Chen describes how, in Taiwan, 'we have always had to politicize cultural studies' "dirty" connection with the left, with Marxism, feminism and queer politics, with new social movements, in order to recover its critical edge. When all the postcolonial rhetoric began to surface, we had to fight the sad battle against the unfounded transportation of these terms' (52–3). What seems to us sad here is the old Stalinist policing of theory and praxis. To quote Chen again, 'Fashionable terms like hybridity, in the local context, become something like a *laissez-faire* pluralism, everything goes, as if every bit of identity bears an equal weight and thus blends together like [in] a juice blender' (53). Surely the fault here lies not in the term itself but how it is used and discursively articulated? We entirely agree with Chen's fight for a politicized cultural studies – we believe that this is one aspect of what both he and we mean, broadly speaking, by the use of the term 'critical' – but politicization is not achieved by the restriction of debate or the assertion of positions which are claimed to be in themselves politically correct because they subscribe to an absolutized theoretical agenda whose Euro-American origins are not even interrogated. We need to question the continuing meaningfulness of the

old binary of 'right' and 'left' politics. This distinction, born of modern capitalist political ideology and originating in the ideas of the French Revolution, can no longer work as the organizing principle for 'politics' in the contemporary world. It is politically nonsensical to forge an alliance between, say, anti-racist groups, environmentalists and workers in the logging industry under the unifying banner, 'the left'. As Laclau has put it: 'Social conflictiveness is so widespread and has taken on such new forms in today's world, that it has more than surpassed the hegemonic capacity of the old left' (1990: 228).

Much the same can be said about Chen's claim that cultural studies should 'generate strategic knowledge in alliances with resisting subject groups' (38). This, again, presupposes a binary structure which denies and suppresses the complexities of the 'postmodern' and 'postcolonial' world. To take one highly charged example, should we support those who want to preserve female genital mutilation as a local cultural practice and are resisting the forces of a (neo)colonizing Euro-American modernity which asserts the rights of women, the values of female genital pleasure and the integrity of the body? It is not enough simply to generalize about alliances with those who resist. Resistance is not necessarily politically 'good'. If this were to be the case, we would find ourselves also supporting the right-extremist terrorists who perpetrated the Oklahoma bombing as an act of 'resistance' against the government! (This example also shows that an absolute anti-statist position as Chen promotes it is deeply problematic, unprepared as it is to conceive of the state not as an oppressive monolith but as itself the possible site of multiple, partial struggles.) The point here is one that can be understood in terms of a revision of the Foucauldian notion of power as a pandemic force. Resistance needs to be understood in its particular and contingent contexts – and, of course, its politics are always partial and provisional and require vigilant interrogation.

Perhaps we should also affirm that, yes, the power relations of the 'old' modern world are still less or more with us; 'Western' hegemony is rampant and, certainly, multinational companies have a terrible power. But this is not all there is. Chen positions himself as a subaltern, identifying himself rather dramatically as 'we who are inside the warzones of the third world', but he speaks in the language of the Master: the master-narrative of a universalizing political discourse with its Manichean verdicts of 'good' and 'bad', the classical Marxist 'mastery of totality' (Laclau, 1990: 94) implied in Chen's absolutization of the antagonism of 'the people' versus the power bloc. Above all, Chen, like many 'third world' intellectuals educated in the USA, has mastered, and internalized, the language of 'Western' theory. This brings us to the most vexed question, and the one at the heart of Chen's article. What can be the political role of theory today? What does a 'politicized' cultural studies entail?

First of all, the status of what we call 'decentred theory' needs to be clarified. By decentred theory, we mean the new situation of that theoretical tradition which has a heritage in 'European' Enlightenment thought. The totalizing perspective of this tradition and its claim to moral and

cultural superiority, which expressed the ascendancy of the 'European' modern capitalist order, is no longer relevant in the present global post-modern condition. Marxism came out of this tradition and its universaliz-ing epistemology is now a handicap. In this respect, one thing conveniently elided from Chen's article and which is becoming central to the problem-atic of decentred theory is the question of intellectual agency and its relation to the local. As a result, Chen risks reproducing, in Rey Chow's words, 'the illusion that, through privileged speech, one is helping to save the wretched of the earth' (1993: 119). What is at stake in applying the ideas of Marx, Derrida or even Spivak and Bhabha in contexts outside of those (Euro-American ones) in which they were forged? The status of theory originating on the geographical and cultural margins of the (post-) Enlightenment tradition and the fact that so much of what goes under the rubric of postcolonial theory has been developed by diasporic intellectuals from (post)colonized nation-states is also worth pondering in a much more serious manner than Chen does when he declares diasporic postcolonial intellectuals his 'intimate enemies'. A beginning to such a thinking-through might be to acknowledge the connection between (post-)Enlightenment theory as a cultural practice and the global establishment of discrepant modernities all more or less historically inflected by the 'European' modernizing project. These should be questions addressed in both cultural studies and postcolonial studies and signal some of the areas in which there is overlap.

Finally, Chen wants to know 'how new social movements can be brought back to cultural studies as a political project'. In this disturbing collapsing of politics and theory into a totalized 'political project' Chen comes dangerously close to the formulation of a vanguardist (Leninist) role for (Western-educated) intellectuals, and one can only guess what their uneasy relationship would be with the range of local political forces they attempt to hegemonize in that project. In our view, cultural studies cannot and must not in itself be identified with a 'political project' in this way – in this sense, even the Gramscian notion of the 'organic intellectual' needs to be problematized in light of current political conditions. 'Theory' and 'politics' cannot be collapsed together; there must be a creative tension between the politics of theory and the politics of politics if neither is to be reduced to the other. This is another aspect of our use of the term 'critical'. As a critical intellectual practice cultural studies should, as Stuart Hall suggests, insist on 'the deadly seriousness of intellectual work', and on 'the irreducibility of the insights which theory can bring to political practice' (1992: 285–6). But this also points to what Hall importantly calls 'the necessary modesty of cultural studies as an intellectual project'. It is in the spirit of this call for modesty that we argue that the claims of cultural studies should always be partial and provisional, aware of their own limits, limitations and limitedness.

Where we agree with Chen is in his recognition that the crisis over the politics of theory has led, in many places and especially in the United States, to an opportunistic depoliticizing of cultural studies. It goes

without saying that this is not actually a depoliticizing but, rather, a conservatizing of it. Like Chen we deplore this but, where his solution is to return to old verities, we believe that cultural studies must find a new politics of intellectual work, a more modest one which addresses the conditions of the present using terms that provide for a critical, though partial and localized, conjunctural interrogation: a cultural studies without guarantees.

References

Chow, R. (1993) *Writing Diaspora: Tactics of Intervention in Contemporary Cultural Studies*, Bloomington: Indiana University Press.

Hall, S. (1992) 'Cultural studies and its theoretical legacies', in L. Grossberg, C. Nelson and P. Treichler (eds), *Cultural Studies*, New York: Routledge: 277–86.

King, A. D. (1990) *Urbanism, Colonialism and the World-Economy*, London: Routledge.

Laclau, E. (1990) *New Reflections on the Revolution of Our Time*, London: Verso.

Laclau, E. and Mouffe, C. (1990) 'Post-Marxism without apologies', in Laclau (1990): 97–132.

Rouse, R. (1995) 'Thinking through transnationalism: notes on the cultural politics of class relations in the contemporary United States', *Public Culture*, 7(2): 353–402.

HENRY KRIPS

QUANTUM MECHANICS AND THE POSTMODERN IN ONE COUNTRY

ABSTRACT

The orthodox interpretation of Quantum Mechanics was banned in the Soviet Union in 1947, an episode usually glossed as another illustration of repressive Soviet science. This paper argues that the roots of this ban should be located at a much deeper level, in a tension existing between the 'postmodern' form of orthodox Quantum Mechanics and an ideology of modernization. In the West a similar ideological tension had a different result: when the occasion demanded, the orthodox interpretation was covertly exchanged for an agnosticism about metaphysical matters, and potential areas of conflict with the principles of modernization were thus defused. The latter strategy benefited the orthodox interpretation, which enjoyed a virtual monopoly in the West from the 1940s through to the 1960s. Using the Freudian notions of 'transference' and 'disavowal', I explain why the ideological tension with modernization was resolved differently in the West and in the Soviet Union.

KEYWORDS

Soviet science; Stalinism; quantum mechanics; Niels Bohr; ideology; postmodernism

If we take in our hands any volume; of divinity or school metaphysics, for instance; let us ask; Does it contain any abstract reasoning concerning quantity or number? No. Does it contain any experimental reasoning concerning matter of fact and existence? No. Commit it then to the flames: for it can contain nothing but sophistry and illusion.

(Hume, 1975: 165)

Acting out: According to Freud, action in which the subject, in the grip of his unconscious wishes and phantasies, relives these in the present with a sensation of immediacy which is heightened by his refusal to recognize their source and their repetitive character.

Such action generally displays an impulsive character relatively out of harmony with the subject's usual motivational patterns ... acting out should be understood in its relationship to the transference.

(Laplanche and Pontalis, 1973: 4)

Introduction

During the 1930s and 1940s in Russia the orthodox interpretation of Quantum Mechanics (QM), also called the Copenhagen interpretation because of its association with the Danish physicist Niels Bohr, was placed under increasing critical scrutiny. In 1930 a speech by Deborin, one of the newly elected members of the Soviet Academy of Sciences, blamed the crisis in contemporary physics upon the failure of relativity theory and orthodox QM to conform to the requirements of dialectical materialism; and in the 1937 edition of *Advances in the Physical Sciences*, the physicist Nikol'skii attacked orthodox QM for being 'idealist' and 'Machist' (Graham, 1987: 323). But the bulk of criticisms came from Stalinist 'New Philosophers', such as Maksimov, Mitin and Kol'man, who waged a more or less unceasing campaign against the alleged idealist excesses of ortho- dox QM (Vucinich, 1991: 239–40, 248–9).

Whatever the reason for the attacks (I return to this question later) the Academy seemed determined to fend them off despite the worst excesses of the Stalinist purges which swirled in and around it at the time (Graham, 1987: 324). Physicists such as Fock argued strenuously that the orthodox interpretation could be reconciled with dialectical materialism (Graham, 1987: 339; Vucinich, 1991: 246). Indeed, Fock could claim to have contributed to such a reconciliation, by persuading Bohr to avoid certain idealist tendencies (such as skepticism about the existence of atoms) and preserve the principle of causality (Graham, 1987: 337–8).[1] Academician Ioffe, director of the famous Moscow Physicochemical Institute, identify- ing himself with Tamm, Frenkel and Fock, the most famous Russian repre- sentatives of the Copenhagen school, accused the New Philosophers of scientific ignorance and fascism (Vucinich, 1991: 241, 245–6).

However, the academicians seem to have underestimated their oppon- ents' ability and will to turn an unequal intellectual struggle into a decis- ive political victory. At a moment when the Academy's battle for intellectual autonomy appeared to have been more or less won, all resist- ance crumbled: within a dramatic six-month period the scientific establish- ment capitulated and banished the orthodox interpretation of QM.

The immediate precipitating factor for this coup seems to have been the speech on 24 June 1947 by Zhadanov, Stalin's assistant in the Central Committee of the Party. Zhadanov attacked the 'Kantian vagaries of modern bourgeois atomic physicists' specifically targeting their alleged 'inferences about the electron's possessing "free will" … attempts to describe matter as only a certain conjunction of waves and other devilish tricks' (Graham, 1987: 15, 325; Cross, 1991: 237). M. A. Markov, the eminent theoretical physicist, defended QM against this attack in the second issue of the journal *Problems of Philosophy*. His defense drew a hostile rejoinder from the Stalinist philosopher Maksimov writing in the *Literary Gazette*. The scientific establishment then sprang to Markov's defense, and the resultant uproar led to official Party intervention, culmi- nating in the removal of Kedrov, the editor of *Problems of Philosophy*. The

reformed editorial board admitted that the journal had 'weakened the position of materialism' and 'made serious mistakes of a philosophical character' (Graham, 1987: 328). Graham concludes:

> In terms of personnel, the immediate casualty of the Markov affair was Kedrov, but in terms of the philosophy of science, the casualty was the principle of complementarity. The period from 1948 to roughly 1960 may be called, with respect to discussions of QM in the Soviet Union, the age of the *banishment* of complementarity.
>
> (Graham, 1987: 328, my emphasis)

The effects of the 'banishment' were far-reaching, however. The physicist Blokhinitsev and influential philosopher of science Omel'ianovskii promoted a rival interpretation of QM, which essentially took Einstein's position that QM was a statistical theory making predictions about ensembles of systems rather than describing what went on in particular cases. Blokhinitsev also indicated that QM might at some future date be replaced by a more complete 'hidden variables theory', thus deferring the need to solve QM's philosophical difficulties (Graham, 1987: 328–36). A few, like Fock, continued to endorse a version of the Copenhagen interpretation, but even they erased characteristic Copenhagen terminology to do with uncertainty (an unacceptably 'idealist' concept) and complementarity; which is not to say that their divergence from the orthodox interpretation was merely terminological. Fock reconstrued the state-descriptions of QM not as subjective accounts of the available information about a system (the early Heisenberg's view), nor as mathematical fictions (Bohr's view), nor even as descriptions of ensembles of systems (Blokhinitsev), but rather as objective descriptions of a single system's 'potential possibilities' (Graham, 1987: 342).[2]

It is tempting to explain the banishment of the orthodox interpretation from within the scientific community as the result of its official suppression on the basis of inconsistency with the party line. But Fock, Frenkel, Ioffe and Tamm had argued earlier that orthodox QM was consistent with the principles of dialectical materialism; and Lenin's *Philosophical Notebooks*, as opposed to the more rigorous *Materialism and Empirio-Criticism*, incorporated conceptions of materialism and dialectics so broad that it would have been difficult for any scientific theory to fail its tests (Vucinich, 1991: 237). In any case, as Graham indicates, despite the critical tenor of Zhadanov's June speech, neither Stalin nor his cohorts seemed overly preoccupied with QM in any of its forms (Graham, 1967: 15, 325). It was, after all, a rather arcane scientific theory, accessible only to a few specialists.

How, then, are we to explain the banishment? One suggestion is that Zhadanov's polemics, his formulaic accusations of 'idealism' were read by the members of the Soviet scientific community not as expressions of official disagreement with orthodox QM but rather as signals that certain members of the scientific community, whose names were associated with the orthodox interpretation, were under serious official scrutiny. The

technique of signalling official disapproval of persons by publicly denouncing their views without mentioning them by name was a well-known rhetorical device in Stalinist Russia, one to which readers at the time became keenly attuned. Specifically, Zhadanov's speech acted as a strong signal that Ioffe and the members of his institute, traditional supporters of the Copenhagen interpretation, were still out of political favor.

Ioffe had experienced a spectacular fall from grace in the immediate pre-war period. This fall was already apparent at the highly publicized March 1936 meeting of the Academy of Sciences, at which the regime expressed its disappointment with Soviet science for failing to deliver the science-led economic recovery of which Ioffe had been one of the principle architects:

> The aim of the meeting was to make it clear to Soviet physicists that their main task was to provide the scientific basis for socialist production. This message was to be conveyed by subjecting Ioffe and his institute – the dominant school of Soviet physics – to 'criticism and self-criticism'.
>
> (Hollaway, 1994: 16)

During the subsequent purges of 1937–8, Ioffe's institute suffered more serious losses than did the two other major institutional settings for physics:

> Several of the leading figures at Ioffe's institute were arrested ... Lurinski was released in 1942, but Bronstein was shot in 1938, and Fredericks died in the camps.
>
> (Hollaway, 1994: 27)

In short, it was clear that the 1936 meeting had been no storm in a teacup. Ioffe had lost even the most basic political clout necessary to protect his workers, although, ironically, he himself survived the purges (Hollaway, 1994: 26, 28).

In the context of this history, Zhadanov's 1947 speech criticizing a point of view strongly associated with the names of Ioffe and his cohorts indicated that in post-war Russia, Soviet science's pre-war failure to deliver the technological goods had not been forgotten. Ioffe and his men were to remain firmly on the outer, as a salutary reminder of what happened to scientists who reneged on their responsibilities to the state. (In this context, it is interesting to note that Ioffe's travel privileges were not restored until 1956.) And such was the climate of fear in Stalinist Russia that this single speech, together with news of the subsequent sacking of Kedrov, was enough to swing the orientation of Soviet physics decisively against orthodox QM.[3]

Unfortunately, the climate of fear explanation raises a problem. The physics community almost instantly (according to Graham, within six months) repudiated the scientific views of some of its most eminent members.[4] No attempt to delay the departure of the Bohr interpretation appears to have been made, nor, having dissociated themselves publicly

from it, did physicists show much sign of residual Bohrian sympathies. The physicists' apparently almost total and immediate co-operation with the authorities is puzzling given the many moving accounts of scientists resisting professional persecution during that period. For example, from 1930 on, through the darkest nights of the Stalinist terror campaigns of 1937–8 and into the cold war period, sections of the biology community continued to resist Lysenkoism despite being harassed no less seriously than the physics community (Joravsky, 1970).

If the reaction by physicists to Zhadanov's speech had been merely the negative one of keeping their heads down, avoiding any public references to orthodox QM, and delaying for as long as possible concessions to official pressure, then the climate of fear explanation might well suffice. Such reactions to authority were prevelant at the time, as a comment attributed to a worker in the Academy indicates: 'In short, it was a matter of selling oneself at the highest possible price and obtaining the maximum of at least outward respect' (Graham, 1967: 129). But what continues to perplex in the story of the banishment of the Copenhagen interpretation is the apparent speed and thoroughness with which the interpretation was repudiated by the majority of the scientific community despite the fact that scientists (like the majority of the audience for official criticisms) must have understood that Zhadanow's criticism of the orthodox interpretation was personal rather than intellectual. It seems, therefore, that a factor other than fear was loading the dice against the orthodox interpretation.

The transference of the orthodox interpretation

From its inception in the mid- to late 1930s, the Bohr interpretation conflicted with the implicit philosophical underpinnings of large-scale projects of modernization such as Stalin's plan for the 'Scientific Management of Society' ('STR' as it was called) which aimed to rationalize along scientific lines the vast 'unskilled' Russian peasantry into a modern industrial work force.[5] Such grand projects embodied an assumption of uniformity suggesting that, at a general enough level, all people (all Russians, at least), shared or could be trained to share the same behavioral dispositions independently of their background. Orthodox QM interrogated the assumption by indicating that the theoretical representations or 'pictures' fitting individual systems are fragmented – dependent upon background conditions. For instance, while classical physics describes both the space-time trajectory (or 'space-time coordination') of a system as well as its causal relations, in orthodox QM spatiotemporal and causal modes of description are mutually exclusive to the extent that if one applies in a particular set of experimental circumstances the other does not. In Bohr's terms, the two modes of description are 'complementary':

The very nature of the quantum theory thus forces us to regard the space-time coordination and the claim of causality, the union of which

characterizes the classical theories, as complementary but exclusive features of the description.

(Bohr, 1932: 349–83)

It may be objected that from a strictly logical point of view heterogeneity of representation for quantum systems does not entail a similar heterogeneity for people. But we are concerned with public perception, not logic. And at that level, the gap between quantum systems and people may narrow to the point of invisibility. Indeed this becomes inevitable in contexts such as the Soviet Union in 1947 where a philosophy of materialism predominated. An important aspect of the orthodox interpretation is its reflexivity, its explicit thematization of degrees of precision of its own pictures. The Heisenberg uncertainty principle, for instance, indicates that the higher the degree of precision (*Genauigkeit*) with which the wave picture (space-time coordination) fits a system, the lower the degree of precision with which the particle picture (the causal mode of description) fits, and vice-versa.[6] By thus theorizing the limits of its own representations, the orthodox interpretation undermined the claim that science offers true representations and thus situated itself squarely in opposition to plans like STR, which depended upon this claim. Moreover, by picturing a chaotic world beyond the possibility of control, in which even electrons, it seems, have 'free will', the Copenhagen interpretation discredited the implicit presupposition of determinism which such plans took for granted. In short, by embodying certain 'regressive', 'post-modern' features – heterogeneity, reflexivity, indeterminism – orthodox QM undermined implicit metaphysical assumptions to which the projects of modernization haunting the Soviet imaginary gave material form.[7]

From 1930 on and in virtue of science's official involvement in STR, the metaphysical assumptions of homogeneity, scientific truth and determinism ran like red threads through the lives of all Soviet scientists, not necessarily as conscious commitments but rather as principles structuring their daily practices. For example, to the extent that scientists engaged in officially assigned tasks of data collection, their practices embodied assumptions of scientific truth. Such assumptions constituted an *ideology*: a collective representation acted out in physicists' daily lives.[8] Zhadanov's speech provided a suitable means of channeling that ideology into the realm of conscious belief, where it swept away much of the intellectual opposition to the principles of modernization arising from the orthodox interpretation of QM. Thus, the speech's apocalyptic effect arose not so much from its intrinsic rhetorical force, or the political clout of its speaker, or indeed the prevailing climate of fear in Stalinist Russia, but rather from the fact that at an unarticulated level those hearing the speech 'knew already' that the emperor from Copenhagen was naked, a knowledge which the speech enabled them to bring to the surface.[9] Which is not to say there had been no explicit opposition to the Bohr interpretation prior to Zhadanov's speech. On the contrary, as I indicated above, Deborin and the New Philosophers had strongly voiced such opposition from the mid-thirties onwards.

But the Zhadanov speech provided a kernel around which a hitherto untapped source of opposition to the orthodox interpretation came to the surface and crystallized.

The mechanism at work in this episode, I argue, is the familiar Freudian scenario of transference in which an authoritative voice, articulating a subject's phantasies, allows certain repressed phantasies to come into consciousness.[10] The voice's authority as in the story of the Emperor's new clothes, is retrospectively conferred by the audience, rather than reflecting a preexisting credibility. The relevant phantasy in the case of the Zhadanov affair is the ideology of modernization. Such an argument requires drawing a connection between the notions of ideology and phantasy. Freud shifted and extended the notion of phantasy in a productive way throughout his work. It came to signify any representation consisting of unarticulated beliefs and desires acted out at the level of practice, but which, because of disharmonies with subjects' conscious commitments, remained concealed at the level of consciousness.[11] In this generalized sense:

> Even aspects of behaviour that are far removed from imaginative activity, and which appear at first glance to be governed soley by the demands of reality, emerge as emanations, as 'derivatives' of unconscious phantasy ... it is the subject's life as a whole which is seen to be shaped and ordered by what might be called, in order to stress this structuring action, 'a phantasmatic' (*une fantasmatique*).
>
> (Laplanche and Pontalis, 1973: 317)

Thus the effects of unconscious fantasies are not restricted to slips or parapraxes, but may include more systematic aspects of subjects' lives. Following Laplanche and Pontalis, I designate this generalized notion of phantasy 'phantasmatic'.

In the context of post-war projects of national reconstruction, in the West as well as the Soviet Union, the discourses associated with the ideology of modernization – political speeches, homolies, autobiographical narratives, and so on – avoided giving voice to the desire for a controlled and homogeneous social order which the practices of modernization nevertheless acted out.[12] Instead, the motivational structures driving the practices of modernization at various local sites tended to be articulated in terms of goals like 'national renewal', 'modernization', 'scientifically based reconstruction', 'economic recovery', and so on. Such articulations were not merely discursive smoke-screens. On the contrary, subjects unconsciously endorsed such goals which, in turn, served as localized 'reaction formations' veiling the effects of the ideology which thus took on the dimensions of a phantasmatic.

When the unarticulated motives structuring such a phantasmatic become associatively connected with primary repressed materials, they become unconscious in the full Freudian sense.[13] The ideology of modernization in the Soviet Union *circa* 1947 exemplifies such a structure, since the desire acted out for a world inhabited by regimented subjects was associatively connected with such primary repressed materials.[14] Evidence of such a connection consists not merely of a *formal* similarity between the desire's

content and one of the classical Freudian primal scenes. Such similarities are notoriously easy to find and often misleading as signs of unconscious connections; as Freud warns us, sometimes a carrot may be just a carrot. Instead, anxieties associated with the ideology of modernization in the Soviet Union of 1947 provide evidence for the connection in question, anxieties which masquerade as 'realistic' in Freud's sense (that is, attached to specific objects comprising identifiable threats) (Laplanche and Pontalis, 1973: 379) but which nevertheless possess a certain excessive character singling them out as 'non-specific', that is, linked to repressed materials. Specifically, the alacrity with which many physicists promoted the principles of modernization in the aftermath of Zhadanov's speech displayed an anxiety which was 'excessive' in exactly this sense, that is, inappropriate to its alleged object. It follows that for those physicists the ideological phantasmatic of modernization constituted an (unconscious) phantasy in the Freudian sense; and, in virtue of its opposition to the principles of that phantasy, orthodox QM functioned as an element of a localized reaction formation.[15]

Which is not to say that the principles of modernization were repressed in the sense of being totally unavailable to consciousness (as is sometimes said for *primally* repressed materials). Instead, their repression amounted to a forced separation between conscious manifestations and their unconscious supports, a separation which meant that cathecting energies associated with the latter were unavailable to the former. In short, the phantasy possessed the topology of an iceberg: the main body of its support subsisting at the level of practice and below the line of consciousness.

Zhadanov, entering into a transferential relation with many physicists in his audience, broke up the structure of repression, breaching the psychic defenses which prevented the cathecting energies from invading the field of consciousness. To be specific, Zhadanov's speech brought the repressed ideological scenario of modernization to the surface, albeit still in suitably veiled form, by making many in his audience experience the grim reality that in Stalin's Russia even electrons were not to be allowed 'free will'. Frivolities such as attributions of free-will to electrons were to be no more tolerated than 'attempts to describe matter as only a certain conjunction of waves and other [such] devilish tricks'. At the same time, the orthodox interpretation of QM, as one aspect of the reaction formation which hitherto had sustained the repression of the ideology of modernization, was swept away.[16] Of course, as I indicated, doubts about the orthodox interpretation preceded Zhadanov's speech, but his intervention provided an opportunity for such opposition to connect with an unconscious base of support rooted in the ideological phantasy of modernization.

This account of the orthodox interpretation's demise explains the difference between physicists' hasty response to Zhadanov's speech and biologists' more measured reaction to the banishment of Mendelism during the Lysenko affair. Despite its lack of determinism, Mendelism never posed a radical threat at a practical ideological level.[17] On the contrary, it endorsed the principles of homogeneity, scientific truth and universality which

structured the project of modernization. The comparative haste to get rid of orthodox QM arose, then, because hidden ideological pressures ready to work against Bohr's ideas came flooding to the surface in a cathartic release occasioned by Zhadanov's speech. Even at the moment of their release, such effects were screened behind Zhadanov's speech through which they were channelled. For this reason the speech appeared to have effects out of all proportion to its actual significance; which in turn created the appearance of a physics community rushing to give in to official criticism.

This explanation of the banishment of orthodox QM brings me to the nub of my question: in the early to mid-twentieth century, 'modernization' in the form of institutionalized processes of rationalization and standardization was a dominant ideology both in Western Europe and Russia. As Huyssen remarks: 'after the Great War and the Russian Revolution ... [a] new Enlightenment demanded rational design for a rational society ... Ruthless denial of the past was as much an essential component of the modern movement as its call for modernization through standardization and rationalization' (Huyssen, 1990: 358–9).[18] But if, as I have argued, contradiction with an ideology of modernization contributed to orthodox QM's demise in the Soviet Union, why was the same interpretation (apparently) so successful in Western Europe, where modernization was at least as potent a social force?[19]

The orthodox interpretation in the West

By the time of the last Como debate in 1935, the Bohr interpretation seemed firmly entrenched in West European physics. Jammer refers to its 'unchallenged monocracy' from 1935 until the 1950s when serious opposition began to re-emerge in the form of hidden variables theories (Jammer, 1974: 250). This 'monocracy', Beller has argued, did not indicate a generalized acceptance of Bohr's ideas by physicists but rather a rhetorical and political exercise in the management of dissent, the result of Bohr's ethos rather than unqualified agreement with the views he represented:

> While not many working physicists shared Bohr's strictures on 'quantum concepts' and 'quantum reality,' their disagreement with Bohr rarely reached the printed page. Yet often such disagreement was unequivocal and quite forceful, though always expressed in a reverent language.
>
> (Beller, 1995: 18)

Other physicists expressed similar reservations in unpublished correspondence with Bohr, sometimes with immense guilt due to challenging Bohr's authority (see Bopp's letters to Bohr AHPQ). Yet in print not many dared, or cared, to enter into territory that only Bohr, so the legend goes ... mastered fully.

> (Beller, 1995: 22)[20]

Born and Heisenberg in particular found themselves increasingly out of sympathy with Bohr's anti-realistic attitude to the new quantum formalism, a point to which I shall return below. Even in the realm of public

pronouncements, there seems to have been no real unanimity on the content of the Bohr interpretation which, Beller claims, was articulated on an *ad hoc* basis as a series of local responses to local problems:

> The most central pillars of the Copenhagen philosophy are indeterminism, wave particle duality and the indispensability of the classical concepts. Yet none of them commands an unwavering commitment even from Bohr's closest collaborators. Nor do they have unchanged and definite meaning for Bohr himself.
>
> (Beller, 1995: 26)

Such public as well as private disagreements between Bohr and his major disciples, as well as inconsistencies in Bohr's own position 'cast heavy doubt on the very existence of the common "Copenhagen interpretation"', Beller claims (Beller, 1995: 26).

Her valuable historical insights help us understand how the orthodox interpretation accommodated the ideology of modernization in the West. From its inception, I shall argue, the Bohr interpretation was split by taking part in a system of covert exchanges with a metaphysically agnostic philosophy, what J.S. Bell has called 'the working philosophy of QM'. This split enabled the orthodox interpretation to conceal its contradictory relation with the repressed ideology of modernization when support for modernizing principles broke through into consciousness. Sometimes, however, the agnostic 'working philosophy' slid even further from Bohr's views into an aggressively anti-metaphysical, instrumentalist approach to QM.[21] As we shall see, part of the art of the orthodox interpretation of QM lay in limiting the potentially damaging effects of this additional slide. How did such rhetorical shifts in the orthodox interpretation come about? How did Bohr's metaphysically supercharged ideas become contaminated with anti- as well as non-metaphysical philosophies even in his own mind? Before turning to these questions distinctions must be made between the working philosophy, instrumentalism, and the Bohr interpretation.

The working philosophy and Bohr's apologetics

Bell argues for the existence of a 'pragmatic philosophy' which 'consciously or unconsciously [is] the *working philosophy* of all who work in quantum theory' (Bell, 1989: 189, emphasis mine). According to this 'purely pragmatic view':

> We have no right whatever to a clear picture of what goes on at the atomic level. We are very lucky that we can form rules of calculation, those of wave mechanics, which work. It is true that in principle there is some ambiguity in the application of these rules, in deciding how the world is to be divided into 'quantum system' and 'classical' remnant. But ... [w]hen in doubt enlarge the quantum system. Then it is found that moving it further makes very little difference ... good taste and

discretion, born of experience, allow us to largely forget, in most circumstances, the instruments of observation.

(Bell, 1989: 188–9)

In short, the 'working philosophy' declares itself agnostic about how to embed the equations of QM in a broader metaphysical framework.[22]

Bohr's interpretation may be seen, then, as an apologetics for the working philosophy. As Bell puts it:

Bohr went further than pragmatism ... Rather than being disturbed by ... the shiftiness of the division between 'quantum system' and 'classical apparatus', he [Bohr] seemed to revel in the contradictions, for example between 'wave' and 'particle' ... he put forward a philosophy which he called complementarity.

(Bell, 1989: 189)

Born makes a similar point:

Every experimental physicist treats his instrumentation as if he were a naive realist. He takes its reality as given priori, and doesn't rack his brains about it. Niels Bohr has made this attitude the basis of his whole philosophy of physics.

(Born, 1962: 21)

And Beller remarks: 'Bohr's doctrine ... worked wonders to alleviate the threat and anxiety connected with symbolic quantum theory', a point she claims 'encouraged ... Heisenberg and Born to publicly defend Bohr's position [despite reservations which they expressed privately]' (Beller, 1995: 22).

How does the Bohr interpretation fulfill its role as an apologetics? The working philosophy lives with the anxiety that at some future moment it will be replaced by or embedded within a coherent and precise metaphysics. The Bohr interpretation defuses this anxiety by rejecting the assumption that such a metaphysical framework can be constructed. Specifically, it claims that representations of micro-systems are *necessarily* incoherent and ambiguous.

Bohr's argument for this claim is tendentious. He starts from the assumption that because language is learnt in the domain of macroscopic phenomena where classical physics is valid, all representational schemata in science are ultimately classical in nature:

It is decisive to recognize that *however far the phenomena transcend the scope of classical physical exploration, the account of all evidence must be expressed in classical terms* ... The argument is simply that by the word 'experiment' we refer to a situation where we can tell others what we have done and what we have learned and that, therefore, the account of the arrangement and the results of the observation must be expressed

in unambiguous language with suitable application of the terminology of classical physics.

Thus all systems must be described ultimately in terms of some combination of classical variables: energy, momentum, spatio-temporal location. But, the laws of QM imply that (a) any system with a definite energy E possesses a frequency of magnitude equal to E divided by a particular positive number h, called 'Planck's constant' (this is the so-called Planck–Einstein relation); and (b) any system with a particular momentum p has a wave-length of magnitude equal to the h divided by p (the so called De Broglie relation). We may summarize these two relations in non-technical terms by saying that they relate the energy and momentum of a system to certain wave-like properties; and it is the *non-zero magnitude of Planck's constant* which sustains these relations.[24] Since a wave, unlike a particle, has no precise position in space, it follows immediately that any system with a definite energy and momentum lacks a definite space-time trajectory.[25] And this, in turn, contradicts the classical notion that systems, such as particles, which possess definite energy and momentum also possess definite space-time trajectories. In sum, the fact that Planck's constant is non-zero ('finite' as Bohr says) implies the failure of the classical conceptual scheme.

Indeed, we can go further. QM implies that classical physics is *nowhere* exactly valid. Which is not to deny that there are aspects of a system which can be classically described in a satisfactory way. On the contrary, those gross aspects of a whole situation (the system and its context) which are insensitive to changes of the order of Planck's constant (that is, Planck's constant could be set to zero without affecting them in any significant way) are describable classically. Bohr refers to such aspects of a system as 'the experimental conditions'. But as we look to more refined aspects of the situation, to which contributions of the order of Planck's constant are non-negligible, we see signs of the classical modes of description running out. Such running out is manifested in a particular way: the more precisely one of the classical modes of description (for example, the wave-picture) fits a particular system, the less precisely another one (the particle-picture) fits. In the classical domain, by contrast, for certain systems *all* classical pictures fit precisely, or, to be more exact, there are no significant effects indicating otherwise.[26] (The matter of precision of fit here is not merely one of predictive accuracy, but rather of having a certain explanatory value and thus degree of truth, a feature in which an instrumentalist would, of course, have no interest except in so far as it was germane to the question of predictive accuracy.[27]) For example, classical particles possess *both* wave-like properties (momentum and frequency) as well as particle-like properties (a definite space-time trajectory).[28]

It follows that for any given quantum system a pair of pictures exist, the wave picture and particle picture, each of which fits to some extent and gives independent partial information. Only one of the pictures fits perfectly, however; and is in contradiction with the other in the sense that

the perfection of its fit precludes the other's perfect fit. According to the Bohr interpretation, the existence of such contradictions is a necessary consequence of the non-zero magnitude of Planck's constant. We see too how the ambiguities noted by Bell arise. Because Planck's constant is non-zero, a domain of non-classical phenomena exists. But QM by itself cannot determine where the boundary between that domain and the quantum world falls, since such a determination must ultimately be a pragmatic matter of deciding how small a deviation from classical behaviour counts as negligible. Such a decision will, of course, vary from one context of investigation to the next, and in that sense is ambiguous. In short, the Bohr interpretation establishes that not only the contradictions but also the ambiguities of the working philosophy are necessary consequences of the finite size of Planck's constant.

The Bohr interpretation also raises the question of how the connection between experimental conditions (which in the context of more modern formalizations of QM would be called 'the state preparation') and the degree of truth of particular pictures (ways of describing the world) should be conceived. It raises this question specifically in the context of the measurement process: how does interaction with a measurement apparatus (which Bohr includes among the experimental conditions pertinent to a particular system) relate to the degrees of truth of particular pictures? Bohr rules out any direct causal connection: measurement does not merely create what it measures. But neither does it passively reveal what is already present. Instead, the experimental conditions, including the fact of being measured, play a constitutive role, setting the scene in which it becomes possible for a picture to attain a certain degree of validity. For instance, setting the magnification on a microscope through which an electron is being observed (the apparatus here is classically described) creates conditions under which the electron in question is localized within a certain volume of space, the size of which coincides with the discriminatory capacities of the microscope. Which volume of space the electron occupies is, of course, up to the electron not the microscope; nevertheless the microscope's presence and the magnification to which it is set constitute conditions necessary for the electron to be localized in the first place. To draw an analogy: intelligence is not an innate disposition passively revealed by IQ-tests, but neither is it simply a property of the way in which people respond to the tests. Instead, the tests provide a situation in which intelligence is constituted. In short, to be intelligent is to have a highly disjunctive and idiosyncratic collection of dispositional abilities which enable one to do well at the tests in question, but the tests themselves provide the situation in which these various abilities come together as it were, emerging as a bona fide property.[29] We can see hints of this sort of account of quantum-mechanical properties in Bohr's answer to the Einstein–Podolski–Rosen argument:

there is . . . no question of a mechanical disturbance of the system under investigation during the last critical stage of the measuring procedure.

But even at this stage there is essentially the question of *an influence on the very conditions which define the possible types of predictions regarding the future behaviour of the system.*

<div align="right">(Bohr, 1935: 697; emphasis his)</div>

In this way, the Bohr interpretation lays to rest the infamous 'measurement problem': how to describe the interaction between a macroscopic measurement apparatus and the quantum system it measures. Bohr's approach is to expose this as a pseudo-problem. The measurement apparatus, by definition, falls within the domain of classically described phenomena, and so a quantum theory of its interaction is not possible: in short, the phrase 'quantum theory of measurement' is an oxymoron.[30]

We can now see how the Bohr interpretation makes a practical difference to those engaged in QM. Specifically, it terminates certain lines of research which the working philosophy opens up. For instance, it lays to rest the measurement problem by showing it to be unresolvable, and demonstrates that certain inconsistencies and ambiguities, the possible removal of which the working philosophy foreshadows, are ineliminable. Thus the Bohr interpretation acts as an apologetics: by proving certain problems unsolvable it excuses the working philosophy's lack of success at solving them.

Bohr's interpretation can be understood not only as an apologetics but also as a means of extending the working philosophy into a metaphysics while preserving the classical descriptive framework. Because of the finite size of Planck's constant, such an extension inevitably results in contradictions and ambiguities. The Bohr interpretation accepts this limitation, arguing indeed, that viable alternatives to classical modes of description do not exist. In other words, it accepts that contradictions and ambiguities are ineliminable aspects of a metaphysics for quantum systems and, in that respect, features of the world rather than flaws of historically transient conceptual schemes.

Now imagine a context in which there are serious reservations about metaphysical excesses but also a recognized need for metaphysics both as apologetics and as a heuristic guide to research. In such a context, since it preserves the classical descriptive apparatus of the working philosophy, the Bohr interpretation represents the best, that is, most metaphysically conservative option. Such was the context for European work in QM, informed not by an outright positivism which refused to recognize any need for metaphysics, but rather by an Occamist reluctance to make 'unnecessary hypotheses' which, since the seventeenth century, has been institutionalized as a norm of European scientific practice (Merton, 1968: 601).

In such a context, provided all other factors nearly enough balance out (which, of course, they did not in the Russian context) the Bohr interpretation and the working philosophy will tend to drift together, or at least interchange. That is, when the task at hand requires a metaphysics (for instance if the question is one of apologetics, or the determination of the

direction of research) then the Bohr interpretation will move to the fore as the best, that is, most conservative, option; but when the task is the application of QM to describing a specific concrete situation, then the working philosophy suffices. In short, all else being equal, in a situation of general scepticism combined with an awareness of the need for a metaphysics, the Bohr interpretation will end up shadowing the working philosophy and vice-versa, each ready to take over from the other as the occasion demands.

As an illustration of such a scenario, consider the aftermath of the banishment of the Bohr interpretation in the Soviet Union. In the short term, physicists successfully reverted to what we have been calling the working philosophy of QM. In other words what Bell calls 'good taste born of experience' sustained Soviet research in QM immediately after 1947. This strategy left certain methodological problems unresolved, such as what to do with the inconsistencies and ambiguities which application of QM to concrete situations inevitably generated: how to deal with the measurement problem, and so on. The orthodox interpretation dissolved these problems by showing them to be insoluble, but in the immediate post-1947 Soviet situation this option was no longer available. In the medium term these difficulties were handled by developing an alternative interpretation of QM which provided the relevant metaphysical support for the working philosophy. Roughly two years after the demise of the orthodox interpretation, Blokhinitsev managed to gain official approval and fairly general acceptance for what amounted to a hidden variables interpretation of QM. This came to function as an official repository of answers for the philosophical questions left unanswered, indeed raised by the working philosophy, although the situation was not deemed satisfactory by those most intimately concerned. As a student of physics at the time described the situation: 'We were taught QM as a set of rules of calculation for handling specific sorts of problems. Lecturers simply shrugged if we raised any basic questions, referring us to Blokhinitsev's book. They were there to teach us how to *do* QM, they told us, not answer deep philosophical questions.'[31]

With the ending of Stalinism, however, a lively debate about the interpretation of QM re-emerged. Although the Bohr interpretation seems never to have recovered its pre-war preeminence, it clearly influenced the shape of the post-Stalinist debate by returning in a form modified to suit the strictures of dialectical materialism, albeit of the more sophisticated Leninist variety within which accommodation of post-classical forms of physics was less of a problem. As Gribanov indicates:

Adherents of dialectical materialism had their own approach to interpretation of micro-objects. The eminent Soviet physicist S.I. Vavilov wrote [1956]:

Matter . . . simultaneously possesses the properties of waves and particles, but . . . is not waves and not particles and not a mixture of the two.

(Gribanov, 1987: 170)

He continues:

V.S. Gott has written in this connection [1967]:
The concepts of substance and field have ... wholly lost [their] sense in phenomena in the microworld.

(Gribanov, 1987: 171)

Gribanov also approvingly quotes Omel'ianovskii's view that: 'In modern physics, experimental data are described in terms of classical physics and are given an interpretation in terms of non-classical theories ... in genuinely dialectical fashion' (Gribanov, 1987: 54). In short, in the long run the need for a metaphysics to guide work in QM was answered by something like the Bohr interpretation re-emerging to supplement the working philosophy. In the next section I shall show how the working philosophy and its shadow, the orthodox interpretation, drew in a third interpretative position, that of instrumentalism.

Instrumentalism

The working philosophy inherits one aspect of the British empiricist tradition: a rhetoric of modest abstention from speculation. But such empiricism is shadowed by a more radical positivist polemic dismissing all metaphysics and exemplified by the famous Humean prescription: 'Commit it then to the flames: for it can contain nothing but sophistry and illusion.'[32] The positivist polemic was given concrete form as an 'instrumentalist' philosophy of science. The aim of scientific theorizing, on this view, is not the provision of true universal schemes of representation but rather the construction of black-box predictors, models which, even when they are totally misleading as detailed accounts of reality, more or less accurately predict the outcomes of particular experimental situations:

Instrumentalism assumes ... the theories can be used to relate and systematize observation statements and to derive some set of observation statements (predictions) from other sets (data); but no question of the truth or reference of the theories themselves arises.

(Edwards, 1972: 407)[33]

As a philosophy of science, instrumentalism was given impetus by the spectacular model-building activities which characterized much nineteenth-century mathematical physics, especially in the areas of thermodynamics and electromagnetism. Such models – for instance an electromagnetic aether filled with bizarre nests of tubes within tubes, and systems of interlocking notched wheels – clearly bore no relation to reality but were remarkably successful predictors. In short, instrumentalism involves a form of what we might call limited skepticism, displacing questions of the overall truth of scientific theories in favor of more limited ones about predictive accuracy.

It is clear, however, that instrumentalism and the corresponding positivistic ways of thinking did not reach a level of general acceptance in

twentieth-century West European theoretical physics, notwithstanding their roots in successful nineteenth-century sciences. For instance, despite Bohr's positivistic rhetoric attacking the formalism of the new QM – 'The mathematical formalism of quantum mechanics ... merely offers rules of calculation' (Bohr, 1958: 60) – Born and Heisenberg both came to favor a thorough-going realist intepretation, that is, that scientific theories should be taken literally as true descriptions of the world. The following evocative paean to Nature displays exactly such an attitude:

> I had the feeling that, through the surface of atomic phenomena, I was looking at a strangely beautiful interior, and felt almost giddy at the thought that I now had to probe this wealth of mathematical structures nature had so generously spread out before me ... If nature leads us to mathematical forms of great simplicity and beauty – coherent systems of hypotheses, axioms, etc ... we cannot help thinking they are 'true', that they reveal genuine features of nature.
>
> (Heisenberg, 1971: 59, 68)[34]

And in other areas of physics, cosmology for example, West European physicists showed even less tendency towards positivism. Instead they seemed, and still seem, willing to embrace radically speculative schemes about the origins of the universe and its first few moments. So much so that Bell addresses one of his articles on QM to 'frustrated cosmologists', who may be puzzled by the positivism of much orthodox QM:

> Cosmologists ... must find the usual interpretative rules of quantum mechanics a bit frustrating ... It would seem that the theory is exclusively concerned with 'results of measurement' and has nothing to say about anything else.
>
> (Bell, 1989: 117) [35]

Concrete effects of the rejection of instrumentalism can also be found within the orthodox interpretation itself. As we have seen, the orthodox interpretation understands QM as providing an account of the precision (*Genauigkeit*) with which certain pictures apply or 'fit' under particular experimental conditions. Heisenberg's writings, however, show a certain ambiguity in connection with the meaning of imprecision ('*Ungenauigkeit*'). On occasions he seems to read it epistemically, as mere uncertainty (hence the popular English label 'uncertainty principle' for Heisenberg's principle). On this reading, the orthodox interpretation veers over into the working philosophy, by incorporating an element of agnosticism about the way the world really is. On other occasions, however, he seems to understand it ontologically, as an indeterminateness, or indeterminacy, closer in meaning to the term '*Unbestimmtheit*' favored by Bohr, which clearly has a more ontological flavour than '*Ungenauigkeit*' (Jammer, 1974: 61).[36] But in neither case (whether 'imprecision' is understood as uncertainty or indeterminacy) is there a question of seeing the degree of precision of a picture in purely operational terms, as its success in predicting the results of measurements.[37]

It is clear, then, that Heisenberg and Bohr, the two main proponents of the orthodox interpretation, did not displace a concern for precision, meaning the degree to which a picture is true, with a concern for mere predictive accuracy. And *a fortiori* a clear distinction can be drawn between their position and instrumentalism.[38] Nevertheless, the literature shows a certain confusion between the two approaches. One source of such confusion is the common fallacy of affirming the consequent, which erases the distinction between a representation's truth and predictive accuracy.[39] Another is the occasional tendency among certain key figures associated with the orthodox interpretation to couch their philosophical remarks in instrumentalist or positivist language: for instance, Bohr's instrumentalist critique of the abstract mathematical formalism of the new QM, and Heisenberg's early positivist approach to scientific theories in general. But perhaps the main source of the confusion is a growing tendency among physicists to favor an anti-metaphysical stance in the specific context of QM, a tendency which slips over easily into instrumentalist rhetoric. Issues of interpretation, especially in QM, have come to be seen as scholastic games, abstract philosophical disputes with little relevance to physics or the real world.[40] More specifically, scepticism has developed, especially among quantum physicists, about schemes which purport to provide a global account of the nature of reality.[41] Any such scheme risks being labelled 'metaphysical' or 'mere philosophical speculation', and irrelevant to the real concerns of physics.[42] The increased prominence of such positivist ways of thinking and the corresponding anti-metaphysical rhetoric has led to a tendency to read the orthodox interpretation along positivist lines, as indistinguishable from an instrumentalist approach. More generally, it has meant that the subtle metaphysical distinctions between the orthodox interpretation, working philosophy and an instrumentalist approach have tended to be erased.[43]

In the next section, and armed with this account of the complex relations between the orthodox interpretation, working philosophy and instrumentalism, I return to the basic question which has driven the second half of this article: how the orthodox interpretation has managed to achieve such a successful accommodation with the ideology of modernization in the West.

How the West was won ...

By remaining agnostic about the content of the future metaphysics which it projects, the working philosophy not only guarantees its own consistency with the metaphysical principles of modernization (scientific truth, homogeneity, determinism) but also caters to a certain institutionalized unease about metaphysical excesses implicit in Merton's norm of skepticism. It follows that in sliding from the orthodox interpretation to the working philosophy, conflicts with ideological principles of modernization can be removed as they arise. And, by reversing this slide, the

working philosophy can be brought to reinhabit a metaphysical persona as the orthodox interpretation, under which guise it can answer significant metaphysical questions and provide guidance to research. Through being called upon regularly in these ways, the slides in question have become incorporated as permanent possibilities into the pragmatics of the orthodox interpretation. The result is not so much an ambiguation of the interpretative apparatus as its contradiction, or splitting: both the working philosophy and its contradictory, the Bohr interpretation, becoming part of an extended interpretative framework which, since the sliding is obscured by various rhetorical shifts discussed in the previous section, continues under the name of Bohr. In short, there has been no lessening of commitment to the Bohr interpretation, but rather an additional and simultaneous commitment to a philosophy which covertly contradicts it.[44]

The slide from the metaphysical excesses of Bohr's views to the metaphysical agnosticism of the working philosophy runs the risk of overshooting the mark, sliding between two senses of '*hypothesis non fingo*', from the agnostic 'I don't know the true metaphysics' to the positivist 'There is no true metaphysics to know'. The various rhetorical slips described in the previous section entail that this slide too is incorporated into the pragmatics of the overall interpretative framework for QM, which thus takes on a complex tripartite structure. The first part is a metaphysically supercharged, 'postmodern' metaphysics associated with Bohr's views (here the contradiction with the ideology of modernization is at its sharpest). The second is a more modest working philosophy, which while professing metaphysical agnosticism ('*Hypothesis non fingo*' in its moderate version), aims to recuperate a coherent and precise metaphysics consistent with the ideology of modernization; the third, a robust antimetaphysical approach associated with instrumentalism – also a case of '*Hypothesis non fingo*', but played in a more strident register. The complexity of this structure, specifically its internal contradictions, is concealed by various rhetorical slides. The art in managing the overall interpretative scheme lies in bringing forward the right bit at the right time: of playing off the innocuous working philosophy against the principles of modernization, but also bringing forward Bohrian metaphysics to cope with metaphysical or methodological difficulties, such as the measurement problem or the persistence of inconsistencies and ambiguities, all the while keeping in check iconoclastic instrumentalist tendencies.

How did such a complicated and apparently unstable way of achieving consistency with the principles of modernization develop and take root in Western Europe, while in the Soviet Union the orthodox interpretation was apparently swept away? I suggest that the path taken by the orthodox interpretation in the West can best be understood as an instance of the phenomenon of disavowal. Freud originally defined this phenomenon as a subject 'refusing to recognize the reality of a traumatic perception'.[45] But by extension, it has come to mean the denial of a proposition and the simultaneous recognition of its truth, the recognition in question being associated with trauma – what Lacan calls 'an approach to the Real', an

experience of primally repressed materials which is 'too close for comfort' thus threatening to unpick the fabric of repression.[46]

Mannoni illustrates this phenomenon in the context of ritual life and belief among the Hopi. The Hopi encourage a belief among their children that the masked dancers who appear at their ceremonies are Gods. However at initiation, to the great consternation of the young initiates, fathers and uncles of the clan are revealed as wearers of the masks. As Talayseva, a Hopi chief, tells the story of his own initiation:

> I was greatly shocked: these weren't spirits . . . I felt unhappy because all my life I had been told that the Katcina were Gods. I was above all shocked and furious to see my clan uncles and fathers dancing as Katcina. But it was even worse to see my own father.
>
> (Mannoni, 1964: 23)

But as they are exposed to this revelation, the initiates are offered another which provides them with a means of filling the awful gap looming at the center of their existence. This second revelation is offered in mythological form, as a nostalgic remembrance of *un autrefois*, a golden age, when the Gods danced among the people:

> You know that the *real* Katcina don't come to dance in the pueblos as they did in other times. They come only in an invisible fashion, and inhabit the masks during the dance days in a mysterious way.
>
> (Mannoni, 1964: 23)

This additional knowledge, integral to the initiation myth, becomes a site of disavowal according to the classical Freudian formula: '*I know* that the Katcina are my uncles and fathers, not spirits, *but even so* the Katcina are present when my uncles and fathers dance in their masks' (Mannoni, 1964: 23). Mannoni goes on to observe that this phenomenon is at the root of religious faith:

> One sees there . . . the moment when belief, abandoning its imaginary form, enters the symbolic mode sufficiently to open out into faith, that is to say, onto commitment [*engagement*].
>
> (Mannoni, 1964: 23–4)

It is in the context of such phenomena, I suggest, that we understand the reception of the Bohr interpretation by Western European physicists.

We have seen that the orthodox interpretation was split by taking part in a covert system of exchanges with the working philosophy. This allowed it to remain the repository of official metaphysics but, when pressured by philosophical objections, shed all metaphysical commitment and slip into the agnostic working philosophy. The art was to know when to push Bohr's ideas and when to let them go: '*I don't know* what the real nature of the world is like, *but even so* . . . the Copenhagen interpretation has important things to say'.[47]

Such 'splitting' was more than a matter of coexisting contradictory commitments, however. As I indicated above, Bohr's interpretation acted

as a site at which science faced the limits, the seams, holding its representations together.[48] But experience of such limits is exactly what Lacan calls 'an approach to the Real', since by 'Real' he means 'the impossible ... the ineliminable residue of all articulation ... that over which the symbolic stumbles' (Lacan, 1981: 280). Of course, endorsement of Bohr's ideas never constituted a direct or unqualified experience of the bounds of representation. On the contrary, any connection between Bohr's interpretation and such bounds was veiled by the fact that his interpretation mapped the limits of its own representations, and thus, in a paradoxical way, circumvented them (since if the limits could be represented, then, it seems, there were no bounds to representation after all).[49] However, such veiling failed to erase all traces of the terrible prospect of a void where the possibility of representation ends. Signs of this failure are apparent in anxieties which often accompanied endorsement of Bohr's ideas, anxieties which expressed themselves as a recurring fear of physics degenerating into sterile philosophical debate (see notes 40 and 42), or nagging concerns over Bohr's failure to treat the abstract formalism of the new QM realistically: 'Both Fock and Born are amazed and frustrated with Bohr's denial of [the universal validity] of [the new] quantum concepts' (Beller, 1995: 19).[50] In short, the affirmation of the Bohr interpretation and its simultaneous denial within the complex interpretative framework discussed above has all the characteristics of a structure of disavowal: specifically, a close (too close, as it turns out) associative connection with the Real and the anxieties which attend such connections. (It is perhaps as well to indicate that this structure of disavowal does not indicate any mass perversion on the part of West European physicists. It is true that Freud often associated the processes of disavowal with fetishism but, as Laplanche and Pontalis point out, this association was neither invariable nor necessary (Laplanche and Pontalis, 1973: 120).

In sum, Beller's claim that the orthodox interpretation was riven by contradictions is correct. I have argued that such contradictions were aspects of a structure of disavowal which enabled situations of open conflict with an ideology of modernization to be managed without damage to either side. But a question then arises: why did the transference effects which, in the Soviet Union, enabled the ideology of modernization to sweep the orthodox interpretation aside fail to eventuate in the West? Or, to put matters the other way around, why didn't the subtle compromise formation which unfolded around the orthodox interpretation in the West develop in the Soviet context, or, if it did, why wasn't it adequate to resisting Zhadanov's crude advances? Here, finally, we return to the question from which we started the second half of this article: if conflict with an ideology of modernization brought about the downfall of orthodox QM in the Soviet Union, why didn't the same happen in Western Europe where there was similar ideological conflict?

On the West European scene figures opposing orthodox QM lacked Zhadanov's political power, and thus were unable to act as channels for transference effects. Also, as I indicated in note 10, in a paradoxical way

Zhadanov's ignorance about scientific matters actually helped transference. His lack of knowledge enabled him to act as a point of identification for his audience: they didn't know, but then neither did he, his claim to authority notwithstanding. Finally, of course, one must take into account that, because of Leninist critique of Mach and Duhem, positivist ideas were more readily accommodated in Western Europe, where they enabled the structure of disavowal by providing it with one of its contradictory poles. In other words, physicists in the Soviet Union had less room to manoeuvre: they were hedged in on one side by a sustained Leninist critique of skepticism as promulgated aggressively by the 'New Philosophers', and on the other by the blunt certainties of Zhadanov's speech, which displayed little sympathy for sophistical attempts to reconcile orthodox QM with the principles of modernization or dialectical materialism. In such a context, the delicate balances required to maintain a structure of disavowal were not possible, and the orthodox interpretation by and large abandoned.[51]

Notes

1 Fock attempted to reconcile the orthodox interpretation with the principle of causality by interpreting the causality requirement as the 'existence of laws of nature [either statistical or deterministic] particularly those connected with the general properties of space and time (finite velocity of action, the impossibility of influencing the past)' (Graham, 1987: 341). See too Cross (1991: 740–2). Note, however, that Beller (in private conversation) indicates that Bohr gave up terms like 'uncontrollable influence' and restored a deterministic metaphysics not because of his interaction with Fock but rather as a consequence of the Einstein–Podolski–Rosen debate.

2 This view echoes that of the later Heisenberg, which we shall mention below.

3 There is a question of whether physicists were subjected to the same terror campaign as the rest of the Russian community. Although the Party had enforced certain political and bureaucratic reforms within the Academy of Sciences, the most extreme Stalinist methods were never employed against its members. For instance, as Graham points out:

> In the long struggle leading to the elections at the end of 1928 and the re-elections in February 1929, the academicians had never been threatened with arrest or violence.... Yet outside the walls of the Academy the use of the purge against non-Party organizations was already a practice of the government.
>
> (Graham, 1967: 120–1)

Even when a purge of the Academy took place in July 1929, only four academicians were arrested and expelled, despite the fact that the Party inspector, Figatner, reported that the Academy was 'an asylum for alien elements hostile to Soviet power ... filled with former landowners, senators, gentlemen of the court, ministers of religion, princely scions' (Graham, 1967: 130). Indeed, the purge was never completed. Volgin, the Party-appointed post-purge president, was able to report that: 'these people [the old members], principally hostile to socialist reconstruction ... are for the Academy ... heavy ballast, interfering

with its forward movement' (Graham, 1967: 130). Nevertheless, during the height of the 'Great Terror' in 1937 and 1938: 'It has been estimated that as many as one hundred physicists were arrested in Leningrad.' Bronstein and Fredericks lost their lives, as we have seen.

4 The theoretical hardware of QM, the equations which generated its concrete predictions, were never at issue. Rather, it was the theory's metaphysical super-structure, its interpretation, which was the subject of official criticism.

5 The emblem of the project for 'The Scientific Management of Society' was the miner Stakhanov, who showed how, with proper motivation and a controlled environment, it was possible to achieve incredible levels of manually driven production – see Aronowitz (1988: 213, 220). It is often claimed that during the Stalinist period of the 1930s the drive for modernization was reversed (see Aronowitz, 1988: 214). But this is a mistake. Stalin actually intensified the Taylorist techniques of human management. It is of course true that he rejected advanced technology transfer which was closely associated with modernization in the West, and only resurfaced in the Soviet Union post-Stalin. But this rejection should not be confused with a rejection of modernization as such. Indeed, as Graham points out, the role of science in Stalin's official plans was central, a point forcefully made in the second paragraph of the 1930 charter of the Academy of Sciences, which directed it to: 'fulfill the needs of the socialist reconstruction of the country and the further growth of the socialist social order'; as Volgin commented: 'The idea of the closest ties of the work of the Academy of Sciences with socialist construction runs like a red thread through the whole new charter' (Graham, 1967: 139).

6 In the last quotation a certain difference in terminology between Bohr and Heisenberg surfaces. Bohr preferred 'claim of causality' and 'space–time coordination' to Heisenberg's 'particle picture' and 'wave picture' respectively. In this context, the term 'claim to causality' is understood as a description of the conserved quantities energy and momentum, since it is via such conservation principles (for isolated systems) that the existence of causal relations are established (by taking failures of conservation as signals of causal intervention). And these quantities, in turn, are designated as 'wave-like' in virtue of the Einstein–de Broglie relations which connect energy to frequency and momentum to wave-length. Thus it would seem that the terminological difference is merely a matter of elegant variation. But this is not the case. According to Jammer, it signals a fundamental disagreement between Bohr and Heisenberg: for Bohr, the term 'wave picture' was something of a misnomer, since from a classical perspective, momentum and energy are particle properties already, and their redesignation as 'wave properties' by QM depends upon the Einstein–de Broglie relations which link them to wave properties. Thus for Bohr, as opposed to Heisenberg, the complementary relation between wave and particle pictures was a consequence rather than fundamental expression of wave-particle duality – see Jammer (1974: Chs 3, 4). But for a contrary view see Beller (1992).

7 Thus it is appropriate to apply the term 'postmodern' to the orthodox interpretation of QM not only because of its form (fragmentary, reflexive, and so on) but also because it exists in a critical relation to the forms of modernization. Note however, that my concern is not to defend a distinction between postmodernist and modernist. On the contrary, I agree with critics like Callinocos (1989) and Harvey (1993) that such a distinction is difficult to sustain; and certainly makes little sense if glossed along purely formal lines.

Instead, the label 'postmodern' functions in my argument purely as a place-holder for certain formal features. Note too that by 'modernization', I mean what Habermas refers to as 'rationalization of the life world' – an artificial uniformity imposed or 'managed' through a system of social control. I return to this point below.

8 Ideology is always 'lived', that is, provides a way of looking at the world which even if it is not consciously articulated, structures human practices. Agents may, then, work totally unintentionally to extend its influence, merely by reproducing their own practices. I am here relying upon a broadly Althusserian conception of the ideological – see Althusser (1971: 121–73).

9 This analogy with the story of the Emperor's new clothes is not perfect. In the story it is less a case of the child's forceful voice and more a matter of the repressed belief, that 'really the emperor is naked', straining the bounds of repression. In the case of Zhadanov's speech, by contrast, the forcefulness of his voice and the climate of fear both seem to have contributed to its effects, as indicated by the fact that Einstein's more softly voiced opposition, spoken without the backing of political terror, did not produce a similar overthrow of the orthodox interpretation in the West.

10 See Laplanche and Pontalis (1973: 60–1; 455–62). There is a question here of why Zhadanov's speech produced a 'cure' of sorts, that is, a cathartic lifting of repression, instead of constituting what Freud calls 'Wild Psycho-Analysis': a deepening of repression by the patient's exposure to knowledge of his or her repressed ideas in uncontrolled circumstances (Laplanche and Pontalis, 1973: 480). Paradoxically, part of the story here is Zhadanov's incompetence. As Lacan tells us, it is a necessary condition for the transferential relation of identification with the analyst that the analyst takes up the position of the Other, the 'one who knows'. But according to Lacan, the Other is 'barred', that is, the Other doesn't know either. Indeed, that is why we can identify with him: 'the analyst, that is to say ... the subject who is supposed to know, but of whom it is certain that he still knows nothing' (Lacan, 1981: 269).

11 In *The Interpretation of Dreams* (1900) Freud conceives phantasy narrowly as a loosely organized collection of repressed materials, unconscious wishes, beliefs, and so on, all stored at a non-verbal, imagistic level (what Freud called '*Sachvorstellungen*', as opposed to '*Wortvorstellungen*'). These comprise the starting points for dreams and surface in subjects' conscious life as slips or parapraxes. But in its more general sense, the notion of phantasy loses this precise metapsychological location within the Freudian topographical schema conscious : preconscious : unconscious; specifically, it comes to include day-dreams (as in Breuer and Freud's 1895 *Studies on Hysteria*), or any 'imaginary scene ... representing the fulfillment of a wish (in the last analysis, an unconscious wish) in a manner that is distorted to a greater or lesser extent by defensive processes' (Laplanche and Pontalis, 1973: 314).

12 Such avoidance also helped conceal a contradiction at the heart of the ideology of modernization (one aptly expressed in another context by the Kantean antinomy between freedom and determinism): if post-war society was to be made into a 'home fit for heroes' in which the welfare of all was provided for, then a certain amount of social engineering was required; but this implied restrictions on individual freedom which, in turn, detracted from the self-same quality of life which the new social arrangements were supposed to achieve. In the English context, Keynesian economics and the emergent disciplines of the 'free market' were supposed to mediate this ideological contradiction; in the

Soviet context other mediations were attempted. For further discussion of this ideological opposition see note 18. (The phrase 'home fit for heroes' which I have used here derives from post-First World War programs of national reconstruction in Britain. The phrase had, of course, lost much of its rhetorical force by the time of the Second World War, indeed, was used ironically to refer to the failure of the great project for a 'war to end all wars'.)

13 According to Freud, 'primal repression' (*Urverdrängung*) involves an idea (*Vorstellung*) associated with one of the 'primal scenes' (seduction, the family romance and castration) becoming a site of attachment (cathexis) for the energies associated with the drives (*Triebe* – what the Standard edition refers to as 'instincts'). That idea is resisted (*widerstandt*), refused entry into the conscious/preconscious, by charging an opposing conscious idea with psychic energies (anticathexis) (Laplanche and Pontalis, 1973: 333). (Note that '*Triebe*' is translated by Lacan not as 'instincts' but as 'drives' – French: '*pulsions*' – to signal that they are not purely organic in nature.)

'Proper repression' (*Nachdrängung*) then follows primal repression: the knot of primally repressed images act as 'unconscious nuclei' to which other ideas are attracted, thus dragging them down into the unconscious where they are kept from rising back into consciousness by 'repulsions operating from the direction of superior agencies' (Laplanche and Pontalis, 1973: 333). 'Superior agencies' here refers specifically to the ego, but the superego and id may be involved as well (Laplanche and Pontalis, 1973: 394).

14 For the purposes of my argument it is essential that I talk in terms of images rather than verbal descriptions since, for Freud, the contents of the unconscious, and *a fortiori* all repressed materials, are 'thing-representations' – *Sachvorstellungen*. Note that my argument means that the failure of discourses of modernization to mention the loss of freedom implicit in the ideological phantasy of modernization was triply determined: as a good rhetorical strategy; an aspect of the ideological work of concealing contradictions; but also a result of repression.

15 The orthodox interpretation of QM constituted a conscious (ego-derived) system of ideas opposing this ideological image, and thus functioned as part of a reaction-formation (*Reaktionsbildung*) keeping the ideology firmly locked down in the unconscious – Laplanche and Pontalis (1973: 376, 446). Although, as I indicated above, such opposition was never unqualified. Fock *et al.* attempted to reconcile the orthodox interpretation with the principles of modernization; indeed, as we shall see in the the next section, the possibility of such reconciliation was an aspect of the Bohr interpretation from its inception in the West.

In advancing such claims, I make a transition from large-scale social structure, from ideologies expressed in terms of beliefs and desires collectively acted out in the domain of practice, to the unconscious or repressed phantasies of individuals. Laplanche and Pontalis express reservations about making just this sort of transition when, in their dicussion of 'acting out', they write:

> Only when the relations between acting out and the analytic transference have been analytically clarified will it be possible to see whether . . . light can be shed on the impulsive acts of everyday life by linking them to relationships of the transference type.
>
> (Laplanche and Pontalis, 1973: 6)

Nevertheless, my assumption is that ideological formations of the type

discussed here – phantasmatic structures with their own reaction formations as well as associative links to primally repressed materials – permit exactly such a transition: from collective ideology to individual ideological phantasy. Elsewhere, I argue for such a transition along more general lines (Krips, 1995). Specifically, I argue that antagonisms within the fabric of social practices function as sites of repetition (*Wiederholubg*) of originary lack. Such repetitions count as sites of repression in exactly the Freudian sense.

16 In terms of this explanation, Zhadanov's authority emerges as in part a retrospective effect, in the same way that the child's authority in the story of the Emperor's new clothes arises not from her clear-sightedness but rather from the fact that she tells people what they already 'really' know. Indeed (as I indicate in note 10) the retrospective nature of Zhadanov's authority was not entirely hidden from those who conferred it: within the physics community Zhadanov's speech, like the child's shout 'But the Emperor is naked', took on the qualified authority which accrues to pronouncements of the innocent (in Zhadanov's case, an 'innocence' born of scientific ignorance).

17 It is, of course, true that Lysenko's supporters openly criticized Mendelism for its dependence upon a random mechanism of mutation, which, they claimed, was not properly materialist. But prior to the Lysenko affair, Mendelism had been accepted into the fold of politically correct theories (by Lenin, for one); had, indeed, been held up as a model of materialist science. As such, Lysenkoist criticisms of Mendelism seem to have been opportunistic, rather than reflecting any real philosophical concerns. Orthodox QM by contrast had always attracted a certain degree of dissent, specifically from Stalinist philosophers. In any case, such tensions refer to the level of ideas, whereas I am concerned with the level of practice of 'lived' representations, to use Althusser's terms.

18 The roots of this process, especially at the level of its accompanying discourses, reside in the aspirations and values constitutive of what Habermas calls 'the project of modernity'. According to Habermas, this project grew out of the Enlightenment search for objective and universal forms of knowledge. He says: 'The project of modernity formulated in the eighteenth century by the philosophers of the Enlightenment consisted in their efforts to develop objective science, universal morality and law, and autonomous art according to their inner logic' (Habermas, 1990: 348). However, as he also points out, the project of modernity was never purely epistemic. From its inception, it sought to turn the knowledges it produced to social ends, namely the rational reform of society: 'The Enlightenment philosophers wanted to utilize this accumulation of specialized culture for the enrichment of everyday life, that is to say, for the rational organization of everyday social life' (Habermas, 1990: 348).

The Fordist assembly line and the great housing projects of the 1920s and 1950s embodied such a process of modernization. The Frankfurt school, especially Adorno, Horkheimer, and Marcuse (Marcuse, 1956; Horkheimer and Adorno, 1972) argue that such homogenizing forces create a de-differentiated or 'alienated' human subject. More specifically, they claim that modernizing machines, like the mass housing project and assembly line, leave the purchase of commodities as the only effective site for the expression and construction of human difference (and identity); the glittering array of differently packaged goods thus conceals a deadening homogeneity, which in turn conceals the effective loss of any real human differences. (The 'postmodern' shift to niche-marketing may be seen as merely one contemporary variant of the concealment of this basic homogeneity behind a simulacrum of difference.)

As tempting as this argument may be, it must be rejected. De Certeau *et al.* argue that subjects resist the regimentary forces of modern life by 'poaching' a life for themselves, finding and making themselves who they are in the gaps or interstices of modernity's normalizing grids (de Certeau, 1984). Indeed, following Lacan, one can criticize the simple socialization model of subjection implicit in the Frankfurt school critique of modernity, and argue instead that human subjects are constituted at the site of contradictions, or gaps, in the fabric of the social. (For a good account of Lacan's theory of the subject, see Zizek, 1989: Chs 1 and 5.) Indeed, even from a Marxist perspective, the notion that contemporary modes of production are homogenizing may be criticized: the de-skilling at the level of the factory floor merely conceals a new class-specific mode of differentiation between intellectual and manual labour, between the information technology of the supervisor and the mindless, repetitive tasks of the worker.

19 To talk as if there were a single uniform approach to QM during the 1930s and 1940s in Western Europe is of course an idealization. QM was banned in Nazi Germany, indeed, Heisenberg was branded a 'white Jew' for his support of orthodox QM (Vucinich, 1991: 246), and in France the PCF (French Communist Party), dominating the *Commissariat de l'Énergie Atomique* during the 1940s until a spill in 1950–1, endorsed a basically Stalinist line on QM. Vigier's development of Bohm's hidden variables approach to QM belongs to the latter historical context (Cross, 1991: 747–9).

20 'AHPQ' refers to Archive for the History of Quantum Physics, American Philosophical Society, Philadelphia, assembled by T.S. Kuhn, J. Heilbron and P. Forman; Rosenfeld (1961) is given by Beller as the source for the legend of Bohr.

21 Beller takes for granted Bohr's anti-realism, indeed, his instrumentalist approach to QM (Beller, 1995). This assumption serves her purpose of emphasizing the divide which opened between Born and Heisenberg on the one hand and Bohr on the other.

22 Bell reads the 'working philosophy' as not totally metaphysically agnostic. Specifically, he sees it as committed to a future metaphysics in which the various ambiguities and inconsistencies characteristic of the 'working' philosophy are ironed out: the 'contradictions ... between "wave" and "particle" removed, and the notion of a "classical system" made precise from within the conceptual structure of QM itself' (Bell, 1989: 189). Bell's account of the working philosophy begs metaphysical questions in favor of a 'hidden variables' reworking of QM.

23 Beller claims that this line of argument grew out of Bohr's interchange with Einstein, specifically around the Einstein–Podolski–Rosen paradox (Beller, 1995: 17). A similar argument with more explicitly Kantean roots can be detected earlier in his work, however.

24 Obviously, if Planck's constant were zero then the wave-length associated with a system in virtue of possessing a certain momentum would be zero and its frequency undefined, thus trivializing its wave-like properties.

25 Strictly speaking waves are infinite in extent, their changes across time being registered as changes in amplitude at the various points where they coexist. Localized 'wave-packets' can be constructed, of course, but only by superimposing waves of different frequencies and wave-lengths, thus losing precision in wave-like properties.

26 Here it is important to remember that the term 'wave picture' refers to the

energy and momentum of a system in virtue of the fact that energy and momentum are connected to the wave-like properties of frequency and wavelength. Thus to say that *both* wave and particle pictures apply in the classical domain is not to embrace the paradoxical claim that classical systems are both particles and waves, but rather that energy and momentum *as well as* location in space and time may be coassigned to such systems. In short, we see that the contradiction involved in the representations of QM is not *between* the wave and particle pictures. Instead, it is a matter of the impossibility of synthesizing a single coherent model which fits precisely.

27 That Bohr is concerned with explanatory value and not predictive accuracy is illustrated by the many little explanations of quantum phenomena undertaken by the Bohr interpretation: famously the explanation of the diffraction patterns cast by electrons involve the assumption that they satisfy the wave-picture to some extent. Chapter 1 of Heisenberg (1930) contains many examples of such explanations.

The point that explanatory value as distinct from predictive accuracy, requires a certain degree of approximation to the truth is illustrated by the billiard ball atomic model of gases, which, although strictly speaking an idealization and thus false, retains a certain explanatory value. This is because even when predictively inaccurate, it postulates structures which have a certain general correspondance with reality. Conversely, the mechanical models of the electromagnetic aether, mentioned briefly above, are predictively accurate but have almost no explanatory value because their correpondence with reality is minimal.

28 Classical electromagnetic waves, by contrast, only satisfy the wave-picture. But they do so independently of experimental conditions – a feature not shared by electromagnetic waves in QM, for which the concept of particle-like photons replaces that of electromagnetic waves.

29 The key point seems to be that intelligence is not well connected with other innate dispositions, as indicated by its radical relativity to education, class, and so on. In short, it lacks the connectivity we expect of well-formed dispositions. On the other hand, intelligence is more than just a matter of acting in a certain way: of scoring well in an IQ-test, for example. On the contrary, the tests provide an opportunity for certain skills to be displayed. But these are so diverse, and the way in which they come together in any one person at a particular time so different from case to case, that there seems no sense to saying that there is single disposition 'intelligence'.

In QM the situation is similar in the sense that the electron's degree of localization is too dependent upon experimental conditions and not well enough connected with other dispositions to be seen as itself dispositional – say, as a disposition to bring about a certain image in the microscope's field. But neither is the electron's localization merely a matter of a certain image being registered by the microscope. On the contrary, the explanatory role played by the electron's localization indicates that the content of its claim to occupy a certain region of space excedes the fact that a certain image registers in the field of the microscope.

30 The dissolution of the measurement problem given here, although basically correct from a Bohrian perspective, remains a little too quick. The boundary separating classically described systems from the quantum world can always be shifted, thus allowing a measuring apparatus to be at least partly described in quantum-mechanical terms. But at some point in that description

the apparatus must be described in classical terms, since, according to Bohr, the traces which comprise the end-products of measurements – say a pointer turning to a particular division on a scale – must be described classically. (Bohr's rationale for this last assumption seems to be that the final results of measurement must be communicable and, therefore, given his general views about language, described classically.) In other words a cut – *Schnitt* – between the classical and quantum-mechanical worlds must be introduced at some point in the post-interaction state description of the measurement apparatus and, wherever that cut is introduced, a totally quantum theoretical account of the measurement process becomes impossible.

It may seem that this difficulty can be avoided by describing the measurement apparatus in terms of the now-standard state vector formalism; and using the Schrödinger equation to describe the apparatus's interaction with the measured system. By describing the measuring apparatus in these terms we treat it as, to some extent, a wave-like system with only imprecise spatial properties but also as, to some extent, particulate in nature. But then it is a mystery how a measurement result gets to be registered, that is, how a pointer comes into precise spatial coincidence with a particular mark on a scale. In other words, it is a mystery how the 'interference effects' which indicate the wave-like aspect of the apparatus vanish. (Schrödinger dramatizes this mystery is his famous 'Cat Paradox'.)

The Schrödinger equation has a wave-like form, and consequently the Schrödinger formalism is often referred to as 'wave mecahnics'. Bell for example, follows this custom – Bell (1989: 171). As a result the Schrödinger formalism is often associated with what Bohr called 'the wave picture'. But this customary nomenclature is misleading, since, as I indicated, the vector formalism carries both wave and particle aspects of the quantum system. This becomes clear when the Born statistical interpretation is applied to the state-vector of a system. The state-vector is seen, then, to be a mnemonic summarizing various statistical data about the system, including the probabilities of it having particular spatial locations. I discuss these problems, and the 'new' measurement problem generated by the Schrödinger formalism in Krips (1990). On this point, it is worth noting that Bohr always retained a skeptical attitude to the Schrödinger formalism, taking it as no more than a formal trick for giving an appearance of unity to the description of quantum systems.

31 Personal conversation.

32 See my opening quotation. Newton's equally famous '*Hypothesis non fingo*' shares the same ambiguity between a modest empiricism and a radical anti-metaphysical polemic.

33 In the latter reference instrumentalism is referred to as 'pragmatism', but this terminological variation is not altogether a happy one, since pragmatism, as usually construed, is a theory about the nature of truth rather than an account of the goal of science. Indeed, in the present context, this terminology is doubly unfortunate since it suppresses one of Murdoch's key distinctions, namely that Bohr should be seen as a pragmatist (following his philosophical mentor Høffding) but not an instrumentalist (see Murdoch, 1987: 225–8). On the same point of Bohr's pragmatism and the relation to Høffding, see Faye (1991: 77–90). More specifically, Murdoch claims Bohr as a realist (as opposed to an instrumentalist) who allows that the pictures of QM may on occasions be true as opposed to merely predictively accurate albeit in a pragmatist sense of truth – Murdoch (1987: 213–18).

34 However, as Beller indicates, in the interests of staving off the common enemy, Schrödinger, both sided publicly with Bohr's more posivistic pronouncements:

> Born, while expressing realist sentiments totally at odds with Bohrian instrumentalism, pledges unity with Bohr and asks for his support against common 'enemy' Schrödinger – Born to Bohr, March 10, 1953.
>
> (Beller, 1995: 18–19)

Although even Bohr did not subscribe fully to instrumentalism. He was, for instance, perfectly realist about atoms, electrons, and so on. To quote Mackinnon:

> [According to Bohr] we do not know what electrons really are, but only how they are approximately represented by various context dependent models. This includes the conceptual models used in discourse [Bohr's 'pictures'] and the instrumental modes used in calculation [the formalism of the new QM]. *But he could never be construed as denying the reality of atoms, electrons and other particles.*
>
> (Mackinnon, 1994: 296–7, my emphasis)

See too Murdoch (1987: 214), Folse (1994: 126), and Krips (1990: 23). Even Faye, who takes Bohr as an anti-realist about the descriptions of atomic systems, concedes Bohr's realism about atoms (Faye, 1994: 99).

The question of Bohr and realism is complicated by Bohr's background: both his Kanteanism, about which much has been written, and the fact that his training was conducted by the last generation of physicists who did not take for granted the existence of atoms. It is not difficult to detect residues of this complex intermingling of philosophy and the physics in his writings. For instance, the 'reality' of macroscopic objects is placed in a different category from that of atoms, electrons, and so on; and is seen as having more to do with the exigencies of language than matters of science. Specifically, the reality of middle-sized objects, such as tables, chairs, and so on, is guaranteed by a universal human need to take them for granted in the process of language acquisition as points of reference in intersubjective communication. I am grateful to J. Ben Dove for discussion on this last point.

35 Reasons for not accepting positivism, especially in the area of QM, were stated clearly in the literature. Positivism was criticized for inhibiting creative theoretical work. Such work depends upon taking abstract notions seriously – 'us[ing] certain new abstract notions for a while, [until] they gradually will become intuitively evident' (Sommerfeld) and allowing 'new conceptions [to] sink down into the unconscious mind, [where] they find adequate names, and are absorbed into the general knowledge' (Born) – instead of dismissing them as mere heuristic devices, as the positivist would do (Beller, 1995: 16).

36 Faye argues that after 1935, and the interchange with Einstein surrounding the Einstein–Podolski–Rosen paradox, Bohr preferred the term '*Unbestimmtheit*' as he came to realize that epistemic arguments were not sufficient to make his case (Faye, 1994: Ch. 7).

37 On the contrary, as Jammer points out, 'The problem which Heisenberg faced in 1927 was ... would such imprecision, if admitted by the theory, be compatible with the optimum of accuracy obtainable in the experimental measurements?' (Jammer, 1974: 61). In its posing, this problem already presupposes a distinction between the predictive accuracy of a picture with respect to the results of measurements and its precision, understood as the degree to which

the picture is true. Jammer argues that such a distinction was at the forefront of Bohr's concerns as well:

> The reciprocal uncertainty which always affects the values of these quantities is essentially an outcome of the limited accuracy with which changes in energy and momentum can be *defined* (not 'measured'!).
>
> (Jammer, 1974: 69)

38 Murdoch makes a similar point. He concludes that despite occasional operationalist and positivist rhetoric, Bohr must be seen as a realist for whom attention to prediction and measurement grew out of a pragmatist conception of truth rather than an instrumentalist or positivist approach (Murdoch, 1987: 214 ff.). According to the pragmatist, for a belief to be true it must 'make a difference'; but this is not the same as equating truth with empirical content as the positivist or operationalist does. The difference here is illustrated by the pragmatist's acceptance of highly theoretical or ethical propositions which have no empirical content but nevertheless make a difference to what one does or thinks will happen relative to a broader background set of beliefs. Mackinnon also goes on to endorse Folse (1985) and Honner (1987):

> For him [Bohr] the basic issue ... is describing reality correctly. He set the limits within which this could be done coherently and pushed descriptions as far as they could go within these limits.
>
> (Mackinnon, 1994: 290)

And Folse himself, commenting upon Bohr's remark that 'Our penetration into the world of atoms ... has removed every trace of the old belief that the coarseness of our senses would forever prevent us from attaining direct information about individual atoms', says: 'I find it hard to imagine that a physicist who could write these words is not misrepresented if categorized as a defender of the anti-realist cause' (Folse, 1994: 126).

Admittedly, following the remark upon which Folse comments, Bohr remarked: 'The new knowledge concerning the behaviour of single atoms and atomic corpuscles has, in fact, revealed an unexpected limit'. But the context of this last remark makes it clear that Bohr is not signalling a retreat to instrumentalism. Rather, it asserts that the new hard-won knowledge about the atomic realm, knowledge construed realistically by Bohr, loses its validity when taken too far. Thus the point is not that the new descriptive protocols for the atomic domain fail in predictive accuracy, but rather that QM incorporates pictures which are true imprecisely. Although note that Faye denies that Bohr is a realist because Bohr refuses to assign truth values to propositions which were impossible to verify (see Faye, 1994: 99).

39 The relevant form of the fallacy of affirming the consequent is:

> If p is true then its predictions are accurate
> p is predictively accurate
> Therefore p is true

To infer the truth of a theory from its predictive accuracy is an enthymeme of this fallacy (with the first premise missing). Which is not to deny that the inference from predictive accuracy to truth is 'reasonable', indeed, the basis of inductive inference. But this does not change the point I am making here, that a slippage between truth and predictive accuracy is rhetorical in nature. Of

course, the slippage between truth and predictive accuracy becomes valid if one adopts a pragmatist conception of truth, as, we have seen, Murdoch claims Bohr did (see note 37).

40 Since the 1950s, various rival interpretations of QM have been promoted to the extent that they now comprise solid minority views: for instance, the de Broglie/Schrödinger/Born view of quantum systems as probability fields (Born, 1926a and 1926b), as well as various hidden variable views, such as Bohm's (Belinfante, 1973). Jammer suggests several causes which contributed to this threat to Copenhagen hegemony: the 'young turk' syndrome, the circulation of Einstein's replies to Bohr, but also various socio-cultural factors such as 'the growing interest in marxist ideology' (1974: 250–1). One of the corollaries of my argument here is that this dispute within QM can be seen as an inflection into the scientific domain of broader tensions between coexisting 'modernist' and 'postmodernist' practico-discursive formations.

Unlike the orthodox interpretation, each of these heterodox views offers a global picture of quantum systems which purports to apply under all experimental conditions, at all times and places. But the radical, even paradoxical, metaphysical assumptions implicit in each of them have hindered their general acceptance. Such radical metaphysical assumptions include the claim that nature is intrinsically indeterministic (thus reversing Einstein's famous dictum 'God does not play dice'), that there is instantaneous action at a distance – 'nonlocality' – and that science is incomplete and perhaps incompletable. For a discussion of the issue of action at a distance, or nonlocality, see Redhead (1987). The issue of incompleteness was raised by the famous Einstein Podolski Rosen paper, which also served to draw attention to the action at a distance issue – on these issues see Redhead (1987), and Krips (1990). As Jammer says, commenting upon the 1960s debate over the interpretation of the Heisenberg principle, 'the battle between the partisans of these two interpretations still continues to be waged unabatedly' (Jammer, 1974: 80).

41 Of course, as I indicated above, such skepticism has been one of the norms of scientific practice from its inception in the seventeenth-century Royal Society. My claim here is that such independent sources of skepticism were supplemented in the particular case of QM by the failure to resolve its interpretative problems in the area of QM. Indeed, there is a case to be made that this specific failure supported a more general skepticism about scientific theorizing, rather than the other way round. For instance, in the *Encyclopedia of Philosophy*, Edwards (1972), under the heading 'Laws and theories – Instrumentalism', we find the claim:

> Instrumentalism [which may be seen as a limited form of skepticism directed only against scientific theory] is also supported by the extreme difficulty in modern physics of finding self-consistent interpretations of the formal calculi of quantum theory ... or for the one theory under different circumstances (as with the quantum particle and wave models).

42 Such skepticism is often coupled with positivistic remarks disparaging philosophical or metaphysical issues as matters of taste, meaningless or empty of any substantive content (*de gustibus non est disputandum*), remarks which typically take their cue from Heisenberg's earlier polemic that 'speculation [about the existence of a hidden deterministic substrate to QM] seems to us to be without value and meaningless, for physics must confine itself to the description of the relationships between perceptions' (Heisenberg, 1927: 197),

and that such issues are 'purely a matter of personal belief (*Geschmacksfrage*)' (Heisenberg, 1930: 20). For example, Rosenfeld (1962), in a critical comment about hidden variables theories, wrote of the interpetation of QM 'this is a question to be decided by experience, not by metaphysics' (Körner, 1957: 42). Consider too Fritz Bopp's remarks uttered during a colloquium about Bohm's hidden variables interpretation of QM:

> The task of physics has been defined by saying that it predicts the possible results of experiments. But what we have done today was predicting the possible development of physics – we were not doing physics but metaphysics.
>
> (Bopp, 1962: 5)

43 The details of this erasure of differences may be formalized as follows. Let p stand for the uncontroversial core component of QM, q for the Bohr interpretations controversial assumptions and q', q" for the various rival metaphysical schema which vie to interpret p. Then the Bohr interpetation may be schematized as 'p&q&(not q')&(not q'). . .'; the working philosophy as 'p&(possibly q)&(possibly q')&. . .'; and the instrumentalist approach to QM as 'p&(not possibly q)&(not possibly q')&. . .'. It is clear that if in a certain rhetorical context the first and third of these schemas are run together, that is, made equivalent, then *a fortiori* the second will be run together with the first since in certain respects (namely with respect to its first two conjuncts) it is sandwiched between the other two (as 'possibly q' is sandwiched between 'q' and 'not possibly q').

44 The working philosophy does not contradict the Bohr interpretation at the level of specific quantum theoretical descriptions. On the contrary, the two interpretations must overlap substantially at this level since Bohr's views act as an apologetics for the working philosophy. Instead, the contradiction resides at the meta-level. The working philosophy maintains an agnosticism about the way the world is, although foreshadowing the possibility of a future metaphysics which resolves the inconsistencies and ambiguities emerging from its own descriptions of reality. The Bohr interpretation, on the other hand, insists that such inconsistencies and ambiguities are aspects of the 'true metaphysics' – not transient flaws on the face of science, but ineliminable necessities. In other words, the working philosophy is agnostic about the content of a future metaphysics. The Bohr interpetation, by contrast, denies that any such metaphysics is achievable, not by opposing metaphysics as such (as the instrumentalist does) but rather by asserting that at a basic level of description nature is both contradictory and ambiguous. In short, the two interpretations differ at the level of cognitive stance: the Bohr interpretation knows what the world is like while the working philosophy professes agnosticism.

At first sight, this system of two interchanging contradictory interpretations does not constitute much of an advance over the Bohr interpretation as far as resolving the contradiction with the ideology of modernization is concerned. Indeed, rather than one contradiction, there are now two: namely, the original one between the ideology of modernization and the Bohr interpretation, to which is now added a second between the two interchanging interpretations. The second, however, is invisible, concealed by a rhetorical slide which covers the differences between the two interpretations. The first can also be rendered invisible, provided care is taken to bring forward the working philosophy

(rather than its Bohrian partner) when consistency with the principles of modernization is at issue.

45 (Laplanche and Pontalis, 1973: 118–20). Freud originally developed the concept of disavowal in the context of the subject's fear of castration and the anxiety occasioned by sighting the mother's lack of a penis.

46 The approach to the Real – the trauma – is always experienced in a concrete situation, but mediated by an associative chain transforming the experience into an approach to something which can never be grasped. According to Lacan, this something which can never be grasped is not one of a set of (real or imagined) primally repressed scenarios, but rather an awful void or lack which is the burnt-out remains of such scenarios, and presents itself as a point of resistance to symbolization; it is also associated with the inescapable residue of non-satisfaction which dogs subjects in virtue of their dependence upon others to satisfy their needs (Lacan, 1981: 51, 55, 280).

Specifically, Lacan figures the Real as that which is 'prior to the assumption of the symbolic, the real in its "raw" state (in the case of the subject, for instance, the organism and its biological needs)' and hence 'that which is lacking in the symbolic order, the ineliminable residue of all articulation, the foreclosed element, which may be approached, but never grasped', which in turn leads to the concept of the Real as 'that over which the symbolic stumbles, that which is refractory, resistant' (Lacan, 1981: 280). This concept of the Real, especially as it is distinguished from a more traditional notion of 'reality', is in part an extension of Freud's important distinction between 'realistic anxiety' (anxiety about an external threat) and instinctual anxiety, which in Lacanian terms arises from too close an approach to the Real (Laplanche and Pontalis, 1973: 379).

47 Strictly speaking this is a slight weakening of the traditional formula for disavowal. That is, a traditional disavowal would say 'I know that the Bohr interpretation is incorrect but even so. . .'. But this logical difference does not affect the spirit of contradiction which haunts the disavowal.

48 Lacan makes a similar point when he refers somewhat cryptically to 'a number of cracks to be heard confusedly in the great consciousnesses responsible for some of the outstanding changes in physics' (Lacan, 1977: 297).

49 What this argument lacks in rigour or clarity it makes up for by a certain rhetorical force. In any case, what is at issue here is the veiling of the limits rather than surpassing them. By taking on the task of mapping its own limits the Bohr interpretation distracts itself from their existence, and in that sense veils them.

50 In this context, of course, it is the fact of anxiety rather than the concrete objects upon which it fixed which is significant. Such objects are merely standins for the awful truth out of which anxiety arises. This last point also explains why the fact (noted earlier) that the *rejection* of Bohr's ideas was also associated with anxieties, supports rather than undermines the claim I am making here.

51 I am indebted to M. Beller, J. Ben Dove, and J. Faye for discussion, as well as the Cohn Institute of the University of Tel Aviv for hospitality during the spring term of 1995. Many of the revisions in this paper arose in a context of friendly opposition to the 'Tel Aviv hypothesis', which appears in this paper under the title 'climate of fear explanation'.

References

Alexander, Jeffrey and Seidman, Steven (1990) editors, *Culture and Society* Cambridge: Cambridge University Press.

Althusser, Louis (1971) *Lenin and Philosophy and Other Essays*, trans. Ben Brewster, London: New Left Books.

Aronowitz, Stanley (1988) *Science as Power*, Houndmills: Macmillan.

Belinfante, F. J. (1973) *A Survey of Hidden-Variable Theories*, Oxford: Pergamon.

Bell, J. S. (1989) *Speakable and Unspeakable in Quantum Mechanics*, Cambridge: Cambridge University Press.

Beller, Mara (1992) 'The birth of Bohr's complementarity: the context and the dialogue', *Studies in History and Philosophy of Science*, 23 (2): 147–80.

—— (1995) 'Rhetoric of antirealism and the Copenhagen spirit', manuscript.

Bohr, Niels (1932) 'Chemistry and the quantum theory of atomic constitution', *Journal of the Chemical Society*, 15 (1): 349–83.

—— (1935) 'Can quantum mechanical description of physical reality be considered complete?', *Physical Review*, 48(3): 696–702.

—— (1949) 'Discussion with Einstein on epistemological problems in atomic physics', in Paul Schilpp (ed.), *Albert Einstein Philosopher-Scientist*, Evanston: Evanston University Press.

—— (1958) *Atomic Physics and Human Knowledge*, New York: Wiley (originally published 1934).

Bopp, Fritz (1962) in Stephen Körner (ed.), *Observation and Interpretation in the Philosophy of Physics*, New York: Dover.

Born, Max (1926a) 'Zur Quantenmechanik der Stossvorgange', *Zeitschrift für Physik*, 37 (2): 863–7.

—— (1926b) 'Zur Quantenmechanik der Stossvorgange', *Zeitschrift für Physik*, 38 (3): 803–27.

—— (1962) *Physics and Politics*, Edinburgh: Oliver & Boyd Press.

Callinocos, Alex (1989) *Against Postmodernism*, Cambridge: Polity Press.

Cross, Andrew (1991) 'The crisis in physics: dialectical materialism and quantum theory', *Social Studies in Science*, 21 (2): 735–59.

de Certeau, Michel (1984) *The Practice of Everyday Life*, trans. Steven Rendell, Berkeley: University of California Press.

Edwards, Paul (1972) *The Encyclopedia of Philosophy*, vol. 5, New York: Macmillan.

Faye, Jan (1991) *Niels Bohr: His Heritage and Legacy*, Dordrecht, Kluver.

—— (1994) 'Non-locality or non-separability', in Faye and Folse (1994).

Faye, Jan and Folse, Henry (1994) editors, *Niels Bohr and Contemporary Philosophy*, Dordrecht: Kluwer.

Folse, Henry (1985) *The Philosophy of Niels Bohr*, Amsterdam, North-Holland.

—— (1994) 'Bohr's framework of complementarity and the realism debate', in Faye and Folse (1994).

Forman, Paul (1971) 'Weimar culture, causality, and quantum theory', in R. McCormmach (ed.), *Historical Studies in the Physical Sciences*, Philadelphia: University of Pennsylvania Press.

Graham, Loren (1967) *The Soviet Academy of Sciences and the Communist Party, 1927-1932*, Princeton: Princeton University Press.

—— (1987) *Science, Philosophy, and Human Behavior in the Soviet Union*, New York: Columbia University Press.

Gribanov, D. P. (1987) *Albert Einstein's Philosophical Views and the Theory of Relativity*, trans. H. Campbell Creighton, Moscow: Progress Publishers.

Habermas, Jurgen (1990) 'Modernity versus postmodernity', in Alexander and Seidman (1990).

Harvey, David (1993) *The Condition of Postmodernity*, Oxford: Blackwell.

Heisenberg, Werner (1927) 'Über den anschaulichen Inhalt der quantentheoretischen Kinematik und Mechanik', *Zeitschrift für Physik*, 43 (4): 172–98.

—— (1929) 'Die Entwicklung der Quantentheorie 1918–1928', *Die Naturwissenschaften*, 17 (3): 490–6.

—— (1930) *The Physical Principles of the Quantum Theory*, trans. Carl Eckhart and Frank Hoyt, Dover: New York.

—— (1931) 'Die Rolle der Unbestimmtheitsrelationen in der modernen Physik', *Monatshefte fur Mathematik und Physik*, 38 (1): 365–72.

—— (1971) *Physics and Beyond*, London: Allen & Unwin.

Hollaway, David (1994) *Stalin and the Bomb*, New Haven: Yale University Press.

Honner, J. (1987) *The Description of Nature*, Oxford, Clarendon.

Horkheimer, Max and Adorno, Theodore (1972) *Dialectic of Enlightenment*, New York: Herder & Herder.

Hume, David (1975) *An Enquiry Concerning Human Understanding*, ed. N. Selby-Bigge, revised G. Nidditch, Oxford: Clarendon Press.

Huyssen, Andreas (1990) 'Mapping the postmodern', in Alexander and Seidman (1990).

Jammer, Max (1974) *The Philosophy of Quantum Mechanics*, New York: Wiley.

Joravsky, David (1970) *The Lysenko Affair*, Chicago: University of Chicago Press.

Körner (1957)

Krips, Henry (1990) *The Metaphysics of Quantum Theory*, Oxford: Clarendon.

—— (1995) 'Interpellation, antagonism, repetition', *Rethinking Marxism*, 7(4): 59–72.

Lacan, Jacques (1977) *Écrits: A Selection*, trans. Alan Sheridan, London: Tavistock Publications.

—— (1981) *The Four Fundamental Concepts of Psychoanalysis*, ed. Jacques-Alain Miller, trans. Alan Sheridan, New York: Norton.

Laplanche, J. and Pontalis, J.-B. (1973) *The Language of Psychoanlysis*, trans. Donald Nicholson Smith, New York: Norton.

Mackinnon, Edward (1994) 'Bohr and the realism debates', in Faye and Folse (1994).

Mannoni, O. (1964) 'Je sais bien, mais quand même . . .', *Les Temps Modernes*, (2): 212–36.

Marcuse, Herbert (1956) *One Dimensional Man*, Boston: Beacon Press.

Merton, Robert (1968) *Social Theory and Social Structure*, New York: The Free Press.

Murdoch, Dugald (1987) *Niels Bohr's Philosophy of Physics*, Cambridge: Cambridge University Press.

Redhead, Michael (1987) *Incompleteness, Nonlocality, and Realism*, Oxford: Clarendon.

Rosenfeld, L. (1961) 'Foundations of quantum theory and complementarity', *Nature*, 190 (2): 348–88.

Rosenfeld, M. (1962) in Stephan Körner (ed.), *Observation and Interpretation in the Philosophy of Physics*, New York: Dover.

Vucinich, Alexander (1991) 'Soviet physics and philosophers in the 1930s: dynamics and conflict', *Social Studies of Science*, 21 (3): 735–9.

Zizek, Slavoj (1989) *The Sublime Object of Ideology*, London: Verso.

JOHN LYNE

QUANTUM MECHANICS, CONSISTENCY, AND THE ART OF RHETORIC: RESPONSE TO H. KRIPS

ABSTRACT

The intellectual and cultural reception of quantum mechanics has been rhetorically mediated, accounting in part for the way it meshed or failed to mesh with ideological and cultural assumptions about science in different national settings. At issue is both the matter of political climate and the way expectations of consistency put pressure on discourse. If one takes consistency to be not just a matter of syntax and semantics, but also of the rhetorical management of meaning, then the *topos* of consistency can play out in a variety of ways, even given a common ideology. Also at issue, in response to Krips, is the relevance of psychoanalytic mechanisms to any account of the pragmatic and epistemological program of the sciences. Peirce's semiotic realism is posed as a theoretical point of purchase for thinking about the 'real' in the context of the discourses of science.

KEYWORDS

rhetoric; rhetoric of science; quantum mechanics; consistency; Peirce; rhetoric of inquiry

Cornel West once used a book title, *The American Evasion of Philosophy* (1989), that might make one anticipate an account of how American thought had missed the boat philosophically. Instead, one finds a kind of celebration of the anti-foundationalist, jazzy and improvisational strain in the tradition. I am reminded a bit of this philosophical 'evasion' in the Western physics community's handling of the ontological implications of QM. Instead of staging a confrontation that would force the issue metaphysically, physicists in the West finessed their way out of contradictions. Evasive psychoanalytic mechanisms may have helped produce that result, but it does not follow that it was a scientific mistake – unless one is committed to a certain account of knowledge. I do not know what Krips's epistemological commitments are, but I do detect some ambivalence concerning inconsistencies in scientific discourse. He seems ambivalent about Bohr, or, at least, with the way Bohr gets used as an authorizing

figure. There is an appreciation of the post-modern edge of Bohr's QM, with its refusal to force-fit things into a single global scheme of representation. On the other hand, there is an implied need for an inclusive metaphysical frame, and suspicion of a Bohrian interpretive scheme that 'bring[s} forward the right bit at the right time'. What does this imply about the dynamics of representation, and specifically, the accountability of the psychoanalytical to the scientific enterprise? The question seems worth exploring.

The psychoanalytic framing prompts further questions about where and how the discourses of science get settled. Are the relevant consistencies essentially psychological in nature? And is the real off limits to scientific articulation in the same way it eludes the (Lacanian) subject? One might of course defer the question of how the psychoanalytic account relates to the epistemological one, but at some point in critiquing the discourses of science one more or less has to take a position on what Nancy Sinatra once called 'truthing'. (I'll show my own hand shortly.)

With all the energy that has been spent making scientific and philosophical sense out of quantum mechanics (hereafter, QM), we are still some way from understanding the complex relationship of this watershed development to the cultures in which it occurred, and particularly, its comparative reception in different cultures. Historians and sociologists have every reason to study it, but so too do students of culture and rhetoric. Krips has made a creative contribution in that direction, moving us toward a conversation about the cultural mediation of physics. The issue of how ideology is related to scientific theory and its reception is something of a mined field, and one must be astute in avoiding the pitfalls represented by the internalist reading of science, on the one hand, and the ideologically determinative reading on the other (I think Krips is). To suggest, as one sometimes hears, that the understanding of a scientific theory is simply pressed out by an ideological template would be no more illuminating than to say that the reception of science is just exfoliated from the science itself. One searches in vain for a map by which one can simply read off in advance the relationships between science, ideology, and rhetoric. Best not to try. Mapping after the fact is a different matter, however, and here there is much to be learned.

Krips accounts for the disposition of QM by psychoanalytic mechanisms. In the Soviet context, the effect of Zhadanov's assault on QM is seen as bringing repressed 'knowledge' to the surface. The key passage is this:

> Thus the speech's apocalyptic effect arose not so much from its intrinsic rhetorical force, or the political clout of its speaker, or indeed the prevailing climate of fear in Stalinist Russia, but rather from the fact that at an unarticulated level those hearing the speech 'knew already' that the emperor from Copenhagen was naked, a knowledge which the speech enabled them to bring to the surface.
>
> (83–4)

The Western reception was, by contrast, mediated by a 'structure of

disavowal', which prevented recognition of the contradictions QM posed to the ideology of modernization. In either case, the assumption is that the issue was how an encroaching reality was to be handled – a reality not to be disentangled from ideology and imagination, nor from the constitutive role of experimental conditions, to be sure – but a reality none the less.

Consistency regimes

Consistency, as I understand it, is not simply a function of syntax and semantics, but of the rhetorical management of meaning. Krips has argued that the so-called orthodox interpretation of QM was inconsistent with the ideology of modernization in place in the Soviet Union and that its interpretation along instrumentalist lines in the West blunted its potential challenge to the ideology of modernization there. Two critical assumptions seem to be: (1) The ideology of modernization was more or less uniform in both Soviet Russia and the industrialized Western nations; and (2) The recognition of the truly radical nature of the orthodox interpretation would likely have been seen as disruptively inconsistent with the ideology of modernization in the West. Taken together, these assumptions hint at a more deterministic role for ideology than I would hold for, just because of the rhetorical deployment of meaning.

It is reasonable to suppose that a scientific doctrine such as QM does not weigh determinately on the socio-political context (or vice-versa). Rather, specific conclusions linking science and ideology are derived, contingently, through rhetorical argument and mediation. Pertinent examples of such rhetorical mediation presently abound, especially in the area of biological theories that are understood as having a bearing on social policy. For instance, the theory that test-oriented intelligence is determined in large part by genes can be used to justify a *laissez-faire* government posture with respect to social intervention, in the manner of Herrnstein and Murray's *The Bell Curve* (1994); or contrarily, the weight of that very theory can be thrown, jujitsu fashion, behind the argument for increased intervention to 'rectify' the perceived problem. Such cases illustrate some of the ways that a purported scientific reality can be harnessed in different ways, even opposite ways, to social purposes.

It is partly through rhetorical moves such as these that social power comes to inhere (or not inhere) in a theory. But such moves are not independent of a political climate, and one must not underestimate the rhetorical consequences of political muscle flexing. Joravsky (1970) lists twenty-two physicists and philosophers of physics who were arrested or repressed between 1936 and 1938, and in some ways the campaign against foreign and 'anti-materialist' influences on science escalated after that. Zhadanov's attack on QM in 1947 needs to be seen in the light not only of courageous efforts to maintain scientific integrity within the Academy, which Krips observes, but also of the continued efforts to undermine that integrity.

The concurrent experience of the Lysenko debâcle, with a turning point

in 1947–8, is instructive for comparison within this time frame. A.A. Zhadanov, the Party's chief of science and culture, had waged a campaign against foreign influence and 'cosmopolitanism' in the arts and sciences. His son, Iurii Zhadanov, was head of the Central Committee's Division of Science (and also Stalin's son-in-law). Although the younger Zhadanov had previously tried to prevent the study of genetics from being trampelled by the the Lysenkoist agricultural program, he wrote a letter to Stalin in July of 1948 apologizing for this stance and pledging to join a campaign for all-out suppression (Joravsky, 1970). A famous session of the Lenin Academy of Agricultural Science that August, newly packed with thirty-five fresh members, was railroaded into taking the anti-genetic, Lysenkoist line. No less a figure than the chief of biological science of the Academy of Science was pressured to resign for his unwillingness to conform, and others were quickly brought around, especially, when Zhadanov published his letter to Stalin on the last day of the session. No one had to be arrested to achieve this capitulation.

Given such machinations, it is not clear that modernization apart from its specific deployment can usefully be considered a single ideological force across different national contexts. As a thought experiment, one might well ask what might have happened if QM had in fact been recognized as posing a radical challenge to reigning assumptions about modernism and modernization in the West. Is it likely that it would have been rejected for that reason? By what mechanism might it have been rejected? No one can give definitive answers to hypotheticals such as these, but even posing the question calls attention to the difference in the way ideological effects are realized in different cultural contexts. I would agree with Krips that it is naive to suppose that the Western nations were non-ideological in their reception of science; but it does not follow that a scientific theory such as QM would or could have been silenced in the West in the way that it could be under the Stalinist regime.

The Stalinists held for imposing a sense of consistency across art, science, and politics, as did the German Nazis. There were in either case state mechanisms avowedly committed to promoting intellectual and political consistency, as well as consistency in science. In England, by contrast, there were countervailing tendencies, given that the dominant political ideology is rooted in anti-rationalistic notions (and hence fertile gound for, say, the immigré Karl Popper and his philosophy of science). In France, as Krips notes, it was those physicists with Communist sympathies who felt a need to make QM consistent with materialist doctrine. The ideology of modernity has always in some important ways had something like a 'pragmatic' reception in the United States.[1] All this suggests that the very sense of inconsistency is heightened and thematized in those contexts where doctrinal consistency across all contexts is an official objective.

So, I would argue, there is reason to believe that the orthodox interpretation of QM was not necessarily incompatible with the ideal of modernization as it had been embodied in the non-Soviet West, partly because of the ideological capacity, often rhetorically explicit, to accept inconsistency

between different ranges of discourse without, *pace* Habermas, experiencing a legitimation crisis. Even McCarthyism in America did not enforce an epistemological or scientific principle, as its partisans saw science as an instrumental enterprise, the key to developing nuclear weapons, east or west. Robert Oppenheimer's loyalty was put in question, not his physics. The question of loyalty, as a political value, was not yoked to any particular epistemological theory, nor does the general ideology of modernism require that yoking. Whether its haidmaiden, 'modernization', requires such consistency is another question, perhaps, but that question can only be answered in the context of rhetorical practices.

'Consistency' as rhetorically mediated

The anti-idealism of the Stalinists was, like other rhetorical vestiges of Leninism, no doubt, a stance adopted when convenient. The anti-Western rhetoric of this period should not be underestimated as a potent consistency demand, however. In that respect, again, the QM case invites comparison to the Lysenko episode, where genetics research was officially stigmatized in the Soviet Union as Western, idealist and anti-materialist. But this characterization was not simply an entailment of dialectical materialism, although it was sometimes presented that way. The linkage between genetics and anti-materialism was created by rhetorical argument, using a series of structured positions, aligning Lysenko's program with everything politically correct and genetics with all that was threatening (Lyne, 1987). Lysenko even held that arguments based on probabilities were anti-materialist. Now that the specific material structure of genes is understood, of course, the notion that genetics is anti-materialist looks ironic indeed. But Lysenko's argument was not just a question of theory – it was offered as a practical way of increasing badly needed crop yields.

These experiences remind us that the rhetorical gesture can often throw the weight of the ideology in a direction *opposite* expectations (jujitsu).[2] At the risk of giving too much to rhetoric, but with a mass of evidence to stand on, one might conclude just this: Whether a theory is consistent with a given world view is a question answered, not by logic, psychology, or ideology alone, but by rhetorical argument. A good example of this in the case of the Forman thesis (Forman, 1971), referred to by Krips, which held that the chaotic life-world of Weimar Germany, plus dissatisfaction with scientific determinism, predisposed thinking in such a way that the very rejection of causal determinism might be, not only a possibility, but an ideologically effect.[3] Without entering the debate over the degree to which social or ideological conditions presuppose, select for, or simply tend to favor specific philosophical or scientific doctrines, I would point to a plausible use of the jujitsu rhetorical strategy in cases just such as this. If the life-world was riddled with chaos in Weimar Germany, then might we not expect, instead of a rejection of causality, a generalized cry for order? Might the very fear of chaos that helped produce the phenomenon of Hitler have helped usher in stricter, deterministic modes of thinking? In

fact, QM was disapproved of by the Nazi regime. Is it implausible to suggest that this reflected a fear of disorder? The story might be so constructed.

As a matter of rhetorical framing, one might describe the Weimar chaos either as a tide sweeping up scientific and philosophical thought, or contrarily, as a condition that cried out for a dialectical corrective. Stated briefly, disorder can be framed either as 'grounding' (for indeterminism) or as 'lack' (for causal orderliness). The relative roles played by the psychoanalytic and the rhetorical in foregrounding one another are achieved rather than given. We know, for instance, that Hitler's program was opportunistically embraced by philosophers and scientists of various stripes (idealist, positivist, pragmatist, et al.), who could all link up by rhetorically constructed pathways (Sluga, 1993). This is not to suggest that rhetorical opportunity comes independently of the ideological and social context in which it operates. But the relationship of rhetoric to these contexts is, I agree with Krips, both mediating and mediated.

Whether a stark confrontation with the orthodox interpretation of QM would have been felt as threatening in the West might depend on how it was discursively configured, and it can be fun to consider the possibilities. There were surely rhetorical resources available to those who might have wished to receive QM as continuous within modernist assumptions. Among these resources one might include the authority of Einstein, whose side might have been taken. Although he was increasingly isolated in his opinion among scientists in rejecting the Copenhagen interpretation, he remained a cultural icon and scientific authority figure of the highest order – and this despite the fact (or perhaps because of the fact) that his general theory of relativity was received as revolutionary and destabilizing.[4] But this raises the question of how broadly one must throw the cultural nets in accounting for the reception of a scientific theory. Outside a highly élite circle of interpreters of the philosophical import of QM, for instance, it is not clear to what audience in the West the paradoxes of QM mattered. Still, one wonders, if Einstein could be domesticated, why not Niels Bohr?

Suppose one were to read the instrumentalist interpretation of QM, not as a cognitive failure, but as a rhetorical strategy for appropriating QM with minimal disruption to existing practices. It may be true that the doctrine of skepticism, a general doctrine to the philosopher, was applied selectively to deal with the problem posed by QM. Such selectivity, I would suggest, is the earmark of rhetorical strategy, deployed to relieve inconsistency. In that sense, 'pragmatic' arguments have often served as rhetorical mediations between beliefs or practices that seem incompatible. One might, for instance, believe at a general level that all human behavior is caused, and yet selectively suspend this perspective in holding persons morally responsible for their actions. Philosophically, this may present a conundrum, but is is quite normal as a rhetorical strategy.

Reading Krips against himself in this instance, the strategy of confining the import of QM by reading it instrumentally might even be characterized as a postmodern strategy. This does not mean that Krips should

necessarily find a merely instrumental interpretation sufficient, and he does not because of his implied commitment to some form of realism. This is a legitimate basis for critique, but if mounted in a postmodern spirit, I would think, such a critique cannot be based merely on the fact that aspects of the general doctrine of skepticism are selectively mobilized.

Deploying credibility

The discourse of QM is subject to analysis for its ways of rhetorically mediating cognition and practice. 'Rhetoric' here presupposes a productive tension between discursive formations and performative action, or event. Understood as an active means of moving people toward judgment by persuading, rhetoric thrives when more than one position can plausibly be held by a relevant audience.[5] When the weight of evidence or precedent seems distributed between competing views, the force of logic seems equally strong on both sides of a case, or when for any reason judgment is weighed in the balance at the moment of rhetorical performance, these are the potentially powerful moments for rhetoric. The reception of a scientific theory can be seen in the context of rhetorical inducement to judgment. This can be understood by examining the role that rhetoric plays in mediating among a variety of claims, values, doctrines and discursive communities.

Viewing rhetoric as an active intervention, one might say that the available means of persuasion are found to be relative to the circumstances, audiences, and subject of argument. The art of persuasion is in no small part an art of positioning, and positioning is always in relation (relative) to other positions, other persons, and other possibilities. A rhetorical performance is relative to concrete circumstances, audiences, the long-term and short-term purposes of the rhetor and, perhaps above all, to the arguments on the other side of the case. But it is never determined solely by its circumstance, whether material or ideological. The ancients spoke of the rhetoric's ability to prove opposites, or to make the worse appear the better cause. The great sophist, Protagoras, alleged that for every argument there is an equal and weighty counter-argument. All of this implies that, for arguments that are rhetorically interesting, there is no logical operation which can preclude counter-argument once and for all. In contexts ranging from the social sciences, to the densely articulated Talmudic tradition, to everyday life (Billig, 1987), there is no real bottom line, even in the most highly rule-coded communities, that will preclude counter-argument. Taking arguments to be not just words but a species of action, this implies means for escaping doctrinal determinism.

The particular kinds of actions I am calling attention to here are the rhetorical performances that mediate between ideology and situated judgments, sometimes triggering the kinds of psychological events Krips recounts in the case of Zhadanov. In the history of QM's reception, there are other pivotal moments, some of them famously so, such as the 1927 Solvay conference, that helped shape the reception of the theory. And these

moments are not simply the result of social forces coming into confluence, but also of skilled rhetorical performance – the ability to construct the right arguments at the right time, make the right affective and ideological links, and, crucially, to make the best use of credibility.

We have been reminded of the powerful authority of Niels Bohr, about whom, along with Heisenberg, the story of orthodox QM usually focuses. Bohr's mythic status is partly the result of his reputation as the father of atomic quantum physics and by the now-mythic debate he had with Einstein, on which seemed to turn the most fundamental questions about the world. Einstein's famous assertion that 'God does not play at dice with the universe' issues from this debate (actually in a letter to Max Born in 1926 (Pais, 1991: 318)), and it marks the sense in which the cultural reception of this debate amplified references to ultimate realities.[6] It was largely through Bohr's legendary powers of persuasion that the Copenhagen interpretation became known as the orthodox interpretation (a term originally applied with pejorative overtones by its critics).

Krips has rightly called attention to the personal force of Bohr in the official discourse of QM. In an obituary for Bohr in 1963, Werner Heisenberg wrote: 'Bohr's influence on the physics and the physicists of our century was stronger than that of anyone else, even than that of Albert Einstein' (Pais, 1991: 14). At the fifth Solvay Congress, held in Belgium in 1927, all the great scientific figures involved in the creation of quantum theory gathered. One of them, Paul Ehrenfest, described Bohr as 'towering completely' over everybody. 'At first not understood at all . . . then step by step defeating everybody' (Pais, 316). Bohr was prodigious in campaigning for his interpretation, often receiving skeptical visitors who found themselves being converted by the visit. His Copenhagen Institute was an immensely important institutional site for propagating his views through major physics journals and through visiting physicists from around the world. Additionally, he carried on written and spoken dialogue not only with Einstein, but with other important stars in the scientific constellation. Rising young American physicists came to Copenhagen to study QM.

That Bohr was crossing disciplinary communities is relevant to our understanding of how the scientist's ethos helps mediate the relationship of science to cultures. In accounting for the dynamics of reception, there are a number of different audiences to be considered. These do not sort out according to static 'spheres' of knowledge, but rather by shifting lines of disciplinarity and publicity, following rhetorical action. Scientists of great public stature, such as Niels Bohr, can be crucial to carrying the influence of scientific theories to these different audiences and shaping the conditions of reception.[7] Bohr's persona, applied in pivotal moments, facilitated the reception of the theory with many of these audiences, within physics and beyond.

Physicist and philosopher James Cushing (1994) has recently argued that the triumph of the Copenhagen orthodoxy was a hegemonic achievement based on timing and the institutional resources that Bohr and associates used to full political advantage. An alternative, 'causal' account,

which can be traced through a lineage from de Broglie to David Bohm (a version of the 'hidden variables' theory discussed by Krips) has received relatively little favor, but Cushing argues that it poses no paradoxes and no measurement problems while purportedly avoiding causal indeterminism. I leave it to the physicists and philosophers (including Krips) to evaluate Cushing's claim. But whether or not it is true that patient causalists might have held out and found a satisfactory solution to the apparent difficulty posed by QM, Cushing shows us some of the role played by personal politicking and emotional fervor in producing what he calls the Copenhagen hegemony. Whoever is right about this particular case, there remains a general question of whether scientific realism should be seen as closing off the theoretical space for a wide range of interpretations. If I am right in locating consistency at the rhetorical level, and not just at the syntactic and semantic levels, realism can leave open a great deal of interpretive space. The key to this, perhaps, is interlocution.

Bohr's ongoing argument with Einstein also shows the dynamic effects of personality and interlocution in the midst of theoretical difference. The need to address Einstein, even after his death, became a driving force for Bohr. According to his associate and biographer, Abraham Pais, Bohr's frustrations at being unable to gain Einstein's assent constantly drove him to elaborate, formulate, and clarify (1991: 12). Had Bohr not been haunted by the voice of Einstein, we may have been denied a great deal of his thinking on the relationship between classical and quantum physics. This is compelling testimony to the importance of an audience in the process of inquiry, even if audiences can remain all but invisible in scientific discourse. It also illustrates (at a level of rarefication where we are unaccustomed to hearing this dictum) that reasonable people may disagree – and not incidentally, why the particulars of argumentation are so important.

The lure of intelligibility

A recurring theme in the literature on QM is the sense of intellectual perplexity it creates, even among those who accept and use it. QM formalism, despite being almost universally accepted, creates a frenzy of intellectual activity trying to 'understand' it in some way that doesn't violate basis intuitions. Its apparent suspension of causal continuity appears to leave many with an attitude of pragmatic resignation. No less a luminary than Murray Gell Mann has observed: 'Quantum mechanics [is] that mysterious, confusing discipline, which none of us really understands but which we know how to use. It works perfectly, as far as we can tell, in describing physical reality, but it is a 'counter-intuitive discipline', as the social scientists would say' (Cushing, 1994: 24).

What does it mean to 'understand' QM, or for that matter, any scientific theory? Knowing how to apply its formalism is one thing, but understanding implies being able to somehow integrate the theory into broader formats and structures of intelligibility. This will be true even for those

completely innocent of hermeneutic theory. Leading physicists associated with the debate over QM – Heisenberg, Bohr, and more recently, David Bohm (1983) – wrote and spoke philosophically about how QM should be understood. Some critics say their bolder speculations about metaphysics are irrelevant to the physics (though I would agree with Krips that this dismissal is sometimes a device for ignoring philosophical implications). Yet such background beliefs are surely not irrelevant to motivations.

What I am calling structures of intelligibility display Peircean thirdness, or stabilizing interpretive habits within an epistemological trajectory. This may include a number of things that are not normally thought of as being specifically ideological.[8] There is evidence to suggest that broad intellectual commitments, including philosophies, influenced both the formulation and the reception of QM. In fact Bohr was apparently regarded by many within the physics community, including Heisenberg, as being a philosopher, not because he had systematically studied philosophy, but because his theorizing seemed to many to be a metaphysics. In his 1958 book, *Physics and Philosophy*, Heisenberg clearly aligns QM with a form of idealism and the rejection of 'the ontology of materialism' (1958, 128–30). Jungian psychology even appears to have played a role with some key advocates of QM, such as Wolfgang Pauli (Cushing, 1994: 151), on grounds that the psyche of the observer needs to be incorporated into observation reports. By contrast, both de Broglie and Bohm, who pursued a causally determinative understanding of QM, were politically left materialists. It would be simplistic to suppose that such doctrines produced the respective scientific positions, or vice-versa; but it would not be implausible to suggest there is a connection. The question of concern here is what might come into play in mediating such a connection.

The challenge to received thinking posed by QM, it would seem, goes beyond the ideology of modernization, as it posed challenges to basic intuitions that are not specific to the modernist period. Physicists prior to the QM developments had typically worked to reconcile theories with visual intuitions, for instance.[9] The increasing difficulty of reconciling visual intuitions to the data pressed Heisenberg and Schrödinger to question visual intuitions as a sound basis for theory, although both held strongly to *intuition* as a proper criterion for judging theory (Miller, 1989). In 1927, Heisenberg proposed a new notion of intuition that did not depend on visualization, and which could accommodate measurable characteristics of unvisualizable particles. And after that Heisenberg reconceived a new basis for imagery, based on the syntax rather than the semantics of the theory. Moreover, the syntax would thereafter render QM mathematically rather than imagistically. The perceptually based language of the ordinary world had apparently become inapplicable to the world of QM. Miller presents this episode as a struggle against the tradition of aligning physics with visual representation that dates from Newton's *Principia*, in 1687. But the break with visual imagery is also a break with something much more primordial than merely a few centuries old. The rootedness of language in the scale and perception of the experienced world is something

far more general than the particular explanatory structures of the Enlightenment.[10] This points to some of the problems that would be involved in constructing intelligible narrratives about QM, as well as some of the ways the sense of consistency might be violated.

The postmodern and the rhetorical

If postmodernism consists mainly in thematizing the conditions of representation and in crediting the contribution of localization to the real, then the Copenhagen version of QM might reasonably qualify as postmodern science.[11] As an interpretive procedure, it moves to the theme of representation to better capture realities, not to discredit them. This is not quite the same as the postmodernism of literary criticism, which (at least to the eye of the realist) has different mandates from physics. If literary understanding strategically values and proliferates multiple interpretations, this is not a part of the official enterprise in physics. But multivalence can help usher the reception of science into other cultural formations (Bohr's extrapolation of complementarity (see p. 124) is a good example). Provided we do not assume that postmodern motifs must transfer unaltered from one discursive domain to another (say, from lit crit to physics), it seems a productive rubric for the investigation of science as a set of wrangling representational practices within society – that is to say, as rhetoric.

Striving to give a rhetorical account gives us additional mandates, however, including an account of rhetorical mediation. This will be enriched by explorations of how rhetoric might, in a given ideological condition, mediate in different, even opposite, ways. Depending on how much faith one has in rhetoric's capacity to do just that, one will look with more or less skepticism at the suggestion that ideology itself can force the acceptance or rejection of a scientific theory. If the stock and trade of rhetoric is to be able to array the 'givens' in strategically advantageous ways in particular instances – even to the point of reconfiguring or upsetting altogether what is seen as given – then we might well look for a more lively and significant role for rhetorical mediation between scientific and social discourses.

Interestingly, from this viewpoint, Pais has stressed Niels Bohr's life-long concern with the issue of communication, and the sense in which he saw theoretical physics as centrally a problem of accurately *communicating* theoretical findings, not a penetration to their essence. Bohr's philosophical work, which is largely independent of the philosophical tradition (East or West), according to Pais, does not show a great deal of interest in ontology. Rather, 'In his opinion communicability was the be all and end all in our quest for knowledge' (1991: 446). Unsurprisingly, physicists have attempted to apply QM while taking on the least amount of metaphysical baggage. Those whose focus is the social arena will have additional concerns. Bohr evidently saw his principle of 'complementarity' not only as a great epistemological lesson, but as a key to clarifying the meaning of terms in various domains.

It might strike the student of rhetoric that his elucidations resemble some of the thinking in contemporary rhetorical theory influenced by Kenneth Burke. In one of his late, non-physics essays, Bohr offered this as a social application of the generalized principle of complementarity: 'Though the closest possible combination of justice and love presents a common goal in all cultures, it must be recognized that in any situation which calls for the strict application of justice there is no room for display of love, and that, conversely, the ultimate exigencies of a feeling of love may conflict with all ideas of justice' (Pais, 1991: 447). Here Bohr is reminiscent of Burke's discussion of the set of general value terms affirmed in the Preamble to the US Constitution – the set of 'generalized wishes' expressed as union, justice, domestic tranquility, the general welfare, and liberty (Burke, 1969). The point for Burke is that pressing on one of these terms single-mindedly leads to the exclusion of the others. The maximum case of liberty, for instance, would be unfettered personal freedom, hence anarchy. But this is incompatible with justice. The *nth* degree of domestic tranquility might also be won only at the expense of liberty, etc. I do not want to press the rhetorician's 'occupational psychosis' too far and suggest that Bohr was grasping a general principle of rhetoric – but when he moves to discussion of topics such as these, he seems to make the case himself.

Locating the real

A running subtext in Krips's analysis is the place of the real in constituting subjects and their relationship to science. The position is essentially Lacanian, in that it places the real outside the realm of symbolic articulation while yet being inscribed in language. It is, as he quotes Lacan to say, 'the impossible ... the ineliminable residue of all articulation ... that over which the symbolic stumbles.' The subject is split between that which is in consciousness and that which is not, and an economy of desire ensues from this estrangement. In the case of the Western European physics community, the argument goes, this economy yielded a slippery system of exchanges, in contrast to an honest cathexis within the Soviet context.

This approach must be commended for recognizing that which eludes articulation as a force *upon* articulation. As one looks to the discourses of science this becomes in some ways an even more interesting dynamic than it is in respect to other discourses of culture. For if we read science as that discourse which posits itself as split between the known and the unknown (or, perhaps, made necessary by the unknown and made possible by the known), then there ought to be edifying tales to be told about a kind of questing subjectivity, struggling to make its way to the grounds of its own being.

If the Lacanian 'Real' is that against which symbolization stumbles, always storing a surplus not captured by signs (Copjec, 1995), it must set conditions on the discourses of science, conditions not themselves given by the science. Such a conception of the real cannot be reduced to the specific effect of discursive relations but must in some sense remain outside of and

unassimilated by any system of representation. So far so good. But then we need to consider that in the discourses of science, the real is seen as being brought into the system of articulation – something like a Dutch land reclamation project that secures one small patch after another against the looming sea. The real is colonized, so to speak. This does not mean that the mix of conscious and unconscious motivations posited by the psycho-analytic model are any less at play, but it does suggest that the 'reality effect' in scientific discourse is produced not just by the subjective experience but also by the relative success of scientific techniques in stabilizing interpretation, that is, establishing aspects of reality.

One question not clearly resolved in Krips's account is what relationship obtains between the psychological and ideological on the one hand, and the epistemological on the other. One gets the clear sense that he does not wish to reduce questions of scientific knowledge to either of those other categories. This seems especially evident in the arguments about instru-mentalism and limited skepticism ('displacing questions of overall truth'), for instance. We might well inquire, therefore, into the notion of the real that is to be associated specifically with the scientific project, but which is in some way being bracketed in the discussion of psychoanalytic notions such as trauma, transference and disavowal.

Since I have already involved Peircean 'thirdness', I will take this open-ing to speak for the semiotic realism of Peirce as having something to say at this point. It too predicates a divided subject, undergirding a dialogical production of representation. This process works within a triangulated relationship to the real, according to which the subject is related to other subjects as it is related to the real (Colapietro, 1989). That is to say, repre-sentation is always representation to other(s) in respect to something which is not simply a relationship-in-perception. Semiosis is dynamic and transformative, not a system of fixities, but a play upon relative and moving stabilities. True acts of representation, moreover, originate as acts of imagination, ranging from bold inferential leaps at the high end, down to the mundane level of assimilating words to experiences and vice-versa.

The Peircean threesomes afford a critique of the psychoanalytic sense of the real. What is ulterior to representation – that which is recalcitrant and against which signification stumbles – is, in Peircean terms, secondness. This sets both limits and potentialities for representation, because it is always intruding to frustrate or reveal. It can in some ways be indicated in language and other forms of representation, specifically by the semiotic operation of indexing, but it is not exhaustively articulable in language. What this position holds about reality, however, is that bumping up against the recalcitrant is not yet to encounter the real. That encounter comes only with stable habits of interpretation, or thirdness. The Peircean categories are threefold. Imagination occupies the category of firstness; that which is experienced as other and irreducible to signification is secondness; and that which comes to us as real is thirdness. Inquiry is a movement toward the real as well as toward social and personal articu-lation.

What one notices throughout the Peircean account is the relationship between the signifying gesture, as action, and the openness of what any such gesture may come to mean in time. This implies, among other things, that attention needs to be directed to the dual aspect of signification as both event and text; likewise as something both determinate (insofar as it constitutes a finite action) and indeterminate (insofar as it opens a range of interpretations). The duality produces a third moment, however, which yields an epistemic trajectory.

Now what might such a model imply about the way scientific claims are socially mediated? Among other things, it would imply that contradiction and consistency are neither simply 'out-there' relations to be faced or disavowed, nor on the other hand, something reducible to psychology. Consistency relations are themselves realized within rhetorical formations, in interpretive communities. The Peircean rhetoric of inquiry, which resists the modernist *cogito* as much as it resists foundationalism, would place imagination and the positioned subject within the overall 'pragmaticist' account. It conceives knowledge within the process of provisional inquiry, as stabilized and de-stabilized but never fulfilled, save in a 'final opinion' of the interpreting community (Apel, 1981). Like all representation, scientific knowing is a matter of both action and text, signifying gesture and promissory note.

Rhetoric of science

The rhetoric of science is now on an irreversible course of examining one set of scientific discourses after another, testing and expanding the rhetorical paradigm as well as the received view of science. The reasons that this is bound to continue include a growing understanding that: (1) the practice and dissemination of science intertwines different expert and non-expert audiences; (2) the influence of scientific theories cannot be adequately understood without reference to the strategic choices embedded in and surrounding those theories; (3) there is cultural encoding in the very language of science of ideological, philosophical, and cultural values; and (4) conversely to the third point, the general culture incorporates scientific and quasi-scientific language, authority, and modes of explanation into its talk about matters of common interest, including human behavior, psychology, gender relations, the environment, and the nature of the cosmos, to name a few. Thus science is a *resource for the invention and performance of rhetoric* in a variety of social contexts.

For rhetoricians, the civic forum has always been first priority, and one can appreciate why some would be concerned that movement into the discourse of science might be a marginal luxury at best, or an abandonment of what is distinctive about rhetoric at worst. To this concern one must reply that the discourse of science is now so much a part of civic discourse that the study of it can no longer be seen as marginal to rhetorical studies. The testimony of scientific experts and the construction of scientific arguments is a part of our daily diet of news and popular

controversy. The way we are to understand, use, and critique scientific discourse, in all its forms, must now be a central concern for rhetorical analysis. Contemporary arguments on the value of a space program, the causes of violence, the impact of social programs, the reliability of DNA tests, and differences between men and women and between races, are rhetorically constructed around scientific motifs. So long as 'science' remains rhetorically unanalyzed, its function in the overall process of persuasion will be misunderstood.

The work of rhetorical analysis might be more adventurous if we are unencumbered by the notion that there must be a single, unified theory of rhetoric, or that it is unseemly to take and use portions of many different theories. There is, for example, no inherent problem in thinking of rhetoric as involving 'the available means of persuasion', as per the Aristotelian formulation, while expanding its purview beyond where Aristotle or even the Isocrateans left it – in a Burkean direction, for instance, in inventing and critically assessing symbolic action. Also, given the way our under-standing of science has changed since the days of ancient Greece, it would be useless to insist on Aristotle's lines of demarcation between science as a domain of 'certainty' and rhetoric as a domain of contingency. Probability is now the order of all orders. Stepping into the world of twentieth-century physics, with orthodox QM, one might even say that nature itself is frought with contingency. Or one might take Peirce's powerful lesson concerning 'fallibilism' in all things. In either case, there is no consistent basis for precluding rhetoric from any territory.

Attempts to contain the rhetoric of science have stalled, or soon will, because they employ irrelevant assumptions about either rhetoric or science. These attempts misunderstand science if they treat it as something apart from persuasive discourse (even though the means of persuasion may include such factors as math, experimental procedures, and special theo-retical mandates). And they misunderstand rhetoric if they hold it to task as a consistent, self-contained world-view. Nor should we insist dogmatic-ally that rhetoric must be understood exclusively as either aesthetic (because Nietzsche did) or epistemic (because others did). Rhetoric is opportunistic in precisely the sense that it uses *all* the available means of persuasion. There is no way to map out in advance what those may be.

The study of rhetoric has always had, at least implicitly, a fundamental two-sidedness, speaking to the production and creations of discourse, on the one hand, and to the critical understanding of discourse, on the other. It does not reduce to culture, ideology, or psychology. Rhetorical perform-ances are shaped by such formations, but they are never determined by them, since within any ideological formation there is room and technique for argument and counter-argument, configuration and reconfiguration. Within any tradition, scientific or otherwise, there is a plurality of possi-bilities for interpretation. And within any situation, there are always multiple ways of configuring what is there, what is to be valued, what is to be done. A rhetorical performance must have a finite point of entry into the social construction, however. For any given user of language, only a

certain portion of the relevant social construction will be within the scope of possibility. Thus, to say that any formation is socially constructed is not yet to say anything about the rhetorical dynamics by which such construction has proceeded or can proceed.

QM is a productive site of rhetorical analysis because it confronts established assumptions in such unsettling ways and because it plays out differently before different audiences. Its meaning and uses are still being constructed and deployed in surprising directions. There is a burgeoning literature at present, for instance, that purports to connect QM with mysticism, New Age precepts, and other currents within the general culture. And philosophers are still trying to see what conclusions it permits about ontology, causality, and representation. The possibilities of rhetorical argument stretch far and wide.

Notes

1 The drive toward consistency in the American context has generally been tempered by a political philosophy that thematizes limitations on power, dynamics of the local, and the limits of rationality – the latter reflected in the strong tradition of American anti-intellectualism and populism. Habermas's overview of Enlightenment thinking makes scant reference to the particular ideological context of that thinking in American political culture. But the political and popular myths of the United States have arguably been dialectical engagements of the very Enlightenment thinking they presuppose.

2 As the need for better crop yields was the practical imperative that overshadowed biology in this period, the desire for atomic weapons overshadowed physics. In fact, the political leaders in all three ideological formations at war on the European front were able to accommodate whatever physics served this end. David Holloway's recent (1994) study shows how easily Stalin's attempt to develop the A-bomb overrode ideological niceties, including concerns about whether both QM and relativity theory were idealist. The Nazis also officially rejected the Copenhagen theory, but Hitler placed Heisenberg himself in charge of his program to develop an atomic weapon. The Americans evidently had no ideological adjustment to make, except perhaps in respect to the massive effort at secrecy.

3 It is worth observing that the notion of indeterminacy in nature had already taken root, prior to Weimar Germany, among some French intellectuals in the late nineteenth century (e.g., Renouvier, Boutroux, who were both influences on Poincaré) as well as in the work of Peirce in America. But the heralding of such a metaphysical position does not have to await causative developments in the life-world. Epicurus, for instance, had held this position against the determinists in ancient Greece.

4 Einstein's status reflects something about modernism that the story of mechanization and universalization leave out, specifically, the place of discovery and revelation, of 'unlocking nature's secrets'. Einstein represented the knowability of the universe, one tenet of the Enlightenment faith, but also of the power of the mind to break successfully with tradition, another tenet of that same faith. Within popular culture Einstein became an eponym for braininess, used in that way on *I Love Lucy*, for audiences who had never heard of Niels Bohr or Werner Heisenberg.

5 By using what is essentially Aristotle's definition, I am not necessarily buying into his entire theory of rhetoric. Gaonkar (1993) has highlighted some of the difficulties involved when an Aristotelian perspective on rhetoric is applied to the discourses of science. These criticisms do not, in my opinion, foreclose the Aristotelian option, although I am not attempting in this essay to vindicate that particular theoretical framework.

6 The practice of linking theoretical physics to a search for the Divine is quite alive in the 1990s. Consider celebrity scientist Stephen Hawking's widely quoted hope to be able to read the mind of God, in addition to similar claims made by physicists supporting the construction of the Texas Super-collider. This motivation is well in the tradition of Newton, and most important physicists who came before him.

7 Scientists play varying roles in influencing intra-, inter-, and extra-disciplinary audiences, which have a complex and dynamic relationship to one another. See Lyne and Howe, 1990.

8 I recognize that Krips may be using a notion of ideology that would also net many of these structures. To the extent that 'modernism' is characterized as an ideology, I would argue that its very specificity as an ideology, to the degree that it can be specified, omits certain structures of intelligibility that nevertheless matter in the present context. Reliance of metaphors that pre-date modernity, for instance, would fall in that category.

9 Miller (1989) tells the story of how Bohr labored to reconcile the ongoing discoveries about atomic quanta to basic visual metaphors and related analogical modes. His 'correspondence principle' aimed to provide a rationale for moving between the macroscopic and microscopic world. As atomic physics evolved, this principle permitted adjustment to preserve analogues to the visual, macroscopic world. Originally, the atom was conceived as analogous to the solar system. But this ran into escalating difficulties. Bohr would not accept Einstein's wave-particle duality theory, because it was counter-intuitive, that is, there was no mechanical or visual model that would correspond to it (331). If light acted as a wave, it could readily be analogized to waves of water. How could it possibly be discontinuous at the same time?

10 See Martin Jay's (1993) massive examination of the place of vision as a feature of Western thought previous to modernity. Jay takes this up in light of the critique of ocularcentric discourse in contemporary French thought.

11 There is a terminological irony here, in so far as the Copenhagen interpretation involves an apparent violation of what is called a 'locality' condition of classical explanation; but this technical notion should not be confused with the notion of localization, used here in contrast to global explanation.

References

Apel, Karl-Otto (1981) *Charles S. Peirce: From Pragmatism to Pragmaticism*, Amherst, MA: University of Massachusetts Press (originally published in German, 1967).

Billig, Michael (1987) *Arguing and Thinking: A Rhetorical Approach to Social Psychology*, New York: Cambridge University Press.

Bohm, David (1983) *Wholeness and the Implicate Order*, New York: Ark Paperbacks (originally published 1980).

Burke, Kenneth (1969) *A Grammar of Motives*, Berkeley: University of California Press (originally published 1945).

Colapietro, Vincent (1989) *Peirce's Approach to the Self: A Semiotic Perspective on Human Subjectivity*, Albany, NY: SUNY Press.

Copjec, Joan (1995) *Read My Desire: Lacan Against the Historicists*, Cambridge, MA: MIT University Press.

Cushing, James. (1994) *Quantum Mechanics: Historical Contingency and the Copenhagen Hegemony*, Chicago: University of Chicago Press.

Forman, P. (1971) 'Weimar culture, causality, and quantum theory, 1918–1927: adaptation by German physicists and mathematicians to a hostile intellectual environment', *Historical Studies in the Physical Sciences*, 3: 1–115.

Gaonkar, Dilip (1993) 'The idea of rhetoric in the rhetoric of science', *The Southern Communication Journal*, 58: 258–95.

Heisenberg, Werner (1958) *Physics and Philosophy*, New York: Harper & Row.

Herrnstein, Richard and Murray, Charles (1994) *The Bell Curve: Intelligence and Class Structure in American Life*, New York: The Free Press.

Holloway, David (1994) *Stalin and the Bomb*, New Haven: Yale University Press.

Jay, Martin (1993) *Downcast Eyes: The Denigration of Vision in Twentieth-Century French Thought*, Berkeley: University of California Press.

Joravsky, David (1970) *The Lysenko Affair*, Chicago: University of Chicago Press.

Lyne, John (1987) 'Learning the lessons of Lysenko: biology, politics, and rhetoric in historical controversy', in Joseph W. Wenzel (ed.), *Argument and Critical Practices: Proceedings of the 1987 Summer Conference on Argument*: 507–12, Annandale,Va: Speech Communication Association.

Lyne, John and Howe, Henry (1990) 'The rhetoric of expertise: E. O. Wilson and sociobiology', *Quarterly Journal of Speech*, 76: 134–51.

Miller, Arthur (1989) 'Imagery, metaphor, and physical reality', in B. Gholson *et al.* (eds), *Psychology of Science: Contributions to Metascience*, Cambridge: Cambridge University Press: 326–41.

Pais, Abraham (1991) *Niels Bohr's Times, in Physics, Philosophy, and Polity*, New York: Oxford University Press.

Sluga, Hans (1993) *Heidegger's Crisis: Philosophy and Politics in Nazi Germany*, Cambridge, Mass: Harvard University Press.

West, Cornel (1989) *The American Evasion of Philosophy: A Genealogy of Pragmatism*, Madison, WI: University of Wisconsin Press.

TONY BENNETT

OUT IN THE OPEN: REFLECTIONS ON THE HISTORY AND PRACTICE OF CULTURAL STUDIES

ABSTRACT

This essay addresses the institutional conditions of cultural studies, especially those bearing on cultural studies teaching. It does so by reviewing the history of the Open University Popular Culture course from an insider's perspective. Whereas most published accounts of this course have related it closely to the concerns of the Birmingham Centre for Contemporary Cultural Studies, this essay suggests that the two projects – while overlapping in certain respects – are more usefully thought of as distinct. Having disentangled the history of the Open University course from that of the Birmingham Centre, the author goes on to advance a more general argument concerning the politics and practice of cultural studies pedagogy. The essay's main contention in this regard is that a conception of cultural studies teaching which connects it to the cultivation of resistive practices in the classroom is incoherent. It is suggested that this now influential current of thought is best assessed as a negative outcome of the encounter between the projects of cultural studies and US liberationist philosophy.

KEYWORDS

culture; pedagogy; popular; open learning; multiculturalism; access

In his recent essay '"A moment of profound danger": British cultural studies away from the Centre', Richard Miller assesses both the virtues and the shortcomings of the Open University *Popular Culture* course (Miller, 1994). He does so, however, with a broader purpose in view: to contribute to a history of cultural studies that will pay closer attention to the institutional conditions which regulate its practices and which, in so doing, may also sometimes constrain and limit its possibilities. His attention thus focuses on the respects in which a careful examination of the *Popular Culture* course – or, as it is now widely known, U203 – can direct our attention to 'the tensions between the theoretical positions that have been staked out by cultural studies and the pedagogical practices it has called on in specific institutional settings to bring others into its field of study' (Miller, 1994: 419).

As the person who convened the production of U203, I do not want to take specific issue with any of the particular failings Miller attributes to the course. It is worth saying, though, that his criticisms are advanced in a productive and helpful spirit precisely because of his concern to relate the pedagogical theory and practice of the course to the institutional conditions of its production. This means that Miller pays close attention to the history and organizational structure of the Open University and this, in turn, allows him to assess what he sees as the course's principal short-comings as being, at least in part, attributable to the fact that the course team was obliged to fashion 'pedagogical solutions out of materials that were not of the team's own making' (Miller, 1994: 434). This does not prevent him – and rightly so – from suggesting that other decisions might have been made which would have led to better teaching outcomes. None the less, his overall purpose is to understand the course as the outcome of – to coin a phrase – particular 'relations of pedagogical production' rather than to attribute its failings to the shortcomings of individuals.

Inevitably, while I agree with some of Miller's criticisms, I think others miss their mark. But then the same is true of the various reviews of, and commentaries on, the course that have been published in what is now an extensive literature of public debate regarding its contributions – warts and all – to cultural studies. It has, naturally enough, been pleasing that the course has been taken so seriously and, at least until now, it has seemed to me that the proper response to this debate has been simply to let it happen rather than be tempted to 'set the record straight' or to defend the course against its critics. This has seemed especially appropriate given that the team which produced the course has not met since 1982 and so has not been in a position to formulate a collective response to the debates its work has occasioned. Certainly, I have not been in a position, and have had no wish, to respond proprietorially on behalf of the course. It is simply not that kind of thing: too many people played major roles in developing and teaching it for an individualized response of that kind to be appropriate.

If, on this occasion, I am inclined to put cursor to screen in reply this is because of the more general issues Miller's discussion raises. It is not, then, what Miller says about *Popular Culture* that I want to dispute. Rather, my concern is to take issue with the more general theoretical and political perspectives which inform his history and criticisms of the course. Toward the end of his article, Miller advises that he sees his discussion of U203 as being consistent with a suggestion I had made, in a recent article, that any adequate understanding of the history of cultural studies will depend on a move away from purely theoreticist accounts of its moves (or stumblings?) from one theoretical position to another and toward an appreciation of its institutional underpinnings in educational contexts and relations (Bennett, 1992). But that then raises questions about how such institutional conditions and relations are appropriately taken account of and incorpo-rated into a history of cultural studies. It is, then, with matters of this kind that I shall concern myself for I think that Miller's approach to such ques-tions – and his related views regarding what should be the proper aims and

methods of cultural studies teaching – are, although conventional enough, beset with difficulties. My purpose is therefore to use Miller's assessment of 'what went wrong' in trying to implement a cultural studies project at the Open University to get 'out in the open' a set of stances and orientations which, I suspect, are widely shared, but which I think stand in the way of developing an adequate approach to both the history of cultural studies and the further development of its present practices.

I shall organize my discussion around three issues. The first concerns the role Miller accords the Birmingham Centre for Contemporary Cultural Studies (CCCS) in his account of the *Popular Culture* course. His overall assessment of the course is that it should be regarded as 'a potentially instructive lost opportunity' (Miller: 1994: 432). This is based on his view that it failed in its attempt to put into effect the suspension of the normal pedagogical relations between teachers and students which, he argues, had characterized the formative period of cultural studies at CCCS. This 'failed attempt', moreover, was one undertaken by a 'Birmingham subject'. According to Miller, U203 was part of a move of cultural studies out from 'the Centre'. This involves seeing it as being planned by (in a formulation which recurs at a number of places in his discussion) 'Tony Bennett, Stuart Hall, David Morley, Paul Willis, Janet Woollacott, and a host of others either directly affiliated with CCCS or associated with its general project' (420). I shall make two points in relation to this account. First, I shall argue that U203 did not 'fail' to emulate the CCCS in suspending the normal relations between teacher and taught simply because it never sought to do so. I also suggest that there are good reasons why such an enterprise would have been unintelligible. Second, I shall show that 'the Birmingham subject' to whom Miller attributes responsiblity for this failed experiment never existed. Of those he lists above, only two (Bennett and Woollacott, neither of whom was or had been connected to Birmingham) played a major ongoing role in the planning and design of the course, and two (Morley and Willis) played no role of this kind whatsoever. More important, the list fails to mention many who *did* play absolutely crucial roles in the course's planning and development. Both these shortcomings, I shall suggest, reflect a distinctively American construction of Birmingham and one which we now need to be free of if there is to be any prospect of a history of cultural studies that is not constantly deflected from its proper ends by phantasms of its own making.

The second set of issues I want to comment on concern the perspective from which Miller broaches the task of writing a history of cultural studies that will take account of the institutional circumstances and conditions of its existence. As his title suggests, he takes his bearings here from Stuart Hall's contention that the institutionalization of cultural studies constitutes a 'moment of profound danger' (Hall, 1992: 285). The difficulty with this account – and it is one I have commented on elsewhere – is that it attributes to cultural studies an initial set of conditions which are viewed as a-institutional, anti-institutional or (more usually) institutionally marginal and then tells its subsequent history as one in which, whether it succumbs

to it or not, it is forever faced by the prospect that the radical potential inherent in its originating conditions will be curtailed (see Bennett, 1993). Miller, alert to the difficulties which such a perspective can occasion, is careful not to idealize Birmingham as some pure moment of origin for cultural studies which then results in its subsequent institutionalization having to be told as a story of inevitable decline and co-option. His focus is more particularizing and differentiating than that in its concern with the different shapes which the pedagogical projects of cultural studies assume when implemented in different institutional contexts. However, what he fails to do is to think beyond the conditions specific to particular institutions to ask what might be the broader factors responsible for the rapid institutional take-up and development of cultural studies. He also fails to consider how these developments might be accounted for by processes which are operating at a more structural level than the intentions, schemes and desires of cultural studies teachers and theorists.

To raise issues of this kind, I shall suggest, entails seeing cultural studies as having been a wholly institutionalized set of practices from the very outset to the degree that the activities of the CCCS and other related developments had their underlying conditions in the changing dynamics of tertiary education over the post-war period. Unless we begin to pitch our histories of cultural studies at this level and so begin also to trace the high degree of 'fit' or congruence between its trajectories and those which have driven the expansion of higher education, there is little prospect that we shall prove able to account for the past of cultural studies in ways that will prove of much service in understanding the educational contexts in which, for better or worse, most of its future work will be located.

This, then, is to question the 'myth of the margins' through which cultural studies has typically accounted for its own development. It is a myth, however, which well merits a dry-eyed farewell in view of the respects in which it incapacitates us from thinking about what the purposes of cultural studies teaching can and should be in the concretely available institutional contexts in which it now takes place. This leads me to the final point on which I wish to take issue with Miller: the norm of what an ideal cultural studies pedagogy might look like which informs his criticisms of U203. For Miller, a pedagogic 'turn to cultural studies' must be committed to nurturing student resistance. It is, he suggests, in those moments 'when students resist, refuse, mock, transform, reinvent and question the various ways the educational mission of cultural studies is being realized in their classrooms, that it becomes clear that the work left to be done involves inventing a pedagogical practice that acknowledges and responds to student resistance' (Miller, 1994: 433). I shall suggest that, to the contrary, we have every reason for 'resisting resistance' as an intelligible generalized goal for cultural studies pedagogy. For it is when it seems to be most transgressive and radical by flaunting its resistive credentials as a theory of pedagogy that cultural studies reveals itself to be in the grip of the most conservative and normalizing of pedagogic machineries.

It will be instructive to look, first, at the procedures through which Miller produces the 'Birmingham subject' and, in the process, a composite authorial 'voice' for U203. Recognizing, in a footnote, that the course materials were written and produced by many people – he cites 26 'authors' by name and notes the role of editors and BBC producers – he acknowledges that the majority of these were not affiliated with the CCCS. The potential significance of this, however, is immediately discounted by stating that 'Bennett as course team leader had substantial control over the general direction of the course's arguments' (1994: 434). Readers familiar with Foucault's 'What is an author?' (Foucault, 1979) will recognize this manoeuvre as one of those through which an author-effect is produced. In this case, it quells the cacophony of divergent voices in the course materials in subjecting them to a unifying and controlling point or origin. Having produced an authorial subject for the course, Miller then feels free to latch this position onto other authorial positions so as to produce a Birmingham voice for U203 in the form of a Hall/Bennett authorial couplet.

A good deal of his argument here rests on the (in)famous passage from Stuart Hall's 'Notes on deconstructing the popular' in which Hall states that the only reason popular culture matters is because it is one of the places where socialism might be constituted and that, otherwise, he 'didn't give a damn about it' (Hall, 1981: 239). Only an incautious reading would be content to take Hall at his word here. The remark – and I have a vivid recollection of the occasion – was clearly a throwaway line made in the context of the cut-and-thrust of debate during a plenary session of a History Workshop conference. It is, I think, a shame that Hall let the remark stand in the printed version of his paper as it so evidently runs counter to the deep intellectual and multi-dimensional political interest he has always shown in popular culture. For Miller, however, Hall's word is good enough – good enough, in fact, to become mine too as the view that popular culture is only of interest from the point of view of constituting a socialist politics is then attributed to me as my view also, although one I am chastised for having failed to express openly! This then allows this view, through a process of authorial contagion, to be presented as that of the course even though no statement of this kind appears in it or has ever been made on its behalf.

It is ironic that procedures of this kind are to be found in an article placed immediately after Paul Jones's 'The myth of "Raymond Hoggart": on "founding fathers" and cultural policy'. This begins with a quote from Williams to the effect that, at the time when he and Hoggart were viewed as inseparable, they had not yet met. The parallel is an inexact one. For I *had* met Stuart Hall before U203 was planned, and his published writings played a major role in helping fashion the course's architecture and design. Hall was also generous with his time in offering myself and the course-team advice regarding the course before he joined the Open University in 1979, and in continuing to do so thereafter. But this is quite a different

matter from suggesting that Bennett, Hall, Morley, Willis, Woollacott and a host of others connected to the CCCS 'set about designing U203' (Miller, 1994: 420). Nothing could be further from the truth. This is a group that never met, never planned or designed any aspect of the course, or made any decision about it in any way, at any time, in any set of circumstances or conditions. The construction of the entity that *did* do these things was the result of a quite different history and set of relations that had nothing to do with an attempt to translate cultural studies 'from Birmingham to Milton Keynes' but were rather rooted in a highly specific aspect of the organization of the Open University's curriculum.

On this matter at least, it is perhaps appropriate that I 'set the record straight'. Perhaps the most important aspect of the institutional context in which U203 emerged – although Miller shows little appreciation of this – is that it was planned as a part of the University's new U-Area. The brain-child of Arnold Kettle, who nourished its development with great care and devotion, this was a small clutch of courses specifically earmarked for broad interdisciplinary functions. U-courses had to draw on the expertise of as many as possible of the University's six Faculties – Arts, Education, Social Sciences, Science, Technology and Mathematics – and be accessible to students who had done their Foundation studies in any one of these faculties. The suggestion that a course in popular culture might be produced for this area was first made by Ken Thompson, Reader in Sociology, and the initial group that steered the proposal through the University comprised Thompson, Janet Woollacott and myself from the Social Science Faculty and Graham Martin, Professor of Literary Studies in the Arts Faculty. The key institutional consideration guiding this stage of the process was to ensure enough inter-faculty input to the course to satisfy the stringent interdisciplinary requirements of the U-Area. This was the key factor governing the constitution of the body that *really* produced the course and made the effective decisions in relation to all the stages of its planning and production: the course-team. The key policy-making figures here were those who held convening responsibilities for specific sections of the course: myself as course chairperson with also specific responsibilities for particular sections of the course, Graham Martin as the deputy chairperson for the course and convenor of one of its blocks, Janet Woollacott as the convenor of the course-team's broadcast subcommittee, the convenors of specialist blocks and summer-school modules – Bernard Waites and Richard Middleton from Arts, James Donald from Education, Grahame Thompson and John Muncie from Social Science, David Elliott from Technology – the BBC producers Susan Boyd Bowman and Vic Lockwood, and Colin Mercer as the course researcher.

These, then, were among the core group of people who met regularly – some from as early as 1977, others joining later – through to 1982 to plan and realize the project of U203. Stuart Hall contributed as much time as he could spare to help this group when he joined the Open University but, as the incoming Professor of Sociology, he had other responsibilities to which he had to accord priority and, in the end, contributed only one unit

to the course – although, as I have indicated, the course made extensive use of his published work and his intellectual presence was manifest in many parts of the course. At no point, however, did Hall and I, or any other members of the course-team or core planning group, discuss or see ourselves as trying to transplant the Birmingham experiment of 'disrupting' normal pedagogical relations to the Open University context. Nor were any planning discussions of this or any other kind held with David Morley or Paul Willis. Their role – and they have never claimed otherwise – was that of consultants engaged to write teaching material to a brief specified by the course-team and, as such, was no different from that of other consultants engaged from other centres representing related fields of work: David Cardiff and Paddy Scannell from the Polytechnic of Central London, for example.

None of this is said to diminish the significance of the input that the Birmingham Centre *did* make to the course. My point is simply that it was an input of a different kind than Miller envisages. Equally important, it was an input *on a par* with the inputs which the course-team – in its concern to produce a balanced course – sought to organize from other centres of cultural studies, not to mention institutions representing other traditions of thought with a stake in the analysis of popular culture. Of primary importance, here, was the work of *Screen*, SEFT and the BFI which substantially influenced the policies governing the television components of the course and supplied most of the material for one of its set-books: *Popular Film and Television* (Bennett *et al.*, 1981). Indeed, this was an area in which we quite specifically sought, and in good measure relied on, the guidance of the education section in the BFI in view of its experience in designing teaching materials for use in adult education contexts.

Birmingham, then, was an important centre of intellectual gravity for the course, but so was the BFI and its various satellites. We drew on the work of both, were generously helped by both, invited representatives of both to present seminars to the course-team, formally sought the advice of both, and were, at the end of the day, very grateful to both, as we were to the many individuals and centres who lent the course their assistance.[1] But none of this was done by anyone particularly connected to Birmingham. To speak for myself, I had never studied or taught there. Indeed, I had never even *been* there and – although I had met Stuart Hall in connection with an earlier Open University course – had not met any other members of the CCCS until I visited it toward the end of 1978, when U203 was already fairly well planned, to outline where our thinking had got to and to seek advice and comment. One of the things I learned then – for although I knew the work that had come out of the Birmingham Centre, I did not know much about its organization, my own involvements having been closer with SEFT – was that the Centre had no undergraduate programmes.

As we shall see, this is not a negligible consideration so far as Miller's overall thesis is concerned. My concern so far, however, has been to convey

some sense of the institutional conditions which most immediately informed our activities as well as to suggest how the field of cultural studies looked, at that time, from Milton Keynes. And my point is that it looked a good deal more dispersed and 'de-Centred' than Miller's account allows. The CCCS was an important point of reference for us, but not a privileged one. Its contribution, in my recollection, consisted mainly in the role that was accorded the Birmingham, and especially Stuart Hall's, reading of Gramsci's concept of hegemony and the associated distinction between culturalism and structuralism as key organizing principles governing the architecture of the course. It was, indeed, this mix of concepts which made it possible for us to fashion a 'teaching object' out of popular culture (see Bennett *et al.*, 1981): that is, to produce a coherence for a field of study which constantly threatened to fracture along multiple theoretical and political fault-lines, and to do so in ways which avoided the 'twin perils' of mass culture critique and populist celebration. However, as Miller suggests, the resulting view of popular culture as an area of negotiation between dominant and subordinate cultures was a fairly conspicuous device which allowed us to organize a debate between different parts of the course which, when looked at closely, were often doing quite different things in accordance with quite different theoretical protocols. This was, in other words, a decision made, in an open-eyed way, for a particular set of teaching purposes rather than a matter of a collective commitment to a shared intellectual position. Indeed, if anything, had the balance of influential opinion within the course-team been pushed in regard to its intellectual preferences, I think it might well have travelled south rather than north of Milton Keynes, to London and the groupings around the BFI rather than to Birmingham, but with a significant body of opinion – and especially that of the social historians working on the course – tending in neither of these directions.

However, this is really of little consequence now. What is of consequence, though, is the Centre-centric view of cultural studies on which Miller's account rests. This is not to dispute the importance of the CCCS's leading role over this period. However, the kinds of preeminence accorded it in accounts like Miller's are very much a retro-effect of the particular forms in which, in the 1980s, British cultural studies was imported into the United States which, in telescoping the American eye too exclusively on the CCCS, have unduly magnified its significance. The deficit of this, as I have tried to show, is that – quite contrary to Miller's declared aims and intentions – it detracts attention from the specific institutional circumstances of other cultural studies practices in construing these as satellites of Birmingham rather than attending to their own distinctive trajectories. However, this is not the greatest flaw in his argument. That consists in the general theoretical premises from which he approaches the question of the institutionalization of cultural studies as these make it unlikely that any set of institutional conditions of and for cultural studies can be adequately understood in terms of their actual nature and positivity.

The institutional conditions of cultural studies

As I have already noted, Miller is wary of the pitfalls of writing the history of cultural studies as the story of a fall from a moment of pure origin. Yet he fully endorses Hall's argument that the moment of cultural studies' institutionalization constitutes 'a moment of profound danger', and then goes on to take a step which Hall does not take in equating this moment of institutionalization with the move of cultural studies 'away from the Centre'. The issue Miller poses is whether the new pedagogic and intellectual practices nurtured at Birmingham could survive this move 'away from the Centre'. What were these practices? Miller follows Hall in describing the early years at Birmingham as ones in which the teachers and students collectively 'made up' cultural studies through collaborative practices. For Miller, these practices define a set of 'intellectual and pedagogical possibilities' that are 'now no longer available' as cultural studies has ceased to be a field 'committed to challenging disciplinary boundaries' and has 'began to be stabilised as an area of study within the academy' (Miller, 1994: 420). Viewed in this light, the move 'from Birmingham to Milton Keynes' is presented as a reinstatement of the 'normal pedagogic relations' between teachers and taught in the form of a highly didactic course which, in delivering cultural studies as a form of packaged and administered knowledge, constructed its students as passive learners in limiting itself to assessing their understanding of what the course had taught them.

There is a good deal of truth in this characterization of U203, although whether this should be regarded as a limitation or as a significant accomplishment is a moot point to which I shall return. But what is most conspicuously absent from Miller's account is any mention of the fact that the move 'from Birmingham to Milton Keynes' – if such it was – was also a move of cultural studies out from a postgraduate setting into a mass undergraduate context. This is by far and away the most important difference between the two contexts. The CCCS was, at the time, an exclusively postgraduate and research centre and, even though it was an extraordinarily productive and inventive one which really did succeed in involving teachers and taught in collaborative projects, this is not an altogether exceptional accomplishment. Indeed, it is a part of the conventional concept of graduate education that the divisions between teachers and taught are *supposed* to weaken, and that collaborative endeavours across this divide resulting in joint working papers, publications, seminars and the like are *supposed* to happen. The move 'from Birmingham to Milton Keynes' has absolutely no bearing on such intellectual and pedagogic possibilities being brought to an end. For these are possibilities which have nothing to do with a particular discipline but are rather ones generated by particular kinds of graduate contexts where staff and graduate activities are able to nucleate around shared intellectual projects. This kind of collaborative work has happened before in contexts which have nothing to do with cultural studies and it has happened since. This is not to underestimate the CCCS achievement. Rather, the point is to dispute the notion

that the accomplishment was a unique one made possible solely by virtue of the disciplinary characteristics of cultural studies or that it can be taken to characterize a distinctive phase of the development of cultural studies that can no longer be emulated.[2]

The central issue, however, and it is one which cannot be faced squarely unless it is posed clearly, is whether the kinds of trainings that are appropriate to and possible at the postgraduate level can constitute a meaningful model for undergraduate curricula. U203 is, from this point of view, a bad case for Miller's argument. More relevant comparisons with the CCCS's work in the 1970s might be provided by undergraduate cultural studies curricula developed over the same period – as at Portsmouth Polytechnic, for example – or, perhaps even more tellingly, by the CCCS's subsequent involvement, from the early 1980s, in planning and teaching an undergraduate programme in cultural studies. I do not know the details of these histories. It would, however, be surprising if the constraints associated with undergraduate teaching – especially at first-year levels – had not resulted in the use of more conventional and clearly delineated roles for teachers and taught, including quite straightforwardly didactic lectures and wholly conventional forms of examination and assessment. This is partly a matter of the pressure of numbers which, especially at commencing undergraduate level, typically restricts the scope for the highly labour-intensive and expensive forms of interactive teaching which Miller views as ideal. However, it also reflects the need, which obtains just as much in cultural studies as elsewhere, for students to receive a certain amount of schooling in the debates and methods of any area of intellectual inquiry before they are able to become the kinds of partners in the learning and research process which, in its heyday, the CCCS accomplished.

It might be suggested that these considerations apply with particular force in the Open University context where the normal constraints of undergraduate teaching are compounded by those associated with the highly mediated forms of distance education which characterize open learning systems. Indeed, this is the tack Miller takes in attributing the shortcomings of U203, and especially its failure to provide 'an oppositional educational experience', to the 'structural limitations of distance education'. In this assessment, the Open University is seen as having 'provided the educators with access to technology that enabled them to disseminate the insights of work in cultural studies to large numbers of previously excluded peoples at very low cost' while, at the same time, constraining 'both the formal presentation of cultural studies' work and the pedagogical encounter between the educators and students' (Miller, 1994: 424). In doing so, he aligns his assessment of the Open University with that of Raymond Williams. Although he always lent the University as much practical support as he could, Williams argued that, compared with the relations of democratic mutuality which he attributed to the relations between teachers and taught in traditional extramural or adult education classes, the Open University imposed a centralized curriculum and a bureaucratization of the teacher–student relationship. In the post-war

extramural class, Williams argues, the students 'retained as a crucial principle the right to decide their own syllabus' (Williams, 1989: 156). By contrast, the Open University, in 'inserting a technology over and above the movement of the culture ... lacks to this day that crucial process of interchange and encounter between the people offering the intellectual disciplines and those using them, who have far more than a right to be tested to see if they are following them or if they are being put in a form which is convenient – when in fact they have this more basic right to define the questions' (Williams, 1989: 157).

The line of argument is a tempting one, especially as, in this particular case, it would result in a generous assessment of U203 in – as Miller proposes – attributing what he sees as the shortcomings of its didacticism to 'the system'. However, it suffers from three major flaws. First, such criticisms of open learning systems and of the communications technologies on which they depend are too easily liable to Derrida's critique of phonocentrism in that they depend absolutely on a privileging of speech over writing, of the face-to-face encounter over a technologically mediated relationship of teacher and student.[3] This is surely a case of the 'rearviewmirrorism' that McLuhan argues characterizes initial encounters with new technologies. Neither the actual nature of open learning teaching systems nor their potential to be developed to allow for greater flexibility in the relations between teachers and taught are helped by viewing them as simply failed tutorials or imperfect seminars. This is to overlook the fact that the tutorial and the seminar are themselves not natural encounters, not simply face-to-face conversations based on principles of communicative reciprocity, but highly formalized teaching technologies which have a history and, indeed, so far as the future development of higher education is concerned, are themselves likely to become increasingly historical as they account for a diminishing proportion of the teaching methods used in higher education. Rather than lapsarian accounts of open learning technologies, then, we need ones which are not a priori prejudiced against them because of their difference from some normative ideal (the seminar or tutorial) whose virtues are taken as unquestioned. For example, surveys of students taking part in the new Open Learning Initiative in Australia have found that, for a good many of those for whom this has been their first contact with higher education, the anonymity of 'the system' – the fact that they do *not* have to meet other students or staff or declare to the world that they are giving university study a go – has been crucial to their preparedness to enrol and submit their work for assessment.

This leads me to my second point for – and it really is an astonishing lapse – Williams's comments on the differences between the Open University and earlier forms of extramural or adult education omit all mention of what is arguably the most crucial difference between them. For what was wholly new and radically progressive about the Open University in the British context was that it provided open access to degree qualifications whereas earlier forms of university extramural or adult education did not usually offer or typically lead to any qualifications. Indeed, it was

this, their utter failure to make any significant progress in credentialing the work of their students, that was primarily responsible for creating the vacuum that the Open University was meant to fill.

This difference was and remains absolutely crucial. Most of the extramural classes offered by British universities from the 1950s to the 1970s in the arts and social sciences were typically taken by students who enrolled on a general interest basis. Very little, if any, work was required of students on a week-by-week basis; no work was submitted for assessment; no formal qualifications resulted. This is not said in criticism. I cut my own professional teeth working for four years as a staff tutor in an extramural department, an experience from which I learned tremendously and which I have always valued. And I spent my next four years working as a staff tutor in one of the Open University's regions where I had regular, direct and extensive contact with students. It was wholly clear, however, that the two contexts were quite different regarding the kinds of political and pedagogic questions they raised. For the Open University context raised questions regarding the politics of credentialism of a kind that were virtually absent from the extramural sector. What might have been counted sufficient as an index of progressive pedagogy in the one case – the democratic mutuality of exchange in Williams's idealized extramural class – had, and still has, very little to contribute to the challenge of providing an unscreened, 'mass' population with open access to programmes of study leading to degree qualifications. In such a context, ensuring that those degree qualifications will stand up, that they will be acceptable to other universities and employers, was, and is, both a political act and the primary responsibility of teachers to students.

I'll return to this issue in the next section. Meanwhile, the third reason for scepticism regarding Williams's account of the differences between extramural education and the Open University has to do with the role which this construction of the extramural has played in accounts of the origins of cultural studies. For one of the overriding disadvantages of constructing the history of cultural studies in the form of a narrative of institutionalization, a move from the margins to the centre, is that, as Derrida predicted it always will, the question of the location of the centre and the margins proves to be a constantly movable feast. For the Hall of 1992, the moment of cultural studies' trans-Atlantic passage stands as the key moment of its institutionalization. For Miller, the move from Birmingham to Milton Keynes is another such moment. In an earlier assessment, however, Hall sees extramural departments as the initial incubators for cultural studies – places marginal to the centres of English academic life where cultural studies could thrive on the nourishment provided by direct contact with working-class students – and its move to the Centre as no more than a refuge, a place to which the politics of the New Left retreated when its engagements with the dirty outside world were no longer possible (see Hall, 1990).

I have argued elsewhere why I think this construction of the extramural sector as an originating radical locale for cultural studies is unconvincing

(see Bennett, 1993). The root of the difficulty does not lie in the view that cultural studies has often gained its first institutional toe-holds in contexts outside the mainstream academic departments of established universities. For it is clearly true that it has and, indeed, continues to flourish more in such contexts: more in new universities than older ones, for example, and more in ex-polytechnics and institutes of technology than in the established university sector. It is also true that there is still a good way to go before cultural studies can claim to seriously rival the institutional power of more established humanities disciplines. But this is a fairly routine story in the emergence and establishment of new areas of inquiry and teaching, and we shall make more concrete progress if we think of it in these terms. The problem with the role accorded the marginality of cultural studies consists rather in the extra political and theoretical freight this marginality has had to carry in additionally being called on to furnish cultural studies with its distinctive epistemological protocols. For its resistive origins, it is often suggested, have given cultural studies a unique access to forms of intellectual wholeness which, in turn, have provided it with a privileged insight into the social totality.

A more pragmatic objection is that, if spatial metaphors are to be applied to the extramural sector, that sector is – when viewed as a whole and in the light of the history of its formation – more intelligibly viewed as the centre's outposts than as its margins. The issues I want to focus on here, however, concern the type of explanation that is embedded in such accounts. For they are rooted in the assumption that the history of cultural studies can be deciphered by retracing the steps of its most notable exponents. This is the kind of logic which, given that Hall, Williams, Hoggart and Thompson all worked in extramural departments, then imputes an institutional marginality to such departments in order that they might provide cultural studies with an appropriately radical originating context. Although not without value or interest, the most notable weakness of such accounts is that they are, so to speak, all agency and no structure – as if, in some way unique to it alone, cultural studies requires no archaeological excavations of the conditions which, even though they may have been entirely outside the frames of conscious intention of its notables, have none the less effectively influenced the contours of its development as a now extended set of intellectual and pedagogic practices.

This, certainly, was what I had in mind when, as Miller notes, I suggested the need for histories of cultural studies to concern themselves with 'the institutional conditions of cultural studies, and especially the changing social composition of tertiary students and teachers' (Bennett, 1992: 33). Carolyn Steedman has suggested what such an account might look like in, from a historian's perspective, seeking the roots of cultural studies not in the trajectories of E. P. Thompson's intellectual biography but rather in the changing practices of history teaching in English secondary schools. This allows her to suggest that the concept of culture as a whole way of life, far from simply springing unaided from the furrowed brows of Williams and Thompson, was in fact an invention of English

secondary schooling required to facilitate children's study of cultural materials in the history classroom as part of a Piagetian pedagogy of child development. Taking a leaf out of Steedman's book would suggest the need to see parallel roots for cultural studies in the uses to which the early texts of Hoggart and Williams were put – long before the days of the CCCS – in secondary-school English teaching. In this context, the pedagogic function of the concept of culture as whole way of life was to extend the reformatory reach of the moral machinery of English in allowing the culture outside the classroom to be brought into the classroom to serve as a vehicle for the political and moral education of a new demographic cohort of students.

Of course, a couple of points like this do not in any way comprise an adequate alternative history of cultural studies of the kind that I am suggesting. However, they do suggest a way in which such a history might be written, not as a move from margins to centre, from a de-institutionalized existence to its institutionalization, but as an always-institutionalized set of practices whose functioning has, in part, to be assessed in terms of their role in organizing a new set of relations between educational institutions and new generations of students who have either lacked, or been unreceptive to the value of, traditional forms of cultural capital.[4] This provides a perspective from which to question two of the assumptions which, if they shape Miller's discussion, do so because they now more or less saturate the field. The first is the assumption that the proper aim of cultural studies teaching is to nurture and cultivate the expression of student resistance. The second consists in the view that the institutionalization of cultural studies is a danger we should be wary of rather than something to be welcomed and explicitly cultivated because of the limited but still worthwhile possibilities it offers.

Resisting resistance

In the penultimate section of his article, Miller offers a detailed assessment of the types of essay and examination questions through which U203 students were assessed in the first year of the course's presentation. His major complaint is that these constituted the students in a largely passive relationship to the course, requiring little more than an ability to summarize and demonstrate a comprehension of the course's main arguments and of its study materials. In doing so, the course failed to encourage students to draw on their own experience or knowledge of popular culture. It neither required nor allowed students to 'wander somewhere beyond the landmarks and approved positions already clearly staked out in the readings' (Miller, 1994: 430). In this respect, he suggests, U203 fell prey to the institutional ideology of the Open University in its insistence that all student work should be 'subject to the same, relatively stable, standardized and objective system of evaluation, despite the fact that that work was produced all over the country by students working in very different circumstances' (431).

This characterization of the first-year's assessment policies of the course is a fair one. These were unduly cautious.[5] Whatever the reasons for this, Miller is right to suggest that, at least in the first year of its presentation, the course did not adequately encourage students to apply analytical or theoretical skills to new contexts. However, I think it is a mistake to attribute this shortcoming to the OU system. The earlier course 'Mass Communications and Society' had successfully trialed group-based projects carrying a collective grade, and many of the history courses produced in the Arts Faculty had been comparably innovative in their assessment strategies. Certainly, the Open University was, at that time, far more open to innovative and flexible forms of assessment than was true of the on-campus courses offered at the majority of British universities. It is also, in my view, a political mistake of the first order to view the bureau-cratic standardization of assessment in the Open University as anything but progressive. This is where the legacy of Williams's failure to appreci-ate the respects in which the Open University and the extramural depart-ment constituted wholly different contexts unfavourably affects the balance of political judgement in Miller's discussion. The work of Pierre Bourdieu and Jean Passeron (1979) has shown how, in the cultural sphere, forms of assessment which encourage the demonstration of forms of cultural *savoir faire* (including a cultural knowingness about popular culture) acquired outside the framework of an administered curriculum favour students from a bourgeois background.[6] Viewed in this light, the bureaucratization of assessment Miller complains of has to be seen as an absolute necessity for an institution like the Open University if it is not to be culturally biased against students lacking traditional forms of cultural capital. U203's compliance with these principles was not so much a matter of a failure to resist such institutional constraints as – at least to speak for myself – one of active and principled support for the politics of pedagogy on which they rested.

The root difficulty here is that, for Miller, the bureaucratization of the teacher-taught relation is a bad thing in and of itself and, when applied to cultural studies curricula, something of an oxymoron. Again, recourse to Williams is instructive here. Contending that it was out of the 'entirely rebellious and untidy' situation of the adult education class that cultural studies emerged, its interdisciplinariness forged in response to the need of adult students to relate knowledge to their whole life and experience, with-out respect or patience for disciplinary boundaries, Williams argues that the Open University, in grafting itself on to this situation, 'had this element in it of a technology inserted over and above the social process of education' (Williams, 1989: 157). The lingering nostalgia which allows the adult education class to be fashioned as both the residual trace of community life and the harbinger of relations of face-to-face mutuality and reciprocal exchange which will characterize the condition of a common culture is clear in such assessments. Their effect is to distract attention from the wholly new conditions of political possibility and calculation which the new technology makes possible and requires if its utilization is

to be at all effective. It is a position which places us in the same situation *vis-à-vis* educational technologies as we would be in relation to the politics of the visual image in conditions of mass reproduction had Benjamin not written his essay 'The work of art in the age of mechanical reproduction'.

Yet this might seem unfair. After all, Miller's primary criticism of U203 echoes that which Benjamin made of the revolutionary hack who makes use of available techniques of production to purvey a radical message without in any way contributing to a transformation of the prevailing relations of intellectual production (see Benjamin, 1973: 92). U203 thus comes to be interpreted as symptomatic of a historical juncture in which those engaged in cultural studies 'defined the politics of their pedagogical practice in terms of the material they transmitted rather than either the relations they established with their students or the educational environment they created for their students' (Miller, 1994: 431). As a corrective to this, and in specifying the pedagogic norm which informs his criticisms of the course, Miller endorses Henry Giroux's contention that a radical pedagogy must 'provide the conditions for students to speak so that their narratives can be affirmed and engaged along with the consistencies and contradictions that characterize such experiences' (Giroux, 1992: 433). This leads Miller to propose, as the litmus test for a cultural studies pedagogy, the degree to which it 'acknowledges and responds to student resistance' (1994: 433).

Miller is, unfortunately, less than explicit about what exactly this might mean. Three possibilities present themselves. The first is that cultural studies teaching should seek to organize and promote resistance to the authority of the teacher. The second is that it should organize and promote resistance to the curriculum, encouraging students to draw on the counter-knowledge of their experience in order to pose alternatives to the formalized knowledges imparted by course contents. The third is that cultural studies teaching should enable and encourage the expression of student resistance to particular forms of cultural power. However, I do not think any of these constitutes a cogent norm from which to assess the pedagogy of a course produced in circumstances of the type which characterized U203 any more than they constitute valid ideals for the development of cultural studies teaching more generally.

The difficulty with the first interpretation is that it posits a pedagogical norm that is the direct opposite of that which provides Miller with his starting point. In face of the ideal of a mutually collaborative set of relations between teachers and taught in which the difference between these two categories is blurred, teachers, on this model, are to organize students in an antagonistic relationship to themselves. Miller seems unaware of the tension between these different standards of evaluation, and this may account for the 'heads U203 loses, tails it fails' flavour of his discussion. For it is clear that any concrete pedagogic practice can always be condemned for its failure to meet these two contradictory imperatives.

The difficulty with the second interpretation is that, in advocating that situations should be created in which students can speak so that their

narratives can be affirmed, it supposes that all such narratives *should* be affirmed and that their being spoken will be a productive and useful activity for all concerned. There are good reasons for doubting this. Let me illustrate my point anecdotally. I well remember encountering a telling instance of student resistance when an obviously well-heeled woman student from the south of England, trembling with what was evidently real distress and indignation, told me how strongly she objected to the summer school module focused on Blackpool. She had, she said, no wish to see or even think about how the yobbo working classes of the north of England spent their holidays, let alone being obliged to do so and to actually have to go to Blackpool in order to meet her assessment requirements for the course. Such feelings have, of course, to be tactfully responded to and, hopefully, put to good use. But this is quite a different matter from planning a course in such a way as to encourage their expression. Yet if this is so, the view that the aim of cultural studies teaching should be to nurture the expression of more politically correct forms of resistance must be regarded as equally questionable.

The third interpretation suffers from similar difficulties in that, at least as applied to the Open University, it reflects a significant misunderstanding of the nature of the student body. Miller suggests at one point that U203 seemed to open up the prospect of 'a course on popular culture taught to "the populace" (broadly construed as those people excluded from pursuing higher education in a more traditional setting)' (1994: 424). This impression – which Miller qualifies only in a footnote – is highly misleading. It was perfectly clear by the time U203 was being planned that the demographic composition of the student population it would recruit would be highly variable. Certainly, the possibility that that population might be construed in populist terms was wholly unviable. It was clear by then that the Open University was recruiting only a very small proportion of its intake from the working classes. Equally, it was clear that it had substantial appeal to members of the professional classes, a good number of whom already had degrees. There were very few black students as the University had made little headway with Britain's post-war migrant communities. The most noted success of the University in access terms consisted in its appeal to women, mostly from a middle-class background.

This was not, in other words, a student population that could be constituted or addressed in terms of a 'pedagogy of the oppressed'. This is not to deny that, for some, the issues the course engaged with would have touched directly on personal experience of cultural oppression or disadvantage in ways that, depending on the particular circumstances and issues concerned, would have acted either as an incentive or disincentive to engaging with the course materials. This was most obviously true of the women who studied the course in so far as the course addressed the role of popular culture in the organization of gendered and sexed identities. For the most part, however, U203 students would have found themselves contradictorily positioned in relation to the different fields of culture and power the course addressed. Recruited, like the staff who taught them,

mainly from the new petit-bourgeoisie and located mainly in the 30–50 age range, this was a student population many of whose members would have had good reason for considering themselves the targets rather than the potential subjects of resistance.

There is a fourth possibility, and one which Miller acknowledges at one point: namely, that the course should have recognized that the radical political content of the study materials would create learning difficulties for a student population with these demographic characteristics, and that the course-team should have developed more specific and more interactive strategies to take account of and respond to these difficulties. This is both a telling criticism and a helpful suggestion which, had we given it more serious consideration, might have resulted in more muted forms of political argument or in teaching strategies more clearly related to students' occupational needs.

However, in subscribing to Giroux's conception of the role of cultural studies in developing a 'border pedagogy', the general tendency of Miller's suggestions pulls in a different direction entirely, one which, at first glance, would resecure cultural studies back in the resistive margins from which it allegedly sprang. For Giroux, 'border pedagogy' is defined as a field of expressive practices, as itself 'a form of cultural production' in opposition to a view of pedagogy in which teaching is viewed as 'the transmission of a particular skill, body of knowledge, or set of values' (Giroux, 1992: 202). Its role, rather, is to assist in 'the production of knowledges, identities, and desires' (202). In performing this role in the context of the multiple cultural borderlands of the American school where subordinate cultures push against both the dominant culture and against one another, cultural studies teaching becomes a part of a broader politics of identity and community, and it does so, essentially, in functioning as a pedagogy of enunciation, a pedagogy and politics of voice and of difference. In analysing the forms of voicelessness produced by the repressions of subordinate groups and in encouraging a coming to voice of the repressed margins, this pedagogy of the borders 'serves to make visible those marginal cultures that have been traditionally suppressed in American schooling' (206). In this way 'radical educators can bring the concepts of culture, voice, and difference together to create a borderland where multiple subjectivities and identities exist as part of a pedagogical practice that provides the potential to expand the politics of democratic community and solidarity' (206). Their role in this regard is, in compensating for the failure of the political system to produce a democratic public sphere, to constitute the public schooling system as a significant zone in 'the ongoing process of educating people to be active and critical citizens capable of fighting for and reconstructing democratic public life' (199).

One reaction to this might be to suggest that a pedagogy which can forego the redistribution of skills and competencies so easily in favour of a commitment to the redistribution of identities is more deeply affected by the politics of American liberalism than it imagines itself to be. Another would be to say that the task of restructuring democratic public life is

asking a lot of teachers and of the school.[7] Yet there is an important sense in which what Giroux proposes does not ask much more of teachers or of the school, or much that is different, from what public education systems have always asked of them. For what is most striking about Giroux's prescriptions is how governmental they are. The garnishings, it is true, are radical and liberationary. But the substance of the argument is wholly governmental in attributing to employees of the state (which, lest we forget it, is what most cultural studies teachers are) a role, performed within the pedagogical machinery of public schooling, in forming and shaping the attributes of a citizenry. A postmodern and radically democratic citizenry, it is true, but this does not alter the fact that Giroux's critical border pedagogue is accorded the same function to be performed in the same place as her/his pedagogic forebears. And that function, moreover, is to be performed in essentially the same way. For what else does the pedagogy and politics of voice he recommends depend on but the redeployment of confessional techniques within the moral machinery of the school? What else is this but the highly governmental organization of voices in order that some voices might be supported, and others be corrected and revised, in the custom-built environment of the school with the teacher as a technician of the soul? And what else, finally, does this border pedagogy depend on but a coming together of the psycomplex and American multiculturalism with a dash of cultural studies thrown in for radical flavouring?

If my answer to these questions might be intuited as 'not much', this should not necessarily be interpreted as a hostile response. To the contrary, although I think he may expect too much from it, Giroux's arguments rest on a view of the schooling system as a governmental apparatus with a crucial role to play in forming the ethical and civic capacities of future citizens. It is therefore appropriate to argue and debate the role which cultural studies curricula might have to play in such processes. Indeed, a part of my point has been that, from the very beginning, cultural studies has been involved in precisely such governmental projects through the role that it played, from a very early stage, in British secondary schooling. Institutionalized from the very start, the institutionalization represented by its trans-Atlantic passage – if we are to think clearly about it – has little to do with the cooption of its radical potential as a result of the careerism of the American academy and has everything to do with its take-up and use in a different educational system. What is at issue, that is to say, is its shift from one institutional context to another.

Still, it is far from clear, to return to Miller, to see why he should regard Giroux's theories as capable of providing a general model for cultural studies. For the way Giroux develops his own views is highly circumstantial: it is the secondary level of the American public schooling system he has in mind. Even supposing one supported his views regarding the pedagogical deployment of cultural studies in this context, this is no reason to grant them any relevance to the role of cultural studies in the university. This inevitably raises questions about the kinds of knowledges and trainings that are to be imparted to students; about the occupations these will

equip them for; about the roles they will play as future intellectuals; about how these roles will stand in relation to the role played by intellectuals trained in adjacent fields. These are vital questions and, if cultural studies is to have a worthwhile future, they are ones that need to be answered clear-sightedly taking into account where cultural studies students are likely to be recruited from, what their career destinies are likely to be, and what roles they can intelligibly be expected to play as intellectuals in diverse fields of governmental and private employment. So long as institutionalization is posed as a moment of danger which threatens cultural studies with the loss of its radical credentials; so long as it is a field in which intellectuals can cultivate and preen a chic radicalism through the grand gesture of turning their backs on the institutional contexts of cultural studies, as if it could have any existence independently of such contexts; so long as it is not realized that cultural studies has been wholly institutionalized and implicated in the field of the governmental from the word go – for just so long, it will fail to appraise its situation and the modest but real possibilities which that situation presents correctly.

Notes

I am most grateful to John Frow, Larry Grossberg and Stuart Hall for their helpful comments on the first draft of this paper.

1 Terry Eagleton and Colin MacCabe are among those who presented seminars to the course team, as did Raymond Williams who also served as the overall assessor for the course. James Walvin and Stanley Cohen served as assessors for particular parts of the course and we were helped in various ways by Ed Buscombe, Geoffrey Nowell Smith and Philip Simpson from the British Film Institute.
2 This is not to gainsay that there may have been particular circumstances which helped to auspice the development of such relations at the CCCS. The state of flux characterizing the disciplines on which the Centre drew in its concern to provide some kind of coherence and a sense of a shared project for the emerging field of cultural studies may have assisted an unusually productive blurring of the distinctions between staff and students.
3 Williams's writings in this area are, I think, quite markedly influenced by his personal preference for speech over writing and his related 'vocalic idealism' or faith that there is something in the full presence of unmediated face-to-face interaction which always exceeds, is somehow beyond, the resources of written forms, a plenitude which writing cannot capture. See Simpson (1992).
4 I should add that considerations of this kind do not exhaust the issues that need to be taken into account in writing the history of cultural studies. The broader field of government policies bearing on the practices of educational institutions and the changing forms and relations of cultural production in the cultural industries have also to be taken into account.
5 My own recollection as to why this was so was that, as we were aware that students would be coming to the course from many different disciplinary backgrounds, and that many of them would find it difficult, we thought it important to keep the assessment tasks plain and simple so as not to unduly disadvantage

those who had no prior acquaintance with the kinds of issues and arguments the course addressed.

6 This is not to suggest that bourgeois students have a greater or better knowledge of popular culture than the members of other classes. What is at issue here concerns different ways of displaying that knowledge and the fit between these and particular forms of assessment. Popular culture curricula which assess students from the point of view of their capacity to demonstrate a bourgeois class *habitus* in evincing particular kinds of familiarity with specific regions of popular culture exist not just as a theoretical possibility.

7 For a history of the school which suggests the need to be more circumspect in what it might be expected to accomplish, see Hunter (1994).

References

Benjamin, Walter (1973) *Understanding Brecht*, London: New Left Books.

Bennett, Tony (1980) 'Popular culture: a teaching object', *Screen Education*, 34.

—— (1992) 'Putting policy into cultural studies' in Grossberg, Treichler and Nelson (1992).

—— (1993) 'Being "in the true" of cultural studies', *Southern Review*, 26(2)

Bennett, Tony, Boyd-Bowman, Susan, Mercer, Colin and Woollacott, Janet (1981) editors, *Popular Television and Film*, London: BFI.

Bourdieu, Pierre and Passeron, J.C. (1979) *The Inheritors: French Students and their Relation to Culture*, Chicago and London: University of Chicago Press.

Foucault, Michel (1979) 'What is an author?', *Screen*, XX(1).

Giroux, Henry A (1992) 'Resisting difference: cultural studies and the discourse of critical pedagogy' in Grossberg, Lawrence, Treichler, Paula and Nelson, Cary (eds) (1992) *Cultural Studies*, New York and London: Routledge.

Grossberg, Lawrence, Treichler, Paula and Cary, Nelson (1992) editors, *Cultural Studies*, New York and London: Routledge.

Hall, Stuart (1981) 'Notes on deconstructing the popular' in Raphael, Samuel (ed.) *People's History and Socialist Theory*, London: Routledge & Kegan Paul.

—— (1990) 'The emergence of cultural studies and the crisis of the humanities', *October*, 53.

—— (1992) 'Cultural Studies and its theoretical legacies', in Grossberg, Treichler and Nelson.

Hunter, Ian (1994) *Rethinking the School: Subjectivity, Bureaucracy and Criticism*, Sydney: Allen & Unwin.

Miller, Richard E (1994) '"A moment of profound danger": British cultural studies away from the Centre', *Cultural Studies*, 8(4).

Simpson, David (1992) 'Raymond Williams: feeling for structures, voicing "history"', *Social Text*, 30, 9–26.

Steedman, Carolyn (1992) 'Culture, cultural studies and the historians' in Grossberg, Treichler and Nelson (1992).

Williams, Raymond (1989) *The Politics of Modernism*, London: Verso.

SMADAR LAVIE AND

TED SWEDENBURG

BETWEEN AND AMONG THE BOUNDARIES OF CULTURE: BRIDGING TEXT AND LIVED EXPERIENCE IN THE THIRD TIMESPACE

ABSTRACT

The anthropological notion of Culture is founded on the presupposition of a radical difference between self and other, here and there, Eurocenter and Third World. This conceptual foundation has increasingly been under challenge, as the Eurocenter is being forcibly relativized by national liberation movements from without and 'new' social movements from within. The relativistic notion of cultures that are autonomous and bounded is now contested by a notion of historically grounded multiple subject positions. A jumble of cultural–political practices and forms of resistance have emerged that have variously been named hybrid, border, or diasporic. The most creative and dynamic of these resistances are located on the borders of essentialism and conjuncturalism. They refuse the binarism of identity politics versus postmodernist fragmentation, opting instead for what Sandoval terms 'differential consciousness'. We name this terrain of practice and theory, this zone of shifting and mobile resistances that refuse fixity yet practice their own arbitrary provisional closures, the third timespace.

The third study of third timespaces aims to displace the canonical anthropological notion of Culture as well as to nudge Cultural Studies away from its text – a Western-centered focus. Such an undertaking will require a revision of the ethnographic distinctions between 'home' and 'the field'. Fieldwork becomes 'homework', as differences between the ethnographer and the subject under study are broken down, as the ethnographer is incorporated into the text, and as theory and text reflect and participate in the multiply-positioned and fluctuating realities of quotidian life.

KEYWORDS

third timespace; culture; ethnography; essentialism; hybridity; border; diaspora

Cultural Studies 10(1) 1996: 154–179 © 1996 Routledge 0950–2386

Un-learning the primal sin

Once upon a time, an old man with pink-veined cheeks and a gray mustache met again with his fellow professors at the Faculty Club. A dozen academics in bow ties milled about, smoking cigars and pipes, or relaxed in leather armchairs, as one scholar languidly played a Chopin waltz. Or maybe they did something else – they didn't want us to know what. They had divided their world into the world 'Here' and the world 'Out There'.

The world Out There was 'scientific Culture' (Williams, 1983: 91). It was colorful, but only in shades of dark. This world of tribes was governed by principles of kinship and recitation of genealogies to sustain them. It was a world of orality and tradition. The people Out There were Cultures – drumming on gourds, dancing in circles, headhunting their enemies, and performing rites of passage. Here, in contrast, was the world of 'culchah' (Williams, 1983: 92)[1] – the grand piano, the canonical leatherbound books, and museums that displayed either high art from Here or artifacts from the cultures Out There.

Here was a world of literacy, though not all had it, of course. Access to literacy was highly correlated with control over the means of production, and created class divisions that congealed into the nation-state. This nation-state, however, was a patriarchal heterosexist construct, where the specificities of gender, sexuality, and race within the class structure were (in)visible to this group of men from their privileged position on top of the 'Graeco-Latin pedestal' (Fanon, 1961: 46). They were proud to live in what they considered a pluralistic democracy. Excluded from their gaze was the nation-state's ruthless colonial exploitation Out There, which enabled them to enjoy the lush scene in their club. But Here was a world of 'pure Aristotelian logic ... follow[ing] the principle of reciprocal exclusivity' (Fanon, 1961: 38–9) – identity was tied to place. In the Faculty Club, those who came back from Out There, the anthropologists, told tales of bizarre collective spaces and communal times outside time.[2] Those who basked in 'culchah', while unable to boast such a variety of times and spaces, argued that ordinary time and space provided just the background against which the brilliant artistic and scientific work of atomized individual geniuses, White and phallogocentric by default, could flower forth. The folk Out There, it was thought, being so immersed in kinship and collective tribalism, were capable of creating exotic artifacts, but not art, or the science and technology that invented modernity's gadgets, from IQ tests to spaceships (Lavie, Narayan, and Rosaldo, 1993). The infra-structure of all this Western 'progress', however, was not only the colonized people living in Africa, Asia and Latin America, but the bodies of millions of people brought from these locations to North America and Western Europe to serve as the tools for building their modernity (see Gilroy, 1992a).

Our education was permeated by the legacy of these men. In addition to the required literary canon of western civilization, we were taught rows of

books with titles such as *Andeman Islanders, Coming of Age in Samoa, The Lele of Kassai, Bedouin of the Negev*.[3] Between the covers we found maps and photographs that fixed Culture into a given, well-bounded place. Although Anthropology lacks an agreed-upon canon, such books, while constantly renegotiated, still end up as the discipline's 'classics'. Our respective graduate departments displayed a big map of the world, the Americas at the center, Africa and Asia dangling at each end. They stuck little colored pins in to indicate the various fieldwork sites where graduate students, postdoctoral fellows, and professors were roughing it. Job ads in the *Anthropology Newsletter* routinely require area specialization either in the hottest areas of the US backyard, Latin America and East Asia, or the discipline's front lawn, the primordial tribal Sub-Saharan Africa or Oceania. Curricula are structured around regional specializations bearing standardized titles like 'Peoples and Cultures Of . . .' (please insert name of favorite region). Underneath it all are some powerful assumptions. One is the homology between a timeless Out There culture and its indigenous space. Another is the homology between the modernist space of the nation-state Here and linear time that progresses toward enlightenment. It is also assumed that if one is positioned in the modernist linear time-space, then one is able to compare and contrast homogeneities of timeless Out There cultures. This inscription of culture, based on the inseparability of identity from place, is not peculiar to Anthropology. In fact this relativistic notion of culture reigns not only in the Humanities and the Social Sciences, but also in the political institutions of the nation-state that shape public discourse.

Conspicuously absent from the anthropological mode of compartmentalizing the globe were the gentlemen in the Faculty Club and their studies of culchah. Perhaps this was because both culchah and Culture were devoid of race. Out There, everyone was dark, but with pluralities of exoticism – one tribe sacrificed cows, another goats. Here, Whiteness was assumed as the default category, and was thus invisible (see Ware, 1992). Most people from racialized minorities Here had no access to the Faculty Club, and those who did lived an underground double life (DuBois, 1903). The present absence of race from the humanistic discourses of both color and noncolor Here, and its consolidation into Otherness Out There, policed the boundaries between cultures, classes, First World 'empires/ nations' (Lavie 1992: 34–5), and Third World colonies.

Such present absence led Anthropology to play a crucial role in the process that homogenized the US-Eurocenter (henceforth, for ease of reading, to be termed simply 'Eurocenter'). Anthropology, practiced only from the Eurocenter, went Out There to do fieldwork and returned to teach that there are so many dark tribes Out There, all different as documented in graphic detail. From the halls of academe and government, the Eurocenter looked homogeneous in comparison. Insecure in its identity as a 'fuzzy' social science rather than a 'precise' natural one, Anthropology tried to legitimate itself by proliferating all manner of scientific-looking models supported by data – Evolutionism, Diffusionism, Cybernetic Ecologism,

Functionalism, Structuralism, Structural-Functionalism, Cultural Materialism, Cognitivism, Psychoanalysis, and Hermeneutics.[4] It succeeded, however, only in producing a scientific allegory – a sanctimoniously didactic yet self-critical story. Anthropology's criticism of the colonialism that had made it possible facilitated the colonizing process by making it more efficient. The scientific allegory served as the textual vehicle to rationalize and legitimate the US–European colonial hegemony of the West over the Rest.[5]

First the Eurocenter primitivized the people it subjected to its rule. This primitivization was perhaps a reaction to local resistances that had to be pacified through a systematic methodology of technologized terror. What followed was the ideological dehumanization of local cultures, and their consolidation within an orderly linear narrative of the savage Other.[6] The process of Othering allowed exotic heterogeneity through the verisimilitude of cultural relativism. This relativism operated under the assumption that the boundaries between cultures Out There were policed by institutions from Here which allowed for this relativism as long as it aided the homogenization of the Eurocenter. Separate but equal, the remnants of each pacified culture were benevolently put on the Cartesian tracks of progress towards a hoped-for modernity.

In the colonial context, Anthropology served as a means of unifying the Eurocenter through the repeated systematic erasure of the Other's coevalness (Fabian, 1983). The Other could be produced and reproduced as living in a tightly bounded timespace radically different from that of the Eurocenter because the Western ethnographer deployed the language of the natural scientist to habitually excise his own presence and that of the colonial apparatus (see Rosaldo, 1986). In the pages that followed the meticulous map and the aerial photograph of the fieldwork site, one would read how the ethnographer mysteriously materialized one thick night in the heart of darkness (M. L. Pratt, 1986). He then abruptly disappeared from these pages, politely clearing the way for the disembodied, desexualized, genderless narration of the 'primitives', and thereby transcended their specific timespace. This was a process whereby essentializing the relation of a culture to a place positioned it beyond history and time. People were then abused as analytical tools for cross-cultural comparison, the theoretical bread and butter of Anthropology and of ethnographers' careers. Thus the various alleged primitivities were textually produced as hermetically sealed entities adequate unto themselves and explicable solely in terms of their own dynamics. In a paradoxical relation, the Eurocentric 'scientific' models developed in the faculty clubs of the West enabled anthropologists to explain the inner workings of Other cultures, supposedly 'on their own terms'.

It is this incredible political and economic power the Eurocenter has to erase itself from the process of producing ethnographic Others that permitted it to imagine its own homogeneity. Yet the 'discursive doubleness' (Bhabha, 1985: 74) of both colonialism and Anthropology led to the opening up of timespaces marked by race. Race, absent from the Eurocenter's

discourse about itself, emerged from the space opened up between the colonizer and the colonized, and was acted out through violence (see Fanon, 1961).

This homogenizing process emerged in the academy as a polarization among scholarly disciplines. Anthropology was the exoic pole. The canonical pole acquired a veneer of civility through the high modernism in literature and the arts that established literary canons. The West, however, was deeply dependent on the notion of its own homogeneity for its consolidation of a Self forcing it to be narrated in a Cartesian, linear manner. Thus the rise of anti-colonial movements opened up ambivalent timespaces for heterogeneous discourses of violence in and about the Eurocenter's margins. These discourses unsettled the Eurocenter because, paradoxically, they were appropriating the colonizers' model of a nation-state in order to break away from colonialism (Chatterjee, 1986). This was the moment when cultural relativism was turned back against the Eurocenter by anti-racist and national liberation movements. The Eurocenter was itself relativized and therefore could no longer purport to be the pinnacle of disinterested, absolute, uncontaminated truth (see Balibar, 1991: 21–2).

This was the moment when the Third World established itself in political distinction from and in opposition to the First. Charismatic Third World leaders called on their constituencies to auto-homogenize,[7] in order to narrate and mobilize Third World resistance *vis-à-vis* the First World along the same linear path in which the First World narrated and practiced itself (see Cabral, 1973; Fanon, 1961). The suppression of the distinct interests of the subaltern populations of these new Third World nation-states – tribes, ethnicities, women, queers, and the like – was the cost of the nationalizing project. What emerged, then, was two dichotomous linear articulations. The Eurocenter narrated itself to itself as the individuated Self, and narrated the Third World as a primitive yet modernizing collective Other. The Third World, in a linear articulation also, narrated its Self, the fragments of the collectivity-that-was, in contra-distinction to the Eurocenter. Yet this was performed in terms of a binary opposition, simultaneously othering the Eurocenter while conceiving it as the dreamspace of desired modernity (see Fanon, 1961; Feuchtwang, 1985).

As the Eurocenter was relativized, its assumed homogeneity and inherent superiority were fractured, both by forces from without – Third World nationalisms and revolutionary movements, and forces within – movements of civil rights, women, immigrants, gays and lesbians. The notion of Culture based on the transmutation of race into cultural relativism, a notion that immutably ties a culture to a fixed terrain, became increasingly problematic. Massive migrations by racialized non-White subjects into the heart of the Eurocenter, and these subjects' refusal of fixity, calls for the dismantling of the humanistic notion of Culture. No longer is the 'savage' in the disciplinary backyard or front lawn. She has invaded the 'home' Here, fissuring it in the process. Her presence not only de-homogenizes and racializes 'home's' Whiteness, but reveals its homogeneity as a mythology sustainable only through control over the global

political economy, which is thereby seemingly fissured as well (see Appadurai, 1990; Harvey, 1991). Thus the First World is 'Third Worlded' (Koptiuch, 1991).

Paradoxically, as the margins resisted and decentered the dominant political economy of identity production, they too transformed, thereby dismantling the center/margin dichotomy and opening spaces between center and margins. Due to the multiplicity of specific historical situations of oppression, several processes of center/margin dissolution could occur in various combinations. Some margins stayed put, but appropriated the center's ideologies and practices. Some margins moved into the center itself. Some margins began to communicate with each other, without the center as interlocutor between them (see Mohanty, 1991: 11). While progressively permeating the Eurocenter, the margins were also opened up to an internal critique of their homogenization (Rutherford, 1990: 23–4).

These within and without processes led, on the one hand, to a certain kind of postmodernist celebration of fragmentation, where identity became an infinite interplay of possibilities and flavors of the month. In this mutation, culture was a multicolored free-floating mosaic,[8] its pieces constantly in flux, its boundaries infinitely porous. The celebration deconstructed the spatially and temporally conceived hierarchical dualities of center/margin. This postmodernist reading of the timespace that had opened up lacked a sense of the hegemonic relations between the West and the Rest. The dizzying array of fragments ignored the power relations between center and margins that still remained. Everyone became equally 'different', despite specific histories of oppressing or being oppressed.

Many minorities, exiles, diasporas and other marginal groups, however, understood not only what historical difference is, but how difference operates, and protested this *Vive-La-Difference* 'privileged's ability to exoticize themselves selectively' (Lubiano, 1991: 155–6). Yet the margins appropriated such fragmentation to facilitate their theorization of racialized difference, so that it is 'prevent[ed] from cohering into essentials' (Lubiano, 1991: 158). 'Gathering and re-using' (Tawadros, 1989: 121) historically was a tactic of the margins. The postmodernist avant-garde from Here appropriated this tactic and brought it to the center, where a handful of daring members of the Faculty Club translated it into a tool to construct their literary and philosophical theories of Otherness. Dress codes in the Faculty Club loosened. 'Gathering and re-using' Here became dehistoricized and thereby universalized. While the center appropriated the space that opened up as 'post'/modern and 'post'/colonial,[9] the margins called for reperiodization of modernity and colonialism (Gilroy, 1992a; Tawadros, 1989).

The minority articulation of the in-between finally succeeded in rupturing the Western linear narrative of the Self as an autonomous, well-bounded subject. In the Faculty Club those who dared became each other's Other, but their otherness was still binaristic, because it did not take place in the porous space between Self and Other. These po-mo theorists failed

to comprehend that positions of the margins were not only multiple and constantly shifting, but also historically anchored to specific locations that allowed for politicized interventions (see Alarcon, 1990).

Despite all this, due to the Third-Worlding Here, in the theoretical space that had opened up between Self and Other some minority cultural workers theorized that subjects under oppression could not maintain their seamless autonomous selfhood of Otherness. Their identity has historically been articulated as 'differential consciousness'. Chela Sandoval, writing of Third World women in the US, explains that 'differential consciousness' involves weaving 'between and among' four types of oppositional consciousness, which she labels 'equal rights' consciousness, 'revolutionary' consciousness, 'supremacist' consciousness, and 'separatist' consciousness. Mobilizing this oppositional tactice involves refusing to opt for any single one of these four tactics, but rather, situationally opting for the most effective improvised plan at the moment: a 'differential' or a *tactical subjectivity* with the capacity of recentering depending upon the kinds of oppression to be confronted' (Sandoval, 1991: 12–14). Such tactics for coping with and articulating the historicity of experience, working with and against postmodernist fragmentation, fractured not only the binaristic linear narrative of the relation between Third World Self and First World Other, but the linearity of the Eurocenter's Self and Other as well.

'Post' Fordism and the New World Order

We wish here to underscore the importance of this paradigm shift from self/other to historically grounded multiple subject positions. As the articulation of such positions wedges open the self/other timespaces within and between First and Third Worlds, they deterritorialize the loci and foci of these dualisms. It should be recalled, however, that these dualisms have not been finally dislodged. Even though racialized and gendered subjects might act out a multiplicity of fractal identities (Gilroy, 1991), dominant forces still police the boundaries of binary opposition. Because the Eurocenter constantly consolidates itself, shoring itself up against the margins' assaults, it continually redeploys these binarisms in an effort to contain the margins by reasserting their identity in the form of the Other.

The battlefield where the Eurocenter most successfully contains the margins is the global political economy, over which it still maintains tremendous control, despite fierce struggles about the political character of the time and space opened up between Center and Margins, Self and Other, and Third and First Worlds. We have been ushered, so we are told, into a new era of capitalist restructuring, an era characterized by the demise of the old Fordist social pact between capital and labor – where high productivity was rewarded with relatively high wages – and by a shift to new 'information technologies'. We should celebrate, at times we are told, the internationalization of financial markets and the reorganization of the geographic division of labor into a vast dispersal of production across the globe (see Appadurai 1990). The Eurocenter's multinational

corporations take advantage of their global organization of production to increase their hegemony, even as they substantially increase their autonomy from community or nation-state control. The economies of both the First and Third World, therefore, are now increasingly subject to global forces. The multinationals constantly threaten to relocate production elsewhere as a weapon to discipline labor, depress wages, and pressure local governments to ease taxation rates and lift environmental and safety regulations. In the interests of 'flexible specialization', the processes of manufacturing and even final assembly have been sprawled across the globe – a production process enhanced by a reduction of institutional barriers to capitalist mobility.

In the arena of the social, meanwhile, the boundaries between Culture and culchah, and therefore Margins and Center, are gradually dissolving – but not peacefully. This is because economic and political power is increasingly centralized by the Eurocenter's decentralizing tactics. This power is still firmly lodged in the hands of multinational firms whose permanence has become detached from place. Their loyalties now appear to transcend community or even national boundaries (Harvey, 1991: 73; see also Harvey, 1989).

This deceptive decentralization is what makes the wrenching of marginal identity from place such a painful process of resistance. Such pain that has yet to enter into the Faculty Club. The multinationals detach themselves from place without having to rework their Eurocentric identity. The Euro-centered mode of production, however, now forces its marginalized workers all over the globe to hybridize their collectivities-that-were, not only with the atomized and hierarchized production relations that they have to enact in order to barely make a living, but also with the deceptively egalitarian hyped-up consumerism that keeps the Eurocenter's wheels turning (see Miyoshi, 1993).[10]

In engaging with this deceptive decentralization, a resistance which only reacts to the Eurocenter by narrating itself linearly in imitation of the model provided by the Eurocenter's narration of itself will fail, as it has in the past, when it crashes tangentially against the large political–economic wall the Eurocenter surrounds itself with. Nevertheless, some concepts and tactics of reactive resistance can be effective if combined with a new, more creative mode of resistance. Creative resistance could capitalize on the multiplicity of in-between timespaces situated around the wall's margins, by interlinking them to encircle the wall, and Wall Street, until it implodes upon itself.

We can now turn to explore in detail these modes of creative resistance, as well as how to combine reactive and creative resistances through the construction of hybridities, on the one hand, and the construction of essences, on the other.

Hybridity – the empire strikes b(l)ack

The wrenching of identity from anthropology's imposition of tribal time-space models has led to an increasing tendency to view culture solely as a

playful conjuncture. The English-speaking White liberal/progressive Left was so inspired by its uncritical absorption of apparently cosmopolitan theories situated in France after high colonialism, theories sensitive to power or gender but colorblind, that it started to come to terms with the failure of its humanistic project of modernizing the primitive. After all, the not-quite-White would always remain a non-White. So the avant-garde chose to perform reversal instead – primitivizing the modern.

Modernist ethnographic theory focused on suturing together the primitive and modern. This mending took place in distant timespace through a deployment of concepts of syncretism and bricolage.[11] But at least by the 1980s such mending became impossible. Alleged primitivities and modernities were colliding at the heart of the Eurocenter. The movements, flows, and interpenetrations of populations and cultural practices have frequently produced startling and creative juxtapositions and cultural fusions – phenomena that Guillermo Gomez-Pena, speaking of the Mexican-Unitedstatesian encounter, has dubbed the hi-tech Aztec, and the heavy metal Nahuatl (Fusco, 1989: 68). The products and processes of fusion and intermingling have been endowed with various names: hybridity, syncretism, cyborgs, interculturation, or transculturation. Despite the vibrancy of those hybrid and syncretic practices, when they are turned into prescriptive models or proclaimed as the only true forms of resistance and oppositionality, often it seems they are celebrated because they appear to replicate the familiar formal characteristics of the Western avant-garde – fragmentation, loss of subjecthood, self-conscious significations, and the blending of popular culture with high artistic forms. Such celebrations, based on textual productions in literature, cinema, and other domains that translate lived experience into highly stylized, mimetic artistic forms, and on the theoretical readings of such texts, once again exclude practices that are not so familiarly postmodern, and are discounted as simply realist, traditionalist, and essentialist. A new hierarchy of cultural practices has emerged, and the old category of the exotic is now occupied by the hybrid. Once again, the Other, now hybrid, is reinscribed by the Eurocenter. The hybrid appears out-landish and weirdly funny to the White Western audiences that consume these textual productions and the theoretical readings of them. This is because of the persistence of our primordial notions of culture as forever fixed and impermeable. Such visual/textual images, currently mobilized in new ethnographies, are now becoming the new terrain of the alien. These images deny Third World agencies and impose a passive mimicry (Bhabha, 1984, 1985), while locking active members of the Third and Fourth Worlds within the panopticon of the First (Jan-Mohamed, 1985).

While the White Western consumer perceives such hybrid articulations as bizarre juxtapositions, these are matters of routinized, everyday life for members of the margins (hooks, 1990: 23–31; Lowe, 1991; Lubiano, 1991). Hybrid products result from a confrontation of unequal cultures and forces. The stronger culture struggles to control, remake, or even eliminate the subordinate partner. But even in the case of meetings between

two sides whose relation is extremely imbalanced, the subordinate partner frequently manages to use for its own sly purposes the cultural elements it was forced to adopt, and rearranges them within a new ensemble (see Sarris, in press). Hybrids subversively appropriate and creolize master codes. They decenter, destabilize, and carnivalize dominance through 'strategic inflections' and 'reaccentuations' (Mercer, 1988: 57). The performances of Gomez-Pena, Marga Gomez, or Po-Mo Afro Homos represent distillations of quotidian flows of experience that occur when the center penetrates the margins, when the margins relocate into the center and force it to implode, and even when the margins stay put. Hybridities that result from the interminglings of disparate cultures necessarily implicate cultures that themselves are already syncretized, always in the process of transformation. All cultures turn out to be, in various ways, hybrid. Intercultural creations and miscegenations therefore expose as a hoax the modernist and colonialist claims that the Eurocenter is culturally homogeneous – a myth sustained only by the Center's stranglehold on the global political economy.

Syncretic practices are differentially gendered, raced and classed. There are no pre-given or singular models of hybridity guaranteed to be 'politically correct'. These creolized articulations mark a shift from the discourse of ethnicity, an inwardly directed discourse of difference, to the discourse of minority, a discourse of coalition politics confronting dominant state formations (Lloyd, 1992). From heterogeneous ethnic enclaves, the minority strikes b(l)ack, resisting the center's violent attempts to assimilate or destroy it. Such processes happen in the urbanscapes of the Eurocenter, where formerly colonized subjects have relocated (see Gilroy, 1987) as well as in geographically desolate zones (see Lavie, 1990; Narayan, in press), where tribes not only reinscribe the Third World nation-state in their fight against becoming homogenized citizenry, but also recast the history of the Eurocenter that 'worlded' the Third World (Spivak, 1985: 243).

Hybridity is a construct with the hegemonic power relation built into its process of constant fragmented articulation. A minority can form alliances with another, based on experiences its heterogeneous membership partially shares, each in his or her fragmented identity, without trying to force all fragments to cohere into a seamless narrative before approaching another minority. Having recognized that insisting on an all-or-nothing approach is counterproductive, minorities are building bridges among themselves based on such overlapping fragments. They tactically suspend their unshared historical specificities, at a price, for the moment. Yet one of the most intractable problems for creating such bridges is the history of the White Left practice, which misperceives the minorities' tactical syncretized articulations as a business-as-usual avant-garde free-floating fragmentation. Despite the post-structuralist collapse of the humanistic enterprise in theory, in practice the White Left still wants to privilege itself with the humanistic role of interlocutor between the various minorities (see Lavie, forthcoming; Mohanty, 1991: 11). This filter remains a bottleneck to the free flow of dialogue minorities need in order to sort out their historical

commonalities and differences. The White Left could best contribute to the inter-minority dialogue by getting out of the way and becoming an active listener rather than a patronizing participant.[12]

Rethinking essence

We live in human bodies that embody difference either because they refuse homogenization, or because they are not allowed to assimilate into the compulsory heterosexual, legally married, middle-class White citizenry. Such differences, however, are culturally learned and then naturalized as essence. We use the word 'nature' here, following the Frankfurt school's distinction between 'First Nature' and 'Second Nature'. First Nature is mute, obvious, and meaningless (see Lukacs, in Buck-Morss, 1989: 422) – pure objects outside the realm of production relations. To learn about First Nature, however, depends on the cultural process of knowing. This is complicated by the fact that the learned First Nature is as fragmentary and transitory as history, and history reads as 'a process of relentless disinte-gration' (Benjamin in Buck-Morss, 1989: 161, 422). Second Nature is the mimetic conjuring up of First Nature. Second Nature is thus always being produced and reproduced from an oscillatory movement between an imag-ined pure form of First Nature and its process of construction and decom-position (Taussig, 1992: 252).

'Second Nature' is comprised of reproductions which can be endlessly replicated. But because they seemingly flow from First Nature, they inspire or provoke a search for an uncontaminated and unruptured original. For minorities, this is a process of selecting one of many possible sets of experi-ences from their history, in order to narrativize it linearly, and frame it as the 'authentic representation'. Tradition, folklore, and realism are authenticity's preferred modes of enframing. Yet we wish to stress not only that such modes conceal hybridity, but also that hybridity is equally 'authentic'.

Here we take 'the "risk" of essence' (Fuss, 1989: 1; see Fusco, 1989: 65). 'Essence' has been defined as a natural property of a given entity, a prop-erty which through a process of transcendence becomes a pure form (see Fuss, 1989). Our discussion of nature, however, highlights it as a dialectic process of historical composition and decay, endlessly reproduced. Such Nature can be transcended only in thought, so even essence is a social construction. Just as we argue that essence is a social construction, we argue that a social construction can become an essence – become essen-tialized. Texts produced by anthropologists who frequented the Faculty Club provide vivid examples of this process. 'Too often, constructivists presume that the category of the social automatically escapes essentialism' (Fuss, 1989: 6).[13] Yet the anthropologists' model of the eternal tribe – their assumption of the naturalized fixity of social structure and organization Out There, unless impinged upon by forces of modernity from Here – demonstrates that even their construction of the social was indeed an essence.

Minorities appropriate ethnographic essentialism as a tactic to authenticate their own experience, as a form of reactive resistance to the Eurocenter (see Spivak, in McRobbie, 1985: 7). Often, this is a political necessity, particularly when the group or culture is threatened with radical effacement. Hybridity does not appear to be a viable tactic in the struggle for Palestine – a case of an exilic identity demanding to return to its historic territory (Swedenburg, 1991, 1992). Such is also frequently the case of Native Americans fighting ethnocide and forced relocation (Sarris, in press). In these contexts essentialism is a process of appropriating the concept of fixity of form and content from the Eurocenter for the margin's own recovery and healing. This is guerrilla warfare, not a war of position – it is a fight against not the Eurocenter's hegemony, but its domination (Gramsci, 1971: 52–7). The tactical acts of appropriation and re-creation must be concealed and denied in such battles even though these non-Eurocentric cultures are themselves hybrid. These processes of essentialization/naturalization (Taussig, 1992) are twofold. Minority national movements want to establish their own cohesive grand narrative as a countercanon to that of the Eurocenter. Such racial/ethnocentric movements also wish to eliminate the role of the White Left as an interlocutor between them. They appropriate the ethnographic method of cross-cultural comparison, hoping that the overlap in their essentialized narratives of resistance and oppositionality would be sufficient for these groups, threatened with effacement, to communicate with each other in order to build coalitions.

Taking the risk of essence, constructed, calls for remapping the terrain between identity-as-essence and identity-as-conjuncture. This undertaking allows us to remap the hybrid space, undevoided of its situated hegemonic construction. Social analysis can thus move beyond the boundaries of the concept of culture that is based on the interplay of alterities that clash only around the essence pole or the conjuncture pole.

Between and among – diasporas, borders and the third timespace[14]

The significance of a new jumble of cultural practices, located in the terrain that calls for yet paradoxically refuses boundaries, invites analysis. This terrain is situated in the borderzone between identity-as-essence and identity-as-conjuncture. Such practices challenge the ludic play with essence and conjuncture as yet another set of postmodernist binarisms.

Much work on resistance has been response-oriented, reacting to the Eurocenter by occupying either the essence pole or the hybrid pole. While the racialized margins succeeded in staking out a territory where they came to voice and gained power, their response-oriented discourse was unable to interrogate effectively and expose Whiteness as a racial category.[15] We stake out a terrain old in experience and memory but new in theory, a third timespace,[16] and we call for its ethnographic examination. This is a terrain where opposition is not only responsive, but creative. It is a guerrilla warfare of the interstices, where minorities rupture categories of race,

gender, sexuality, class, nation, and empire in the center as well as on the margins. The third timespace goes beyond the old model of culture, but not as another fixity – it designates phenomena too heterogeneous, mobile, and discontinuous for that, on the one hand, while remaining anchored in the politics of history/location on the other (Mohanty, 1987; M. B. Pratt, 1984).

Diaspora, an 'out-of-country, ... even out-of-language' experience (Rushdie, 1991: 2), is one attempt to name this hodgepodge of everyday experience and its textual representations. Challenging our received notions of place, those spatial units of analysis like nation and culture, it accounts for one type of displacement. It refers to the doubled relationship, the dual loyalty that migrants, exiles and refugees have to places – their connections to the space they currently occupy and their continuing involvement with 'back home'. Diasporas frequently occupy no singular cultural space, but are enmeshed in a *circuit* of social, economic and cultural ties encompassing both the mother country and the country of settlement (Rouse, 1991). Diasporas call for reimagining the 'areas' of Area Studies as units of analysis that enable us to understand the dynamics of transnational cultural processes that challenge the conceptual limits imposed by national and ethnic/racial boundaries (see Gilroy, 1992b; Rafael, 1994). [17] Yet we wish to emphasize that diaspora is taken here 'beyond its symbolic status as the fragmentary opposite of an imported racial essence' (Gilroy, 1991: 15). Diaspora theories are derived from the historically specific experience of 'the Black Atlantic', a term that transnationalizes Area Studies by addressing the complex socio-economic and cultural interconnections between the Caribbean, Europe, Africa, and Afro-America (see Gilroy, 1992b, 1993; Hall, 1989: 75–9, 1990).[18]

Borders are another attempt to name this hodgepodge of everyday experiences and its textual representation. As in the case of diasporas, the border theories articulated by Chicana and Chicano cultural workers have emerged from everyday experience rooted in the boundary region between the US and Mexico. In a path-breaking book, Gloria Anzaldua, a Chicana Lesbian poet from a working-class South Texas background, is writing the ethnography of her community, devoid of the voyeuristic gaze of some of those who trained in Anthropology Here and went Out There to do fieldwork. For Anzaldua, the border is an 'open wound ... where the Third World grates against the First and bleeds. And before a scab forms it hemorrhages again, the lifeblood of two worlds merging to form a third country – a border culture' (Anzaldua, 1987: 2–3). Yet this culture moves beyond the reification of space. Anzaldua writes, 'a borderland is a vague and undetermined place created by the emotional residue of an unnatural boundary. It is in a constant state of transition' (Anzaldua, 1987: 3).

Borderzones are sites of creative cultural creolizations, places where criss-crossed identities are forged out of the debris of corroded, formerly (would-be) homogeneous identities, zones where the residents often refuse the geo-political univocality of the lines (Alarcon, in press). The border,

being both an 'intellectual laboratory and ... conceptual territory ... deconstruct[s] binary opposition' (Fusco, 1989: 53, 61). As such, the border is a process of deterritorialization that occurs both to, and between, the delimited political realities of a First World and the Third World. Yet borders are not just places of imaginative interminglings and happy hybridities to be celebrated. They are mobile territories whose constant clash with the Eurocenter's imposition of fixity of culture makes them minefields (see Fusco, 1989: 58). They are zones of loss, alienation, pain, death – spaces where 'formations of violence are continuously in the making' (Alarcon, in press).[19]

Borders and diasporas offer new units of analysis that resist and transcend national boundaries through their creative articulations of practices that demonstrate possible modes of corroding the Eurocenter by actively Third-Worlding it. Such Third-Worldings shove a mirror in the unwilling face of the Eurocenter, forcing it to examine its now-miscegenated Self (Chandler, in press). Yet studies of borders and diasporas tend to focus on the processual shuttling of peoples and capital between two distinct territorial entities. Such concepts moreover appear mainly in analyses of artistic textual representations of the shuttle, and therefore miss the fact that in practice, not all marginals take it. At times, imperialist capitalism writes off marginal timespaces, letting them die a slow death or self-destruct. In other times and places, people do not need to get on the shuttle because the Eurocenter will reach out to grab them right where they are (see Lavie, 1990; Narayan, in press). And even for those shuttling back and forth, the reasons for travel are as heterogeneous as the vehicles (see Cohen, 1987). Occasionally, literary theorists conceive migrants' experiences in such a way that the poetic ruminations of Salman Rushdie seem to be equivalent to the vagaries of the daily life of pious Muslim workers in Bradford (see Asad, 1993). But Rushdie's diasporic texts fissure the Eurocenter in ways very different from the practices of the London community which the media labels 'Bradford mullahs'. Before Iranian ayatollahs called for his execution and forced him into hiding, Rushdie was able to indulge in the postcolonial bohemian privileges of the borderzone. The Bradford immigrants still live dangerously on the racial borderline of neocolonialism.[20]

Borders and diasporas are phenomena that blow up – both enlarge and explode – the hyphen: Arab–Jew, African–American, Franco–Maghrebi, Black–British. Avoiding the dual axes of migration between the distinct territorial entities, the hyphen thus becomes the third timespace. A sense of time is created in the interstices between 'nonsynchronic fragments and essentialist nostalgia' (Hicks, 1991: 6). A space is charted in the interstices between the displacement of 'the histories that constitute it' (Bhabha, 1990: 211) and the rootedness of these histories in the politics of location. The third timespace is thus an imaginary homeland (Rushdie, 1991: 9) where 'the fragmentation of identity' is conceived *not* 'as a kind of pure anarchic liberalism or voluntarism, but ... as a recognition of the importance of the alienation of the Self in the construction of forms of solidarity ... [It] articulat[es] minority constituencies across disjunctive and

differential social positions [so that] political subjectivity as a multi-dimensional, conflictual form of identification' is mobilized and able to form coalition politics (Bhabha, 1990: 213, 220–1).[21] It is a timespace of the 'lives of those who dare to mix while differing ... [in] the realm in-between, where predetermined rules cannot fully apply' (Trinh, 1991: 157), the realm of 'subjects-in-the-making' (Trinh, 1989: 102). The third timespace is that of creativity and community, in spite of political skepticism. In it, subjects who are fragments of collectivities-that-were 'return to a derived identity and cultural heritage' (Trinh, 1991: 187).

Yet the hyphenated timespace is not a process of becoming a something, but a process that remains active and intransitive (Trinh, 1991: 161). This processual becoming 'does not limit itself to a duality between two cultural heritages. It leads, on the one hand, to an active "search of our mother's garden" ... – the consciousness of "root values" ...; and on the other hand, to a heightened awareness of the other "minority" sensitivities, hence of a Third World solidarity, and by extension, of the necessity for new alliances' (Trinh, 1991: 159).

But the Eurocenter craves borders and diasporas, because they invite its civilizing mission of taming them by absorbing them into its maw (see Anzaldua, 1987: 11).[22] In order to prevent border crossings from being 'both the "self" and "other" that they are', the Eurocenter operates its 'border-machine, with its border patrol agents, secondary inspection, helicopters, shifts in policy' (Hicks, 1991: xxv). Third timespaces, however, frustrate frontierization and throw the Eurocenter's policing energy back upon itself, thereby making the fissures between identity and place unmendable.

Both essences and conjunctures have created counter-institutions to challenge the institutions of the Eurocenter. But the third timespace, the borderzone between identity-as-essence and identity-as-conjuncture, resists institutionalization. Third timespaces refuse closure because they move through fluid, constantly shifting zones to create fissures in both institutions and counter-institutions. Paradoxically, however, they achieve their own arbitrary provisional closures, in order to enact agency toward dismantling the Eurocenter, or to enact identity politics beyond the reactive mode (see Hall, 1988: 45; Trinh, 1991: 158).

Third spaces, third texts, third scenarios are concepts articulated in the interdisciplinary field of Minority Discourse through usage of Cultural Studies methodologies. Thus the cultural materials currently analyzed by using the modalities of 'the third' are highly stylized domains of knowledge, framed as dramatic, literary, cinematic, artistic and musical texts. Bridging Ethnography, Cultural Studies, and Minority Discourse will be possible if we return to the primary daily realities from which such textual representations are derived. We call for reconceptualization, from lived identities and physical places, not just from texts, of the multiplicities of identity and place. As they are forced into constantly shifting configurations of partial overlap, their ragged edges cannot be smoothed out. Identity and place perpetually create both new outer borders, where the

overlap has not occurred, and inner borders between the areas of overlap and vestigial spaces of non-overlap. The grating that results from their forced combination sparks inchoate energies that mobilize and activate. The agency of coalition politics.

Third texts/third practices – methodological bridges

Developing an understanding of the interstices that constitute third time-spaces calls for revising the ethnographic method in order to displace the anthropological notion of Culture. Thus culture, decolonized, can mediate between studies of texts in Minority Discourse and Cultural Studies, and studies of lived experience by ethnographers.

Based on a simulated relation between theory and experience, and identity and place, Anthropology in the past played a pivotal role in establishing the concept of Culture. According to the anthropological definition, Culture always happened in the empire's outback. But the anthropological notion of Culture infiltrated the discourse the Eurocenter produced about itself, by being extended to encompass and buttress the imagined nation. Today, curiously, as the oppositional field of Cultural Studies mushrooms in the US academy, its orientation so emphasizes textuality that it views the text itself as a practice. Anthropology, decolonized or not, is rarely present. While Cultural Studies makes powerful interventions on issues of race, gender and difference, its tendency is to frame its inquiries around the study of Western geo-historical periods, Western culture (minority or majority) under Western capital, or Euro–US textual practices of literary and media productions (see Rooney, 1990: 23–4). Even when Culture à la Cultural Studies deigns to travel, its caravansary has its preferred anglophile vacation spots. India definitely wins out over Syria. Papua New Guinea is beyond the pale, unless encountered through deconstructing the Banana Republic catalog.[23] Ghettos and barrios are discussed only in the context of the Western metropole, not in Cairo or Bangkok.

But Culture is not only a cut'n'mix of films, soundtracks, new age advertisements, or great counter-hegemonic novels. It also includes everyday lived experience. Cultural Studies scholars might argue that when they merely enter libraries, archives, movie theaters, art galleries, or even New Age trekkie conferences, from a subaltern, racialized position of oppositionality, they go through the ethnographic experience. This experience rarely appears explicitly in their own texts, though traces of it may be discernable between the lines. Furthermore, theories derived from such experience take a shorter time to produce and publish, because the text to be analyzed is already there, in usually no more than a couple of languages, although embedded in its political/cultural fabric, which now is analyzed as well. Such research, however, does not involve a long-term immersion in minute everyday actions that cannot be theorized unless they make sense in retrospect (see Bruner, 1986), after the data has been translated from several languages into English – the imperialistic language required for being quoted and promoted. Thus experience-rooted analysis

finds itself lagging behind in its participation in the move to dismantle the phallogocentric theories of culture.[24]

Despite this, anthropologists currently working in third timespaces are deeply indebted to Cultural Studies, because it has enabled us to problematize our concepts of lived experience, and to deconstruct the process of fieldwork itself. Anthropology, therefore, has an important contribution to make to these burgeoning sites of criticism and resistance. Perhaps anthropology could help Cultural Studies avoid its threatened institutionalization in English literature departments. It is not our expectation that those trained in literary and archival methods will immediately undertake fieldwork in the Kalahari desert or in south-central LA. We do propose, though, that experience-rooted analysis of the quotidian must be integrated as a crucial method of enunciating the multivalent critique of culture. Such a critique, therefore, will not be limited only to reaction, but will provide necessary tools allowing the project of Cultural Studies cum Anthropology to chart the new geographies of identity. These geographies and histories of identity can be charted using Sandoval's groundbreaking contribution to Minority Discourse – the tactic of differential oppositional consciousness discussed above (Sandoval, 1991: 12–14). This tactic, the method of daily living and surviving in the third timespace, also calls for radical revisions of the ethnographic method.

Such revision demands rethinking of 'field' sites and 'home' sites. In the past the field was located in exotic and allochronic loci, radically different and distant from home. Yet when roughing it Out There, the fieldworker habitually took with him the necessary apparatus of his home institution, which he efficiently installed in his tent (see Rosaldo, 1986, 1989). Such well-outfitted forays are increasingly put into question. The standard ontology of fieldwork, based on the attempt to actively forget graduate coursework epistemologies, required one to return from the field brandishing a 'new' epistemology, 'the native point of view'. This new epistemology was to distill the entire history and present life of a society Out There, given a grand total of around twelve months to spend in the heart of darkness until the grant money ran out.

These days, we from Out There also live Here, perhaps next door, and read and protest our neighbors' depiction of us. We have Ph.D.'s in Anthropology ourselves, having survived the monochromatic élitist boot camp of graduate school. Some of us from Out There might even be invited to join The Faculty Club, and sit in decision-making rooms with those who used to rely on our silence in order to ethnograph us. Many of our colleagues are still irritated by our ability to talk back, and in multiple tongues: the language of Here, the language of Out There, and the languages of the third timespace. For us, field and home blur. Sites of research (what used to be roughing it in the field Out There) and sites of writing (what used to be the detached contemplation at home, Here) intermingle. Out There is still home.

The method of studying third timespaces requires an ongoing negotiation and renegotiation of positionalities, rather than a one-time journey

into a faraway wilderness. This method is a process Kamala Viswesvaran has termed 'homework'. Viswesvaran tries to understand why feminist 'field' work is what she terms 'failure ... a project that may no longer be attempted' (Viswesvaran, 1994). Acknowledgement of such failure, she argues, takes us homeward rather than away. She interrogates the moment when the practice of Anthropology at home became acceptable, and connects it to the move to decolonize Anthropology. This move assumes that 'a critical eye would necessarily be cast upon a whole range of practices at "home" which authorized American interventions in the "Third World"' (Viswesvaran, forthcoming). She distinguishes, however, between Anthropology at home, which, she points out, is still mainly practiced by White fieldworkers, and what she terms 'homework', when the White West is dehegemonized and studied as a fieldsite as well. In the process of decolonizing fieldwork and making it into homework, home is destabilized and cannot remain 'an illusion of coherence and safety based on the exclusion of specific histories of oppression and resistance, the repression of differences even within oneself' (Martin and Mohanty, 1986: 196). The moment of shifting from 'field'work to 'home'work signals a response to the failure of the Eurocenter to unlearn its own epistemologies, whether these are essentialist or conjuncturalist.

Doing homework as a consequence of breaking down the difference between ethnographer and subject of study, the ethnographer becomes engaged, blowing up, both enlarging and exploding, the oxymoronic hyphenated identity of participant-observer by taking an active role in the shaping of her home (Kondo, in press). This is no longer the safe Eurocentric home, rooted in Whiteness from time immemorial. Rather, it is the diasporic-at-home, whose geography and identity are multiply positioned and in flux. Like Anzaldua, she becomes the chronicler of third timespaces by involving herself in making culture, not only by producing ethnographic texts, but also by engaging in political activism (see Fusco, 1989: 70).

Such movements within and between various positionalities call for dismantling the method of detached narration through naturalized observation. Capturing the fragmented, rapidly shifting registers and modalities of the forces that shape everyday life in third timespaces requires writing by mixing and juxtaposing genres.[25] She needs to be a multicultural 'smuggler ... choos[ing] a strategy of translation rather than representations ... [in order to] ultimately undermine the distinction between original and alien culture' (Hicks, 1991: xxxi, xxiii; see Bhabha, 1990: 209). She needs to acknowledge her presence in the construction of her text, writing it up in the 'polyphonic montage technique developed by DuBois in *The Souls of Black Folk*' (Gilroy, 1991: 14). But the polyphonies should not succumb to her writer's authority. When she writes up third timespaces, she ought to 'gather and reuse' (Tawadros, 1989) theories as tactics of her guerrilla toolkit, so that she creates an organic connection between such theories and the quotidian flows of experience that led to their articulation.

The shift from 'field' to 'home' opens up more third timespaces in the

interstices between the raw experiences of the everyday, and the mimetic texts about them. Just as identity and place grate up against each other, and are forced into constantly shifting configurations of partial overlap, so do the locations of home and of field, and those of text and experience, scrape up against each other, only partially overlapping, creating methodological borders along their contiguities. These realignments of the formerly hierarchical arrangement of the power/knowledge binarism are redefining not only our work, but Anthropology itself.

Acknowledgements

This essay began as an attempt to write an introduction to our forthcoming edited collection, *Displacement, Diaspora, and Geographies of Identity* (Duke University Press). As the attempt was becoming a failure, the ideas took on a life of their own, as they traveled between and among Irvine, Berkeley, Tel Aviv, Cairo, Palo Alto and Washington DC. We started contemplating third times and spaces as we wrote the abstract for an American Anthropological Association 1991 panel, bearing the same title as the book. Thanks to Abdul R. JanMohamed, in spring 1992 we presented a sketchy draft of the essay to the Minority Discourse 'Dependency and Autonomy: The Relation of Minority Discourse to Dominant Culture' collaboration at the Humanities Research Institute of the University of California, Irvine. There we benefited from the careful readings of Norma Alarcon, Abdul JanMohamed, and Cedric Robinson. We also wish to thank all the contributors to our edited collection for their critical engagement with these materials. In particular, we thank Ruth Frankenberg, Dorinne Kondo, Kristen Koptiuch, Lata Mani, Kirin Narayan, and Greg Sarris. We are grateful for Anna Tsing, whose long letter helped us to bring forward the main themes of the essay. Helpful and encouraging as well were comments at presentations of earlier drafts of this paper at the Unit for Criticism and Interpretive Theory of the University of Illinois at Champaign-Urbana, the Department of Anthropology at the University of California, Davis, the Department of Anthropology at the London School of Oriental and African Studies, and the Center for Critical and Cultural Theory at the University of Wales, College of Cardiff.

Notes

1 We find Raymond Williams's definition of these two categories of culture very helpful in tracing the historical development of the concepts 'Here' and 'Out There' (Williams, 1983: 87–93). Given the weighty influence of his work on the history of the field of Cultural Studies, one can attribute to this distinction the chasm that has opened up between Cultural Studies and Anthropology. Cultural Studies chose to dismantle the concept of 'culchah', collapsing the boundaries between its 'high' and 'low' components, while rejecting wholesale the anthropological notion of culture, regarding it as a colonial allegory. As

anthropologists who work in the Israel/Palestine minefield, and thus constantly pay a professional price for our political activism in both academia and the public sphere, we applaud the Cultural Studies dismantling project, but wish to salvage whatever may be of value in the anthropological method of studying culture, in order to bridge this historical rift.

2 A good example of such colonial temporal analysis of the relationship between communal space and time can be found in Leach (1961).

3 Although some of these works were written by women anthropologists, they still succumb to the White and androcentric premises of the profession.

4 Given the popularity of hermeneutics in fields such as Theoretical Particle Physics, we consider it, along with the others mentioned, a scientific model.

5 Here we differ from Clifford (1986), who conceives of Ethnography as an allegory of salvaging a culture by redeeming it in text. While attuned to the salvage aspects of the allegory, we wish to emphasize the alleged scientific nature of its modeling. Our own ethnographies, despite their overt anticolonial positions, are rigorously studied by the oppressive regimes against which they are written.

6 This insightful model developed by Taussig (1987) is drawn from his extensive fieldwork and archival research in Columbia.

7 They thus more or less routinized their charisma (see Weber, 1946).

8 While this image of mosaic was attributed to culture in the 1950s (see Coon, 1951), its pieces in those days were assumed to be distinctive and impermeable.

9 Appiah (1991) provides a somewhat cynical discussion on the relationship between postmodernity and postcoloniality. Shohat (1992), Coombes (1992), Frankenberg and Mani (1993), and McClintock (1992) provide eloquent analyses of the 'post''s fake temporality and lack of a situated political edge.

10 In his recent bold critique of the institutionalization of 'post'coloniality as the cutting edge in English literature departments, Miyoshi (1993) charts the relationships between the inscription of postcoloniality and the erasure of multinational corporate economics from the agenda of liberal/progressive academe.

11 Concepts of syncretism and bricolage arose in Western Europe in opposition to the US theories of acculturation (see Levi-Strauss, 1966: 17–33; Worsley, 1968). Narayan (1993: 498, 503) suggests that we need to take a closer look at US anthropologists' earlier theories of cultural contact such as diffusionism and acculturation. She notes as well that such theories assume a culture/space homogeneity and ignore power inequalities.

12 The genealogy of the White Left's attempts to dismantle 'the master's house' with 'the master's tools' can be traced to Audre Lorde (1984). Yet a germinal essay by Diana Jeater (1992) suggests that considerable work, both academic and activist, needs to be done in order for progressive Whites to participate in the dismantling project. Whiteness as a category needs to be interrogated so that the hybridity built into the category 'whiteness' brought to the surface of both social relations and the analytical discourse about them. Instead of progressive Whites borrowing/exploring/putting on/exoticizing the trappings of other ethnicities, they need to radicalize and deprivilege their own.

13 See also the groundbreaking article by Epstein (1987), which, we assume, permitted Fuss (1989) to take 'the risk of essence'.

14 For this discussion, we trace the anthropological genealogy of our thinking to the germinal (seminal?) work of Gupta and Ferguson (1992), to whom we are gratefully indebted.

15 A brilliant recent body of feminist work written from the intersection of race, gender and sexuality with categories of nation and empire, is analyzing Whiteness as a racial category (Bloom, 1993; Frankenberg, 1993; Ware, 1992).

16 A third space, without the temporal component, was suggested as an option for theoretical exploration by Bhabha (1990). While Bhabha's third space lacks the feminist-of-color concept of the politics of location, Trinh (1991), writing from the positionality of a woman of color, theorizes the time element of this space, and anchors this third space/time grid in the politics of location, in'The third scenario: no light no shade' (Trinh, 1991: 155–236). Bhabha and Trinh theorize this space from texts. We call for examination of the everydayness of this space and time.

17 In a recent article Rafael (1993) characterizes Area Studies as reproductions of the Orientalism that underwrites the discourse of plural liberalism which depends on First World government funding. Using as an example Southeast Asian Studies, he calls for the radical revision of Area Studies in order to put at its crux what he terms 'immigrant imaginary' to relocate the bits and pieces of a so-called area which thus can no longer be visible as the seamless Out There.

18 A different historically specific example of a diasporic circuit is the Levant. The founding of the European, Zionist settler state of Israel in Palestine displaced both Arabs and Jews who were historically situated in the Levant. This is examined in the pioneering work of Alcalay (1993) and Shohat (1989). Other Middle Eastern conceptualizations of diasporic circuits examine the North Africa/Western Europe axis (Gross, McMurray and Swedenburg, in press, and McMurray, forthcoming) and the Iran/Los Angeles axis (Naficy, 1991).

19 The case of Palestine/Israel provides a historically specific site for studying borders as well. Lavie (1992) and Torstrick (1993), enacting a 'traveling theory' à la Said (1983), find out through ethnographic examination that unlike the Said argument, that theory tends to mellow as it travels, Chicana/o border theory gets radicalized on its journey to the Arab/Israeli borderlands.

20 On postcoloniality, see Shohat (1992), Coombes (1992), Frankenberg and Mani (1993), and McClintock (1993).

21 While we have reservations about Bhabha's path-breaking early work on colonial mimicry, due to its underemphasis on the possibility of subaltern agency, we find this deficiency remedied in his current work, from which we quote here.

22 The articulation of the history of the Eurocenter's voracious appetite for frontiers can be traced to the turn of the century, with the work of F. J. Turner (1963/1893).

23 This, despite the fact that Papua New Guinea has enjoyed a celebrated status similar to that of India in the history of British Anthropology.

24 Yet at the same time we acknowledge the limitations of a socio-historical understanding based solely on experience conceived as a methodological fetish, given that many historical structures and movements are inaccessible to field-work-based experience. This caution is discussed in Asad (1994).

25 Examples of such juxtapositions are the pioneering feminists-of-color anthologies *This Bridge Called My Back: Writings by Radical Women of Color*, edited by Cherrie Moraga and Gloria Anzaldua (1983), *All the Women Are White, All the Blacks are Men, But Some of Us Are Brave*, edited by Hull *et al.* (1982), and *Making Face, Making Soul, Haciendo Caras: Creative and Critical Perspectives by Women of Color*, edited by Anzaldua (1990), published in the

US, and *Charting the Journey: Writings by Black and Third World Women*, edited by Grewal *et al.* (1988) and published in England. A forthcoming anthropological anthology with the same aims, *Women Writing Culture*, edited by Ruth Behar and Deborah Gordon, also mixes genres of writing and traces their historical trajectory.

References

Alarcon, Norma (1990) 'The theoretical subject(s) of *This Bridge Called My Back* and Anglo-American Feminism', in Anzaldua (1990): 356–69.

—— (in press) 'Anzaldua's *Frontera*: inscribing gynetics', in S. Lavie and T. Swedenburg (eds), *Displacement, Diaspora, and Geographies of Identity*, Duke University Press (in press).

Alcalay, Ammiel (1993) *After Jews and Arabs: Remaking Levantine Culture*, Minneapolis: University of Minnesota Press.

Anzaldua, Glora (1987) *Borderlands/La Frontera: The New Mestiza*, San Francisco: Spinsters/Aunt Lute.

—— (1990) editor, *Making Face, Making Soul, Haciendo Caras: Creative and Critical Perspectives by Feminists of Color*, San Francisco: Aunt Lute.

Appadurai, Arjun (1990) 'Disfuncture and difference in the global cultural economy', *Public Culture*, 2(2): 1–24.

Appiah, Kwame Anthony (1991) 'Is the post- in postmodernism the post- in postcolonial? *Critical Inquiry*, 17(2): 336–57.

Asad, Talal (1993) *Genealogics of Religion*, Baltimore: Johns Hopkins University Press.

—— (1994) 'Ethnographic representation, statistics and modern power', *Social Research* 61(1): 55–89.

Balibar, Etienne (1991) 'Is there a 'neo-racism'?' in E. Balibar and I. Wallerstein, *Race, Nation, Class: Ambiguous Identities*, London: Verso: 17–28.

Behar, Ruth and Gordon, Deborah (in press) *Women Writing Culture*, Berkeley: University of California Press.

Bhabha, Homi (1984) 'Of mimicry and man: the ambivalence of colonial discourse', *October*, 28: 125–33.

—— (1985) 'Signs taken for wonders: questions of ambivalence and authority under a tree outside Delhi, May 1817', *Critical Inquiry*, 12(1): 144–65.

—— (1990) 'The third space: interview with Homi Bhabha', in Rutherford (1990): 207–21.

Bloom, Lisa (1993) *Gender on Ice: American Ideologies of Polar Expeditions*, Minneapolis: University of Minnesota Press.

Bruner, Edward M. (1986) 'Experience and its expressions', in V. W. Turner and E. Bruner (eds), *The Anthropology of Experience*, Urbana, IL: University of Illinois Press: 3–30.

Buck-Morss, Susan (1989) *The Dialectics of Seeing: Walter Benjamin and the Arcades Project*, Cambridge: The MIT Press.

Cabral, Amilcar (1973) *Return to the Source: Selected Speeches of Amilcar Cabral*, New York: Monthly Review Press.

Chandler, Nahum (in press) 'The signification of the autobiographical in the work of W. E. B. DuBois', in Lavie and Swedenburg (in press).

Chatterjee, Partha (1986) *Nationalist Thought and the Colonial World: A Derivative Discourse?*, London: Zed Books.

Clifford, James (1986) 'On ethnographic allegory', in Clifford and Marcus (1986): 98–121.

Clifford, James and Marcus, G. (1986) editors, *Writing Culture: The Poetics and Politics of Ethnography*, Berkeley, CA: University of California Press.

Cohen, Robin (1987) *The New Helots: Migrants in the International Division of Labour*, Aldershot: Grower Publishing Company.

Coombes, Annie E. (1992) 'Inventing the 'postcolonial': hybridity and constituency in contemporary curating', *New Formations*, 18: 39–52.

Coon, Charles S. (1951) *Caravan: The Story of the Middle East*, New York: Holt.

DuBois, W. E. B. (1903) *The Souls of Black Folk*, Chicago: McClurg & Co.

Epstein, Steven (1987) 'Gay politics, ethnic identity: the limits of social construction', *Socialist Review*, 17(3/4): 9–54.

Fabian, Johannes (1983) *Time and the Other: How Anthropology Makes its Object*, New York: Columbia University Press.

Fanon, Frantz (1963) *The Wretched of the Earth*, New York: Grove Weidenfeld.

Feuchtwang, Stephen (1985) 'Fanon's politics of culture: the colonial situation and its extension', *Economy and Society*, 14(4): 450–73.

Frankenberg, Ruth (1993) *White Women, Race Matters:* The Social Construction of Whiteness, Minneapolis: University of Minnesota Press.

Frankenberg, Ruth and Mani, Lata (1993) 'Crosscurrents, crosstalk: race, "postcoloniality" and the politics of location', *Cultural Studies*, 7(2): 292–310.

Fusco, Coco (1989) 'The Border Art Workshop/Taller de Arte Fronterizo: Interview with Guillermo Gomez-Pena and Emily Hicks', *Third Text*, 7: 53–76.

Fuss, Diana (1989) *Essentially Speaking: Feminism, Nature, and Difference*, New York: Routledge.

Gilroy, Paul (1987) *There Ain't No Black in the Union Jack: The Cultural Politics of Race and Nation*, London: Hutchinson.

—— (1991) 'It ain't where you're from, it's where you're at ... the dialectics of diasporic identification', *Third Text*, 13: 3–16.

—— (1992a) 'Masters, slaves, and the antinomies of modernity', a talk given at the Center for Comparative Studies in History, Culture and Society, University of California at Davis, 6 April.

—— (1992b) 'Cultural studies and ethnic absolutism', in Grossberg *et al.* (eds): 187–98.

—— (1993) *The Black Atlantic: Modernity and Double Consciousness*, Cambridge: Harvard University Press.

Gramsci, Antonio (1971) *Selections from the Prison Notebooks*, New York: International Publishers.

Grewal, Shabnam, Kay, Jackie, Landor, Liliane, Lewis, Gail and Parmar, Pratibha (1988) editors, *Charting the Journey: Writings by Black and Third World Women*, London: Sheba Feminist Publishers.

Gross, Joan, McMurray, David and Swedenburg, Ted (in press) 'Arab noise and Ramadan nights: *Rai*, rap, and Franco-Maghrabi identities', *Diaspora*, 1, 3–39.

Grossberg, Lawrence, Treichler, Paula and Cary, Nelson (1992) *Cultural Studies*, New York and London: Routledge.

Gupta, Akhil and Ferguson, James (1992) 'Beyond 'culture': space, identity, and the politics of difference', *Cultural Anthropology*, 7(1): 6–22.

Hall, Stuart (1988) 'New ethnicities', *ICA Documents*, 7: 27–31.

—— (1989) 'Cultural identity and cinematic representation', *Framework*, 36: 68–81.

—— (1990) 'Cultural identity and diaspora', Rutherford (1990): 222–37.

Harvey, David (1989) *The Condition of Postmodernity*, Oxford: Basil Blackwell.
—— (1991) 'Flexibility' threat or opportunity?' *Socialist Review*, 21(1): 65–78.
Hicks, Emily (1991) *Border Writing: The Multidimensional Text*, Minneapolis: University of Minnesota Press.
hooks, bell (1990) 'Postmodern Blackness', in *Yearning: Race, Gender, and Cultural Politics*, Boston: South End Press: 23–31.
Hull, Gloria T., Scott, Patricia B. and Smith, Barbara (1982) editors, *All the Women Are White, All the Blacks are Men, But Some of Us Are Brave*, Westbury, NY: Feminist Press.
JanMohamed, Abdul R. (1985) 'The economy of Manichean allegory: the function of racial difference in colonialist literature', *Critical Inquiry*, 12(1): 59–87.
Jeater, Diana (1992) 'Roast beef and reggae music: the passing of whiteness', *New Formations*, 18: 107–21.
Kondo, Dorinne (in press) 'The narrative production of 'home', community, and political identity in Asian American theatre', in Lavie and Swedenburg (in press).
Koptiuch, Kristin (1991) 'Third-Worlding at home', *Social Text*, 29: 87–99.
Lavie, Smadar (1990) *The Poetics of Military Occupation: Mzeina Allegories Under Israeli and Egyptian Rule*, Berkeley: University of California Press.
—— (1992) 'Blow-ups in the borderzones: Third World Israeli authors' gropings for home', *New Formations*, 18: 84–105.
—— (forthcoming) 'Silenced from all directions: Third World Israeli women writing in the race/gender borderzone of the nation', in N. Alarcon, K. Kaplan and M. Mooalem (eds), *Between Women and Nation*, Durham: Duke University Press.
Lavie, Smadar, Narayan, Kirin and Rosaldo, Renato (1993) editors, *Creativity/ Anthropology*, Ithaca: Cornell University Press.
Lavie, Smadar and Swedenburg (in press) editors, *Displacement, Diaspora, and Geographies of Identity*, Duke University Press.
Leach, Edmund L. (1961) 'Two essays concerning the symbolic representation of time', in *Rethinking Anthropology*, London: Athlone Press: 124–136.
Levi-Strauss, Claude (1966) *The Savage Mind*, Chicago: The University of Chicago Press.
Lloyd, David (1992) 'Ethnic cultures, minority discourse, and the state', presented at the weekly seminar of the Minority Discourse Research Group, University of California, Irvine: Humanities Research Institute, 21 February.
Lorde, Audre (1984) 'The master's tools will never dismantle the master's house', in *Sister Outsider: Essays and Speeches by Audre Lorde*, Freedom, CA: The Crossing Press: 110–13.
Lowe, Lisa (1991) 'Heterogeneity, hybridity, multiplicity: marking Asian American differences', *Diaspora*, 1(1): 24–43.
Lubiano, Wahneema (1991) 'Shuckin' off the African–American native other: what's 'Po-Mo' got to do with it?', *Cultural Critique*, Spring: 149–86.
Martin, Biddy and Mohanty, Chandra Talpade (1986) 'Feminist politics: what's home got to do with it?', in Teresa de Lauretis (ed.), *Feminist Studies/Critical Studies*, Bloomington: University of Indiana Press: 191–212.
McClintock, Anne (1992) 'The angel of progress: pitfalls of the term "postcolonialism"', *Social Text*, 31/32: 84–98.
McMurray, David (forthcoming) 'The impact of international Labor Migration on the culture of Nador, Morocco', University of Minnesota Press.
McRobbie, Angela (1985) 'Strategies of vigilance: an interview with Gayatri Chakravorti Spivak', *Block*, 10: 5–9.

Mercer, Kobena (1988) 'Diaspora culture and the dialogic imagination', in Mbye B. Cham and Claire Andrade-Watkins (eds), *Blackframes: Critical Perspectives on Black Independent Cinema*, Cambridge: MIT University Press: 40–61.

Miyoshi, Masao (1993) 'A borderless world? From colonialism to transnationalism and the decline of the nation-state', *Critical Inquiry*, 19(4): 726–51.

Mohanty, Chandra Talpade (1987) 'Feminist encounters: locating the politics of experience', *Copyright*, 1: 30–44.

—— (1991) 'Cartographies of struggle: Third World women and the politics of feminism', in Chandra Talpade Mohanty, Ann Russo, and Lourdes Torres (eds), *Third World Woman and the Politics of Feminism*, Bloomington: University of Indiana Press: 1–47.

Moraga, Cherrie and Anzaldua, Gloria (1983) editors, *This Bridge Called My Back: Writings by Radical Women of Color*, New York: Kitchen Table Press.

Naficy, Hamid (1991) 'The poetics and practice of Iranian nostalgia in exile', *Diaspora*, 1(3): 285–302.

Narayan, Kirin (1993) 'Refractions of the field at home: American representations of Hindu holy men in the 19th and 20th centuries', *Cultural Anthropology*, 8(4): 476–509.

—— (in press) 'Songs lodged in some hearts: displacements of Indian women's knowledge at home', in Lavie and Swedenburg (in press).

Pratt, Mary Louis (1986) 'Fieldwork in common places', in J. Clifford and G. Marcus (eds), *Writing Culture: The Poetics and Politics of Ethnography*, Berkeley: University of California Press: 27–50.

Pratt, Minnie Bruce (1984) 'Identity: skin blood heart', in Elly Bulkin, Minnie Bruce Pratt and Barbara Smith (eds), *Yours in Struggle: Three Feminist Perspectives on Anti-Semitism and Racism*, Brooklyn: Long Haul Press: 11–63.

Rafael, Vincente (1993) 'The cultures of area studies in the US', *Social Text*, Winter 1994 (41): 91–112.

Rooney, Ellen (1990) 'Discipline and vanish: feminism, the resistance to theory, and the politics of cultural studies', *Differences*, 2(3): 14–28.

Rosaldo, Renato I. (1986) 'From the door of his tent: the fieldworker and the inquisitor', in Clifford and Marcus (1986): 77–97.

—— (1989) *Culture and Truth: The Remaking of Social Analysis*, Boston: Beacon Press.

Rouse, Roger (1991) 'Mexican migration and the social space of postmodernism', *Diaspora*, 1(1): 8–23.

Rushdie, Salman (1991) *Imaginary Homelands*, London: Granta Books.

Rutherford, Jonathan (1990) *Identity: Community, Culture, Difference*, London: Lawrence & Wishart.

Said, Edward (1983) 'Traveling theory', in *The World, The Text, and the Critic*, Cambridge: Harvard University Press.

Sandoval, Chela (1991) 'U.S. Third World feminism: the theory and method of oppositional consciousness in the postmodern world', *Genders*, 10: 1–24.

Sarris, Greg (in press) 'Living with miracles: the politics and poetics of writing American Indian resistance and identity', in Lavie and Swedenburg (in press).

Shohat, Ella (1989) *Israeli Cinema: East/West and the Politics of Representation*, Austin: University of Texas Press.

—— (1992) 'Notes on the 'post-colonial'', *Social Text*, 30/31: 99–113.

Spivak, Gayatri Chakravorty (1985) 'The Rani of Sirmur', in F. Barker *et al.* (eds), *Europe and Its Others*, Vol. 1, Colchester: University of Essex Press: 128–51.

Swedenburg, Ted (1991) 'Popular memory and the Palestinian national past', in J.

O'Brian and W. Roseberry (eds), *Golden Ages, Dark Ages: Imagining the Past in History and Anthropology*, Berkeley: University of California Press: 152–79.

—— (1992) 'Occupational hazards revisited: reply to Moshe Shokeid', *Cultural Anthropology*, 7(4): 478–95.

Taussig, Michael (1987) *Shamanism, Colonialism, and the Wild Man: A Study in Terror and Healing*, Chicago: University of Chicago Press.

—— (1992) *Mimesis and Alterity: A Particular History of the Senses*, New York: Routledge.

Tawadros, Gilane (1989) 'Beyond the boundary: the work of three black women artists in Britain', *Third Text*, 8/9: 121–50.

Torstrick, Rebecca L. (1993) 'Raising and rupturing boundaries: the politics of identity in Acre, Israel', Ph.D. dissertation submitted to the department of Anthropology, Washington University, St Louis.

Trinh, Minh-ha T. (1989) *Woman, Native, Other: Writing Postcoloniality and Feminism*, Bloomington: Indiana University Press.

—— (1991) *When the Moon Waxes Red*, New York: Routledge.

Turner, Frederick Jackson (1963 [1893]) *The Significance of the Frontier in American History*, edited, with an introduction, by Harold P. Simonson, New York: Frederick Ungar Publishing.

Visweswaran, Kamala (1994) *Fictions of Feminist Ethnography*, Minneapolis: University of Minnesota Press.

Ware, Vron (1992) *Beyond the Pale: White Women, Racism and History*, London: Verso.

Weber, Max (1946) 'The sociology of charismatic authority', in H. H. Gerth and C. Wright Mills (eds and trans.), *From Max Weber: Essays in Sociology*, New York: Oxford University Press: 245–52.

Williams, Raymond (1983) *Keywords: A Vocabulary of Culture and Society*, New York: Oxford University Press.

Worsley, Peter (1968) *The Trumpet Shall Sound: A Study of 'Cargo' Cults in Melanesia*, New York: Schocken.

Problems of Perspective

Jim Cook

■ Lester Friedman (ed.), *British Cinema and Thatcherism* (London: UCL Press Ltd, 1993) 320pp., ISBN 1 85728 072 5 £35 Hbk, ISBN 1 85728 073 3 £12.95 Pbk.

This book presents the usual problem of anthology reviewing which is to balance comment on the general aims of the collection with some assessment both of the appositeness of the individual contributions to the realization of those aims and, which is often not the same thing, of the individual contributions' intrinsic interest. This particular anthology also presents reviewing problems of its own which derive from its origins in the North American growth industry of promiscuous publication of books about cinema, a strategy designed as much to drive as feed the home educational market and also to achieve sales in various overseas territories. For a British reviewer, therefore, when the chosen territory comprises a 'local' publishing industry already investing heavily in books about media, an educational market individually and institutionally strapped for cash and consequently needing to shop carefully, and a discursive terrain which potential buyers are likely both to have an investment in and curiosity about, then finding the appropriate criteria for assessing and evaluating the book becomes quite problematic.

At this point in case it's not self-evident a disclaimer must be made that where negative assessments appear in this review they are not born out of a critical little Englandism, churlishly refusing the qualifications of 'others' to investigate 'our' cinematic culture. After all, for a long time American cinema was the unproblematic site for critical writing emanating from all over the world, and in a reverse movement books such as Marcia Landy's (1991) work on British cinema attest to the productivity of an outsider's view. Furthermore a number of the contributors to this volume are anyway not Americans but ex-pat Brits (Wollen, Giles, Lant and Williams) or 'home'-based Brit (Higson) or European (Elsaesser). The point is rather that overall the book simply does not live up to its title. Rather than pursuing a coherent analysis of the phenomenon 'Thatcherism' and of its effect on a specific cultural industry, the book presents a series of essays on aspects of British film-making in the 1980s and this must be in large part an entailment of its being in effect a general overview anthology about British cinema targeted primarily at the North American college-student market where arguably such generality is sufficient. Whether the gap between the title's promise and what is delivered will be as easily surmountable for a British readership is a more open question which I hope to pursue throughout this review.

The key consequence of the book's provenance is that the *Zeitgeist*; base:super-structure; text:context, call it what you will, problematic is never directly addressed despite the editor's prefatory claim that 'the writers in this anthology situate these texts into an amalgam of cultural, social, institutional, and historical conditions' (p. xviii). Thus for all the prominence given to '*Thatcherism*' in the title and in regular footnote references in individual essays to analysts such as Hall, Skidesky, Minogue and Biddiss *et al.* nowhere is there offered a consistent working account of either the phenomenon as manifest at broad economic and cultural levels nor, more

seriously, of its effects on the financing, production, distribution and exhibition of British movies in the 1980s. This absence in the body of the text is particularly marked given the inclusion of two epigraphs from Peter Sainsbury and Geoffrey Nowell-Smith where issues of industry, government, financial provision and cultural policy are quite properly offered as being of fundamental importance.

What in fact we are offered in the only essay directly addressing the terms of the anthology's title – Leonard Quart's 'The religion of the market: Thatcherite politics and the British film of the 1980s' – is a quite useful overview of Thatcher's broad political trajectory, expressed somewhat archaically (and therefore reductively?) – 'Thatcher recreated the Tory Party by taking power out of the hands of the squirearchy and aristocracy' etc.; of Thatcherism's impact upon lifestyle – 'acquisitive individualism and aggressive self-interest'; and of institutional and individual liberal/left creative revulsion and reaction. This is then followed by observations on films deemed to endorse Thatcherism (*Chariots of Fire* [1981]) or to criticize it (*Brittania Hospital* [1982], *The Ploughman's Lunch* [1983], *My Beautiful Laundrette* [1985], *High Hopes* [1988], etc). (Such criticisms are presumably the fires which were started and 'explain' the otherwise mysterious 'Fires were Started' which appears as a subtitle on the book's title page but not on its cover).

Given the undoubted complexities entailed in trying to explain Thatcherism to a prime-target audience of North American college students the limitations in this account are perhaps understandable. More worrying, since ways of rendering the account more sophisticated are available and accessible (Barr, 1986; Hill, 1986; Murphy, 1989) is the editor's approach to British cinema where a preference for auteurist accounts is set against 'a world dominated by poststructuralist thought' and defended on the grounds that 'one person (often the director) must ultimately decide what is and is not included in the final work' (p. xv). (I assume the editor's own authorial stamp is present in the colons which relentlessly punctuate each essay's title.) In Friedman's introductory essay 'The Empire strikes out: an American perspective on the British film industry', the auteurist proposition leads to the suggestion of a kind of collective (un?)consciousness among British film-makers whereby 'the British cinema depicts a persistent vision of irreconcilable binary opposites: of working class and management, of capitalism and socialism, of the lower and upper classes engaged in a ceaseless war against each other' (p. 8). In the Preface a particular manifestation of this condition is proposed for the 1980s in which 'the only common element connecting these directors is their revulsion, to one degree or another, for the ideology of Thatcherism, though their methods of expressing that distaste cover the spectrum of aesthetic options' (p. xix). For Quart the entailment of following the Friedman programme is the accounts referred to above where individual directors do or don't contest Thatcher in particular ways. The limitations of this approach are clearly evident in his comments on *My Beautiful Laundrette* where a concern with Frears' and Kureishi's depiction of 'Thatcher's England as dominated by racism, greed and social injustice' (p. 32) blocks any engagement with the film's confused fantasies around the imbrications of race and sexuality.

In other words what's absent in these overview pieces although, as with the political analyses, more sophisticated accounts like those of Barr (1986), Hill (1986) and Murphy (1989) are regularly cited, is any engagement with the historical and textual methodologies which in the past decade have productively been brought to bear on descriptions of British cinema's dominant narrative and representational strategies: its dialectical play between realism and melodrama; its complex traditions of comedy; its predilection for the specificities of place and landscape.

If these overview essays constitute the weakest part of the book and thus bring into question its ability adequately and coherently to justify its title, the very incoherence and lack of a sustaining focus in the rest of the book enable some interesting work to appear and it is here that the happenstance strengths and value of the collection are to be found.

The structure of the book is Friedman's introductory essay followed by seven essays in 'Part 1 – Cultural contexts and cinematic constructions', and eight in 'Part 2 – Filmmakers during the Thatcher era', and, as my comments above imply, Quart's overview essay fits just as logically as a companion piece to Friedman's overall introduction rather than occupying the position it does as the first piece in Part 1.

The remaining six pieces in this first section do manifest a certain broad homogeneity since in various ways and to differing degrees they all focus on 'cinematic constructions' and representations, as a way into saying things about 'cultural contexts'. Thomas Elsaesser in 'Images for sale: the "new" British cinema', Paul Giles in 'History with holes: Channel 4 Television films of the 1980s', and Andrew Higson in 'Re-presenting the national past: nostalgia and pastiche in the heritage film' constitute the core of this section as they analyse the construction and productivity of images generated out of the Thatcher years which variously respond to, interact with, oppose and modify the dominant ones proposed by 'Thatcherism'.

Elsaesser's argument is dense, elliptical and uncharacteristically opaque in places, but his basic concern is not to lose sight of the commodification process at work in the circulation of any mass-produced images, and particularly those arguably constructing a 'national identity', while at the same time wanting to hold on to the vestiges of some notion of 'relative autonomy' for these images even if this is only born out of their very diversity. In their accounts of, respectively, Channel 4's production of films set in an eponymous *Another Time, Another Place* (1983) *Dance with a Stranger* (1984), *Maurice* (1987), *The Dressmaker* (1988), etc.) and of the more diversely originated 'cycle of costume dramas' (*A Room with a View* (1986), *A Handful of Dust* (1987), *Little Dorrit* (1987), etc.), Giles and Higson bear out this thesis by skilfully balancing a discussion of the conservative nature of the dominant images engendered with arguments about the spaces for oppositional readings of them. For Giles there is something about the very simultaneity of the television image which enjoins upon it the portrayal of the past not just in a nostalgic way 'but rather in a manner that maintains a complex, bifurcated perspective shifting between past and present' (p. 81), while for Higson there is a marked tension between the visuals and the narratives in heritage pictures with the former offering all the static flat pastiche of the heritage enterprise as the narratives tell of societies wracked by internal tensions and, from the teleological position of hindsight, in decline.

Of the remaining pieces in this section two propose new and insightful readings in their chosen area. In 'The last new wave: modernism in the British films of the Thatcher era', Peter Wollen offers a concise but more complex overview of Thatcherism than Quart's. Broadly, his argument is that Thatcherism's hostility to creativity enforced on film-makers like Greenaway and Jarman an articulation of their modernist roots in opposition to the dominance of realism and a yoking of these into the service of a highly visual cinema which is simultaneously a cinema of political and aesthetic opposition. As a piece of cultural and cinematic history which describes a relatively unknown current of British art cinema and forges convincing connections between it and Greenaway's and Jarman's very different practices, this is a stimulating essay. It's characteristic, however, of the anthology's confusing structure that there are separate essays on Greenaway and Jarman in Part 2 by, respectively, Michael Walsh, and Chris Lippard and Guy Johnson. These offer

readings in some ways consonant with Wollen's approach – Walsh via psychoanalytic readings of Greenaway's films and Lippard and Johnson through concerns with Jarman's representations of the body, but again editorial cross-connections are never made.

In 'Free from the apron strings: representations of mothers in the maternal British state', Mary Desjardins summarizes issues about 'popular memory' and relates them to filmic and other discursive constructions of the home front understood as 'a site of battle winnable by mothers' (p. 138) in World War II and subsequently. She then goes on to consider representations of the maternal in *Hope and Glory* (1987) and *The Krays* (1990). Quite properly eschewing any discussion of the 'problem' of realist referents in bio- and autobiopix she focuses on the possible meanings of images of disruptive mothers which the films construct and map back on to the earlier more maternal image precisely at a moment when 'a female prime minister tried to free "the people" from a supposedly infantilizing maternal state' (p. 138). Her conclusion is that the two films are characterized respectively by a sense of bitter-sweet irony and cynicism, and as such her account generally is productively insightful into how the rewriting of history complexly involves also the re-visioning of representations. Again, this is clearly consonant with Elsaesser's position and again the editorial fails to make any connection. At a textual level, although her reading of neither film exhausts its potential meanings, Desjardins usefully opens up areas previously ignored in the dominant discussions of each film in terms of male fictions.

The remaining essay in this section by Brian McIlroy on 'The repression of communities: visual representations of Northern Ireland during the Thatcher years' is an overview of how 'the Catholic Community and the IRA; the Security Forces; and the Protestant Community and its Paramilitary Offshoots' have been depicted in a number of films. Lacking any analysis of these representations, or of their history, or of their relation to history, the essay's main value is as an information resource and as such it would have benefited, as indeed would the rest of the book, from some indication of the sources of availability for the films cited.

While, as I've tried to indicate, there is a certain consistency in Part 1's concerns with representation and cultural context, Part 2 is considerably more arbitrary with, as in the case of the Greenaway and Jarman essays already discussed, an equal rationale for them all going into one mega 'Cultural contexts and cinematic constructions' section. In fact the only justification for the separateness of this section seems to be the editor's auteurist principles. Except that it does also contain two essays on workshop collectives . . .

Manthia Diawara's 'Power and territory: the emergence of Black British film collectives' and Antonia Lant's 'Women's independent cinema: the case of Leeds Animation Workshop [LAW]', both raise again the problem of the intended readership. Diawara's lucid summary of theses around Third Cinema, issues of hybridity, and the institutional histories of Sankofa, Black Audio Film Collective, and Ceddo along with commentary on their best-known pictures will undoubtedly prove illuminating to North American college students but, despite the works cited, in itself the piece does no more than go over ground already covered in Britain in more detail (see, for example, Julien and Mercer, 1988; Auguiste *et al.*, 1988; and especially Mercer, 1989). Nor does it address directly the fundamental challenge proffered by Black British film-makers to British cinema's dominant representational strategies.

The Lant piece is rather different in that, valuably, it offers a unique in-depth account of the principles and practices elaborated by LAW in their production of

socially committed left feminist animation. The problem here is that, since broader surveys such as that recently produced by Jayne Pilling (1992) will almost certainly reach a narrower readership than this essay, LAW may consequently be taken by default (in North America mainly, but arguably by British and other readers also) to be the *only* source of feminist animation produced in this country in the 1980s.

The remaining essays in this section arbitrarily omit, for example, Bill Forsyth, Ken Loach, Mike Leigh, and Sally Potter and equally arbitrarily survey the work of Ken Russell, Nicholas Roeg, Stephen Frears, and Terence Davies. Citing Charles Barr's (1986) essay 'Amnesia and schizophrenia', Barry Keith Grant in 'The body politic: Ken Russell in the 1980s' promises to situate his subject across the opposition of realism and fantasy in British cinema but in fact falls into reductive literalisms whereby 'Russell's shocking images of physical decomposition and violence in his recent films are, perhaps, the visual equivalent of Britain's excessive show of strength in the Falkland Islands' (p. 196). Similarly over-literal, Jim Leach's 'Everyone's an American now: Thatcherite ideology in the films of Nicholas Roeg' offers conventional accounts of Roeg's ambiguities tacked on to condensed summaries of Thatcherism here correspondingly characterized as hybrid and contradictory.

Given that Frears' subject matter does seem to be more unproblematically about what it seems to be about than does Russell's or Roeg's, Susan Torrey Barber's title 'Difficulties and moments of ecstasy: crossing class, ethnic and sexual barriers in the films of Stephen Frears' more or less accurately describes her readings of the films and the uncontentious extrapolations of overt social comment she draws from them. As such it's a competent enough auteur study but I must say that I cherish it more for its endearing demonstration of the linguistic slippage between British English and American English revealed when the author tells us apropos of *Prick up Your Ears* that Orton's 'one night stands were frequently with men just encountered in the tube, public toilets, and cottages' (p. 226).

The most achieved of these auteurist studies, not least because of its comprehensive and relevant bibliography, is Tony Williams's 'The masochistic fix: gender oppression in the films of Terence Davies', in which Davies's 'cultural and cinematic contexts' are deftly linked to accounts of the films which draw lightly but confidently and productively on insights derived as much from gender politics as from film theory.

I started this review by noting the particular problems that this anthology added to the normal ones of adequately reviewing such volumes and I make no apology for having said something, no matter how briefly in the space available, about all of the contributions. This has been done in part out of an intellectual concern to respond comprehensively to the strong claims for its project which the book's title implies and which the contents overall don't deliver. (Incidentally, I suspect that a more modest title about 'British cinema in the 1980s' might have found me responding to individual contributions in a less harsh and possibly uncharitable fashion). I've also attempted a comprehensive account simply and strategically so that potential purchasers will have as clear an idea as possible of what they will be getting. From my point of view if what you're after out of a sixteen-essay anthology is eight stimulating textual/cultural analyses – Wollen; Walsh; Lippard and Johnson; Elsaesser; Giles; Higson; Desjardins; Williams – or ten if you're not familiar with the work of the Black British Film Collectives and Leeds Animation Workshop, then arguably it will be money reasonably well spent. What you won't be getting however is an account of British cinema and Thatcherism.

To start to achieve this, a much more coherent working definition of Thatcherism

would need to be offered which enabled account to be taken of the impact which free market philosophy has had on British film production. Thus consideration would need to be given, for example, to the shifting funding and hence changing definitions of the independent sector; to the divergent and shifting trading interests of producers, distributors and exhibitors; to the role of domestic video; and to the impact of Euro-funding. Only then would it be possible to start addressing the issues raised by Sainsbury and Nowell-Smith in the book's epigraphs about the institutional neglect of cinema in British cultural life and from there to go on to speculate about the impact of Thatcherism on British cinema's representations *and crucially* on its audiences – a central concern of any cultural analysis and about which this volume is totally silent.

References

Auguiste, Reece, Gilroy, Paul and Pines, Jim (1988) *Handsworth Songs*, Framework 35.

Barr, Charles (1986) 'Introduction: amnesia and schizophrenia' in Charles Barr (ed.) *All Our Yesterdays*, London: British Film Institute.

Hill, John (1986) *Sex, Class, and Realism in British Cinema 1956–63*, London: British Film Institute.

Julien, Isaac and Mercer, Kobena (1988) 'Introduction: de margin and de centre', *Screen* 29(4).

Landy, Marcia (1991) *British Genres: Cinema and Society 1930–1960*, NJ: Princeton University Press.

Mercer, Kobena (ed.) (1989) *ICA Documents No. 7. Black Film, British Cinema*, London: Institute of Contemporary Arts.

Murphy, Robert (1989) *Realism and Tinsel*, London and New York: Routledge.

Pilling, Jayne (1992) *Women and Animation – a Compendium*, London: British Film Institute.

Cultural policy studies – or, how to be useful *and* critical
Jim McGuigan

■ Franco Bianchini and Michael Parkinson (eds), *Cultural Policy and Urban Regeneration – The West European Experience* (Manchester University Press, 1993) 220pp, £35 Hbk.

The debate on 'cultural policy studies' in Australia and in this journal has largely been conducted in a peculiarly inward-looking manner, as though it were only about future directions for cultural studies as an academic discipline. Tony Bennett's (1992a) criticisms of the almost exclusively significatory politics of cultural studies, its neglect of institutional conditions, and his proposals concerning how cultural studies might intervene in the policy process, have indeed been well put. It is not surprising, however, that he should be chided for overstating the case (O'Regan, 1992), nor surprising that he should feel it necessary to defend his position as having been, perhaps, misunderstood (Bennett, 1992b). Although Bennett developed his original argument in an interesting way, rightly reconnecting 'culture' with

'governmentality' in the broadest sense and by deploying a Foucauldian conception of power against the zero sum game of hegemony theory, what he has to say is hardly startling if you view it from anywhere other than deep inside cultural studies.

Research that might have some political consequence, Bennett contends, must be useful to those who can do something with it, for instance, 'museum curators, pressure groups . . ., committees of management, teams of designers, curators, sometimes even boards of trustees' (Bennett, 1992a: 31). It is not enough, according to this newfound practicality, to deride the governance of culture from the outside: instead, we should try to meet the agents of cultural policy halfway. This is exactly the kind of policy-oriented research that consultancies like Comedia in Britain have been engaged in for many years, providing 'useful knowledge' concerning local cultural needs and the opportunities for stimulating cultural industry in urban districts, and they were commissioned to do so, usually by local and regional governments under socialist control. In fact, during the 1970s and 1980s, cultural policy suddenly obtained a much enhanced official recognition on the soft left and then moved further to the right for mainly economic reasons. This was an international phenomenon of advanced capitalist countries generally, yet it also took specifically localized and regionalized forms, particularly around strategies for urban regeneration in once-great industrial cities.

Many of the city-based policies that were introduced into Europe in the 1980s were inspired by strategies adopted by some cities in the United States during the 1970s. David Harvey (1989) has dated these developments from the early 1970s, the time of the OPEC oil crisis and the coincidental reaction against the sort of modern architecture which symbolized a massified modernity and was functional to it. From around that period the Fordist system of mass production and consumption went into decline in the advanced capitalist world and capital shifted into a much more flexible mode of accumulation. Large-scale factory production, for instance, was switched increasingly from comparatively high-pay countries and cities to cheaper labour markets on the periphery of the First World and in the Third World. Labour costs were reduced, new technologies were rapidly deployed, and differentiation of commodities and styles became more fashionable than mass-standardization in the sphere of consumption.

These developments were traumatic for many old industrial regions and conurbations. Some went into seemingly terminal decline; others more or less swiftly began to adapt to the new economic and cultural conditions. Most notably, city governments, at first in the USA, formulated urban renewal strategies to replace older forms of industrialism with newer high-tech and service industries; and, programmes were adopted for refurbishing cityscapes with postmodern architecture and various kinds of cultural provision. Such strategies are now widely familiar but there is very little comparative analysis of urban cultural policy and its successes or failures. The book edited by Franco Bianchini and Michael Parkinson, *Cultural Policy and Urban Regeneration*, goes some considerable way to filling the knowledge gap concerning Western Europe for both practical and critical purposes.

David Harvey, as well as offering a compelling account of economic and cultural change over the past couple of decades, has been very scathing about the kind of adaptive policies that were pioneered in the USA. For example, cities have been forced into wasteful competition with one another, with the aims of attracting internationally mobile capital and tapping new sources of investment. Many of them have tended to simply replicate one another's solutions to their problems by creating the same kind of cultural spectacles and institutions. He asks sardonically, 'How many successful convention centres, sports stadia, disney-worlds, and harbour

places can there be?' (1989: 273) On the level of abstraction and global sweep at which Harvey operates, it is reasonable and easy to be scathing, but when it comes to practical considerations of employment and the qualities of everyday life in cities that may be losing out in the restructuring process any available opportunities for urban renewal, however predictable and possibly dubious the strategies, tend to represent hope. This has been so throughout Western Europe, as is documented in the Bianchini and Parkinson book.

The series of case studies on cities, including Glasgow, Rotterdam, Bilbao, Bologna, Hamburg, Montpellier, Liverpool and Rennes, in *Cultural Policy and Urban Regeneration*, pose a set of classic problems concerning comparative analysis. They tend to be very detailed and scholarly accounts of the trajectories taken by these cities, all of which have their own particular problems and strategic solutions. It is difficult when reading this book, however, not to become bogged down in the particularities; and, any city that one happens to know or is very interested in for whatever reason will seem very particular indeed. However, the key analytic task for such comparative research is to transcend the differences, albeit respecting them, in order to overcome apparent incommensurabilities between particular cases, by identifying similarities that provide some basis for generaliz-ation. In this discussion of the Bianchini and Parkinson book, then, I shall draw out a few of the available generalizations that can be culled about urban cultural policy across Europe, using specific examples as appropriate.

Another analytical issue is to do with the tension between useful knowledge and critical knowledge. In the main, the case studies collected by Bianchini and Parkinson take the form of useful knowledge, describing strategies and evaluating their effectiveness in such a way that inferences might be drawn for selecting and implementing cultural policies. However, the studies are not like the kind of commissioned research that tends to pull its punches so as not to offend a lucrative client. In David Lazarsfeld's (1941) and Theodor Adorno's (1945) distinction, that would be an 'administrative' and politically decontextualized type of research which is quite the opposite of a 'critical' research, which pipes to no pay master but at the same time runs the risk of political marginalization. Jay Blumler (1978) once identified a form of research which seeks to reconcile 'administrative' and 'critical' objectives, and dubbed it 'meliorative' research. Generally speaking, the case studies in the Bianchini and Parkinson book fall into this third category. While assuming a broadly positive attitude to the aims of European urban cultural policies, they also display a critical distance which identifies faults in the policies under consideration and alternative directions for policy.

A good example of a critically engaged cultural policy analysis is Maarten Hayer's case study of Rotterdam, where he concludes by arguing for a turn towards Michael Walzer's (1986) idea of 'open-minded space' in city centres. City-centre zoning of niche developments in shopping extravaganzas, prestige arts centres and so on, tends to have a socially exclusionary effect, attracting certain groups and putting others off, thereby denying possibilities of coexistence between different cultural and economic groups.

A notable British example of this would be Centenery Square and the develop-ments around it in Birmingham, the city where cultural studies made its name. Arguably, Centenary Square, with its convention centre, concert hall housing the City of Birmingham Symphony Orchestra, repertory theatre and luxury hotel, is not a very 'open-minded space'. 'Open-minded space', by definition, would avoid confining such a showpiece public place to an exclusively upmarket and mono-cultural appeal. The principal aim of Birmingham City's Labour Council would

seem, however, to have been to secure this prestigious space for the cultured middle-class in a way similar to other city centre developments across Western Europe, including Rotterdam. Astonishingly, in 1991, Birmingham Council erected a £275,000 fibre-glass, neo-Stalinist monument to post-industrial labour called 'Forward' just about the time when innumerable similar statues were being pulled down across Eastern Europe and could, presumably, have been had for nothing. Its meaning to the multi-ethnic and deindustrialized Birmingham populace probably bears some resemblance to the popular disapproval for those fallen statues of Communism.

The case studies in *Cultural Policy and Urban Regeneration* are sandwiched by Franco Bianchini's excellent introductory and concluding chapters. Bianchini points out that the urban cultural policies of the 1980s were encouraged by political decentralization. Western European central governments devolved power and money to regions and cities. France, where the state has been exceptionally centralized since Napoleon, is the most notable instance of this decentralization process, and rather different from, say, Germany where under the Lander system cities like Hamburg have had enormous autonomy traditionally. When the Socialists came to power in France in 1981 they introduced decentralizing legislation and put communications and cultural policies much nearer the top of their agenda than had been the case for the outgoing Giscardian government. Patrick Le Gales reports on the typically French case in his study of Rennes in Britanny. In October 1982, Mitterrand's Minister of Culture, the celebrated Jack Lang, signed a convention with Rennes city council agreeing to fund an expansion of spending on culture in the city and outlying region. This kind of arrangement was not peculiar to Rennes. There is also a study of Montpellier, a rather different example, in the Bianchini and Parkinson book. Between 1978 and 1990 the major French cities' expenditure on culture rose from, on average, 8 per cent of their budgets to 15 per cent. As well as improving 'the quality of life', the aim, then, of the French Socialist governments during the 1980s was to stimulate economic growth at local and regional levels; and this was not uncommon throughout Europe.

Even in Britain, where regional and local democracy was reduced and spending was restrained by Conservative central government during the 1980s and since, significant developments also occurred in the cities and regions. There was, for example, a substantial devolution of funds from the English Arts Council to the Regional Arts Associations that have subsequently been renamed Regional Arts Boards. The Urban Development Corporations (UDCs) that were set up in the 1980s also encouraged cultural developments with a regenerative and economic purpose. These UDCs are quangos formed by central government to appropriate the kind of responsibilities held previously by democratically elected metropolitan county councils until they were abolished for nakedly ideological reasons in the mid 1980s. For example, the Merseyside Development Corporation was an important player in the Liverpool Garden Festival and the refurbishment of the Albert Dock to house the Tate Gallery in the North, shops and restaurants. So, although Britain has been somewhat backward in cultural policy by Western European standards, the same trends as in France, Holland and similarly comparable countries were evident: this in spite of the fact that public expenditure on culture has been generally much lower in Britain than in such countries.

In another important respect Britain has been in step with the rest of Western Europe and, to some extent, ahead of it by shifting cultural policy out of an exclus- ively state subsidized sector. Across Western Europe, during the 1980s, public/ private partnerships arose, bringing together local governments and businesses to

formulate and fund policies of urban regeneration. And, whereas the newer cultural policies had originated on the left, very often inspired by 1960s and 1970s counter-cultural movements, they became increasingly of interest to business and the political right, thus creating a new kind of consensus regarding culture, economy and polity at regional and local levels.

The striking thing, however, confirmed by most of the studies in the Bianchini and Parkinson book, is that there is very little evidence of direct economic benefit derived from cultural investment strategies in Western European cities. In their study of Hamburg, Jurgen Friedrichs and Jens Dangschat go so far as to argue that 'economic growth can be induced without a clear cultural policy and spectacular new buildings for culture'. And, 'most probably', they say, 'investment in culture is not a major factor for success in urban regeneration strategies' (p. 132). However, as Friedrichs and Dangschat note, by and large, cities pursuing ambitious cultural policies have succeeded in repositioning their images, the most spectacular example being Glasgow which went from a reputation for being a rundown and violent city through the 'Glasgow's Miles Better' campaign of the early 1980s to become European City of Culture in 1990. Other cities have had similar successes but not quite so dramatic, such as Rotterdam and Bilbao. In effect, then, these cities, in addition to expenditure on festivals, performance venues, galleries and museums, and general improvements to the built environment, have engaged in 'city marketing', which may have indirect economic effects by attracting new businesses though not necessarily, if at all, in the cultural field. But, even then, the evidence suggests that companies' decisions about relocation tend to be based much more on local labour-market conditions, transport, and housing, rather than on the ambience and cultural provisions of a city. None the less, the aim is clearly to appeal to better-off managerial and service sector professionals who are the main vultures of culture in North America and Europe, perhaps to the detriment of the local working-class, unemployed and marginalized groups, including ethnic minorities whose spending power is not high. That, obviously, sets up one of the key tensions in urban regeneration strategies conducted through cultural policy.

In concluding *Cultural Policy and Urban Regeneration*, Franco Bianchini makes a pitch for his own distinctive perspective of an 'holistic cultural planning'. The main virtue of a recently unfashionable but now rekindled holism in social and cultural analysis is the emphasis on a totality of relations, the interrelatedness of various aspects of a problem. Economistic cultural policy is extremely vulnerable to holistic criticism since it privileges the economic over aesthetic and social considerations: everything becomes subordinated to economic goals which, ironically, are seen to have doubtful success, as the case studies in Bianchini's and Parkinson's book indicate. Perhaps the most obvious issues in Europe for politics in general and for the politics of culture in particular, though by no means exclusively in Europe, are the problems of the American-termed 'underclass' and the racial and ethnic tensions that exist in the modern city. Economistic cultural policy has very little, if anything, to offer here. It is John Kenneth Galbraith's (1992) income-tax mean 'culture of contentment' which is best served by such policy, not the casualties of deindustrialization and racism.

Bianchini also identifies three structuring 'dilemmas in urban cultural policy development'. First, there are spatial dilemmas, for example, illustrated by those city-centre strategies that have, indeed, been successful, in terms of revivifying the public domain of cities while neglecting rundown inner-city districts and the cultural privatization of the suburbs. Another familiar problem in this respect is the process of gentrification whereby decaying localities are recovered for the cultured middle

class, very often in the first instance by artists or at least lifestyle aesthetes of a radical hue, often to the disadvantage and eventual exclusion of low-income groups (see Zukin, 1989). Bianchini cites the alternative model of the Red city of Bologna's strategy, documented by Jude Bloomfield, in terms of its attention to neighbourhood youth and cultural centres in addition to the more prestigious city-centre provisions.

Second, there are dilemmas around the pursuit of consumption and production strategies for cultural policy, whether to develop the city as a cornucopia of consumption or to try and establish an infrastructure of cultural production which may have significant employment and representational value. It is much easier to attract chain stores to a new shopping development than to build upon or construct from scratch production-based cultural industries.

Third, there are dilemmas concerning whether to put resources into 'ephemeral' and perhaps transient forms such as festivals or into permanent institutions such as concert halls and prestigious arts centres. The often potentially wider appealing ephemera are the first to go when cut backs in cultural policy spending happen. But cities may also run the risk, on the other hand, of landing themselves with expensive white elephants.

Ultimately, according to Bianchini, the real test of cultural policy is not economic but political in the sense of contributing to a deepening and broadening of citizenship rights in the context of genuine democracy. His claim, which is a debatable one, is that 1980s economism is passé, although it seemed so new and glitteringly golden only yesterday. The agenda for the 1990s is one of a renewal of citizenship which assumes that people do not live on bread alone.

References

Adorno, T. (1945) 'A social critique of radio music', *Kenyon Review* 7, Spring.

Bennett, T. (1992a) 'Putting policy into cultural studies' in L. Grossberg, C. Nelson and P. Treichler (eds) *Cultural Studies*, New York: Routledge.

—— (1992b) 'Useful culture', *Cultural Studies* 6(3).

Blumler, J. (1978) 'Purposes of mass communication research: a transatlantic perspective', *Journalism Quarterly* Summer.

Galbraith, J. (1992) *The Culture of Contentment*, London: Sinclair Stevenson.

Harvey, D. (1989) *The Urban Experience*, Oxford: Basil Blackwell.

Lazarsfeld, D. (1941) 'Administrative and critical communications research', *Studies in Philosophy and Social Science* 9.

O'Regan, T. (1992) '(Mis)taking cultural policy: notes on the cultural policy debate', *Cultural Studies* 6(3).

Walzer, M. (1986) 'Pleasures and costs of urbanity', *Dissent* 470.

Zukin, S. (1989) *Loft Living*, N.J.: Rutgers University Press.

Notes on contributors

IEN ANG teaches in the School of Humanities at Murdoch University, Perth, Western Australia, where she is also Director of the Centre for Research in Culture and Communication. Her latest book is *Living Room Wars: Rethinking Media Audiences for a Postmodern World* (Routledge, 1995) ... TONY BENNETT is Professor of Cultural Studies and Founding Director of the Institute for Cultural Policy Studies at Griffith University in Brisbane, Australia ... JIM COOK worked for ten years in the Education Department of the British Film Institute and is now a freelance writer and lecturer ... KUAN-HSING CHEN is with the Center for Cultural Studies, National Tsing Hua University, Taipei. He is the author of *Media/Cultural Criticism: A Popular-Democratic Line of Flight* (Taipei, 1992), *Intellectual Moods and Geo-Colonial Sites: Cultural Studies from the Postmodern to Decolonization* (Taipei, 1996), and the co-editor of *Cultural Studies: the Implosion of MacDonalds* (Taipei, 1992), (with David Morley) *Stuart Hall: Critical Dialogues* (Routledge, 1996) and *Trajectories: Towards a New Internationalist Cultural Studies* (forthcoming) ... STUART HALL is Professor of Sociology at The Open University ... HENRY KRIPS is Professor of Communication at the University of Pittsburgh, where he coordinates the area of rhetoric of science. He has published extensively in the foundations of physics, including a book-length study of *The Metaphysics of Quantum Theory*. Recently, he has worked on connections between social theory, cultural studies and theories of the subject ... SMADAR LAVIE is Associate Professor of Anthropology and Critical Theory at the University of California at Davis. She is the author of *Poetics of Military Occupation* (University of California Press, 1990) and co-editor of *Creativity/Anthropology Identity* (Duke University Press, in press). She is working on a book about Third World (Palestinian and Mizrahim) Israeli writers ... JOHN LYNE is a Professor in the Department of Communication Studies at the University of Iowa. During the 1994–95 academic year, when he wrote his essay, he was a Visiting Fellow at the Center for Philosophy of Science, University of Pittsburgh ... SABA MAHMOOD works on issues of modernity, gender and politico-religious movements. She is currently doing field work in Egypt as part of the doctoral program in anthropology at Stanford University ... JIM McGUIGAN is co-editor of *Studying Culture* and teaches Communication and Cultural Studies at Coventry University, UK ... JON STRATTON is Senior Lecturer in Cultural Studies at Curtin University of Technology and, at present, Visiting Associate Professor in the Communications Program at Murdoch University. His most recent book is *The Desirable Body: Cultural Fetishism and the Erotics of Consumption* (Manchester University Press, 1996) ... TED SWEDENBURG is Assistant Professor of Anthropology at the American University in Cairo. He is the author of *Memories of Revolt: The 1936–1939 Rebellion and the Palestinian National Past* (University of Minnesota Press, 1995) and co-editor of *Displacement, Diaspora, and Geographies of Identity* (Duke University Press, in press). He is currently investigating how diaspori ethnic and national identities are articulated through various genres of Arab–Islamic musics.

191

Call for Papers and Contributions for a Special Issue on The Institutionalization of Cultural Studies

The editors propose an issue of *Cultural Studies* on the question of the institutionalization of cultural studies in the academy.

It is obvious that many colleges and universities, journals and publishers are moving, in a variety of ways, to locate themselves within the field of cultural studies. A number of universities already have programs in cultural studies and even more are either just beginning or in the planning stage, although these vary widely. Some have curricular responsibilities at either the undergraduate or graduate level; some offer majors and degrees, while others function as interdisciplinary supplements to existing degree programs. Some are purely involved in encouraging and supporting interdisciplinary activities and scholarship. The status of these programs, as well as their official designation, varies widely. Some are funded by their home institutions while others have received foundation grants to support their activities. Finally, different programs, although united in their commitment to cultural studies, define cultural studies very differently, some narrowly and others more broadly.

We would like this issue to serve two distinct but related functions: first, as a source of information about existing or planned programs; and second, as a forum for discussions about different strategies for institutionalizing cultural studies and the significance of different strategies for the project of cultural studies itself. We are particularly concerned that this issue be as international as possible.

We invite people involved in any existing or planned program in cultural studies, to submit a description of the program. This description should include such things as: the operating definition of cultural studies; the range of activities and responsibilities; institutional forms and powers; sources of funding; a brief history; participating departments and/or faculty; contact address; etc. We will publish these as a resource, both to help create an international network of cultural studies programs, and as a guide for others hoping to create such programs. If your own institution has such a program or is planning such a program, we would appreciate hearing from you. If you know of other institutions which should be included, please pass this call on to them or contact us and we will send them a copy. We will endeavor to update this list on a regular basis.

Furthermore, we invite interested people to submit essays on the challenges and dangers of institutionalization for cultural studies. We are hoping that the issue of the journal can address a wide range of viewpoints, including different expectations, attempts, and experiences with institutionalizing cultural studies. Such essays might reflect on the history of the formation of specific programs, or on the politics of specific forms and strategies of institutionalization, or they might address more general themes of interest to cultural studies scholars.

Deadline for Submissions: January 1997.

Call for Papers

For a proposed collection on Victorian women's emigration to the colonies and dominions, edited by R. S. Kranidis. Any theoretical and historical approach, any discipline. Subjects may include, among others: the politics of emigration, Victorian women and the Empire, emigration discourse, the 'unauthorized' colonial experience, etc. Submit a two-page proposal, or essay, by September 29, to: R. S. Kranidis, English Department, Radford University, Radford, VA 24142-6935, USA.

Travel-to-Collections Grants

Three or more grants of up to $750 are available from the John W. Hartman Center for Sales, Advertising, and Marketing History, Special Collections Library, Duke University to: (1) graduate students in any academic field who wish to use the resources of the Center for research toward M.A., Ph.D., or other postgraduate degrees; (2) faculty members working on research projects; or (3) independent scholars working on nonprofit projects. Funds may be used to help defray costs of travel to Durham and local accommodations.

In 1966, for the first time, the travel-to-collections program will include three J. Walter Thompson Research Fellowships. In addition to the regular TTC grants (awards of up to $570 available to faculty, graduate students, and independent researchers) the Hartman Center will fund three J. Walter Thompson Research Fellows. Each fellow will receive a stipend of $1,000 during their stay in Durham. Fellowships are available to researchers planning to spend a minimum of two weeks at Duke doing research in the J. Walter Thompson Company Archives.

The major collections available at the Hartman Center at the current time are the extensive Archives of the J. Walter Thompson Company (JWT) – the oldest advertising agency in the US and a major international agency since the 1920s – and the advertisements (1932+) and a moderate amount of agency documentation from D'Arcy, Masius, Benton & Bowles (DMB&B). The Center holds several other smaller collections relating to nineteenth- and twentieth-century advertising and marketing.

Requirements: Awards may be used between December 1, 1995 and December 31, 1996. Graduate student applicants (1) must be currently enrolled in a postgraduate program in any academic department and (2) must enclose a letter of recommendation from the student's adviser or project director. Please address questions and requests for application forms to: Marion Hirsch, John W. Hartman Center for Sales, Advertising and Marketing History, Special Collections Library, Duke University, Box 90185, Durham, NC 27708-0185; Phone: 919-660-5827; Fax: 919-684-2855; E-mail:

Deadlines: Applications for 1994–95 awards must be received or postmarked by October 15, 1994. Awards will be announced by mid-November.